Cor

Aaron Sorkin

Considering Aaron Sorkin

Essays on the Politics, Poetics and Sleight of Hand in the Films and Television Series

Edited by THOMAS FAHY

McFarland & Company, Inc., Publishers
Jefferson, North Carolina, and London

LIBRARY OF CONGRESS CATALOGUING-IN-PUBLICATION DATA

Considering Aaron Sorkin : essays on the politics, poetics and sleight of hand
in the films and television series / edited by Thomas Fahy.
 p. cm.
Includes bibliographical references and index.

ISBN-13: 978-0-7864-2120-6
(softcover : 50# alkaline paper) ∞

1. Sorkin, Aaron — Criticism and interpretation. I. Fahy, Thomas Richard.
 PN1992.4.S62C66 2005 812'.54 — dc22 2005000091

British Library cataloguing data are available

Cover photograph ©2005 PhotoSpin

Manufactured in the United States of America

McFarland & Company, Inc., Publishers
Box 611, Jefferson, North Carolina 28640
www.mcfarlandpub.com

Contents

Introduction

Thomas Fahy

As a culture, we are fascinated with stories about genius and the process of creation. After the birth of her first child, Sylvia Plath dealt with her insomnia and depression by getting up at four in the morning and writing poetry. Jane Austen worked in the parlor of her house, secretly writing novels on a notebook that she hid during social visits. And Sir Arthur Conan Doyle often scrawled ideas for stories about his character Sherlock Holmes on napkins at dinner parties. Given the tremendous popularity of biographies (from tabloids to television programs), it is not surprising that we enjoy hearing and retelling such stories. They humanize public figures and connect genius with the everyday. In this media-saturated age, the inherent intimacy of television (a television sits in most living rooms and bedrooms in America, for example) encourages an obsession with celebrity — a desire to learn more about those in the public eye.

Writer and producer Aaron Sorkin has received his share of such attention. As with so many prominent figures, a mythology surrounds him and his work. One of the most famous legends refers to the play that launched his career, *A Few Good Men* (1989). As Sorkin recalls in an interview with Charlie Rose (August 13, 2003):

> I wrote [*A Few Good Men*] on cocktail napkins during the first act of Broadway shows where I was serving as a bartender. You work what's called the "walk-in," which is the half hour before the show when people are coming in; you work the fifteen minutes of intermission. During the first act you have nothing to do, and I was writing *A Few Good Men* on cocktail napkins. I'd go home with my pockets filled with cocktail napkins; I'd dump them out. I had a Mac 512 K which was the second-generation MacIntosh computer which my roommates and I — we pooled

1

our money and we bought it — and I'd start to type it and that would be my first polish that I was doing. I'd type it out, and I'd cross things out, and I'd type it again. I would do seven, eight, nine, ten drafts before I would even show anybody the thing. But on *The West Wing*, we'd shoot my first draft. There wasn't time to polish it.*

This story is part of the mythology that characterizes Sorkin as a genius — a writer with words spilling out of him feverishly, almost uncontrollably. A writer who turns in television scripts at the last minute and doesn't compromise his vision.

Of course, Sorkin is not an actor or politician or rock star; he's primarily a writer, someone who spends most of his time in front of a computer screen, not a camera. So how do we explain his highly visible presence in the media? It's difficult to think of another screenwriter with a comparable public profile. Perhaps David E. Kelley — the creator of shows such as *Boston Public, Ally McBeal, The Practice, Chicago Hope,* and *Picket Fences* — comes close, but we know far less about his writing process than we do about Aaron Sorkin's. And no matter what accolades Martin Sheen or Allison Janney receive for their work on *The West Wing*, Aaron Sorkin is always prominently featured in discussions of the show. We don't think about the team of writers behind *Sports Night* or the staff generating story ideas for *The West Wing*; we think only of Sorkin. Whether intentionally or not, Sorkin has made himself and his image an integral part of his work.

The language commonly used to describe Sorkin's work also distinguishes him from most other television writers. Even some of his harshest critics consider Sorkin's writing "brilliant," evidence of "genius." These labels, along with his prolific output, critical successes, and, of course, his highly publicized drug problem, place Sorkin in a long tradition of literary genius. It is rather clichéd to talk of writers with alcohol and drug problems, but this is particularly relevant to Sorkin's public image. We associate genius with such problems. We see it as something out of bounds, as something that goes hand in hand with self-destructive behavior. In the introduction to *The West Wing Script Book* (2002), Sorkin subtly links his problem with drugs to his art:

My first play, *A Few Good Men*, opened on Broadway when I was 28 and didn't close for another 497 performances. I followed that with an off–Broadway disaster called *Making Movies*. I followed

*Excerpts from this interview with Charlie Rose are available at http://westwing.bewarne.com/credits/sorkin.html.

that with the screen adaptation of *A Few Good Men* and then *Malice* and then *The American President.* I followed *The American President* with a 28 day stay at the Hazelden Center in Minnesota to kick a cocaine habit [3].

By following this long list of accomplishments with a reference to his addiction, Sorkin makes his cocaine habit part and parcel of his artistic identity. He has been both a writer and a drug addict. We accept it almost as nonchalantly as Sorkin writes about it because we typically define genius in terms of extraordinary accomplishment as well as manic and self-destructive behavior. Sorkin has both, and both have made him an icon in American culture.

Fast Talkers: The Craft of Aaron Sorkin

Like Aaron Sorkin, Arthur Conan Doyle was an incredibly prolific and diverse writer. Both writers wrote on napkins. Both appeal to a popular market. Both use episodic formulas (detective fiction and teleplays), recurring characters who behave in predictable ways, and highly structured plots. Writing in the 1890s, Conan Doyle examined the increasing complexity of life in London at the height of the British Empire. His Sherlock Holmes balances keen rationalism with intuition to solve crimes. A master of disguise, Holmes takes on the London underworld in order to understand it, recognizing the need to get his hands dirty in order to engage with the moral complexity of right and wrong. Yet in the end, he still emerges with certain ideals intact. Justice and harmony are restored, and we are better for confronting these social problems.

Aaron Sorkin also takes his audience on an oftentimes dirty and frustrating journey into moral complexity. The politics of law, art, education, gender, sexuality, and race preoccupy much of Sorkin's work, and, as he reminds us, politics is messy. To illustrate this, Sorkin often presents good people doing the "wrong" thing for the "right" reason. An intern working for the White House in "Take Out This Trash Day" (*The West Wing*), for example, reveals sensitive information about Leo McGarry (chief of staff) after reading his personnel file. What starts out as an unethical violation of trust becomes something that the audience can understand and even forgive:

> LEO: When you read in my personnel file that I had been treated for alcohol and drug abuse, what went through your mind? ...
> KAREN: My father drank a lot.... My father used to ... You have all these important decisions to make in your job. Every day.... People's lives....

This stilted revelation about her father mitigates the egregiousness of her act (for which she is fired), and Leo's decision to rehire her inspires our forgiveness as well. This kind of personal or ethical ambiguity characterizes Sorkin's writing. His characters and their interactions feel real, in part, because Sorkin intersects the complex and often messy world of personal experience with the equally murky terrain of political and social issues. The challenge for his characters, and the audience, is to recognize the complexity and make informed and humane decisions. In this way, Sorkin uses the "pulpit" of television to raise the level of debate about important issues, such as the death penalty, racism, and public funding for the arts.

Sorkin's films clearly showcase some of the characteristics that would later define his television writing — particularly his use of language. With a musician's sense for rhythm, Sorkin crafts dialogue that brings characters to life. His crisp, tight language, like David Mamet's and Ernest Hemingway's, is not only exciting to listen to but often poetic in its beauty and power. Deft wordplay appears throughout his films. In *A Few Good Men* (1992), one of Daniel Kaffee's daily rituals includes parrying clichés with Luther, the attendant of a local newsstand:

> KAFFEE: How's it goin', Luther?
> LUTHER: Another day, another dollar, captain.
> KAFFEE: You gotta play 'em as they lay, Luther.
> LUTHER: What comes around, goes around, you know what I'm sayin'.
> KAFFEE: If you can't beat 'em, join 'em.
> LUTHER: Hey, if you've got your health, you got everything.
> KAFFEE: Love makes the world go round. I'll see you tomorrow, Luther.

This lighthearted banter not only offers some comic relief from the tensions of the murder case, but it also underscores the thematic importance of language in the film — Kaffee's attempt to get those on trial to tell the truth.

This kind of exchange can be found throughout Sorkin's television work. Many of his characters, for example, relish correcting grammar and reciting statistics in the face of ignorance. They often define themselves by what they know and demonstrate their knowledge through fast-talking debates and a quick wit. Given Sorkin's investment in the power of words, it is not surprising that his television drama is set primarily in the workplace. Rarely, if ever, do we see the characters' homes in *The West Wing* and *Sports Night*. (Arguably, Kaffee's apartment in *A Few Good Men* is more of an ad hoc office than a home. And most of the action in *The American President* happens either in the White House or in Sydney Wade's office.) The

workplace (an office, a courtroom) is a place of action and ideas, not rest. And if nothing else, Sorkin's television characters are always on the move. Tirelessly walking through halls at a lightning pace, their energized movement is a metaphor for their professional passion. They readily sacrifice their personal lives for work because they believe so strongly in the social and moral value of what they're doing. As Leo explains to his wife in "Five Votes Down" (*The West Wing*):

> LEO: This is the most important thing I'll ever do, Jenny. I have to do it well.
> JENNY: It's not more important than your marriage.
> LEO: It is more important than my marriage, right now. These few years while I'm doing this, yes, it's more important than my marriage.

The workplace is where individuals can do important things (often for others), and it is a space that offers Sorkin a wide range of discourses — debate (about social justice, principle, and ethics), competitive banter, humorous play, no-nonsense professionalism, and even tenderness. As Sorkin told me in the interview included in this collection, "Anything that I write is going to be on the talky side. Basically, we're talking about people in rooms — talking."

Overview

This collection, *Considering Aaron Sorkin*, brings together scholars from a variety of fields (film studies, literary criticism, art history, political science, theater studies, American history) to examine the rhetorical strategies and thematic content of Sorkin's writing. Beginning with two essays on the neo-noir thriller *Malice,* seemingly the most atypical work in Sorkin's oeuvre, critics Robert F. Gross and Susann Cokal discuss the portrayal of gender and the role of storytelling in this film.

In "Mannerist Noir: *Malice,*" Robert F. Gross situates this film in the traditions of Mannerism and film noir. The concern in Mannerist art with imitation stems from the "fear that all good stories have been told already, and told well." The challenge facing contemporary screenwriters, therefore, is innovation. How does the writer create something new in the existing constraints of film, television, and drama? As Gross explains, this question is complicated even further in the conventions of neo-noir: "From the start, film noir has manifested a tendency toward Mannerist contrivances, needing to pile double-cross upon double-cross and thrilling revelation upon

revelation, all in a desperate attempt to tease out one more variation on an oh-so-familiar theme." Gross focuses on Andy's violent initiation into manhood as an example of the film's deft ability to rework the standard noir plot. Though Andy is able to overcome his "naïve vision of gender" and move beyond his sentimentalized view of the world, he is left without words of his own. He ends the film by quoting his mother-in-law, and Gross reads this as reflecting both Andy's literal sterility and Hollywood's in its endless drive to reproduce the same types of film.

Susann Cokal also touches on the conventions of noir in *Malice*, but her essay, "In Plain View and the Dark Unknown: Narratives of the Feminine Body in *Malice*," argues that the film's preoccupation with knowing the female body shapes its narrative structure and use of light and dark. The female body is a dark, unknowable space that men — academics, doctors, and even serial killers — probe in an attempt to control and understand. By making her own body vulnerable, however, Tracy retains control of her story, which enables her to manipulate those around her. Cokal further shows that the use of light and dark in *Malice* reinforces the deceptiveness of the character: "The movie emphasizes vision as a way of both constructing and deconstructing narratives about the body. *Malice* differs from typical narratives of the female body in that the emphasis on darkness helps to create it not only as a medical uncertainty but, more importantly, as a quantity over which the individual — in this case, Tracy — can take control, precisely (and perhaps paradoxically) by virtue of its unknowability."

With my essay, "Athletes, Grammar Geeks, and Porn Stars: The Liberal Education of *Sports Night*," the collection begins to consider Aaron Sorkin's narrative techniques for television. Unlike film, the medium of television enables a writer to develop characters and story ideas over a long period of time. In both genres, Sorkin relies on dialogue to pace the action, shape narrative, and establish important thematic issues. Through his portrayal of intelligent, witty, fast-talking characters, for example, Sorkin makes education a heroic virtue in *Sports Night* (as well as in *The West Wing*). His characters often achieve heroic status because they continually strive to educate (or better) themselves, and in this way, the show embodies some of the traditional tenets of a liberal education — namely the value of a universal education and the importance of prioritizing community over the self. For Sorkin, education has the power to make people better citizens morally and socially, but this can only be achieved through self-examination and debate. All of the characters in *Sports Night* struggle to achieve the type of self-awareness that encourages personal sacrifice. At times, this message is derailed by humor that uses knowledge to belittle people, but ultimately, *Sports Night* teaches its audience about the value of education.

Douglas Keesey's "A Phantom Fly and Frightening Fish: The Unconscious Speaks in *Sports Night*" offers a psychoanalytic reading of *Sports Night*, examining the images that enable characters to reveal their unconscious desires. Casey's preoccupation with a fly that no one else sees and Dana's fear of fish, for example, reflect their repressed desire for each other. Keesey argues that "many of the couples in *Sports Night* receive promptings from their unconscious which call upon them to recognize and declare their desire for each other." Only by confronting the unconscious, Keesey states, can the characters of *Sports Night* articulate and understand their fears and desires. In the end, "these surreptitious signals — words and images affected by the unconscious — allow the self to comprehend and dispel the fears that have clouded the free expression of desire."

Kirstin Ringelberg sees Sorkin's stereotypical depiction of women as another barrier between men and women and between Sorkin's writing and his audience. "His Girl Friday (and Every Day): Brilliant Women Put to Poor Use" argues that Sorkin's fast-talking, quick-witted women are fundamentally modeled on the heroines in 1930s and 1940s screwball comedies — "no-nonsense women ... are finally incapable of existing without the protection, adoration, and support of the men." Even though the female characters in films like *His Girl Friday, Bringing Up Baby,* and *Mr. Smith Goes to Washington* are masterful talkers who verbally spar with men to demonstrate their strength and independence, they ultimately cannot survive without men. Given the importance of dialogue for Sorkin, it is not surprising that he is drawn to these types of characters, but Ringelberg suggests that this enchanting, intelligent language is deceptive. It does not change the subordination of women to men in Sorkin's writing. She concludes that Sorkin — despite being "understood as a mainstream film and television writer whose work promotes progressive liberal objectives, including gender equality, and envisions a 'better' America for those traditionally oppressed — is, in the end, trapped in a conservative past."

Fiona Mills continues with these concerns about Sorkin's portrayal of women in her analysis of *A Few Good Men*. "Depictions of the U.S. Military: Only 'A Few Good Men' Need Apply" argues that the admirable qualities of Jo's character — her moral convictions, intelligence, assertiveness, and drive — are repeatedly undercut by the belittling remarks and attitudes of the men around her. Even as the play "triumphs over the military's policy of silence and hyper-masculinity," Jo never achieves a true voice. As Mills explains, "Jo's moral turpitude enables the drama to zero in on Danny's struggle to overcome his inner demons and step out from under his father's shadow — an act that solidifies Jo's position as a dramatic prop used to propel the real, i.e. male, drama forward." Mills concludes that Jo is not only

rendered voiceless in the narrative, but her degrading subordination through-
out the story also parallels the subordination of women in the U.S. military
today.

The rest of the collection focuses primarily on *The West Wing* and
Sorkin's first work on the politics in the White House, *The American Presi-
dent*. In "Giving Propaganda a Good Name," Ann C. Hall argues that *The
West Wing* can be seen as an example of postmodern propaganda. After
beginning with a discussion of the term "propaganda" and its typical asso-
ciations with totalitarianism, Hall uses Nancy Snow's broader definition
(which includes the strategies used in advertising, public relations, and polit-
ical campaigns) to show that *The West Wing* "is not naïve or idealized, as
some critics have claimed, but, rather, a successful piece of postmodern pro-
paganda whose goal is to create greater faith in the American political
process." Through its thematic content and filmic style, *The West Wing* is a
show that "presents government processes in particular and people working
together in general in a positive light."

Both Spencer Downing and Nathan A. Paxton examine issues of virtue
and duty in Sorkin's political writing. In "Handling the Truth: Sorkin's Lib-
eral Vision," Downing returns to some of the issues of liberalism and lib-
eral education raised in my essay by looking at the virtues of civil service in
A Few Good Men, The American President, and *The West Wing.* Downing
argues that "Sorkin strives to re-inscribe liberalism into the political main-
stream by encouraging audiences to see liberal values as plausible, pragmatic,
and patriotic." Sorkin's drama, in other words, promotes a liberal under-
standing of the world, embracing what historian Arthur Schlesinger, Jr., calls
a "vital center"—a view of liberalism that acknowledges the complexities of
the world while embracing individual values and a belief in social welfare.
Downing discusses this liberal impulse running through Sorkin's work and
the rhetorical strategies he uses to show, in fact, that government has a
responsibility to take an active part in the lives of its citizens.

"Virtue from Vice: Duty, Power, and *The West Wing*" explores the moti-
vations of characters who dedicate themselves with single-minded enthusi-
asm and endless self-sacrifice to politics and public policy. Surprisingly, as
author Nathan A. Paxton explains, it is not power but "duty that motivates
and rewards" these figures. At times, the sense of duty on the show is prob-
lematic: "Their commitment to their duty is so clear that they forsake rela-
tionships, marriages, money, and perhaps even their lives in service of an
ideal. For the viewer, such a commitment to duty can provoke admiration,
but, in its inaccessibility, it is ignorable and finally ineffective." *The West
Wing* also shows how duty and power are inextricably linked in American
politics, and Paxton places this relationship in the history of American

government and political thought. *The West Wing*'s fundamental premise is that duty must temper power; otherwise, the pursuit of power becomes dangerous for the self and the public. And Sorkin clearly rewards those who act out of duty. For Paxton, this emphasis on duty is one of the innovations of *The West Wing*: "For in framing the solution to the challenges of American common life in terms of duty, subsuming the pursuit of power to something more ennobling, *The West Wing*'s creative team suggest a way out of our perceived miasma of partisanship and posturing."

Laura K. Garrett revisits Kirstin Ringelberg's concerns with Sorkin's deceptive portraits of women — women who are powerful and capable on the surface, yet still embody conventional stereotypes. Garrett's "Women of *The West Wing*: Gender Stereotypes in the Political Fiction" compares contemporary portraits of women in politics with Sorkin's characters. By juxtaposing Hillary Clinton and Dee Dee Meyers with their fictional counterparts, Abigail Bartlet and C. J. Cregg, Garrett argues that Sorkin ultimately relies on the media-constructed stereotypes of powerful women in politics to shape his fictional characters: "By limiting Abigail to confrontational scenarios with the president, [for example,] Sorkin fails to mine the potential depths of her character or allow her to grow." Garrett concludes that Sorkin relegates even his most powerful women to peripheral positions, missing an invaluable opportunity to reject stereotypical portraits of powerful women in the media and to promote images of gender equality.

The collection concludes with a filmmaker's view on the works of Aaron Sorkin. In "The Republic of Sorkin: A View from the Cheap Seats," John Nein's discussion of virtue resonates with the essays of Spencer Downing and Nathan A. Paxton. For Nein, the dramatic power of Sorkin's writing comes from his willingness to explore the political and moral complexity of key issues. Through dilemma and debate, Sorkin challenges audiences to engage with this complexity, not to settle for simple answers — a dimension absent from most mainstream television and film. As Nein explains, "Sorkin's *The West Wing* might not be real, but its ideal depiction of politics as the realm of difficult decision-making by enlightened humanists and rigorous thinkers not only creates a moral complexity that is sadly lacking in both popular entertainment and the public face of politics, but begs the question, why should we so readily dismiss its idealism? His writing is an exploration of virtue and the seemingly naive merit of idealism – the courage of conviction amidst a world of compromise."

The essays collected here offer a range of critical perspectives on the politics, poetics, and sleight of hand in Aaron Sorkin's works. From his innovative portrayal of complex social issues and well-educated people to his skillful use of dialogue in crafting stories and creating believable characters,

Sorkin knows how to work magic on his audiences. At times, it is easy to get caught up in the rhythm and beauty of his prose and overlook some of the contradictions in his works. But ultimately, his work reminds us of the potential that television and film have to produce great art.

An Interview with Aaron Sorkin

Thomas Fahy

Aaron Sorkin graduated from Syracuse University in 1983 with a bachelor of fine arts in theater and moved to New York in the hopes of carving out a career as an actor. But it would be writing, not acting, that would catapult him to fame. The Broadway success of his first play, *A Few Good Men* (1989), ultimately led him to Hollywood, where he wrote three screenplays: an adaptation of *A Few Good Men* (1992) and two original works, *Malice* (1993) and *The American President* (1995). The popular success of these films opened doors for him in the television industry, and he subsequently wrote and produced the Emmy Award–winning show *Sports Night*, which ran on ABC for two seasons (1998–2000), and *The West Wing*, which premiered in 1999. Sorkin was the latter show's executive producer and primary writer for four years, and among its many awards, *The West Wing* received the Emmy for Outstanding Drama each of those years.

On January 27, 2004, I was fortunate enough to interview Aaron Sorkin for this collection. My questions addressed some of the issues raised in this volume, but since the interview happened after the manuscript was completed, none of the contributors had access to it. Sorkin's observations about politics, gender, intellectualism, and language in art resonate with the critical discussions offered here. And to hear Sorkin talk about talking — to listen to the rhythm and repetition of his own words — further illustrates the importance of language in his works. In this way, the transcript of this interview offers an effective starting point for this collection. I began by asking him about the works that have shaped his writing.

TF: Several essays in this volume discuss your work in relation to the film and television that have come before it. What have been the most important influences on you as a playwright and as a television and film writer?

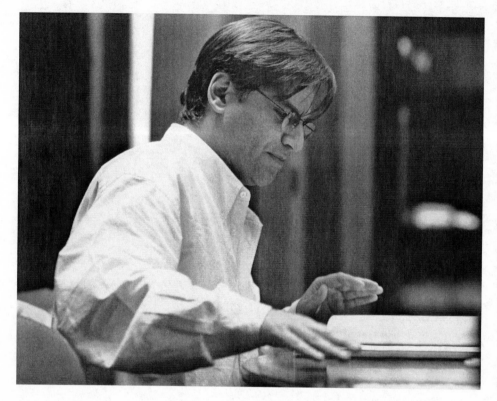

Aaron Sorkin

AS: I'm influenced by almost everything that has come before. In fact, I'm very easily influenced. So much so that when I'm writing something — whether I'm in the middle of *The West Wing* or writing a screenplay or a play — I don't often go to the movies or watch other TV shows just, because I feel like I'll come home wanting to do that. And it will be hard to be focused.

In terms of television shows, I think that *M.A.S.H.* was probably a big influence for a lot of people who are writing right now.... Let me put it this way. *Murphy Brown* was a great show and was very funny, but for *Murphy Brown* to work, we're not expected to believe that *60 Minutes* really gets put together that way — five people at a linoleum table in the lobby by the elevator door. That's a comedy set. It has lots of doors, lots of entrances and exits, and it's meant to serve the comedy. The same thing is true with *The Mary Tyler Moore Show,* which I think a lot of people would agree is one of the greatest television shows ever. We're not meant to believe that that is how the six o'clock news is put together.

But on *M.A.S.H.*, Larry Gelbart said that the first thing that I'm going

to do is make you believe that this is for real. I don't know what a hospital in the Korean War looked like. But I bought that. He wanted us to buy that. He knew that if he could establish the reality — these guys are really doctors, this is really a hospital, this is really a war — that he can have drama, tension, and emotion not just in the same series as comedy, not just in the same episode as comedy, but oftentimes in the same scene as comedy. Look at the operating room scenes — that was a big deal for me.

TF: So establishing that kind of realism is important to you.

AS: Yes, selling the reality first and respecting it.

TF: Did these shows also influence your writing for the theater or would you attribute your style as a playwright to other works?

AS: I would attribute that to a host of things — not the least of which is the fact that I used to go to plays all the time. When I was little, my parents took me to the theater all the time, and I still go all the time. I love the sound of dialogue. I went to see plays before I was old enough to understand what they were about, and I just kind of liked these big voices speaking in musical cadences. I loved that and wanted to imitate that sound.

TF: How does the medium shape your writing? Is your approach to writing a television script different from that of a play?

AS: It's not that different.... Well, it's no different, and it's entirely different in that you kind of want to use the strength of the medium that you're in. Anything that I write is going to be on the talky side. Basically, we're talking about people in rooms — talking.

Going back and forth between the two, I always find the one that I'm about to do harder. I'm finishing a screenplay right now, but then I'm about to write a new play that is going to premiere at the Abby Theater in Dublin. There is a story that I want to tell, but for the life of me, I can't figure out how to tell it without a camera pushing in on an object or having lots of sets. So I have to remember how to do that again. In each case, what I'm looking for is an intention and an obstacle.

TF: This makes me think of your episode "Isaac and Ishmael" on *The West Wing*, which was explicitly presented as a play. I was curious as to why you felt that distinction was important — what were you hoping to communicate to the television audience by asking them to see it that way?

AS: The reason why I felt that distinction was important is because "Isaac and Ishmael" was an anomaly. As I say in my preface to "Isaac and Ishmael" in *The West Wing Seasons 3 and 4: The Shooting Scripts,* I felt that I had to tell the audience that what you're about to see is not part of the television series *The West Wing.* We had left off at a certain point in the story with the season finale; we're picking up at that exact moment in the season premiere. But in between, we're putting in this episode that doesn't take place in time — it doesn't take place in the story line of the series.

TF: You were talking earlier about the importance of realism in your writing. Did you feel that announcing "Isaac and Ishamel" as a play was a way of distancing this episode from the actual events of nine-eleven?

AS: What I really wanted to do was postpone our premiere for six months. Nine-eleven had just happened, and I didn't want the show to go on the air. I felt it was in bad taste, but that was not an option from the network. I had to go on the air with something, and I badly did not want to go on the air right away with our season premiere. I wanted the show to do something that said it understood that Democrats verses Republicans, Congress verses the White House, and North versus South were just not funny right now. Donna and Josh flirting and C.J. yapping at the press corps just aren't where our hearts are right now. I wanted the show to not do any of that. The only thing I could think of to do was to write an episode that somehow recreated the conversations that we were all having at our kitchen tables, at our offices, and in our schools. And it had to be done very quickly, so this is what I decided to do — to talk about the history of terrorism.

TF: I'd like to continue with some of the social and political dimensions of your writing. George Orwell once wrote that great art needs to engage with the political. Your work is clearly invested in politics (whether it's the politics of the White House, a courtroom, an office, or the politics of romance). Why are you so drawn to this material, and do you feel that great art needs to engage with social and political issues?

AS: Well, the last thing that I would pretend to know is the answer to what great art is, so I'm going to pass on that question. In regards to my writing, I've never had anything I've wanted to convince you of or tell you or teach you or show you where you're wrong. I don't have a political background, and I'm not a political sophisticate. All of my training has been in theater and plays. But as it turns out, my style is a kind of Romantic idealistic style.

I also really enjoy going behind the scenes of places. I like selling you on the reality. I enjoy writing a moment where we, the audience, don't know what the characters are talking about, but what we come away with is that they sure knew what they were talking about. It lights me up.

So a place like the White House, which I've used twice now, is just great for that. It's a fantastic world to look behind the scenes of. It's extremely glamorous and appealing, and the possibility to be Romantic and idealistic is huge. There is a tremendous amount of conflict. There is tremendous potential for intention and obstacle.

Some people have complained that *The West Wing* is too liberal — that it's too political, that I shouldn't be putting my own political views in there. The answer is that for me to sell you on the reality, these people have to believe in something. You're going to have to hear words that you don't usually hear on TV, like Democrat and Republican, left and right. So, that is who these characters are.

TF: We also have a number of essays that examine your female characters. How do you write women characters? When you tackle issues of gender inequality, for example, what are the greatest difficulties for you?

AS: My greatest difficulties have to do with how much I like women personally. What I mean by that is that when I'm doing it badly, I'm writing the woman in terms of the man…. For example, you have the Tom Cruise character, who is the hero, and you have the woman who basically serves the role of a cool glass of lemonade. When I can *not* do that, I'm doing it fine.

I remember when I was writing the first thing that I wrote. A friend of mine read it and, referring to all the female characters, said, "It feels like you write female characters because you want to meet the actress who is going to play the part." And he was absolutely right, and that's when it can get tough for you.

TF: Your work seems highly invested in the importance and value of education. You depict well-educated people — people who accomplish great things and work hard to better themselves and others. This is possible, in part, because of their education. When I compare your drama to that of David Mamet or the television writing of *The Sopranos* and *Six Feet Under,* these writers don't tend to focus on intellectuals. They have smart characters, but they just aren't invested in academic knowledge. Why are those characters so important to you as a writer? And was this a risky thing to do? We don't typically see these kinds of characters on television.

AS: I didn't really realize that. I grew up in Scarsdale, New York — in an upper-middle class suburb of New York City with a nationally regarded public school system. It was a terrific school system not just because of the quality of the academic education, but there were trees ... and things that you liked to look at.

Academic excellence was stressed — about a quarter of the graduating class went to Ivy League schools. My friends that I grew up with, whom I liked a lot, were all smarter than I was, as is the rest of my family. My interest was always drama. I was doing things with the drama club and community theater, going to the city and taking classes. And for some reason, I'm not exactly sure how I got into my clique of friends, but the conversations that I heard — whether it was around the dinner table, around a poker table, at a friend's house, or while watching a football game — were always dynamic. There was always somebody who could say, "But look at it this way." And I just always loved the sound of a really smart argument. Again coupling that with my like of dialogue, this was the life I grew up in.

I really have a lot of admiration for people who are able to write using characters who do not communicate well — like Mamet's characters, as you mentioned. Or the way David Chase does it in *The Sopranos*. I think if I tried to write that way it would seem pathetically inauthentic. I just named two writers who, I can tell you, have been around people who communicate that way. They have experience with that kind of language.

TF: Speaking of David Chase, I wanted to ask you about some of the differences between network and cable television. The challenges of writing a twenty-two-episode season must be enormous, especially when you consider that a series on HBO has only thirteen episodes per season. Do you think the future of television is moving in that direction — that it will begin to imitate the HBO model? In other words, do you see things changing on network television to make writing and production more manageable?

AS: Well, I don't think networks and studios care about making it manageable. Let me start out by saying that doing thirteen instead of twenty-two is a huge difference — not just on the things that you would imagine like the writing, which you can do at a slightly less ferocious pace. For instance, with *The Sopranos*, David and his staff will write all of them, shoot all of them, and then he will begin editing the first one. You're going to learn some stuff by doing it that way. You're going to learn what's important about this thirteen-episode arc. You're going to know about the end as you start cutting the beginning. That is a huge luxury. They have other great things,

too, like no commercials and basically starting their season when they're ready to start their season.

I don't know what the future of television is anymore. It seems to me like a couple of years ago television got eaten, and it's something else now. I think broadcast networks are absolutely capable of doing good TV, and HBO is absolutely capable of doing lousy TV. But I wish I was smart enough to answer your question of how to fix this. Unless the networks go to four seasons a year where the first quarter you're doing *The West Wing*, the second quarter you're doing *ER,* the third quarter you're doing *The Practice*, that kind of thing, I don't know.

Chances are that the future of television is what it has always been. Network shows will be built to turn out twenty-two episodes a year, which isn't necessarily going to get you the best thing on the screen.

Mannerist Noir: *Malice*

Robert F. Gross

> Mannerism understands the situation precisely as death,
> the death of cinema; you can't do anything new, you
> can only produce illusions of the new. Mannerism is ill
> with claustrophobia.
>
> — Gleb Aleinikov, "Mannerism
> and Claustrophobia" (335)

Malice, for which Aaron Sorkin was co-credited for both story and screenplay, is an entertainment for a Mannerist era; an era of exhausted artistic possibilities in which artists feel themselves to be epigones, laboring to produce ingenious imitations after the cripplingly impressive achievements of their predecessors (Aleinikov, 335). In Mannerism, imitation is pushed to new lengths of grotesquerie and parody (Maiorino, 60). Irony and self-consciousness predominate. Mannerist works of art communicate an extreme tension between the virtuosic display of inherited forms to emotionally manipulative ends, and raw, seemingly unmediated moments of shock (Pentzell, 24).

Mannerism is a "post-" moment. The period most frequently labeled "Mannerist" is that of *cinquecento*, with its visual artists who having to deal with coming after the magnificent and anxiety-producing achievements of Michelangelo and Raphael, and writers who were responding to the collapse of the Renaissance humanist vision after the Sack of Rome in 1527. But it has also been located in moments closer to our own: in film following the death of director Rainer Werner Fassbinder (Aleinikov, 333-334) and in the domestic drama of Edward Albee following the achievement of Eugene O'Neill's *Long Day's Journey into Night* (Pentzell, 25). Umberto Eco has gone so far as to wonder if "postmodernism is not the modern name for mannerism" (66). It is certainly not surprising that an age which contemplates its

post-Enlightenment, post-modern, post-industrial, post-colonial, post-historical, post-human (and you are free to continue by adding any other posts-that suit your fancy) is prone to the sense of aesthetic belatedness that gives rise to Mannerism.

Contaminatio is a common strategy not only of Italian Mannerism, as Louise George Clubb has shown (6-7), but of contemporary Mannerism as well. A response to aesthetic belatedness, it is a writerly defense against the Mannerist fear that all the good stories have been told already, and told well. All that remains is the increasingly difficult challenge of turning out new, virtuosic variations on antiquated themes. In *contaminatio*, the writer combines the plots of two or more works into a new, more varied and complicated whole, following the assumption that a sophisticated audience's attention can be held by the invention of greater narrative and formal contrivance. This technique, and the anxiety that accompanies it, goes back at least as far as Republican Rome, where Terence defended his *Andria* as combining the plots of two Greek comedies by Menander, *Andria* and *Perinthia*. In the *cinquecento*, which saw the rise of Mannerist art, *contaminatio* became a common and much admired technique of ringing changes on classic material: Ariosto drew attention to how his comedy, *I Suppositi*, was an artful amalgam of Plautus's *Captivi* and Terence's *Eunuchus* (Clubb, 32). But one suspects that the anxious belatedness of Terence and Ariosto were nothing when compared to that of a contemporary Hollywood screenwriter who not only has the heritage of Western literature to contend with, but a never-ending deluge of narratives produced for the mass market — adaptations, imitations, re-makes, sequels, prequels, *hommages*, spoofs and rip-offs — often exuding ingenious bravado and desperate exhaustion. Indeed, it has become a running joke that Hollywood's latest products are often *contaminatio* of earlier hits — following an "x meets y" formula. So *Gosford Park* can be described as "*Upstairs, Downstairs* meets *Murder on the Orient Express*," and *Legally Blonde 2* becomes "*Mr. Smith Goes to Washington* meets *Gentlemen Prefer Blondes*."

The challenge of *contaminatio* is how to create greater complexity and, thus novelty, but within the usual time restraints of theater or film: although the writer may be fusing two full-length works, there is not twice the performance time. So, as a result, stories must be told quickly, transitions need to be condensed, characters simplified, and the audience's earlier experiences with the stories used to enable the rapid telegraphing of material that cannot be set out in detail, due to time constraints. The writers of *contaminatio* tend to be savvy and sophisticated consumers of narrative, who know all the conventions, tricks and devices that have been generated in the history of the forms and genres in which they work, and assume that their audiences do as well.

The anxiety of belatedness is nowhere more strongly felt than in the revival of film noir in recent decades, of which *Malice* is an intriguing example. The jacket for the M-G-M videocassette of the movie markets it as noir, quoting Home Box Office's description of it as a "moody, contemporary *noir.*" Now, while film scholars have never agreed, and no doubt never will agree, on whether film noir describes a genre, style, or series of movies, or whether it has ever even existed at all, HBO, popular reviewers and the writers of copy for VHS and DVD jackets seem to use the term broadly, but with seeming assurance that the filmgoing public will know what the term means.[1]

Putting critical subtleties aside, the nonacademic film buff's understanding of noir embraces a grouping of Hollywood crime films from *The Maltese Falcon* (1941), *Double Indemnity* (1944) and *The Postman Always Rings Twice* (1946) to *Kiss Me Deadly* (1955) with Orson Welles creating the period's Mannerist "epitaph" in *Touch of Evil* (1958) (Schrader 107). Following a hiatus from the late '50s to early '70s, there has been a gradual revival of noir, led by Roman Polanski's *Chinatown* (1973), and eventually followed in the '80s and '90s with a stream of films that seem self-consciously noir. These include remakes of earlier noirs such as *The Postman Always Rings Twice* (1981), *Out of the Past* (under the title *Against All Odds*) (1984), *D.O.A* (1988) and *Night and the City* (1992); new variations on familiar noir motifs and themes as *Body Heat* (1981), *Blue Velvet* (1986), *Black Widow* (1987), *The Grifters* (1990), *Body of Evidence* (1993) and *Palmetto* (1999); and spoofs such as *Dead Men Don't Wear Plaid* (1982) and *Who Framed Roger Rabbit?* (1988). The *noir* as it has developed since the 1970s (sometimes usefully referred to as "neo-noir") departs from its 1940 and '50s prototypes in its use of color photography, far more explicit depictions of sex and violence, and increasingly complicated plots. But, despite all the individual variations that Hollywood has produced over the past two decades, the VHS or DVD cover that identifies its contents as a noir is usually promising the viewer a tough, steamy and amoral atmosphere, with cynical, sex-driven guys, hot, calculating babes, and a plot rife with transgressive heterosexuality, deviously plotted crimes, and ingenious double-crosses.

James Damico provides a useful description of what he considers the paradigmatic noir plot, one that is particularly illuminating in relationship to *Malice*:

> Either because he is fated to do so or by chance, or because he has been hired for a job specifically associated with her, a man whose experience of life has left him sanguine and often bitter meets a not-innocent woman of similar outlook to whom he is sexually and fatally attracted. Through this attraction, either because the woman

induces him to it or because it is the natural result of their relation-
ship, the man comes to cheat, attempt to murder, or actually murder
a second man to whom the woman is unhappily or unwillingly
attached (generally he is her husband or lover), an act which often
leads to the woman's betrayal of the protagonist, but which in any
event brings about the sometimes metaphoric but usually literal
destruction of the woman, the man to whom she is attracted, and
frequently the protagonist himself [137].

Damico explains that he is not out to create a rigid, invariant model, but,
rather one that allows all sorts of "variants, substitutions, combinations,
splinterings and reversals of the constituents" (137). At the same time, his
description points to the inherent limitations of working within the genre.
Noir, as he describes it, is built around a heterosexual triangle in which the
woman lures the man through sexual attraction to transgressive acts, usually
against the triangle's second man. To reduce Damico's scenario even further,
noir shows a male rivalry instigated and brought to violent crisis by a duplic-
itous woman, ending in disaster from one or all of the figures in the trian-
gle. Damico's scenario suggests that the murder of a husband by adulterous
lovers is the basic noir plot and that sexual infidelity is the primal "double-
cross." It may well be that the ultimate literary precursor of the form is Emile
Zola's *Thérèse Raquin*, with its depiction of intense, frenzied adulterous love
leading to the husband's murder and its disastrous aftermath, along with the
gritty, naturalistic atmosphere so common to film noir. A Freudian reading,
of course, could reduce Damico's paradigm still further, and see it as a vio-
lent and unsuccessful attempt to resolve the Oedipal crisis. In *Malice*, it
would take the form of son–Andy alone with mother–Tracy until the intru-
sion of father–Jed, with his witnessing of their sexual activity the climactic,
primal scene, and Andy's revenge following.

But Damico's paradigm also indicates the limitations of noir narrative
and its potential for quick exhaustion. For, despite all the complications the
screenwriter can contrive on top of the basic situation, there is a predictability
to the core story, due to the centrality of transgressive and fatal desire inspired
by the woman. (After all, how many ways are there, when you come right
down to it, for a femme to be fatale?) From the start, film noir has mani-
fested a tendency toward Mannerist contrivances, needing to pile double-
cross upon double-cross and thrilling revelation upon revelation, all in a
desperate attempt to tease out one more variation on an oh-so-familiar
theme.

In *Malice* Sorkin and his collaborators work a clever variation on the
standard noir plot by shifting the position of the protagonist, much like Tom
Stoppard in *Rosencrantz and Guildenstern are Dead*, who put an enlivening

spin on *Hamlet* by resituating minor figures in Shakespeare's original as protagonists in his belated reworking. A comparison of Damico's synopsis with *Malice* immediately reveals what distinguishes it from the great mass of noirs: here, the betrayed husband, rather than the lover, is the protagonist. To illustrate the implications of this structural shift more fully, let me revise the plot of *Malice* back into conformity with the paradigm: Young surgeon Jed Hill (Alec Baldwin) meets Tracy Kennsinger (Nicole Kidman), the sexually and economically unfulfilled wife of Andy, a college administrator (Bill Pullman). Tracy seduces Jed and makes him her accomplice in an elaborate medical malpractice scam, which, in its course, will destroy her marriage and make them both rich. After the fraud is successfully completed, the law begins to catch up with them, and Tracy is revealed to be a psychopath who is even capable of plotting to kill a child to protect her ill-gotten gains. In a quarrel she shoots Jed, and is caught by the police before killing the juvenile witness.

In *Malice*, the noir plot is only gradually revealed in the second half of the film, as Andy assumes the role of detective, uncovers his wife's scheme and brings her to justice through a counter-scheme of his own. The Mannerist *contaminatio* comes from the conflation of Damico's noir plot with a detective plot initiated by the protagonist.

In *Malice*, the noir's story of transgressive desire and crime is subordinated to the story of the hero's violent initiation into masculinity. The first model that leaps to mind is Sam Peckinpah's *Straw Dogs* (1971) — with its bloodied academic protagonist facing murderous violence from other men and estrangement from his marriage. But even that film, over twenty years before *Malice*, had elements of Mannerism, as it used excesses of sex and violence, along with assaultive editing techniques, to give one more turn on what was already a well-worn cinematic formula. As David Weddle points out, *Straw Dogs* was already

> pure exploitation melodrama with a plot as old as the movies: the meek bookworm pushed too far. When his passive facade cracks, the professor turns on his tormentors in righteous wrath and emerges victorious. The story had been used in hundreds of westerns, gangster and boxing pictures and by such comedians as Buster Keaton, Harold Lloyd and Harry Langdon [20].

And, if Weddle's chronicle of cinematic belatedness is not enough, one can think back beyond the invention of movies to a much earlier example of college boy turned revenge machine: *Hamlet*.

To put it in the current formulation, *Malice* is "*Double Indemnity* meets *Straw Dogs*." But this *contaminatio* has an unusual effect on the cuckolded

and often murdered husband of film noir. Here, the adulterous lovers do not destroy the husband, but most uncharacteristically, make a "man" of him.

Andy makes his first appearance dressed in Hollywood's standard issue for male academics — a corduroy suit, blue button-down shirt and muted necktie. Played with boyish charm by Bill Pullman, Andy enters into spaces sheepishly, often avoids eye contact, and often falls into a self-deprecating manner. Realizing that newly arrived surgeon Jed is no other than "Gallopin' Jed Hill" from their days at Van Buren High, and reminding Jed of those youthful days of glory while Jed does not remember Andy at all, Andy appears to play a wistful Laura Wingfield from *The Glass Menagerie* to Jed's Gentleman Caller. "Looks like you're big man on campus again," observes Andy with unabashed admiration.

Just as Andy subordinates himself to the macho style of Jed (established early on by such gestures as his ability to casually warn a new colleague that he had better behave himself or "I'll take out your lungs with a fucking ice cream scoop"), he also plays a subordinate role at home. Watching from the shadows as Tracy kisses her lawyer, Dennis Riley (Peter Frechette), good night, Andy is unable to summon up sufficient indignation to make his wife feel the force of either his suspicions or annoyance. Lying in bed in his tee-shirt and boxer shorts (in contrast to the repeated shots of Jed in various stages of impressively muscled undress), he tries unsuccessfully to eat Chinese food with chopsticks, and complains that he is too tired to finish eating it without a fork. In response, Tracy straddles him in bed, taking charge of the chopsticks, feeding him and speaking to him as if he were a child: "Open up ... good boy ... delicious." Motherly nurturance becomes seduction as feeding gives way to sex play, and the scene establishes Tracy's confident manipulation of the roles of mother and lover in her marriage, as well as Andy's submissiveness.

Working in a women's college, making sure that his female charges, who put their feet up on his desk and tell him transparent lies, wake up in time to take their examinations, yet not being able to earn the salary to renovate the house he lives in with his emotionally dominant wife, Andy is initially drawn as a weak, feminized man in a woman's world.

Suddenly, however, Andy is transformed. While earlier he had been unable to protect his students from attack (while Jed had at least been able to save one of them in the operating room), and had endangered his domestic space by naively allowing his adolescent crush on Jed to let this far more masculine man into his home over his wife's apparent objections (leading us to rightly suspect a potential adultery plot), a completely unanticipated reversal suddenly turns Andy into the heroic protector of vulnerable womanhood.

Stumbling upon the evidence that custodian Earl Leemus (Tobin Bell) is the serial killer, Andy is forced to fight for his life. The presence of the serial killer plot, which only runs halfway through the film, works causally independent of the noir plot and becomes a major episode in the initiation plot, though it almost functions as a third, sketchily developed, independent plot line, suggesting that *Malice* might actually be a triple *contamniatio*—"*Double Indemnity* meets *Straw Dogs* meets *Frenzy.*"

The Leemus plot serves several functions. First, and most importantly, it provides a dramatic event that can quickly transform Andy from a passive, feminized man required for the earlier scenes to the tougher, more masculine figure required for the later ones. Second, it provides an opportunity for Andy to go to the hospital and become re-acquainted with Jed (though one can imagine any number of pretenses for that action). Third, it allows the suspicion that Andy might be the killer to force him to have that all-important semen test that will reveal that he is sterile (though one might think that a couple unsuccessfully trying to conceive might have had that test done under less melodramatic circumstances). Fourth, in a tactic of Mannerist misdirection, it misleads us by suggesting that we are in a suspense film, not a film noir: *Double Indemnity* hides behind *Straw Dogs*, which hides behind *Frenzy.*

Most subtly, however, the fact that Andy has to be cleared as a murder suspect sets up an interesting atmosphere of suspicion. Since there has been no attempt to provide us with an array of suspects, Andy seems both a totally unlikely suspect, and the only possible one. For a moment, we are prodded to consider we may be in a Jekyll-and-Hyde world of split personalities, a consideration that will not be confirmed by Andy's semen test or the arrest of the murderer, but through the presentation of Tracy. For, in the Mannerist mode of *Malice*, plot is contrived and character is fragmented.

The clearest and most immediate function of Earl's capture is the transformation of Andy. But the detection and defeat of the serial killer, which we were led to think was the film's major plot, turns out to carry us only halfway through the film, and Andy's triumph over a figure of masculine violence is not masculinity securely achieved, but merely a preparation for battle against a much wilier and more dangerous opponent — his wife. Andy's single-handed vanquishing of the serial killer is celebrated in a minor key, with tough, slightly mocking badinage. "Meet the professor, a very tough guy," Dana says to a resuscitation dummy, in mock introduction to a bruised and bloodied Andy. "If you want something done right, godamnit, you call a teacher," responds Andy in a combination of pride and self-conscious irony at the creation of a seeming oxymoron, "butch teacher." But Dana quickly puts Andy's new-found virility to the test in the scene that follows: "How

well do you know Tracy?" she asks him, and invites him back to her office
to see something in her possession.

In the next scene, Andy is seen driving up to a hotel, a sequence accom-
panied by pulsing, percussive music. He bounds out of his car and demands
to see Jed. Andy has been transformed from the boyish, self-abnegating figure
of the earlier scenes. In his bloodied shirt, bandaged and bruised, he is out
for revenge. According to he police lab report on his semen, he is sterile and
therefore could not have made Tracy pregnant. Andy's language has suddenly
become coarse and aggressive. "She reamed us both," he explains to Jed,
using the language of sexual penetration to express his feelings at how he's
been betrayed: Tracy's sexual initiative in the earlier bedroom scene morphs
into anal rape.

This abrupt shift in Andy's character is poorly justified in terms of real-
istic motivation — the Andy of the earlier scenes would have been far more
likely to collapse when confronted with Dana's news than to have erupted
in anger. Nothing in the noir plot has prepared us for this transformation.
But here we see the skillful use of *contaminatio* at work. Through the mas-
culine initiation plot, Andy has become a new man. By having him find the
man who has terrorized the women under his protection, fight for his own
life against this killer and vanquish him, the film metamorphoses Andy from
feminine to masculine male. Bloodied and toughened by his near-fatal
encounter, Andy emerges ready to take on the revelation of his wife's
infidelity "like a man." The conflation of the two plots creates a narrative
that works more by mythic connotation than realistic causality.

The masculinized Andy's quest becomes one of learning the truth about
Woman. Early in the film, he had shown Jed a statuette of a ballerina by
Edouard Degas, commenting that Tracy's father gave it to her and that "I
think its original." Later, Andy sees an identical statuette in the apartment
of Tracy's mother, Mrs. Kennsinger, and learns that it is a cheap department
store knockoff. Andy's weakness is that he has not been able to discriminate
between genuine femininity and its cheap imitation — but then again, nei-
ther has the viewer. Andy's initiation into manhood depends on coming to
an accurate and unidealized knowledge of his wife. "I'm gonna go out and
get to know my wife," he tells Jed, and he discovers that she is a murderess.

Tracy double-crosses Andy by pretending to be loving wife and aspir-
ing mother, and she double-crosses Jed by becoming pregnant. *Malice* poses
the challenge of seeing into the female body, looking for traces of the psy-
che in its anatomy. At first it might seem as if Andy's naive, uxorious lay-
man's gaze is to be contrasted with the superiority of Jed's macho and
obstetric gaze, but Jed is as surprised and thrown off balance when he dis-
covers in the operating room that Tracy is pregnant, just as Andy will be

surprised later. The female body in *Malice* turns out to register its own desires in way that remain ineluctably Other to the males.

Transformed into a revenge machine, Andy lurches from Jed's hotel room to Dennis's office and to Mrs. Kennsinger's cramped and cluttered apartment. In a narrative leap typical of this film, Andy declares to Dennis one moment that he is going to find Tracy's mother, and is seen entering her apartment in the rain the next: the realistic work of detection is not shown, but merely implied. Since we were told early in the film that Mrs. Kennsinger (Anne Bancroft) was dead, the effect of her mysterious appearance in the second half of the film has an element of the *unheimlich*, that uncanniness that Freud associated with the return of the repressed, and above all, with the repressed memory of the maternal (244–249). In hopes of finding out the truth about his deceptive mother-wife Tracy, Andy has sought out her — or perhaps his own — spectral mother.

The encounter between Andy and his mother-in-law is the film's wittiest and most evocative scene, due to its snappy writing and expert playing from both Pullman and Bancroft. Using a bottle of single malt Scotch to gain entry into her cramped and cluttered apartment (a witty offering to the seedy sybil, a classy sop to Cerberus), he finds his mother-in-law a tough-talking dame who easily undercuts the aggressive bravado Andy had displayed before Jed and Dennis. Like Tracy, she reduces him to a boy, but through putdowns, not flirtation: "Take your medicine like a good little boy and go home," she taunts him. Forcing him to participate in a sleight of hand card trick, she reveals how the world of *Malice* works. Andy draws from the deck, not a patriarchal king, but the far more boyish jack of clubs, which turns out to be where any son or susceptible male can be — in mother's pocket. By the end of the scene, Mrs. Kennsinger not only furnishes Andy with a more accurate picture of his wife and information leading to her exposure, but with a new and less sentimental model of the world.

The interview with Mrs. Kennsinger opens the way for Andy and the viewer to discover the film's noir configuration. Up to this point, it has been obscured because the quintessential noir figure of the femme fatale has been masquerading as maternal nurturer.[2] As Laura Mulvey has pointed out, the femme fatale of the film noir has been a enigmatic figure from the start, a sultry mask behind which dangerous desires and death lurk (59). In Mannerist gesture, the masked woman of mystery assumes yet another mask on top of that, this time painted with the peaches-and-cream wholesomeness of its opposing type, the aspiring mother.

In the early scenes of the film, Tracy is anything but the femme fatale described by Slavoj Žižek as the quintessentially noir figure:

In the classical hard-boiled novel and *film noir*, the *femme fatale* is an agent of (evil) fate: the moment she appears (and these moments of her first appearance are perhaps the most sublime in *film noir*: the entry of Barbara Stanwyck in *Double Indemnity*, of Jane Greer in *Out of the Past*, of Lana Turner in *The Postman Always Rings Twice*, of Yvonne de Carlo in *Criss-Cross*...), the hero's fate is sealed, events take their inexorable course [Žižek, 169].

Malice, however, does not provide Nicole Kidman with a sublime cinematic entrance to place her in the noir pantheon beside Barbara Stanwyck and Lana Turner. Rather, she is introduced to us as the antithesis of *fatale*, busy doing volunteer work in the children's ward of the hospital with beatific patience. Soon after, the dialogue builds on that cinematic first impression of her as a maternal figure: Andy tells Jed that he and Tracy want to have children and that they both are "nuts" about them.[3]

In *Malice*, the sentimental depiction of nurturing motherhood turns out to be a calculated facade that conceals its murderous, infanticidal opposite. The traditional good girl/bad girl dichotomy in noir was open to interesting variations from the start (think of Rita Hayworth in *Gilda* (1946), who is finally revealed to have only been pretending to be bad all along, or of Lizabeth Scott in *Pitfall* (1948), who proves to be dangerous only because of the brutal and obsessive man who harasses her), but the situation of the hero caught between the nurturing woman and the femme fatale was usually handled stereotypically, from *Force of Evil* (1948) and *Night and the City* (1950) to the more recent *Body of Evidence* and *Palmetto* (Stables, 170). Maternity is associated with good girls, while femme fatales are presented as figures of sex without procreation.

But Tracy differs from the femme fatale in an important way. A conflation of two familiar movie character types, the maternal nurturer and scenery-chewing psycho killer, she never is given the chance to embody (in the words of S. N. Behrman) "the eternal glamor of the illicit" (233), as had Lana Turner, Rita Hayworth, Ava Gardner and the other goddesses of noir who preceded her. Instead, we see her as first too normative and later too psychotic to qualify as a classic *femme fatale*. Although she occupies the place of the femme fatale in the movie's plot structure, she is actually a Mannerist *contaminatio* on the level of characterization. Eugene Waith's description of the Mannerist character constructions of Beaumont and Fletcher's Jacobean dramas could be applied to *Malice*: "strange, unpredictable characters, who belong in a world of theatrical contrivance. They are monsters and saints, living abstractions and combinations of irreconcilable extremes" (38). With Tracy, the audience is surprised and delighted to see two opposing types welded into a single character, just as it is

surprised to see the feminized professor existing along with the tough guy detective.

When Andy tells Tracy, with an assured toughness toward her that has not been associated with his character, that he wants a sizable cut of her and Jed's stash, it gives Andy the temporary appearance of having become a noir tough guy, and momentarily gives the appearance of confirming that we are in a noir universe, in which cynicism and self-interest can infect even the most idealistic of men. But this time, not only Tracy is being set up, but we are as well. In the first half of the film, the audience is deceived along with Andy; as we reach the end of the film, we are deceived along with Tracy, as Andy and Dana set a trap for her, appropriately enough, using an innocent child.

Tracy's angry outburst when Jed warns her not to harm "the kid" could as easily be the words of a woman infuriated with an unwanted pregnancy as a criminal wanting to eliminate an eyewitness. Furiously reviling the boy as "a little fucking troll who deserves to be put out of his misery for fucking up my life," Tracy gives expression to an infanticidal rage that far exceeds the portrait of a greedy woman that her mother painted for Andy. Yet this eruption elicits as much spectatorial delight as shock. For anyone in the audience (myself included) who found Tracy and Andy's parental aspirations in the early scenes of the film a bit clichéd, this Mannerist reversal into a hyperbolic eruption of demonic, child-hating vehemence is nothing less than camp at its most invigorating. It is not that the screenplay moves from a superficial and illusory view of Tracy to a "deeper" and "truer" one, but that a sentimental cliché from domestic drama is forced to give way to a rush of equally artificial anti-sentimentality.

As Tracy enters the house to kill the boy she believes has witnessed her crime, fresh from shooting Jed, she no longer bears marks of the femme fatale, but has been transformed into a homicidal maniac. In one of the few sequences in the film shot from her point of view, she enters the neighbor's house, goes up to the boy's room, and sees him with his back turned to her, sitting in a chair. When she whirls the chair around to face her, she (and the spectators) are surprised to see that the child has been replaced with a resuscitation dummy. This jarring appearance of an inanimate object where we expected a human being, the responsive face of a human being replaced by an artificial face, is undoubtedly the most bizarre and gratuitously flashy moment in *Malice*. In a flash, we realize, as Tracy does, that Andy has anticipated her attack on the child and made a mocking substitution. But in the split second before that realization, as the dummy's eyes unaccountably open and stare back at us, the child-dummy appears *unheimlich*, a demonic conflation of the living and non-living, a final image in the series of aborted

and miscarried fetuses. Beneath the film's attempt to realistically justify Tracy's actions as greed is the more oneiric suggestion of a woman enraged by her own capacity for procreation, driven mad by the re-appearance of Child as Thing, mocking and indestructible. Realizing that she has been duped, Tracy turns on Andy in a fury, driving him through the railing of the staircase, crashing onto a table and through it to the floor below, then landing on top of him. This image of Tracy on top registers off the much earlier image of Tracy on top of Andy in bed as she simultaneously fed and seduced him. Although Andy has seemingly grown in masculinity since that early scene, he is still not able to vanquish Tracy on his own; she reaches for a piece of wood to finish off her pesky spouse. Andy is only safe when Dana shows up brandishing a gun at his wife, and hauls her off to the squad car. It is Andy, not Tracy, who looks considerably worse for wear from the final tussle, and we later see him with one arm in a sling.

Slavoj Žižek has observed that in the classic *noir* (his example is taken from *The Maltese Falcon*), the femme fatale is often seen to disintegrate "into a formless, mucous slime without proper ontological consistency the moment the hard-boiled hero rejects her, i.e., breaks her spell upon him" (155). Certainly Andy's challenge to his once-adored wife sets her off on a final, self-destructive killing spree unjustified in the light of her earlier behavior, in which all caution is thrown to the wind. But what transforms her from a cool conspirator to a psychotic killer who suddenly pulls a gun on Jed and shoots him dead, sets out to kill a child and finally explodes in inchoate rage, murderously assaulting her ex-husband? The scene with Mrs. Kennsinger sets up the possible motivation that Tracy had always been obsessed with money, greed being, as Joan Copjec has pointed out, a common character trait of the femme fatale (194). If we follow this interpretation, Tracy's premeditated miscarriage for cash foreshadows her later plan to kill the child next door. Her maternal impulses have been supplanted by avarice; her insistence on using her own ability to become pregnant and terminate her pregnancy for financial gain are finally taken to their most maniacal conclusion.

As *Malice* resolves the threat posed by the serial killer Earl Leemus in order to focus on and contain the threat posed by Tracy Kennsinger, the threat of male violence against women is supplanted by the threat of female violence against children. The greed that causes Tracy to have an abortion, then engineer her own pregnancy and miscarriage, and finally causes her to set out to kill the ten-year-old boy next door, who she believes saw Jed give her an injection of Perganol, winds up making her a serial killer, the female equivalent of Earl Leemus. While violent repetitions of the virtually unchar-acterized Earl are vaguely linked to his mother (a stock cinematic explana-tion for male serial killers since *Psycho*), Tracy's psychopathology is linked

to an absent and exploitative father. In both cases, violent repetition is linked to, though far from explained by, the perpetrator's relationship to a parent of the opposite sex.

Although it might appear that *Malice* is simply a misogynistic narrative, that would be an oversimplification. While the figure of Tracy certainly registers '90s anxieties about the aspirations and freedoms of white, middle-class women, other female figures in the movie complicate it. While the Mannerist *contaminatio* of maternal nurturer and villainess, of benign Madonna and Psycho-Whore from Hell, in the figure of Tracy undercuts the sentimental stereotype with a demonic one, it also clears the way for other, more realistically conceived female figures who stand outside of that dichotomy.

Both police detective Dana (Bebe Neuwirth) and Mrs. Kennsinger are women who help Andy by disillusioning him with his naive vision of gender in his marriage. They do not gloss over his limitations or hesitate to deflate his vision of his own masculinity. They reveal to him his infertility, naïveté, and confusion. The tough-talking Dana (whose very name constitutes an *hommage* to noir and crime film actor Dana Andrews, the star of *Laura, Where the Sidewalk Ends, While the City Sleeps* and *Beyond a Reasonable Doubt*) never once softens into flirtation or winsomeness. This no-nonsense cop, who has often been accused of "wielding my sense of honesty like a blunt instrument," is a delightful, cross-gendered reinvention of a traditionally male role. It is the feminine illusion that proves dangerous in *Malice*, while the woman who is willing to bruise a male ego in the pursuit of truth turns out to be an ally.

Furthermore, although *Malice* registers considerable anxiety about contemporary white, middle-class, American women through the figure of Tracy, it does not display any nostalgia for an absent male-dominated order. The one patriarchal figure who appears, Jed's one-time supervisor Dr. Kessler (George C. Scott), gives evidence at the legal inquiry that is easily put to the service of Jed and Tracy's scheme, and the only father who is described at any length, Tracy's, turns out to have been nothing but a crook who robbed his wife and daughter. And, although conjugal love can easily be manipulated to the interests of a confidence game, the story of Andy and Jed shows that a homoerotic crush on an alpha male is no less manipulable. In this new version of noir, a man can best learn to be tough by studying tough dames.

Malice feels by turns both feminist and anti-feminist, a narrative of masculine initiation in which masculinity is repeatedly disabused of its fantasies of power. The figures of mother and child are marked with disturbing overtones of the *unheimlich*: men are baffled by the duplicity and biology of mothers, while women are enraged by the threat boys pose to their fantasies

of power and pleasure. In a world of diminished patriarchal power, *Malice* is by turns disturbed by a deeply inscribed estrangement between men and women, and willing to take the estrangement with good grace and appreciation.

The final moments of *Malice* reverberate against those of *Straw Dogs*. While the bloodied and masculinized hero of Peckinpah's film drives away from his house into the night with the mentally retarded man he has defended, admitting that he does not know where he is going, the end of *Malice* shows our wounded protagonist strolling away from his house and getting into the car with his female police detective defender as driver, with the declared intention of finding some Scotch. If *Straw Dogs* concludes with the suggestion of a male Nora who has walked out with a buddy into some undefined road movie, *Malice* gives no indication that women either will or should be eliminated from the hero's world, or that they even be subordinated. Sure, Andy butches it up with his observation that "Blended whiskey is crap. Somebody told me that." But we remember perfectly well who that "somebody" was: Mrs. Kennsinger. In its final line of dialogue, almost in a throwaway, *Malice* delivers its most intriguing and gender-bending insight: that a man is never so swaggeringly, persuasively butch as when he imitates Mom.

While the film noir of the '40s and early '50s was often characterized by its claims to realism, and lost its force as it gave way to stylization (Richardson 1–11), the neo-noirs of the '80s and '90s, of which *Malice* is a particularly interesting example, are marked by extravagances of plot and stylization that are best understood as Mannerist. No device better points up the highly Mannerist aesthetic of this film than the final revelation that the boy next door is blind. Considered from a realistic perspective, this final revelation is ludicrous. Are we to believe that neither Jed, nor Andy (who claims to be "nuts" about kids) nor Tracy (who pretends to be) never noticed that the boy next door was not only blind, but walked with a cane? If the movie had showed the moment in which Andy learned this fact, it would not only make it more ludicrous that Tracy never noticed it, but would completely undermine the flashiness of this final irony. For the moment to have any impact whatsoever *all* the characters, and the audience, have to be kept in the dark until the last moment.

Malice repeatedly puts the spectator in a state of ignorance in order to deliver a series of surprising revelations. When examined as a work of realism, it generates a series of questions. To list just a few: How does Jed get a job at the hospital in Tracy's community? How does he happen to be the doctor on call the night she collapses? How does her collapse happen at a time when the pathology lab is closed? Why does Tracy leave a syringe with

traces of Perganol behind in the house? What are the mysterious terms of Mrs. Kennsinger's sequestration? How are we to square the two accounts of Jed's professional past, one as a hotshot young surgeon and another as a healthcare provider in a public clinic? If Tracy and Jed were involved in an earlier scam at the clinic, how were they able to vanish from there with impunity? And why doesn't someone hang up curtains in that bedroom? The fact that we ask few of these questions while watching the film is a tribute to its Mannerist skill at sleight of hand. It remains just ingenious, entertaining and flashy enough to distract us from precisely the questions we would otherwise ask. Similarly, realistic characterization is replaced by a series of shifting *personae*, which actually go beyond the dichotomous figures I referred to earlier. Just as the script allows us to see Tracy as yuppie wife and aspiring mother, embittered, avenging plaintiff, sex-driven adulteress *and* as child killer, linked by the simple assertion that the first two identities were merely deceptions, so the script allows us to consider, in turn, Andy as feminized wimp, Andy as possible serial killer, Andy as action hero, Andy as sterile cuckold, Andy as hardened "tough guy," and Andy as heroic wannabe.

The Mannerist aesthetic of *Malice* is that of Mrs. Kennsinger: the quick and self-assured playing of a sleight of hand trick. Far from adopting philosopher Gilles Deleuze's idealistic cinematic mission, "Restoring our belief in the world — this is the power of modern cinema (when it stops being bad)" (172), *Malice* is trapped within an increasingly exhausted system of popular representations which it manipulates with intriguing audacity. While the film's major trope is the trick, whether the card game, the con of the homicidal female who pretends to be maternal, or the con of the *film noir* that sets out to disguise itself as another kind of film, its animating anxiety is the specter of sterility. Perhaps this anxiety is not so much Andy's as that of the desperately belated Hollywood screenwriter, who is constantly challenged to ring changes on a genre that appears increasingly infertile. For if, as both Damico and Žižek's discussions of noir imply, the genre is based on the manipulation of strongly charged beliefs surrounding sexuality that were at once normative (heterosexual) and transgressive (extramarital), the liberalization of sexual mores in Hollywood films since the 1940s leave the creators of recent noirs straining to somehow manufacture the eternal glamor of the illicit out of material that seems less and less dangerous. *Malice* tries to reintroduce danger by redrawing the femme fatale's trajectory, replacing the classic movement from seduction to crime to one that moves from nurturing wifely maternity to self-mutilation, miscarriage and murder, but it is impossible to endow this new narrative with the old glamor. Rather, desperate ingenuity replaces glamorous ease.

The effort with which the movie manipulates this reformulation of noir moves it ever further into the realm of Mannerism, where, as Russian film-maker Gleb Aleinikov observes, "you can't do anything new, you can only produce illusions of the new" (335). The problem of sexual reproduction in *Malice* resonates against the problem of Hollywood production in a Man-nerist age. The exhaustion of noir becomes displaced onto the exhaustion connoted by male sterility, and the crisis of the hero comes to reflect the cri-sis of the Hollywood screenwriter. After all, what is the status of the new in a movie that ends with its hero having no words of his own, but only a quo-tation from his tough-talking mother-in-law? Andy may have won the bat-tle with his wife but he remains sterile, and is left at the end with nothing of his own to say. *Malice* is stalked, not by serial killers, but by the specter of fin-de-siècle, Hollywood's own sterility.

Notes

1. For a very loose categorization according to "classification by motif and tone" (84), see Durgnant, who extends it broadly enough to include *Broken Blossoms*, *King Kong* and *Lolita*. For an approach that limits Durgnant's definition through periodization, see Schrader. For a categorization based on style, see Richardson. For a discussion that explores noir through narrative strategies, see Telotte. For a definition through plot, see Damico. For a provocative argument against the legitimacy of the term, see Vernet.

2. As it often happens in the belated world of neo-noir, this characterological sub-terfuge is not new. Concealing the femme fatale behind a mask of innocence goes back at least as far as Otto Preminger's 1953 *Angel Face*. The difference is that *Malice*'s young heroine is not an ingenue but pretends to have maternal aspirations.

3. All quotations of dialogue from *Malice* have been transcribed from the videocas-sette of the film. In transcribing, I have tried to use punctuation to indicate the rhythms of the actors' delivery.

Works Cited

Aleinikov, Gleb. "Mannerism and Claustrophobia, or Postmodernism: Life after Death." Trans. Anesa Miller-Pogacar. In *Re-Entering the Sign: Articulating New Russian Cul-ture*. Ed. Ellen E. Berry and Anesa Miller-Pogacar. Ann Arbor: U of Michigan P, 1995. 333-336.

Behrman, S. N. *Brief Moment*. New York: Farrar and Rinehart, 1931.

Clubb, Louise George. *Italian Drama in Shakespeare's Time*. New Haven: Yale U P, 1989.

Copjec, Joan. "The Phenomenal Nonphenomenal: Private Space in *Film Noir*." In *Shades of Noir: A Reader*. Ed. Joan Copjec. London: Verso, 1993. 167–197.

Damico, James. "Film Noir: A Modest Proposal." *Perspectives on Film Noir*. Ed. R. Bar-ton Palmer. New York: G. K. Hall, 1996. 129-140.

Deleuze, Gilles. *Cinema 2: The Time-Image*. Trans. Hugh Tomlinson and Robert Galeta. Minneapolis: U of Minnesota P, 1989.

Durgnant, Raymond. "Paint It Black: The Family Tree of Film Noir." *Perspectives on Film Noir.* Ed. R. Barton Palmer. New York: G. K. Hall, 1996. 83-98.

Eco, Umberto. Postscript to *The Name of the Rose.* New York: Harcourt, Brace, Jovanovich, 1984.

Freud, Sigmund. "The Uncanny." Ed. James Strachey, *et al. The Standard Edition of the Complete Psychological Works of Sigmund Freud* v. 17. London: Hogarth, 1955. 217-252.

Maiorino, Giancarlo. "Postmodernism and the Used-Uppness of Titles: A Neo-Baroque Dilemma." *Yearbook of Comparative and General Literature* 49 (2001): 57-100.

Malice. Dir. Harold Becker. Story by Aaron Sorkin and Jonas McCord. Screenplay by Aaron Sorkin and Scott Frank. Perf. Bill Pullman, Nicole Kidman, Alec Baldwin. Videocassette. MGM Home Entertainment, 1993.

Mulvey, Laura. "Pandora: Topographies of the Mask and Curiosity." *Sexuality and Space.* Ed. Beatriz Colomina. New York: Princeton Architectural P, 1992: 53-71.

Pentzell, Raymond J. "*The Changeling*: Notes on Mannerism in Dramatic Form." *Comparative Drama*: 9 (1975): 3-28.

Richardson, Carl. *Autopsy: An Element of Realism in Film Noir.* Metuchen: Scarecrow, 1992.

Schrader, Paul. "Notes on Film Noir." *Perspectives on Film Noir.* Ed. R. Barton Palmer. New York: G. K. Hall, 1996: 99-109.

Stables, Kate. "The Postmodern Always Rings Twice: Constructing the *Femme Fatale* in 90's Cinema." *Women in Film Noir.* Ed. E. Ann Kaplan. New Edition. London: BFI Publishing, 1998. 164-182.

Telotte, J. P. *Voices in the Dark: The Narrative Pattern of Film Noir.* Urbana: U of Illinois P, 1989.

Vernet, Marc. "*Film Noir* on the Edge of Doom." Trans. J. Swenson. *Shades of Noir: A Reader.* Ed. Joan Copjec. London: Verso, 1993. 1–31.

Waith, Eugene M. *The Pattern of Tragicomedy in Beaumont and Fletcher.* Yale Studies in English, v. 203. New Haven: Yale University Press, 1952.

Weddle, David. "They Want to See the Brains Flying Out?" *Sight and Sound* n.s. 5.2 (February 1995): 20-25.

Žižek, Slavoj. *Enjoy Your Symptom! Jacques Lacan In Hollywood and Out.* Revised edition. New York: Routledge, 2001.

In Plain View and the Dark Unknown: Narratives of the Feminine Body in *Malice*

Susann Cokal

One of the principal female figures in *Malice* (directed by Harold Becker, screenplay by Aaron Sorkin and Scott Frank) is precisely that — a figure, a bronze Degas ballerina with her arms twined behind her back and one toe pointed in first position. She is a woman who has learned to control her body so well that she will strike her pose forever, telling a story of discipline, innocence, and painless artistry.

This dainty ballerina belongs to Tracy Kennsinger Safian (played by Nicole Kidman), the apparently sweet orphan, day-care volunteer, and wife of a college dean. She has told her husband, Andy Safian (Bill Pullman), that her father gave the Degas to her, and the two of them "think it's an original." In the end, it turns out to be a reproduction that can be had at any department store for $89.95, and Tracy is a *noir*ish vixen who has convinced gullible Andy to marry her, buy an old house with bad plumbing, accept a tenant, and plan a family. Her ultimate goal is to sue that tenant, a doctor and co-conspirator, for gynecological malpractice, turning her body into an authentic moneymaker that can rake in as much as a real Degas would. She and Dr. Jed Hill (a hypermasculine Alec Baldwin) are also sexually involved, and the plot they have constructed depends on a judicious use of light and darkness, animate and inanimate, physical and imaginary: shining the right sorts of light into Tracy's mysterious bodily plumbing, keeping Andy — despite his experience with coeds — in the dark, using bodies to play with minds. As Andy attempts to restructure the house in which they all live together, Tracy and Jed will restructure his reality.

If Tracy's body is the most plainly visible element of the story, what it

contains is also the least knowable, the darkest part of the plan — the physical and psychological experiences that are both causes and side-effects of the medical con. It is a dark world into which the faux Degas points with one delicately extended toe.

"Only the Surface Was Necrotic": The Structure of Malice

When Jed first enters that old house, he utters a most peculiar line: "Architecture is my life. If I hadn't 've been a doctor, I'd have been a ... I'd have been a building." This remark seems to make no sense — why would someone intend to spend his life as an inanimate structure? If this is Jed's idea of a joke, it falls flat; even Andy hardly reacts to it. Jed is not really paying attention to what he himself is saying; he's visibly distracted, having just picked up a framed newspaper picture with a text proclaiming, "Professor Marries Favorite Student." Awareness of the story Tracy has built around Andy may be causing Jed to present his own life in terms of a building, an apparatus whose true life comes from the inhabitants who move within it. Despite his obvious machismo and power, he is not the architect of Tracy's plot. Even at his most active, when he dismantles and reassembles Tracy's body, his function will be in some sense to blend into the woodwork (or the plumbing), serving as part of the structure of medical technology, vision, and discourse on which the plan rests.

The true building — in several senses of the word — belongs to Tracy. She is the animating force of the story, as Jed reminds us by asking immediately when he notices the Degas (always referred to by the name of its masculine creator) and asks about its provenance. Tracy builds her story within a number of feminized spaces: the hospital day-care center, the old house's kitchen, bathroom, and bedroom. The house's structure is in plain sight, but it refers to Tracy's hidden structure (ovaries, uterus), which is in a more dramatic, if unseen, process of rebuilding. And that particular remodeling scheme is, in turn, serving a larger project, the construction of the grand narrative about Tracy's life and an impending disaster that will get her what she really wants: money to live on the rest of her life — or at least until the next irresistible urge overtakes her. Jed is a character in the new life she is constructing, a figure she reduces to bare elements in service of the story by the same process with which Sorkin described his own use of character in 1995: "It's fiction. They don't eat, they don't do anything except help my story" (nyscreenwriter.com). Beyond that narrative, however, a different disaster awaits Tracy, and it, too, will be worked upon her body.

Malice is structured through several narratives of the female body—schemes written by means of that body, about that body. This focus on the body is typical of noir films and indeed of late-twentieth-century female-driven narratives in general. Jane Gallop has theorized that contemporary women tend to think with their bodies because their bodies so largely define them; she also suggests that these women attempt to think beyond the body's boundaries in order to escape those definitions.[1] As Tracy injects herself with drugs to poison her ovaries, she is undoubtedly plotting with her body; by ridding herself of a reproductive system that has caused her trouble in the past, she is also forging through her body's boundaries. She is rather like an Amazon who cuts off a breast: This is an act of empowerment, her way of using traditional physical limits—a body historically defined by its ability to give birth—to transcend both those limits and the more figurative boundaries that have kept her, at least in her own mind, unfairly impoverished.

The movie is quick to identify the female reproductive system within a context of endangerment. The film opens along with the college doors, which emit a flood of young women; as the actors' names fade in and out, the cameras follow one young girl who climbs onto her bicycle and rides up to a pleasantly picket-fenced house, where an unseen man grabs her. The off-camera rape establishes the vulnerability of this part of the body, and eventually there will be three victims: Carol Latham (raped before the movie begins), Bridget Kelly (the girl on the bicycle), and Paula Bell (one of Andy's special charges). Although we never find out exactly what happens to the victims' intimate parts, the experiences have clearly been brutal. We may assume that all three sustain considerable internal trauma, as evidenced by Jed's last-second rescue of Bridget Kelly. The hospital where he works, Saint Agnes's, is named after a third-century martyr who chose torture rather than surrendering her virginity. When she remained steadfast, she was either beheaded or, in another version of the legend, sent to a whorehouse, where she still managed to retain her maidenhead. That version has her burned alive (Englebert 28). The story is probably unfamiliar to most viewers, but the mere name of the hospital associates women with weakness, and those who know the legend will also make the connection between torture and women's sexual parts. The fact that Jed operates inside Saint Agnes's suggests that his primary work is within the female body, as will most significantly be the case with Tracy.

It is clear from the outset that Tracy is not to be spared serious injury. When we first see her, she is working in a day-care center associated with the hospital (her mother will later refer to it as a children's ward, but none of the children appear to be sick), and she is supervising a roomful of children engaged in various activities, all of them taking place beneath a giant

cross. That cross is not of the Christian variety we might expect, given the name of the hospital; it is made of a giant-sized Band-Aid wrapper, torn in two and criss-crossed — a decidedly odd wall decoration for what appears to be a haven for healthy children. When Tracy helps a little boy with his paints, she reveals a large purple splotch on her hand, a splotch that recalls the bruising on the body of the raped girl. Tracy, of course, is not one of the serial rapist's victims; but her symbolic self-rape pushes both her narrative imagination and her physical body to their limits, and the blotch is there to remind us what those limits will be. Immediately after we see it, she stops a boy from wrapping his head in plastic — the technique she'll try to use later, when she tries to eliminate the neighbor's spying son and thereby dooms herself completely.

The physical act of self-fragmentation would mean nothing without an imaginative act of storytelling; together, they make up an almost brilliant confidence game, a work of narrative art that combines the physical with the mental. Tracy structures her con through several carefully composed stories, many of which rely on Andy's surprising gullibility: She says that her parents are dead, her father gave her the statuette by Degas ("an original"), she has been seeing a Boston doctor for her abdominal pains, and she would like to take in a tenant for the third floor, so she and Andy can afford to fix the plumbing and buy a sofa. In fact, she is a con artist of long standing, and she hopes finally to have created a story that will pay off. She and Jed met over an abortion, when Tracy's attempt to trap a rich man into marriage did not work out; eventually the audience learns that Jed's disgruntlement over not receiving a promotion at Harvard Medical School has made him eager not only to cash in on his years as a doctor but also to exact a sort of revenge against his old mentor. It is a lucky coincidence that Galloping Jed Hill was a running back at Andy's old high school, and thus someone Andy already admires. It is also lucky that Jed is on call the night Tracy's necrotic ovaries cause her final collapse, and that in fact just one ovary is truly dead; only the surface of the other is necrotic, and Jed's apparent misdiagnosis, resulting in her sterility, wins Tracy twenty million dollars. Her willingness to put the time into making Andy fall in love with her, marrying him, and then beginning the visits to Boston and the sabotage of her ovaries, shows she is committed to constructing this story.

But Tracy attempts to do too much. She overembellishes narratives of the otherwise insignificant ballerina and her own reproductive system. There is, for example, no real reason for her to make up a false provenance for the statue; she seems to think it will make for a better, more convincing, and more sympathetic life-narrative. Similarly, she conceives a child, knowing that a miscarriage will win her more money in the lawsuit, even though it

is not part of her original plan with Jed. That plot point, which she expects to be the crowning touch, is her first undoing, in large part because it brings her into a narrative over which she has no control. As Andy tells the still apparently innocent Jed, "The twenty million was for the victim — they [the lawyers] thought they were up against Snow White." She seems slotted into an archetypal role of feminine purity, but circumstances show her to be all *noir*. Jed's warning, "Don't overestimate yourself, Tracy," comes too late.

With the planned/unplanned pregnancy, Tracy's storyline intersects significantly with the one that actually begins the movie in the title sequence, a narrative of serial rape to which she has paid little attention. Although Jed saves Bridget Kelly's life in a scene that shows him to be both brilliant and a rebel, and although Andy is deeply concerned about this girl and the next victim, Paula Bell (played by Gwyneth Paltrow), Tracy hardly talks about the situation. She shows no interest in the rape storyline, beyond assuring Andy (at his insistence) that she will be safe coming home after dark. She has been absorbed in her con, but she has not had the imaginative foresight to test all possible scenarios, and it turns out that Andy could not have impregnated her. When he is a suspect in the rape case, the semen sample he is forced to provide gives evidence that he is not a figure in the rape story; at the same time, it reveals he is not playing the role he thought he was in his own life, either. As the policewoman, Dana, tells him over a drink meant to be both congratulatory (as he has just defeated the actual rapist) and consolatory, he is sterile. Indirectly, Tracy suffers the repercussions of ignoring other women's pain.

Andy's sterility trumps Tracy's fertile imagination, and he embarks on a mission to pull apart her narrative, which has now become the film's principal focus.[2] Reeling from the shock, Andy goes deep into the darkness of Tracy's body and his own in order to see the light; he determines that Tracy's version of her body is as false as he will find her Degas is, and even more easily deconstructed. Finally, he becomes the interpreter and filter of the "real" stories here: He solves the mystery of the rapist-murderer among the pipes in the college basement, deciphers the clues of Tracy's past, and stages a drama that traps her and reveals her to the world, in a police car's flashing lights, as the con artist and murderess that she really is. At the same time, Andy's one-act play overshadows some of her most important characteristics, and the film's.

"Am I Talking to My Shadow?": Light and Dark, Space and Vision

Malice is a murky film. Characters creep around in half-light, arguing, kissing, working virtuously or nefariously; almost the only figure consistently

represented in the light is the neighbor boy who, in the final frames, turns out to be blind and thus not to need the light. The camera constantly shows us fixtures with unlit bulbs, particularly in Andy and Tracy's house; at the college, Andy works late under the light of a single green-shaded lamp, and when the bulb goes out he ventures into the Cimmerian college basement rather than turning on an overhead light. Andy finds Paula Bell's raped and murdered body in broad daylight, but the police and paramedics collect it and process the crime scene after nightfall, using three spotlights that isolate the body in a context of overwhelming blackness. And the operations on Tracy and the raped girls take place in what must surely be the darkest hospital in America.

When Tracy's mother asks Andy rhetorically, "Am I talking to my shadow?" she might not be far off the mark; in this film, it is hard to see the characters for the shadows, and in the darkness they all take on the roles of deceiver and deceived, raconteur and audience. On the most obvious level, this darkness helps to identify the film noir genre with which the filmmakers are playing, and it handily represents Andy's groping toward the light of truth; but it also plays with our conceptions of the power of seeing, and particularly seeing into the female body, which are at the heart of modern gynecology and medical narratives in general.

From the open wounds reflected in the surgeons' safety glasses to the suddenly staring eyes of the victims and the CPR dummy, the movie emphasizes vision as a way of both constructing and deconstructing narratives about the body. *Malice* differs from typical narratives of the female body in that the emphasis on darkness helps to create it not only as a medical uncertainty but, more importantly, as a quantity over which the individual — in this case, Tracy — can take control, precisely (and perhaps paradoxically) by virtue of its unknowability. Both light and dark render the body vulnerable, but they do it in different ways; while light empowers the viewer, darkness empowers the individual inside that body, who may then manipulate its visible signs. Tracy's illness is what is visible, truth the dark unknown; judiciously trained lights can give the illusion of truth and knowledge, but Andy must descend into darkness and shine his own lights there in order to get at the origins of her story. Inevitably, he will do some reconstructive work, both to make sense of her story and to change its outcome.

The film nonetheless appears to resist its own tendency toward darkness. It places great emphasis on the sources and uses of light, in a symbolic system that puts the power of vision into contrast with the power to create illusions and control how others will see them. Through verbal and visual references, then, *Malice* brings the inner workings of the body selectively into the light. It does this primarily through a metaphoric use of architec-

tural structures that will eventually give meaning to Jed's peculiar remark about his choice of career. Tracy's physical situation is figured in the old house she and Andy are remodeling: a house that played a role in the Underground Railroad, a house with a questionable circulatory system of pipes and plumbing.

Some of the brightest scenes, for example, put an emphasis on plumbing, and that system of water and waste alludes to the body's own hidden passageways. The hospital scenes naturally include episodes of suction and irrigation, but the more subtle and significant references occur elsewhere. Tracy first advocates finding a tenant because fixing the plumbing in the historic house will cost nearly fourteen thousand dollars; she and Jed share an intense and enigmatic moment when he walks in on her preparing a bath; the nurse Tanya scurries naked and giggling from the bathroom to Jed's bedroom, flipping on the light before she enters; and in the red-and-white kitchen, even as she enters her final collapse, Tracy draws a glass of water in order to take her pills. The faulty plumbing seems to be working just fine; perhaps it points to the ruse Tracy is perpetrating with her own pipes. It is another way in which the clues to the puzzle remain in plain sight, for Andy simply cannot understand them. The film never follows him into the darkest spaces of either the house or Tracy's psyche: When he visits a cellar, it is at the college, and when he visits Tracy's past, it is through a sordid story from her drunken mother — an occasionally contradictory story that gives us some plot points but little insight into what actually goes on in Tracy's own mind. We realize fully the insignificance of light when the next-door neighbor, a nurse, leads her son into the house: The key figure in Andy's own scheme has been blind all along.

It would be easy to identify the building as domestic space and to note that as Tracy begins to deconstruct a gentle family man's world, she uses domestic space as a weapon[3]; but in fact Andy is more closely identified with the house, in a way that partly explains his relationship with his wife. Tracy may collect plumbers' estimates and bring home the take-out meals, but Andy is the one who domesticates the house, making coffee in it, telling stories about it, dosing it with chemicals that may do him physical harm (he is applying harsh strippers and refinishers to the banister when Jed enters for the first time). In short, he does to the house what Tracy does to her body, and eventually the film will have him take over for her and narrate Tracy's body as well. At first, however, Andy relays the presumably genuine the story of the house, along with the false one about his wife; his dedicated care for the house echoes his practically unquestioning care for her. He is the domesticated servant to her narrative.

Deep in the bowels of the college building, Andy will discover his own

ability to affect and effect stories. He is working late when the bulb in his desk lamp (remarkably similar in shape to the operating-room light fixture we have just seen dangling over Tracy) goes out; his quest for illumination leads him into the basement, where he finds the secret bedroom where the janitor, Earl Leemus, has been sleeping clandestinely. As French philosopher Gaston Bachelard would have it, Andy descends from the rational space of the upper floors into the "dark entity ... the one that partakes of subterranean forces" (18), and encounters raw, violent emotion. Thus a very minor character, barely glimpsed in a previous scene, is suddenly revealed as part of the infrastructure of both building and film. Andy finds a tuft of blond hair sticking out of a picture frame — hidden in plain sight — and makes the connection to the rapes. He also discovers his own anger; those hitherto hidden passions, hidden once again, will be his means of empowerment and the key to his narrative act.

When Andy leaves Leemus's room in the basement, the camera pans along a tangle of pipes before stopping on Andy's thoughtful face — quickly distorted as the janitor attacks. This is where Andy becomes a tough guy; he knees Leemus in the groin (the focus of virility and bodily plumbing) and brains him with what is probably an unpainted fire extinguisher. This gray tank recalls the red one pointing into Tracy's abdominal cavity in the hospital scene; the change in color here blends the extinguisher into the surroundings, making it another tube in the system of steam and water — by no difficult stretch of the imagination, a phallus for Andy to wield and as integral a part of the system as a penis is in fact a part of the human body. This is the scene in which Andy embarks on his violent and hard-drinking journey toward traditional virility; significantly, that journey utilizes the building's veins and arteries, much as Tracy's path toward power has made use of her own circulatory system. Perhaps if Andy hadn't 've been a professor, *he* would have been a building; he is coming to understand vernacular architecture as he will soon understand the structure of the female body and, ultimately, the architecture of Tracy's con game. In the very next sequence, after an unseen medic patches up his wounds, he will learn about his sterility. Fortunately his recent experience has helped him envision the invisible, and from this point he will be able to break down Tracy's body narrative and reassemble it in the proper structure.

Generally speaking, the body is the dark unknown, and the purpose of *Malice*'s medical storyline is to test the limits of its knowability and narratability. Any visit to a doctor's office involves a narrative act: A doctor reads symptoms, discusses the history of those symptoms with the patient, and composes a narrative about what is going on inside the body. In order to construct the most authentic narrative possible, doctors use a barrage of

instruments, including knives (the phallic value of which will not go unnoticed in this film), tubes (medical plumbing), and light sources. The success of the narrative depends on the survival and quality of life of the patient, and whether he or she decides to sue. But neither in the real world nor in the filmed one is a doctor supposed to be a real creator, someone who invents stories; he is supposed to get at the truth of the dark body. With his medical knowledge, Jed makes Tracy's body conform to preexisting symptoms — structures — of disease; he is methodical, not inventive. To use another of the film's persistent metaphors, Jed is still that high school running back; the quarterback, the player who calls out encoded strategy, is Tracy. As Jed trumpets, "Physicians don't get to choose."

Nonetheless, *Malice* makes much of the "God complex" that is said to afflict some doctors, including Jed. In the conference room scene during which the malpractice suit is discussed, Jed describes how it feels to wield the power of life and death, concluding: "If you're looking for God, he was in operating room number two on November seventeenth and he doesn't like to be second-guessed. You ask me if I have a God complex? Let me tell you something: I am God. And this sideshow is over."[4] Alarming as this pronouncement is to the other medical men present, Jed's putative complex (his pathology) is a cornerstone of the story he and Tracy have constructed around *her* pathology. However, it is important to note that even Jed claims to be godly only within a confined space, the operating room.[5] As we have seen, Tracy's downfall comes about because of her refusal to limit her own creation; she expands her story too far, into terrain she does not know.

In order to cut, a doctor must be able to see, and much modern medical research has been dedicated to improving surgical vision. X-rays, microscopes as thin as a blood vessel, and other devices allow the doctor to project light into the body, and Jed's education trains him to make proper use of that light and really *see* what he is seeing. Michel Foucault has written that when modern medicine was gestating at the end of the eighteenth century, to look at a patient's body meant

> to experience its greatest corporal opacity; the solidity, the obscurity, the density of things closed in upon themselves, have powers of truth that they owe not to light, but to the slowness of the gaze that passes over them, around them, and gradually into them, bringing them nothing more than its own light.... The gaze is no longer reductive, it is, rather, that which establishes the individual in his irreducible quantity [*Birth of the Clinic*, xiii–xiv].

In other words, at the birth of the current medical age, light became less important than the ability to see properly; it is informed sight, rather than

mere visibility, that understands a body and composes the correct case history for it. The doctor brings knowledge and experience under the lamp, then puts the body under the knife.

The female body in particular is an unknown continent; light and medical instruments allow the doctor to explore and reshape it. As Mary Ann Doane has written, "Light ... enables the look, the male gaze — it makes the woman specularizable. The doctor's light legitimates scopophilia" (*Desire to Desire* 61). X-ray photographs, which require light to illuminate a shadow image of the body's interior without actually opening that body up, are perhaps cinema's most common means of representing bodily interiors — and a means that itself employs a kind of film. They hang prominently in all of *Malice*'s operating-room scenes; it is Tracy's X-ray that proves her to be pregnant. Alice E. Adams suggests that the doctor's "penetration of the murky darkness of the womb brings the fetus to life — not only because visual access to the fetus permits him to diagnose disease and prescribe treatment, but also because his seminal gaze rescues the fetus from the oblivion of its union with the mother" (157). In this case, Jed literally has been seminal; the baby is his, and on the figurative level his medical recognition of the fetus adds to the story Tracy has been incubating.

There is one apparatus developed specifically to open the female body and let light penetrate, allowing scopophilic doctors an unparalleled opportunity to deploy their medical gazes. The speculum, which is implied in *Malice* largely through the use of surgical spreaders, was invented between 1844 and 1849 by Dr. J. Marion Sims. He experimented with spoons and various other contraptions to open slave women's vaginas and examine the fistulas within (some of those women endured the anesthesia-free operations as many as thirty times each). Sims reaped his reward: Dubbed "the Architect of the Vagina," he declared, "I saw everything, as no man had ever seen before" (Kapsalis 31–45). As his triumphant claim indicates, the speculum not only admits light but also allows a re-creation of the space — even the body itself— in which a doctor can work. Essentially, it makes the woman's body his for the time in which the speculum is open; her agency is virtually erased, and he becomes her architect.[6] It is a rare woman who can manipulate possession of the light shone into her body, the male gaze that interprets that light, and her own state of health.

Jed, whom we never see at work on a male patient, certainly seems to possess the ideal power of seeing. His Harvard credentials and long list of achievements testify to the accuracy of his medical gaze, and by going against the general opinion, he manages a heroic rescue for Bridget Kelly. His God complex may even seem justifiable; he trains light judiciously, fragmenting the body into just the pieces he needs to see, and he reconstructs Bridget's

body according to textbook configurations of health. Later he sees into Tracy's body with such authority as to carry out her secret wishes and "twist" her — she will use that word later, in their argument — into the medical picture central to their con: that of the beautiful young woman robbed, through her surgeon's negligence, of a perfectly healthy ovary along with a necrotic and potentially fatal one. By virtue of his educated gaze, he transforms the light into a certain construction of the body, and he cuts it accordingly, with the open red space reflected in his glasses. He sees, he alters, and he presents the body again for others to look upon.

Of course, in order to be successful in this situation, Jed must pretend not to possess this great gift: He must pretend to misread what he sees in Tracy's ovaries, and he must manipulate the situation such that his various specula confirm or at least fail to refute his diagnosis. It is fortunate for our two con artists that the lab is closed and cannot perform a biopsy, just as it is lucky, also, that the drugs Tracy has been injecting have killed off only one ovary, not both — which must surely have been a danger. They have gambled on the timing and extent of the medical catastrophe, and Tracy's body has cooperated perfectly: It collapsed after hours and with the most lucrative possible configuration of disease. Up to this point, Tracy (like Jed, who has been prescribing her ovary-killing Perganol) has been working in the dark; but then it is in the dark that she does her best work. She has even kept Jed in the dark while conceiving a child with him; he first learns of it in the operating room, when an assistant shows him the fetus on the X-ray. His powers of vision temporarily defeated, for a few moments he stares at the unconscious Tracy, his expression as hard to read as hers until a black nurse with a strong accent calls him to attention: "Dr. Heal?" It is time to heal Tracy and to evict the tenant that has taken up residence in her body, much as he will evict himself from the Civil War house after the operation.

If Jed is the God who wields light, Andy is the unseeing man he loves to torture: Dana says Andy is "like fuckin' Job — shit just happens to you." It may be that, sitting blindly in his dungheap of a house, Andy has invited some of his own misery. A different kind of doctor, he has been unable to see into female minds and bodies, even though the film drives home the fact that he has had several opportunities of doing so. These occasions also emphasize female vulnerability rather than empowerment. He is dean of students at what appears to be an all-girls college (*Malice* was filmed in part at Smith), but his duties appear to involve more counseling than academics. When he calls truant student Paula Bell into his office, she sits with one leg propped on his desk in a position that indicates not only sullen disrespect but also, in the movie's subtext, female vulnerability: It is an excellent position for a gynecological exam. While in this position, Paula claims she can't

control everything in her life, even the times when she might show up for her academic exams; out of control, she will in fact be the third girl raped, the first one murdered.

Andy has failed to give Paula a proper exam, and she will be easy prey for Leemus, who glimpses her during that appointment (and nearly knocks into her with a large filing cabinet he is carrying). We do not know exactly what he does to her genitals or her internal structure, but it is enough to kill her; in the absence of other signs such as stab wounds or neck bruises, we must conclude that he gives her, like Bridget Kelly, the worst kind of pelvic examination. Leemus also takes another trophy, a narrative sign which will end up giving him away. The sexual significance of the locks of raped girls' hair is even clearer when Andy finds that hair inside a box (the symbolism scarcely needs pointing out).[7] Like the other tresses Leemus has collected, this one comes from the victim's head, but his trophy collecting represents a displacement upward: Symbolizing his violent activity in the girls' genital regions, the tresses refer more to pubic hair than to what sits on the girls' heads — and bear a more than passing resemblance to Nicole Kidman's own curly blonde locks. By following this bodily trace, Andy masters a little gynecology and delves into the mysteries of male violence and female mutilation.

Tracy, unlike Paula, seems admirably capable of controlling every detail, right down to the ordinarily unpredictable necrosis that must set into her ovary if her scheme is to work. Her body, too, assumes the awkward position for intimate examination one morning: She is sitting on a high stool in the kitchen, elbows on a rather low central table, so her bottom is raised and appears to be presented to Jed when he comes in from jogging. But Jed is her co-conspirator, and even positions of apparent vulnerability point to her strength and her command over her own body through that conspiracy; in this kitchen scene, for example, she barely looks at him, and she remains in control and self-contained. Later, of course, she engineers her own violation on the operating table. Jed is in this sense merely a part of the machinery she uses (a physician who doesn't get to choose); she needs his tools, but in the end it is her con, her body, her narrative.

Fragmentation is a key part of the process of Tracy's con game. She harms her ovaries deliberately and invites fragmentation from doctors; this is, perhaps paradoxically, her way of claiming her body and pulling her narrative together. One of her most powerful weapons is the unifying force of her beauty. For example, all key players in the lawsuit scene are male, except Tracy; but the situation empowers her. Her lawyer points out that the jury will see a beautiful girl who was living out a Norman Rockwell painting with her husband until Jed "tore it apart." This gratuitous reference to her

beauty emphasizes the value of her particular body, now internally damaged and thus structurally unsound. Acknowledging the power of her beauty underscores the inner fragmentation and helps her to win her millions — at the same time as mentioning the painting reminds the audience of Tracy's artistic construction.

Tracy begins to fragment in the hospital, where the light breaks her body into pieces, highlighting certain parts and ignoring others. It focuses attention on her ovaries and uterus, just as it presumably has done for the raped girls' vaginas. Tracy's deliberate splintering in fact contrasts with the raped girls' victimization, even as the film makes deliberate connections between the two processes. When Tracy collapses in the kitchen, for example, she is dressed in a short, flippy skirt, black tights, and a jacket — virtually the same outfit Bridget Kelly is wearing (Paula also wears the flippy skirt when she is found, but naturally her tights have been removed).

The hospital light also presents an imagistic violation: During her operation, Tracy's mouth gapes open the same way Paula's does in the bushes where Andy finds her, and the thick plastic tube that helps Tracy breathe reminds us of certain acts that must have taken place in the rapes. Moreover, the only reason Tracy's eyes aren't open and staring like Paula's is that they have been taped shut. This unconscious and symbolically violated face is, together with the gaping red wound in which Jed is working, all the scene shows of Tracy; and if there is any danger of overlooking the symbolism of that incision, bleeding profusely, staining the fingers and knives that probe it, a cylindrical red fire extinguisher hangs prominently on the wall, as if about to dip into the wound. All signs point to her vulnerability and violation, and later she will walk out on Andy, who agreed to the operation that would save her life, with the words, "He took my insides out, and you gave him permission. Good-bye, Andy." She appears to have staged her victimization perfectly.

In plain sight, Tracy's body is split and twisted in pieces; what remains in the dark is the unifying story of her con, and for that we turn first to the con's single most visible sign.

"Looks Just Like the Real Thing": The Ballerina and the Dummy

Malice makes the point, like many noir films before it, that appearances deceive; what is plainly visible, what sits in the light, is often false or at the least misleading.[8] The prime example of this deception is the Degas ballerina. The true original is known as the *Petite danseuse de quatorze ans (Little Dancer*

of Fourteen Years); she is thirty-nine inches tall and, at the time of *Malice*, about 112 years old. Several examples still exist in private collections, made of wax, silk, satin ribbon, and real hair[9] — in essence, many of the same ingredients Tracy brings to her representation of childlike innocence. She, too, wears a short, flippy skirt. The ballet's tightly choreographed movements are also a highly visible figure for the con game Tracy and Jed are playing: Their plot requires Tracy to twist her body (namely, her ovaries) into the proper position and strike a pose of innocence. The arms twined behind the ballerina's back make her body appear fragmented, as Tracy's will be; it is also curiously phallic, constantly juxtaposed against more circular spaces. Like the statue, Tracy must resist a close examination or risk losing everything, and her phallic power is illusionary.

Tracy invites the uninformed gaze belonging to the lawyers and doctors to inspect the construct she has made — there is no other way to win the game. But Andy does not remain uninformed. When the rape subplot uncovers the hole in her story, he is suddenly put into the position of her doctor; he reviews her symptoms and the narrative she has made of them, decides what's authentic, makes a diagnosis. Now that his gaze has entered her story, she is unable to control it fully; her overnarration is exposed to view, and she is truly vulnerable. That failure leads Andy eventually to another woman's narrative, another version of Tracy's life. This time the storyteller is her mother, Mrs. Kennsinger (Anne Bancroft), who articulates some of the information that Andy needs to fill out the story structure (accordingly, her name emphasizes the ghostly female voices that sing over the titles and credits, the same tune the neighbor boy plinks out on his electronic keyboard). Soon after he enters Mrs. Kennsinger's grim apartment, bottle of single malt whisky in hand, Andy thinks he recognizes the Degas on the mantelpiece. He says, "It was in my house — I know Tracy's been here." Now Mrs. Kennsinger tells him the truth. The statue is a fake, and a duplicate fake at that: "You can buy it in any department store for eighty-nine ninety-five — looks just like the real thing." The ballerina becomes definitively a sign of the games women play.

The Degas also points to Tracy's father's absence, and the story Mrs. Kennsinger tells about her daughter's childhood offers some easy explanations, grounding structures, for Tracy's scheming ways. Apparently Tracy "sure loved her daddy. Second-best confidence man in South Boston. Taught her everything." He also robbed her blind; Tracy saved the money he gave her for candy and kept it in her mattress, and when he left the twelve-year-old little girl (almost the same age as the *Petite danseuse de quatorze ans*), he emptied not only the family's bank account but also that mattress. Tracy, once her father's dupe, has spent her life using the skills he taught her in

order to win a fantastic sum, the amount of which has increased as she has grown up. Two hundred lost dollars became the eighty thousand she stole from the abortion clinic where she worked for "Dr. Lilienfield"; then, of course, the twenty million she is promised for her ovaries and miscarriage. In the story she tells Andy, the ballerina is a clear sign of the father; to herself, it is also a sign of the powers to hurt others and to tell stories.

The phallic ballerina has a male counterpart: "Junior," the CPR dummy to whom policewoman Dana introduces Andy after he defeats the evil janitor. Junior is repeatedly identified with Andy, and his role in safety training classes makes him another Safian; his bushy brown hair even mirrors Andy's, and his red sweater slots him into a color system within the film that refers to blood, violence, and the female or feminized body. He will never truly come to life; he is a sort of ghost haunting the film with the threat of unrevivifiable manhood. What is most striking about his appearance, however, is his mouth, which gapes open in a wide hole that suggests either stupidity or feminized vulnerability, again associated with the female: We have already seen such gaping mouths with Paula's raped body and Tracy's anaesthetized one. We have also seen Junior before; he is an eerie presence in a black-and-white photo pinned to the bulletin board behind Jed after his heroic rescue of Bridget Kelly, and that picture pops in and out of view as Andy's head bobs in the next scene, when he and Jed talk about the operation. With his passing similarity to Andy, Junior suggests the professor's initial status as a powerless dupe. Andy is the man with the repeatedly open mouth — first in bed, with Tracy coaxing, "Open ... open," so she can insert the chopsticks with which she is expert (before assuming a position of sexual power on top of Andy's immobile body); later in the cliff house, as he gapes at the realization that Tracy and Jed have conspired. Junior also echoes the hapless fetus, the one who might have been Andy Junior, aborted in Tracy's operation.

A perpetual victim, as Andy at first seems destined to be, Junior is also part of an established storytelling apparatus. He exists to train lifesavers — presumably the students Dana serves and protects — in a series of staged trauma scenes. Dana introduces Andy to the dummy: "Junior, have you met the professor? Very tough guy." Andy has just beaten the janitor, Leemus, to unconsciousness, but at this point he is still hardly what one would normally call a tough guy; he even hints as much when he replies, wryly, "When you want something done right, goddammit, you call in a teacher." Being forced to give the sperm sample was his symbolic rape,[10] but meeting Junior in the flesh (or rubber) is his reward for getting revenge on the actual rapist. Junior will help him avenge himself on the woman who "reamed" him and violated his trust, for those trauma scenes in which Junior routinely figures

are fictions, and the dummy is, like the teacher, ultimately a figure of power. Shadowed against a lit room, his is the body that Andy will use to construct the narrative that rescues him and dooms Tracy: Hidden in plain sight, mouth receptively open, Junior redeems and re-creates Andy, just as the more substantial ballerina brings Tracy down by revealing the gaping holes in her story. He will teach Andy to save his own life (or at least improve its probable course); through Junior, Andy learns that if his mouth must gape, it may do so to further his own story, not for the insertion of another's. Andy learns to use darkness, the unseeable, and to manipulate what's in plain sight.

It is more important that Andy be tough mentally, that he craft a good story — a play, a movie — than that he be able to prevail in a physical fight. After all, he does not need to enter the nurse's house in order to trap Tracy; he chooses to do so. He sees Tracy pull the plastic wrap over Junior's head, sees Junior's eyes fly eerily open — and then Tracy (also seeing at last) goes berserk, attacking first the dummy and then her husband. And when Tracy and Andy's final struggle caves in one side of Junior's head, his wounds mirror those Andy received in the fight with the janitor. Tracy, too, receives a wound on her forehead just like Andy's: All three of them have been duped, have been manipulated and violated in assorted narratives. Junior stares at Tracy with blind but all-seeing eyes. Thus, if the ballerina's pointing toe indicates first Andy's gullibility, then Tracy's faulty narrative, Junior points to Andy's worth, more as a wily storyteller than as a tough guy. The movie does not mention Junior's price, but a high-quality CPR dummy would cost more than the knockoff ballerina — the dummy is more valuable than the Degas. Andy has learned from Junior's gaping mouth, and he animates his manikin prop much more savvily than Tracy manages hers.

The last time we see the Degas statue, it is tipped sideways in a wicker box at the house Tracy shares with Jed, sharing its space with two baby dolls (who perhaps represent the two babies Tracy has aborted, or the two girls we've seen raped, or the two with whom Jed is drinking and flirting when he is summoned to operate on Tracy). There is no reason for her to have brought the fake with her. Its presence shows that she is pathologically unable to give up her impulse to narrate, even if she must house her narration in a structure as flimsy as wicker. In fact, Tracy's own narrative seems to have taken her over. She at last sinks to murder — first of Jed and then, abortively, of the dummy she thinks is the neighbor boy — in order to rescue the story. This is another of Tracy's worst mistakes: Insurance fraud would send her to prison, certainly, but murder will guarantee her a lifetime therein. Murder ends her self-driven narrative at last, contains her in the structure of a prison where she will be enclosed among pipelike bars and constantly watched. The ballerina's presence in the cliff house shows Tracy has held on to her com-

pulsion to narrate, but the careless tilt within the basket shows Tracy is no longer controlling every detail. Or then again, maybe she has come to believe the history she has constructed for it — the worst mistake of all.

Animated Structure: "Where Does It Hurt?"

What Andy is unable to uncover, or even to imagine, is the intangible set of sensations that lie (truthfully) within Tracy's body and animate the narrative structures she creates. To him, she remains as insensate as the old house, the ballerina, and the dummy; for example, it is impossible for him to determine the amount of real pain she feels as her ovary dies. This physical sensation seems to be obscured with Tracy's lies, and he and the filmmakers pay it little attention once it is no longer useful for creating sympathy for Tracy's character. The management of her agony, though largely unacknowledged, has surely been one of Tracy's greatest challenges, as it threatens to pull her attention away from the imaginative construct of her new narrative. And the pain also, to a certain extent, obscures another animating element of the larger story's structure: Tracy's psyche.

Pain gives the ring of truth to a medical narrative; it gives significance to the structure of bones and tissues that make up a body or a character. Foucault argues that the modern clinic — and thus, I would say, modern storytelling — began when doctors stopped asking, "What is the matter?" and started asking instead, "Where does it hurt?" (xviii). Being able to locate pain specifically in space naturally explains what is the matter, and it gives the physician the information necessary for an empowered, imaginative seeing into the dark spaces of the body. For example, when Jed knows where Tracy wants to feel her pain, he knows what drugs to give her; when she reports back on her pain, they can decipher the progress of their story.

Although no system of light or darkness can represent pain, Tracy's is very real; the film shows her breaking down in private, without an onscreen audience. While an inevitable part of the narrative she is constructing, the pain also controls and constructs her in perhaps unexpected ways. Tracy may be able to withstand pain that would defeat an ordinary person, but what she feels in her abdomen reminds her and the audience of the limits of what a human body can endure. In relying on those limits, the pain — with the decaying flesh that creates it — establishes boundaries for the con perhaps even more significant than Andy's gullibility (which seems boundless) and Jed's skill (which, once we know what he and Tracy have planned, never comes into question). Tracy's pain and her inscrutable psychology both define and animate the story structures she has composed.

As we have seen, those limits are materially figured in the old house with its decayed plumbing, its banisters in need of heavy chemical treatment, its charming but ancient light fixtures. The house is not what Jed might have been if he were not a doctor; it is what Tracy has in fact chosen to be. As she gets deeper into the physical aspect of her con, the film points more and more insistently to certain spaces within the house and Tracy's body, limiting our awareness of both architecture and body to those circumscribed areas. The filmmakers draw parallels between her body's necrosis and the old house's deterioration: All of the scenes of pain take place inside the house, and the one in the bathroom makes an explicit visual connection between turning on the tap and feeling a twinge in the ovaries. Her world shrinks when she feels the pain in her ovaries, until the space of which she and the audience are aware is limited to her abdomen (in which the pain is located), figured by the kitchen and bathroom (in which the pain is felt).[11] To underscore the symbolic connection, after Tracy leaves the house for the hospital — where we see into the locus of pain, her abdomen itself— the movie will not refer to her pain again.

Accordingly, the storyline involving the old house's restoration falls away once Andy discovers what Tracy is up to. Compared to what has been going on in his wife's body, the home-improvement project loses interest for him; from the writers' and director's point of view, the symbolic value of this structural representation is gone. Once we have finally followed Andy into a basement — this one at the women's college, not in his house — we no longer need to inspect the above-ground structure in which he has been dwelling. Now, as a result of the tussle with Leemus, the film turns to Andy's physical pain, just as he turns his attention to narrative structure, pulling apart the underpinnings of Tracy's story. The wounds on his forehead and lips, mirror images of those seen on Paula, remind us of that pain, but Andy dismisses them in order to concentrate on his emotional agony: When Jed asks, "What the hell happened to you?", Andy says, "It wasn't my baby"; when Jed asks again, Andy says, "It doesn't matter." The Leemus story is finished, and it truly does not matter now. What matters is that those red wounds remind us of the limits of storytelling and the body; after all, Paula's red wounds killed her, and there is only so much that a body can withstand.[12]

Andy may focus on either pain or the story, not both at the same time. He makes a choice that is not available to Tracy. This is one way in which the body and mind usually work against each other. Scarry proposes a significant, polarized relationship between pain and the imagination: "That is, pain and imagining are the 'framing events' within whose boundaries all other perceptual, somatic, and emotional events occur; thus, between the

two extremes can be mapped the whole terrain of the human psyche" (165). Pain, she is arguing, is the body at its most bodily; when the body is in extreme pain, the ability to imagine or reimagine the world shuts down. But, as Scarry herself points out, in a typical doctor's-office narrative, a patient needs to use imagination in order to describe pain through the similes and metaphors that offer the only ways to characterize it: "It's a dull throb"; "It's like a nail driven into my head." In this less extreme situation, pain and imagination are coming together. Tracy is both torturer and victim, so she must reconcile the two poles of experience more dramatically.

The polarization plays out visibly in Tracy's con. She imagines the story into which she must fit her body, and she experiences the pain that, by virtue of the polarity, will potentially limit the story she can tell. Her pain appears, however, short-lived; it is intense before the operation, and she is weak immediately afterward, but in the very next scene we see her leaving Andy and striding out the door. Lighting and foliage indicate the film's entire action spins out in one season, perhaps even one month; in this compressed time span, the absence of pain is keenly felt. In the lawsuit scene she is strong, confident, and so unmarked by her suffering that she never even mentions the suffering, only the situation that created it (pain is not a fact; it is a sensation, and the story is focused on facts at this point). At the cliff house, she feels well enough to tumble wildly into bed with Jed. The only pain she seems to feel then comes from the hypodermic needle Andy leaves in the bed as a sign that he has unraveled her story. Her vocalization over this pain is much stronger than it was over her ovaries: What hurts Tracy most is the destruction of her narrative, not the violation of her body.

Andy finds that needle when he leaves Mrs. Kennsinger and goes home. He sees a photo of Tracy on the now–Degas-free bureau and, in a second fit of anger, he sweeps the bureau clean, and in the litter of fallen objects he finds, astonishingly, a half-full syringe — and looks up to see the boy at the keyboard. A visit to the cliff house follows. After she in turn discovers a needle where it should not be, Tracy tries to wrest the phallic power away from Andy again. Dressed in a vampy suit — a departure from her wifely flannel and jeans, and a visual reminder of the *law* suit — she meets him in a bar and attempts to win him over by snaking one foot up his pant leg as if it were a pipe. By now, however, her foot is as useless as the statuette's; her body has lost meaning for Andy, and he reminds her he is "running the show with *trace* amounts of Perganol" (emphasis added), the fertility drug that causes ovarian cysts when taken in excessive doses. Andy has taken charge of the trace — assumed Tracy's role, devalued her body and invested his own energy into the imaginative act of storytelling.

Andy opens Tracy's con-narrative with the same sort of apparatus that

Jed has used on her body. The speculum this time is psychology, as the film suggests that Tracy's con was inspired by past psychological damage; Andy may not make the interpretation explicit, but the writers, like good teachers, give the audience the information they need to draw their own conclusions. The Freudian overtones in Mrs. Kennsinger's version of Tracy's childhood are highly visible: When a father takes money from his daughter's mattress when she is the age for a probable onset of menses and puberty, after his convincing and seductive enactment of an indulgent papa giving a preadolescent daughter plenty of money for candy, he symbolically rapes her. Naturally Tracy stops trusting men and starts tricking them to get their money. We need hardly mention that a decent hooker might earn two hundred dollars for a trick on the mattress, or that Tracy continues to see mattresses as money in the bank. Although Mrs. Kennsinger says Tracy loved him, she doesn't think the little girl minded when he left; what she minded was the theft of the two hundred dollars. Thus we trace the origins of a con woman who turns out, like her ballerina, not to be an original. She learned first to emulate her father, then perhaps to avenge herself on men by using them for money. Her self-narrative has now killed off her father and invested his power in the phallic statuette of the *danseuse*, making the assembly-line ballerina an "original" character in Tracy's own life.

Tracy has been overfertilizing her body and her imagination, and together they bring her down. When Andy renarrates to Tracy the chain of events she has put together, she makes her true nature visible at last. She devises a last desperate plan and, in a surprisingly brisk scene, shoots Jed for being unwilling to carry it further. She attempts to kill the keyboard-playing boy — replaced with Junior — and then, finally, loses her temper. In her rage at Junior, she tackles Andy and crashes through the second-story railing of the neighbor's house, a near-mirror of her own. Emotion, which animates story structure, also has the power to destroy that structure. It is only while Tracy's emotion and motivation remain hidden within a solid structure that her story can succeed. The feminine body — like all bodies, even plastic ones — is eminently narratable, but its deceptive narration is best accomplished while keeping most story elements, such as motivation, in the dark.

Conclusion: "This Sideshow Is Over"

In manipulating her body's reproductive powers, and then in refusing reproduction, Tracy produces herself as a single entity — an entity as sterile and apparently unfeeling as a statue, with as inscrutable a provenance. But,

unlike the Degas ballerina, she will not be copied (that is, again, reproduced); she will in this sense remain an original. A man who has seen inside the pose works with a dummy and a boy who, like a fetus, is blind to the narrative expressions of the visible body; together they make sure that she will be locked away in a prison where, presumably, time will grind to a standstill and narrative will end. Languishing as a con(vict), Tracy will fade away. There will be no more narrative left to her; she will become unknown and uninteresting.

There are several other unknowns animating the plot of *Malice*: how Tracy and Jed choose Andy as their mark; how Tracy meets, seduces, and marries him; and why someone as smart and cultured as Andy Safian, Ph.D., seems to be would not recognize the Degas as a reproduction. These are the mysterious assumptions on which the plot depends, requiring suspension of disbelief (or a refusal to scrutinize narrative) from all involved — moviegoers, screenwriters, and characters. It is equally a mystery that Tracy does not change her name; born Tracy Kennsinger, she makes it easy to trace to her origins (at several moments, Jed and Andy call her "Trace"), whereas even Jed renames himself David Lilienfield.[13] It would seem in this case that Tracy is incapable of a fundamental act of imagination; she feels compelled to narrate her own life and to claim it with her own name, and thus her con story fails. The answers to the rest of these questions are as elusive as Tracy would otherwise like to be. They represent, perhaps, the story that she would like to tell, perhaps even a story that might exonerate her or foster real sympathy for her.

Malice itself is another unknown in *Malice*, highly visible in the title but not necessarily in the actions of the characters. The word's prominence would seem to suggest it is the narrative's primary motivation, but are Tracy and Jed truly malicious? Or simply conniving? The only actual malice in the film seems to come in the word's secondary meaning, intent to break the law. We might then ask for the motivation behind that intent. In the sense of spite, malice is usually directed toward another person: There is, as I have said, no explanation other than greed offered for Tracy's actions. Jed, it is true, acts in part out of resentment toward the doctor who accused him of having a God complex, but as he laments during a seaside stroll, he cannot let Dr. Kessler know he himself was "pulling the string"; thus he has no revenge. Tracy has chosen Andy simply for convenience, not to satisfy a grudge. There could be some secret in Jed and Andy's shared high school past causing Jed to single Andy out now — but that seems unlikely, given that they "moved in different circles." If anyone feels malice, it might be Andy — but then he is too good for such petty motivations; he is merely seeking truth and justice. The word "malice," in fact, is never uttered, and

we no more know why malice is felt, or who is feeling it, than we ultimately discover what is going on inside the female bodies here. So the narrative's motivation, like the Degas's fakery, like Tracy's body, seems to be hiding in plain sight, and we will never know it fully.

Thus the title of the film points to the realm of the invisible and unknown, even as the plays of light and dark, animate and inanimate, physical and imaginative emphasize some of the most basic elements of storytelling. The narratives of the female body ultimately demonstrate that in the con game that is cinema, what is in plain sight is not always knowable, and what we don't see may in the end be what matters most to us. We are all groping toward the light, digging within a wound, trying to build a structure that works.

Notes

1. See *Thinking Through the Body,* especially the introduction.

2. *Malice* is unusual in that there is so little intersection between the two main narratives. Given the conventions of the thriller in general, viewers might expect Tracy to be raped or Jed to turn out to be the rapist.

3. Elaine Scarry writes that in torture, a technique used in war, "the unmaking of civilization inevitably requires a return to and mutilation of the domestic, the ground of all making," and that "This world unmaking ... becomes itself the cause of the pain" (45).

4. The film presents him reaching this point in stages of metaphor. At first he is figured as a devil, when he walks into a hospital elevator in which Andy and Tracy have been holding a heated discussion about him:

> ANDY: Speak of the devil ...
> JED: ... and the devil appears.

Later, Jed is compared to an angel; when Andy and Tracy are guessing who might be at the door, Tracy says, "Angels could dance on pinheads, Andy, but they don't. It's Jed." So it is perhaps no surprise that he wings his way up to God status. These multiple identities show the possibility within the medical profession — a doctor can harm, help, or even create life — and the progression among them indicates the stages by which a physician or a storyteller may proceed from, say, bad intentions to a sense of omnipotence.

5. Jed also acknowledges he's not the best storyteller when he stops himself from instructing Andy to take a B12 vitamin complex to prevent headaches from paint remover. Andy is already doing "the smart thing" by leaving the front door open; Andy will also turn out to be a better narrativist.

6. The speculum thus offers the same sort of power the movie camera and lights give the director, for in a very real sense a movie's camera is like a speculum. The shutter opens to register the distribution of light over film, and it gives the audience a selective, fragmented view of the scene. In this regard, *Malice* invites the audience to participate in the doctors' reduction of the female body and narrative. It is, however, impossible for an audience to take control of a printed movie.

7. Furthermore, in Bachelard's theories of space, items such as locked and closed boxes represent "the unfathomable store of daydreams of intimacy," our very model for intimacy itself (78). Leemus's box of hairy locks symbolizes every sexual relationship in the film: Tracy and Jed, Tracy and Andy, Leemus and the girls — all of these couplings are based on narratives of a kind of perverted intimacy of the kind that takes such trophies.

8. As Doane has written in *Femmes Fatales*, "the subtextual theme recurrent in filmic texts, which resists the dominant theme whereby vision is constantly ratified, is that appearances can be deceiving. And surely they are most apt to deceive when they involve a woman" (46).

9. For example, see the statuette from the collection of Mr. and Mrs. Paul Mellon, Upperville, Virginia, photographed in *The New Painting: Impressionism 1874–1886*: 336.

10. One critic suggests that "Tracy's amputation of her organs is ... grasped as a castration of Andy's own penis, and, consequently, of his social phallus" (Abend); but in my reading of the film, Andy himself perceives the ovariectomy and incidental miscarriage more as a tragedy than a castration; the true castration is in the story she has made him believe, and his physical violation comes with the sperm sample brought up, presumably, through his own masturbation.

11. Similarly, Elaine Scarry has theorized that a torture victim (and Tracy makes herself into one) experiences the world as shrinking: He or she knows only the confines of the room in which the torture takes place, and the torturer's "weapons, his acts, and his words, all necessarily drawn from the world, all make visible the nature of his engagement with the world, though the scale differs in the three. The more physical each is, the smaller the world it represents" (36, 39). Torturing the body limits the victim's sense of the outside world and his or her role within it — though Tracy, as torturer as well as victim, keeps an eye firmly on the grand scheme of things outside house and hospital.

12. Paula's rape causes her injury in a part of the body Andy does not possess; but *Malice* eventually presents a symbolic and triumphant deflowering for Professor Safian. Our final reminder of the connection between architecture, the body, and narrative comes at the end, with the success of Andy's con in the next-door neighbor's equally ancient home. When Tracy discovers she has been tricked, her rage and physical attack on Andy hurtle both of them out of the little boy's room and through the railing that separates the second-floor rooms from the perilous empty space dropping directly to the first floor. When they touch down on the floor in a tangle of limbs — in the sort of physical exhaustion that the explicitly sexual scenes have left out — we see again that these old houses, like Tracy's story, are flimsy and easily broken. The rupture of the railing is a sort of hymeneal moment: If Andy were a building, this railing would be the last physical reminder of his virginal innocence; and it is the last feminine image associated with him. Even if he has learned some of his tricks through women, he is now a real man, master of the body and the story.

As if to drive home this point and to illustrate again Andy's ability to shape identity and narrative for the female body, policewoman Dana walks in to admire the collapsed couple and congratulate the triumphant husband. In this somewhat scopophilic moment, she stands in for the audience who are also admiring Andy's machistic triumph and the new vulnerability of Tracy's body. Dana herself is dressed in an old-fashioned, ultrafeminine version of a nurse's uniform, complete with white dress, cap, and cape (the nurses at Saint Agnes's wear the more practical, shapeless scrubs). There is a hint, too, that she and Andy will become romantically involved: They agree to go out for a drink — Andy will choose the type of Scotch Tracy's mother prefers — and engage in a bit of mild

banter as the cameras pull away and the credits (which lay bare the construction of the entire movie's narrative) begin to roll. Andy has deconstructed Tracy's narrative con and mastered it with his own narrative coda, and in that mini-play, he has finally both broken into masculinity and inscribed Dana in a feminine role.

13. If Tracy married Jed, she would become Tracy Lilienfield — assuming the name of a well-known real-life casting director. I have been unable to establish a link between the real Tracy Lilienfield and Aaron Sorkin, but to cinemagoers who study the crew's end credits religiously, the name points to the artifice of not only Tracy's story but the film *Malice* as well: Tracy Lilienfield is in the business of choosing and manipulating physical bodies to represent imaginary characters.

Works Cited

Abend, Dror. "'Don't Overestimate Yourself Tracy' or '"Malice"': Men in Danger': Representations of Birth and Abortion, and the Construction of Gender in Harold Becker's Film, *Malice*." *Deep South* 1:2 (May 1995). http://www.otago.ac.nz/Deep South/vol1no2/abend_issue2.html, accessed 19 October 2003.

Adams, Alice E. *Reproducing the Womb: Images of Childbirth in Science, Feminist Theory, and Literature*. Ithaca: Cornell U P, 1994.

Bachelard, Gaston. *The Poetics of Space*. Transl. Maria Jolas. Boston: Beacon, 1964.

Doane, Mary Ann. *The Desire to Desire*. Bloomington: Indiana U P, 1987.

_____. *Femmes Fatales: Feminism, Film Theory, Psychoanalysis*. New York: Routledge, 1991.

Englebert, Omer. *The Lives of the Saints*. Trans. Christopher and Anne Fremantle. New York: Barnes and Noble, 1951, 1994.

Foucault, Michel. *The Birth of the Clinic: An Archeology of Medical Perception*. Trans. A. M. Sheridan Smith. New York: Vintage, 1973.

Gallop, Jane. *Thinking Through the Body*. New York: Columbia U P, 1988.

Kapsalis, Terri. *Public Privates: Performing Gynecology from Both Ends of the Speculum*. Durham: Duke U P, 1997.

The New Painting: Impressionism 1874–1886. Exhibition catalog for The Fine Arts Museums of San Francisco and the National Gallery of Art, Washington. Geneva, Switzerland: Richard Burton SA, Publishers, 1986.

Scarry, Elaine. *The Body in Pain: The Making and Unmaking of the World*. New York: Oxford U P, 1985.

Sorkin, Aaron. Interview. January 1995 (unidentified interviewer). *Screenwriter Magazine*, online edition. http://www.nyscreenwriter.com/article8.htm. Accessed 13 November 2003.

_____. *Malice*. Dir. Harold Becker. Screenplay Aaron Sorkin and Scott Frank, story by Aaron Sorkin and Jonas McCord. Castle Rock / New Line Cinema, 1993.

Athletes, Grammar Geeks, and Porn Stars: The Liberal Education of *Sports Night*

Thomas Fahy

Out of frustration with Dana Whitaker's commitment to her job as executive producer of the cable show *Sports Night*, her boyfriend, Gordon, says: "It's just sports." In many respects the entire series suggests that he is wrong. In a show that has little to do with actual sporting events and only tangentially with reporting them, sports become a metaphor for human accomplishment, drive, pain, loss, and disappointment. From politically oppressed marathon runners to a long-distance jumper who holds the world record for only a few seconds, sports stories reflect on and ennoble the personal struggles of the show's characters. But the metaphor also extends to the nature of competition itself. In most sports, both mental and physical skills are essential for success. Likewise, the characters of *Sports Night* battle each other literally (in games of garbage-can basketball, poker, and popularity polls) and linguistically (with words and wit). This latter aspect — the competitive play with language — has moral and social implications that are central to the show's message about education.

Despite the hierarchies that exist within this fictional television organization (the network, managing editor, executive producer, associate producers, anchors, etc.), there is an egalitarian quality to the world of *Sports Night*. Aaron Sorkin creates a place where everyone from a network executive to a porn star is conversant with history, Greek mythology, drama, and Romantic poetry. His characters speak quickly and with grammatical precision ("And why don't we use semicolons anymore?" Dana laments.). Like *The West Wing*, *Sports Night* validates education by making intelligence a heroic virtue. We root for anchors Dan Rydell and Casey McCall, like President

Bartlet and his staff, in part because they are smart, because they outwit the competition while still laughing at their own shortcomings.

More specifically, *Sports Night* presents education both as something that we must strive for to better ourselves and as a necessary tool for engaging social and political issues. In this way, Sorkin makes television a powerful forum for learning. As we identify with Dan's misguided attempts at altruism, Dana's struggle with maintaining ethical integrity in a ratings-driven market, or Isaac Jaffe's conflicted stand against racial discrimination, for example, we evaluate our own accountability to such issues, and the show suggests that this kind of social engagement requires moral integrity and personal sacrifice. For Sorkin, this type of action makes a true intellectual.

Even though *Sports Night* presents cultural literacy as something that all people can — and should — have, knowledge can also be dangerous. The series was dropped after two seasons for low ratings (an issue that also drove the fictional narrative of season two). *Sports Night*'s failure to attract a large audience suggests that the network and public didn't fully embrace the idea that intelligence is as laudable as scoring the winning touchdown. This is partially due to the fact that Sorkin's characters often use knowledge as a weapon. Education that fuels hubris and derision is destructive, and *Sports Night* often slips into a type of intellectual elitism. In a moment, a playful correction to someone's grammar can become an ugly, belittling attack. Even though *Sports Night* creates a world where everyone — grammar geeks, athletes, and porn stars — can be an intellectual, it does not always overcome the mean-spirited arrogance of its characters and content.

A Liberal Education

Most of Sorkin's work is characterized by a certain didacticism, and this tendency comes, in part, from the fact that he sees his writing as art. Trained in the theater, Sorkin began his career as a playwright and even structures his scripts (or teleplays) for *The West Wing* as four-act plays.[1] In his hands, television becomes a stage for issues that are not only socially and politically engaging but also, to a large extent, instructive. In an interview with Terence Smith on *The News Hour with Jim Lehrer* (September 27, 2000), Sorkin highlights the importance of education in *The West Wing*:

> [The characters are] fairly heroic. That's unusual in American
> popular culture, by and large. Our leaders, government people, are
> portrayed either as dolts or as Machiavellian somehow. The char-
> acters in this show are neither. They are flawed, to be sure, because
> you need characters in drama to have flaws. But they, all of them,

have set aside probably more lucrative lives for public service. They are dedicated not just to this president, but to doing good, rather than doing well. The show is kind of a valentine to public service. It celebrates our institutions. It celebrates education often. These characters are very well educated, and while sometimes playfully snobby about it, there is, in all of them, a love of learning and appreciation of education.[2]

In his drama, Sorkin explicitly links the idea of public service with education, suggesting that real learning involves social commitment. This understanding of education is central to both *The West Wing* and *Sports Night.* Sorkin's characters want to "do good," and they learn how to do so through self-examination and debate. In this way, Sorkin transforms television into a classroom that, intentionally or not, embodies the traditional tenets of a "liberal" education. *Sports Night* not only values the social and personal importance of education, but it also tries to communicate this message to its viewers.

Under thinkers from Aristotle to the Stoics of early Greek and Roman society, a liberal education was designed to liberate the mind from prejudice and routine. It challenged learners to value community, in a global sense, over the self. As Martha C. Nussbaum explains in *Cultivating Humanity: A Classical Defense of Reform in Liberal Education*, this type of education requires a "cultivation of the whole human being for the functions of citizenship and life generally" (9). Nussbaum argues that the recent trend in universities and colleges to develop a more multicultural curriculum is not merely a nod to political correctness but also an essential component for helping students achieve a truly liberal — or free-minded — education. She traces this concept to Stoic philosophers who believed that "we should give our first allegiance to *no* mere form of government, to temporal power, but to a moral community made up by the humanity of all human beings" (59). Sorkin's characters continually wrestle with this idea of contributing to and participating in a moral community. His stories challenge them — and arguably the viewers — to recognize the needs and humanity of others. If they falter because of fear, envy, insecurity, or pettiness, Sorkin instructs them in the importance of striving for the good of the team (whether the show itself or society more broadly).

Two precepts of a liberal education seem to be at the heart of *Sports Night.* Sorkin presents the first one as a given: education should be universal. As we have seen, almost all of the characters in *Sports Night* are well educated. None of them balk at references to literature or Greek mythology, and they are quick to debate cultural, historical, and popular issues. In short, they recognize and readily use cultural references — even their mistakes show

a kind of erudition. In "The Hungry and the Hunted," for example, the ensemble has a tongue-and-cheek debate about the author of a poem.

> DAN: I must go down to the sea again, to the lonely sea and the sky, to the flung spume and the blown spray and the — I don't know — thing in my eye... That was a poem by Mr. Henry David Thoreau.
>
> CASEY: It's Wordsworth.
>
> DAN: Or Wordsworth.
>
> ELLIOTT: Uh, it might be Whitman.
>
> KIM: Might be Byron.
>
> DAN: It's not Byron.
>
> CASEY: I think it is Whitman...
>
> ISAAC: It's not Walt Whitman...
>
> DAC: There's a chance it might be Dylan Thomas.
>
> DANA: You have to imagine, Danny, how much I don't give a damn about blown spume.
>
> DAN: It's *flung* spume and *blown* spray, but, actually, I like your way better.

Throughout the show, playful discussions like this are presented as commonplace, in part, because Sorkin creates a world where all of his characters share a general knowledge of art — in this case, nineteenth-century poetry. Even though no one guesses the correct poet (John Masefield [1878–1967]) — an omission which adds to the humor of the scene for some viewers — the debate presents cultural knowledge as ordinary. Poetry, mythology, and allusions to Shakespeare are tossed off as quickly and easily as sports statistics. Thus Sorkin suggests that "high" culture can be just as valuable to the technical supervisor on a television show as it can to a literature professor. Great art speaks to humanity, to truths shared by everyone, and Sorkin conveys this philosophy through characters who have achieved a deep appreciation for all kinds of knowledge. Their facility with both artistic and popular culture blurs the line between high and low.[3] It serves as a model for what is possible, for what all of us should strive for and achieve.

Socrates and the Roman Stoics also felt that a "liberal" education required self-examination (through interrogation and debate) and a sense of social accountability. "According to the Stoics," Nussbaum explains, "critical argument leads to intellectual strength and freedom [and] people who have conducted a critical examination of their beliefs about what matters will be better citizens — better in emotion as well as in thought" (29). Indeed, *Sports Night* presents this challenge to its characters and viewers. Most of the show's drama comes from verbal debates about how to treat people, how to

be altruistic, how to change someone else's mind, and how to participate meaningfully in the world. True to Socrates' well-known method of forcing students to ask questions and seek answers, these exchanges in *Sports Night* suggest that critical debate and self-awareness are essential for becoming better citizens.

"The Six Southern Gentlemen of Tennessee Tech" uses two moments of self-examination and instruction to suggest the importance of community. The show begins with Dan criticizing his on-air partner, Casey, for not learning the names of the crew: "You should rededicate yourself to the idea that this is a team. You play for a team — a team with many players.... See, a team's made up of a group of individuals ... who forsake their own individual needs to pursue a common goal — the team goal." Casey agrees with this idea in the abstract, but his arrogance prevents him from treating others as equals. After appearing on an episode of *The View* and taking tacit credit for his stylish outfits, however, Casey is confronted by Monica, the assistant wardrobe supervisor for *Sports Night*, who lectures him on his responsibility to others:

> I think you hurt the feelings of the woman I work for.... Mr. McCall, you get so much attention and so much praise for what you actually do, and all of it's deserved. When you go on a talk show and get complimented on something you didn't, how hard would it be to say, "That's not me. That's a woman named Maureen who's been working for us since the first day. Maureen dresses me every night...." Do you have any idea what that would've meant to her? Do you have any idea how many times she would've played that tape for her husband and her kids?

Unlike Dan's general reprimand at the beginning of the episode, Monica's speech about a specific woman's feelings succeeds in forcing Casey to confront his own selfishness.[4] She uses a moral argument, suggesting that he has been wrong to act this way — to be dismissive of those around him — because his actions have been hurtful. As Casey becomes increasingly uncomfortable, he recognizes the consequences of inaction. Only after this moment of learning can he empathize with Maureen and appreciate the crew's contributions to his celebrity. He subsequently learns every crew member's name and thanks them on the air. His newfound investment in the community is a moment of celebration as well as the climax of the episode.

The second instructional moment in this episode emphasizes similar themes but does so by challenging viewers to see community as something that transcends racial difference. This storyline focuses on an African-American football player named Roland Shepard who refuses to play college

football while a Confederate flag hangs outside the school stadium. Roland is not only an exceptional athlete but, as associate producer Jeremy Goodwin explains, a talented student as well: "He's carrying a 3.3 GPA with a major in chemical engineering, and the engineering department at Tennessee Western is for real." However, if Roland's boycott continues, the university will revoke his scholarship, effectively forcing him to drop out. When Roland officially decides to leave the team, Isaac Jaffe, the managing editor of *Sports Night*, starts identifying with the six teammates who quit in solidarity. He tells Dan that these young men — "two of them white and none of them starters" — are, in many ways, making the greater sacrifice. Roland will be recruited by another school, but in all likelihood, the others will not. As the title of this episode suggests ("The Six Southern Gentlemen of Tennessee Tech"), this act of communal solidarity has power. It involves the kind of commitment and sacrifice that, according to the show, can inspire real social change. Thus, the episode uses Isaac to pose the question: Who among the viewing audience would have the courage to join these six gentlemen?

Sorkin presents Isaac with an ethical dilemma that forces him to choose between personal comfort and social responsibility — a concept that is also rooted in the principles of a liberal education. Stoic philosophers believed that the primary goal of education was to help students overcome their own passivity in order to engage in social issues. As Cicero writes, "Nothing is in the power of the man who never assents to anything. [If] it does not occur to the mind what one's duty is, a man will never do anything at all, he will never be impelled toward anything, he will never be moved" (Clark 79). It is education, ultimately, that makes people aware of this responsibility to take meaningful action. Education asks people to formulate their own ideas, to make their own choices, and to ask themselves what they stand for. This is the challenge facing Isaac in this episode. Even though he recognizes the courage of Roland's teammates, Isaac is afraid to make the same kind of sacrifice because Luther Sachs, CEO of the corporation that owns the show and an alumnus of Tennessee Western University, might fire him. (Isaac even pressures Dan to prepare an editorial on the positive legacy of Southern culture and history to placate Luther.) Dan, however, repeatedly questions Isaac's decision not to speak out in protest, reminding him of his own responsibility as a reporter, as an African American, and as a human being.

In the final moments of the episode, Isaac reconsiders, and in an on-air editorial, he proclaims his solidarity with Roland Shepard's teammates: "And I choose to join them at this moment." He describes the Confederate flag as a banner of hatred, separatism, ignorance, and violence: "And to ask young black men and women, young Jewish men and women, Asians, Native American — to ask Americans to walk beneath its shadow is a humiliation

of irreducible proportion." He concludes by challenging Luther to call the chancellor and demand that he take down the flag: "I challenge you to do the right thing." Clearly, this call to action extends to the viewing audience as well. Sorkin suggests that all of us need to act, to "do the right thing." In the face of racism and other social problems, we have a moral obligation to get in the game (a common metaphor on the show) and to act on behalf of others. Not surprisingly, Sorkin also makes this call to action a call for education. As Isaac reminds the audience at the end of his editorial, "You've got to put these young men back in a classroom, and I mean pronto." Education is crucial for society and the self; it helps people overcome prejudice and recognize their own ethical responsibility to society. So when Isaac finally joins Roland and the six gentlemen from Tennessee, the show suggests that we need to do the same.

Sorkin also presents the need for individual sacrifice and communal solidarity in "The Quality of Mercy at 29K." This episode emphasizes the importance of social responsibility by interrogating the motives behind altruism. Even though the individual cannot be expected to solve the problems of homelessness, for example, this is not an excuse for apathy and inaction. Sorkin, therefore, shapes the entire episode around questions of personal motivation and principle, explicitly asking several characters what they stand for. The central story involves Dan's struggle to give money to a "good" cause. While looking through his mail, Dan laments: "Everybody needs money ... medical research, hospitals, schools, animal shelters, day-care centers.... I'd love to give money to all these people, but then I'd have no money." Dan, in his earnest desire to do something, is paralyzed by the amount of need in the world and states in frustration: "I'm inactive. I don't act. I talk a pretty good game, but in the end I just sit there completely inactive." In a show in which characters define themselves by rhetorical skill, not action (we rarely see them outside of the office, for example), it is not surprising that Dan limits himself to the idea of giving money. Even though he is aware that writing a check may simply ease his sense of liberal guilt, he never considers an active sacrifice, such as volunteering. At one point, when Natalie announces that building security has asked employees to report any homeless people who are using the lobby to escape from the cold, Dan says to the staff, himself, and arguably the audience, "Wait a second. Shouldn't we be doing something for them?"

Dan then spends the rest of the show asking various characters how they make donations, and Sorkin uses this question and answer format to instruct the audience on how to act. Interestingly, the answers to these questions are not about solving social problems — an unrealistic goal for a thirty-minute sitcom — but about the value of doing something, anything. For Sorkin, it

is the act of social engagement that matters; it is a necessary starting point for change. For example, Isaac, who committed his first act of engagement with the Tennessee Tech editorial, contributes to many good causes but still feels the need to do something for the homeless people he encounters every day.

> ISAAC: So as I'm stepping over them [on my way to work],
> I reach into my pocket and give them whatever I've got.
> DAN: You're not afraid they're gonna spend it on booze?
> ISAAC: I'm hoping they're gonna spend it on booze. Look, Danny,
> these people — most of them — it's not like they're one hot
> meal away from turning it around. For most of them the clock
> has pretty much run out. You'll be home soon enough. What's
> wrong with giving them a little Novocain to get them through
> the night?

Isaac sees value in the gesture. He doesn't pretend that his spare change is more than a temporary salve, but at the same time, the gesture has the potential to ease someone else's suffering. Casey explicitly makes this point at the end of the episode: "You're not going to solve everybody's problems. In fact, you're not gonna solve anybody's problems. So you know what you should do? ... Anything. As much of it and as often as you can." Here Sorkin lectures Dan and the audience through Casey, insisting that the act matters more than the result — as long as it is motivated by an honest desire to help.

The episode links the struggle to do good to the story of Desmond Corey, a man whose climb to the peak of Mount Everest is being televised by *Sports Night*. As the crew waits for Desmond and his team to reach the top, they marvel at the skill, sacrifices, ambition, and dedication it takes to achieve such a goal. Natalie remarks: "Two guys have ascended five miles into the sky. They walked up a wall of ice and are preparing to knock on the door of Heaven itself. There's really no end to what we can do. You know what the trick is? ... Get in the game." While waiting to see if Corey will make it, Dan, who hasn't eaten all day, finds half a turkey sandwich in his office, and there he encounters a homeless man. At first, Dan reacts with fear and indignation. "How did you get up here? You're not supposed to be up here.... You can't stay here." He then decides not to call security, instead offering his sandwich to the man: "I'm gonna sit with you while you eat." Dan turns on the television and starts telling the homeless man about the men climbing Everest. The homeless man cuts the sandwich in two, handing half to Dan. They watch the final climb to the summit together and Dan says, "Look what we can do."

Certainly, few people can climb Everest or write great music (Dana

marvels at the beautiful music of *The Lion King* throughout the episode), but Sorkin shows that making a meaningful contribution doesn't require such a grand act. It merely requires active engagement, a thoughtful contribution. Instead of suggesting that one person can "solve" the homeless problem, Sorkin wants us to see Dan's quest to do the right thing as a lesson in the importance of action, to see that even the smallest act of personal sacrifice counts. At the same time, the "resolution" of "The Quality of Mercy at 29K" is highly sentimentalized. Dan's choice may be a step in the right direction — and it is certainly more active than giving money — but nothing suggested in the episode will bring about lasting change. Even though Dan's gesture is presented as heroic, the homeless man presumably returns to the street that night, disappearing from the narrative and remaining nameless.

Dangers of the Pulpit: Knowledge as a Weapon

As "The Six Southern Gentlemen of Tennessee Tech" and "The Quality of Mercy at 29K" demonstrate, Sorkin tends to lecture his audience. At the same time, he does recognize the dangers of didacticism in entertainment. In a 1999 interview for *Written By*, Sorkin warns that "the big pothole for anyone in Hollywood telling a story that has anything to do with politics — is not to tell anyone to eat their vegetables, not to create TV that is good for you."[5] He has used this analogy on several occasions to argue that television is, first and foremost, entertainment and that any show or film that is too political or didactic will jeopardize its appeal. But oftentimes, Sorkin does tell his viewers to eat their vegetables — a message that has had mixed results.

Many critics responded quite negatively to the first episode of *The West Wing* following the terrorist attacks on September 11, 2001. In short, this episode, "Isaac and Ishmael," offers a crash course on the dangers of prejudice and ignorance through two alternating stories of interrogation. Set in two rooms (the White House cafeteria and an office for questioning a suspected terrorist), this "play" takes place during a security lockdown of the White House. In the cafeteria, a group of gifted and inquisitive high school students, who have won a trip to the White House, become captive to Josh Lyman and the rest of the staff as they lecture on the history of Islam, the causes and effects of terrorism, and prejudice. While the students ask questions such as "Why is everybody trying to kill us?", the White House Chief of Staff, Leo McGarry, interrogates an Arab-American employee whose name — Raqim Ali — matches an alias for a recently captured terrorist.

Sorkin immediately transforms the cafeteria into a classroom, as Josh

writes an SAT-like analogy on a dry-erase board: "Islamic extremist is to Islam as _____ is to Christianity." After a few students guess, he writes "KKK" and then explains that "it couldn't have less to do with Islamic men and women of faith of whom there are millions and millions. Muslims defend this country in the Army, Navy, Air Force, Marine Corps, National Guard, police and fire departments." Class is in session for the high school students sitting around the room, staring up at Josh, Toby Ziegler, and C. J. Cregg, and for the television audience as well. The students articulate many of the questions and conversations that viewers had immediately after the attacks, and Sorkin provides the answers. As Toby states, "The Taliban isn't the recognized government of Afghanistan.... When you think of Afghanistan, think of Poland. When you think of the Taliban, think of the Nazis. When you think of the people of Afghanistan, think of Jews in concentration camps." Then a student asks Sam Seaborn, "What do you call a society that has to just live every day with the idea that the pizza place you are eating in could just blow up without any warning?" Sam replies: "Israel."

As it turns out, the suspected terrorist is just a hard-working Arab American in the White House, and Leo's interrogation is held up as a lesson in the dangers of prejudice. Meanwhile, both Toby and Josh seem to offer two morals for the other storyline of the episode. "Bad people," Toby explains, "can't be recognized on sight. There's no point in trying." And Josh concludes that pluralism and intellectual inquiry is the solution: "Remember pluralism. You want to get these people? I mean, you really what to reach in and kill them where they live? Keep accepting more than one idea. It makes them absolutely crazy."

With its literal and liberal classroom setting, this episode once again reminds us that education is central to Sorkin's artistic and social mission.[6] Here the question and answer format is used to instruct the American public on the dangers of prejudice — a valuable lesson, to be sure. But as the critical reaction to this episode suggests, people don't like to be preached at. Tom Shales of *The Washington Post*, for example, described it as "a lecture, a sermon, a seminar [that] came across as pretentious and pietistic hubris" (C01), and the *New York Post*'s review, "'West Wing' Wimps Out on Terror," called it pompous. James Poniewozik of *Time* magazine also considered it "God-awful in its condescending pedantry" (1). In a series that often walks a tenuous line between entertainment and education, "Isaac and Ishmael" errs on the side of telling us to eat our vegetables.

Certainly, as this essay has discussed, *Sports Night* tends to lecture its audience as well. Not only does it walk the line between entertainment and education, but its humor also wavers between edgy fun and mean-spirited arrogance. This meanness often stems from the show's intellectual content,

particularly when knowledge is used to insult, to distance oneself emotionally, and lastly, to shirk one's communal responsibility. Together these moments and the selfish impulses that motivate them undermine the liberal education of *Sports Night*. In the episode "Shane," the staff tries to pick the "athlete of the millennium," and Jeremy suggests Melankomas, a fighter in 49 A.D. who won every match without throwing a punch. To this, Dan asks, "Would he just talk his way into the opponent surrendering?" And Jeremy replies, "Possibly. And if that's the case, then *Sports Night* certainly found its poster boy." This playful exchange actually reveals something more sinister about *Sports Night*— that verbal sparring is often about making someone surrender. And it is this dimension of Sorkin's comedy that often undermines the more positive portrait of intellectualism and education in the show.

Most of the time, the comedy of *Sports Night* comes from intellectual banter about mistakes, such as verbal slips, forgotten details, and baffling references. This humor stems from the fact that the show takes knowledge so seriously. Within the first few episodes, for example, Sorkin gives the audience a resume for most of the main characters: Dan graduated from Dartmouth; Isaac received the Pulitzer Prize as a journalist; Casey is a member of Phi Beta Kappa and envies post-graduate degrees; Dana was educated at an exclusive all-girl school and, according to Jeremy, is a mixture "of brilliance [as a professional] and less than brilliance outside of the office." Sorkin includes this information, in part, to present knowledge as laudable and to make the intellectual content of the show more realistic.

Since the show's preoccupation with education can have elitist overtones, Sorkin tries to temper the dangers of appearing "too smart" with humor. In "When Something Wicked This Way Comes," Dan misuses the word "secular" in front of Hillary Clinton at a fundraising breakfast and subsequently panics about her perception of him: "Hillary Clinton thinks I'm an idiot! ... I went to an Ivy League school, Casey." Later in the episode, he complains:

> DAN: You know a lie can make it halfway around the world
> before the truth has a chance to get its boots on?
> CASEY: What are you, Burl Ives all of a sudden?
> DAN: As a matter of fact, that was Mark Twain.
> CASEY: I know who it was.
> DAN: And so do I. And I'm able to quote him because I'm
> educated. I know things.

Dan's attempts to compensate for his verbal blunder in front of Hillary Clinton drive the humor for the rest of the episode, and even though he isn't able to laugh at himself, we can. Sorkin balances Dan's talents and abilities (qualities that come from being well educated) with minor mistakes, and this

juxtaposition serves to mitigate his arrogance, while offering a fleeting lesson in humility.

Sorkin's comedy does not always compensate for moments of hubris and meanness, however. Throughout the series, many characters display their intelligence by correcting someone's grammar or diction in order to shut down communication. In effect, they become punitive teachers, hiding their emotional and personal needs behind what they know. This tendency to use knowledge as a weapon not only distances these characters from those around them (as well as the audience), but it also undermines the more humanistic vision of education presented in *Sports Night*. In "Sally," for example, Dana is upset when her boyfriend, Gordon, cancels their dinner date. As she tries to convince herself (and those around her) that nothing is wrong with their relationship, Natalie disagrees:

> NATALIE: Here's my theory — you don't really like Gordon.... This is you and me talking, Dana. I'm not other people. This is our little coven of women.
> DANA [*patronizingly*]: "Coven" is a group of witches.
> NATALIE: I thought a coven was just a group.
> DANA: It's a group of witches... And also because a coven is more than two.
> NATALIE: Are you sure?
> DANA: Yes... I'm just saying if you're going to misuse a word, you should do it properly.
> NATALIE: You don't like Gordon.
> DANA: I love Gordon. I'm telling you —
> NATALIE: And I'm telling you that when you use that word in a romantic context, you have absolutely no idea what you're talking about!
> DANA: That was a lousy thing to say about Gordon.
> NATALIE: I didn't say it about Gordon. I said it about you.

As soon as Natalie questions Dana's feelings for Gordon, Dana corrects her diction, intentionally derailing their conversation. The implication here is that Dana knows more than Natalie and, in effect, this interruption creates an instructor-student dynamic — a dynamic that inherently devalues Natalie's opinion. Even though Dana desperately wants to talk, she doesn't want to listen. This kind of deflection is common in Sorkin's writing, and so is the fact that neither character apologizes. Natalie's comments are more personal — and arguably more inappropriate — than Dana's, but both have acted hurtfully. Yet Dana's words and her need to correct the flaws in others remind us that not all the minds on *Sports Night* are considered equal after all.

Similarly, in "Draft Day Part I: It Can't Rain at Indian Wells," Dana defends herself against Dan's insults by correcting his grammar. After explaining that *Sports Night* might do extended coverage of Draft Day if it rains at Indian Wells, Dan protests.

> DAN: I'm not staying on the air... I'm playing golf this afternoon [with David Duvall].
> DANA: With whom you play golf three times a year.
> DAN: And with whom I'm playing golf this afternoon.
> DANA: Well, not if it rains at Indian Wells...
> DAN: Casey can anchor the second round by himself.
> DANA: I know, but it's better if he has a partner.
> DAN: Better for who, Dana?
> DANA: Whom, Dan. Better for whom.
> DAN: Dana —
> DANA: Better for the show.

In the world of Sorkin's fiction, where every character takes considerable pride in his or her education, Dana's insult has power. Certainly, Dan's behavior throughout the episode is immature and spiteful, but Dana's choice to use grammar as a tool for striking back suggests that knowledge is also about wielding power. It can tear down just as easily as it can elevate.[7]

Just as *The West Wing*'s "Isaac and Ishmael" depicts a clear hierarchy between instructor (the White House staff) and student (everyone else), *Sports Night* makes similar distinctions between intelligence and ignorance, high and low. And these moments often undermine our ability to admire the heroes of this show. In "Eli's Coming," for example, Casey and Dana are fighting about the fact that she handed off the show to another producer one evening in order to be with her boyfriend. At one point, Casey decides to discuss the tension between them:

> CASEY: I think the show is going well.
> DANA: Do you?
> CASEY: Yes.
> DANA: 'Cause your approval is so important to me.
> CASEY: Dana, whatever we're going to do, can we not do it in front of the help?

This is a moment about hierarchies, a moment that once again calls into question the show's egalitarian vision of education. The staff, despite the assumption that they are smart, is still "the help" to Casey, suggesting that the lessons of "The Six Southern Gentlemen of Tennessee Tech" have not fully been learned.

Quo Vadimus

With the title of the final episode of *Sports Night*, Sorkin leaves us with another question: "Quo Vadimus" or "Where are we going?" It seems appropriate for a show invested in education to end by asking us, in part, about what we have learned and how we will use it. Sorkin encourages debate and discussion because he sees these as essential for growth and learning. Certainly, his writing takes us in this direction. It engages with literature, art, and music. It asks us to see cultural and political history as essential for understanding the world today. And it celebrates learning and the power of education to change people's minds and to make the world a better place.

Sorkin believes that education has the power to make people better citizens morally and socially, and he communicates this philosophy by incorporating two tenets of a liberal education into the show—the value of a universal education and the importance of prioritizing community over the self. The latter can only be achieved through self-examination and debate, and all of the characters in *Sports Night* struggle to achieve the type of self-awareness that encourages personal sacrifice. At times, this message is derailed by humor that uses knowledge to belittle people. The mean-spirited exchanges between characters often come from an "I'm smarter than you" standpoint that undermines communal solidarity. In moments of insecurity and pain, many of these characters use knowledge as a weapon, and the social-moral lessons of *Sports Night* are momentarily lost amidst its hubris and elitism.

This intellectual arrogance helps to explain *Sports Night*'s problematic ratings and cancellation after the second season. The blatant elitism and Ivy League pretension of *The West Wing*, however, occurs in a much less jarring context. Audiences expect a certain intellectual dimension to legal, political, and medical shows. They expect intellectualism of politicians, but not of people in sports. As critic Patrick Finn suggests, "shows like *Law and Order* and *The West Wing* allow viewers to believe they have a firm grasp on the complexities in their world — or at least of America's world" (123). Indeed, Sorkin appeals to our desire to feel smart and sophisticated. Yet, as this essay has demonstrated, he intersects the world of intellectualism and athletics in *Sports Night* to blur the boundaries between high and low, to suggest that both are a valuable part of our society. Both are worthy of study and appreciation.

Overall, *Sports Night* is the "valentine" to education and public service that Sorkin promises. It offers a liberal education that challenges us to take moral action and to practice selflessness. And it does so through flawed characters who try, fail, and try again. Ultimately, *Sports Night* raises the bar for

contemporary television, re-imagining the possibilities for the sitcom and reminding its audience of the social and personal value of education.

Notes

1. Sorkin divides his scripts into four parts, which he labels "acts." These acts correspond with the requisite commercial breaks in the hour-long format on network television. See *The West Wing Script Book.*

2. For a transcript of this interview, go to http://www.pbs.org/newshour/media/west_wing/sorkin.html.

3. Historian Lawrence W. Levine, in his famous study *Highbrow/Lowbrow: The Emergence of Cultural Hierarchy in America*, argues that the categories of high and low culture were not rigidly enforced until the late nineteenth century. At this point in American history, the social elite began "to transform public spaces by rules, systems of taste, and canons of behavior of their own choosing; and finally, to convert the strangers so that their modes of behavior and cultural predilections emulated those of the elites" (177). These efforts were primarily a response to the social mobility of the middle classes and were enabled, in part, by the "cult of etiquette" (198). Most of our contemporary notions about high and low culture stem from this period. Sorkin's *Sports Night*, however, rejects such rigid categories, and, as this example suggests, it offers a more fluid understanding of culture.

4. The role of lecturer is not uncommon among Sorkin's characters; speeches and unsolicited advice are given all the time. In "Smoky," for example, Dana describes her flirtation with Casey as "a class." And in "How Are Things in Glocca Morra?", Jeremy advises his sister in similar terms: "All right, ready for the lecture now? Under no circumstances are you to leave school. End of lecture. There will be a test on the material."

5. For a transcript of this interview, go to http://www.wga.org/WrittenBy/0999/sorkin.html.

6. Sorkin highlights the importance of education throughout the series. In "Six Meetings before Lunch," for example, Sam says, "Education is everything.... Schools should be palaces; the competition for the best teachers should be fierce; they should be making six figure salaries. Schools should be incredibly expensive for government and absolutely free of charge to its citizens like national defense."

7. This moment also returns to the importance of sacrificing one's personal interest for the group. Dan's failure to put the group first (to the extent that he embarrasses Casey on television) is selfish, and he spends the subsequent episode apologizing for this act.

Works Cited

Buckman, Adam. "'West Wing' Wimps Out on Terror." *New York Post* 4 Oct. 2001: 1.

Clark, Gordon H. *Selections from Hellenistic Philosophy.* New York: Appleton-Century-Crofts, 1940.

Finn, Patrick. "*The West Wing's* Textual President: American Constitutional Stability and the New Public Intellectual in the Age of Information." The West Wing: *The*

American Presidency as Television Drama. Eds. Peter C. Rollins and John E. O'Connor. Syracuse, New York: Syracuse University Press, 2003. 101–124.

Levin, Lawrence W. *Highbrow/Lowbrow: The Emergence of Cultural Hierarchy in America.* Cambridge, Mass: Harvard University Press, 1988.

Nussbaum, Martha C. *Cultivating Humanity: A Classical Defense of Reform in Liberal Education.* Cambridge, Mass: Harvard University Press, 1997.

Poniewozik, James. "'West Wing': Terrorism 101." *Time* 4 Oct. 2001, online edition.

Shales, Tom. "'The West Wing' Assumes the Role of Moral Compass." *The Washington Post.* 5 Oct. 2001: C01.

Sorkin, Aaron. Interview with Terence Smith. *NewsHour with Jim Lehrer.* PBS. 27 Sept. 2000. http://www.pbs.org/newshour/media/west_wing/sorkin.html.

_____. Interview. *Written By.* Sept. 1999. http://www.wga.org/WrittenBy/0999/sorkin.html.

Sports Night

"Draft Day Part 1: It Can't Rain at Indian Wells." Teleplay: Matt Tarses and Aaron Sorkin. Dir.: Bryan Gordon. ABC. 14 March 2000.

"Draft Day Part 2: The Fall of Ryan O'Brian." Teleplay: Aaron Sorkin. Story: Kevin Falls. Dir.: Danny Leiner. ABC. 21 March 2000.

"Eli's Coming." Teleplay: Aaron Sorkin. Dir.: Robert Berlinger. ABC. 30 March 1999.

"The Hungry and the Hunted." Teleplay: Aaron Sorkin. Dir.: Thomas Schlamme. ABC. 6 Oct. 1998.

"The Quality of Mercy at 29K." Teleplay: Bill Wrubel and Aaron Sorkin. Dir.: Thomas Schlamme. ABC. 1 Dec. 1998.

"Sally." Teleplay: Rachel Sweet and Aaron Sorkin. Dir.: Robert Berlinger. ABC. 23 Feb. 1999.

"Shane." Teleplay: Kevin Falls, Matt Tarses, Bill Wrubel. Dir.: Robert Berlinger. ABC. 7 Dec. 1999.

"The Six Southern Gentlemen of Tennessee Tech." Teleplay: Aaron Sorkin, Matt Tarses, David Walpert, Bill Wrubel. Dir.: Robert Berlinger. ABC. 15 Dec. 1998.

"When Something Wicked This Way Comes." Teleplay: Aaron Sorkin. Dir.: Robert Berlinger. ABC. 12 Oct. 1999.

The West Wing

"Isaac and Ishmael." Teleplay: Aaron Sorkin. Dir.: Christopher Misiano. NBC. 3 Oct. 2001.

"Six Meetings Before Lunch." Teleplay: Aaron Sorkin. Dir.: Clark Johnson. NBC. 5 April 2000.

A Phantom Fly
and Frightening Fish:
The Unconscious Speaks
in *Sports Night*

Douglas Keesey

Sports Night anchor Casey McCall is ducking his head and swiping at the air with his hands. He insists he's being pestered by a fly in the studio, but no one else can see it. The show's producer, Dana Whitaker, calls it a "phantom fly" (episode 4). At the same time, Dana is about to go on a date with a man named Gordon with whom she hopes to have a "good time," and as she is leaving, Casey mutters under his breath, "I'll bet you will." Casey's comment could be taken as a sign of jealousy, but Dana argues that he's not really harboring any love for her, that it's just in his head — like the fly. Casey counters that it is Dana who has serious feelings for him, even though she has said that she's "not the one being hunted by an imaginary insect." At the end of this episode, Dana is hit by a fly.[1]

The fly is one of many examples in *Sports Night* of words and images through which the unconscious speaks. Casey and Dana are both pestered by a nagging feeling which they can't deny but which they can't quite admit to themselves: they love each other. Since this internal feeling is disavowed (not "owned" as theirs), it seems to come at them from the outside — as a dive-bombing fly. Their shared sense of being "hunted by an imaginary insect" is a return of their repressed love, a feeling that won't let them alone until they admit it's real. The "phantom fly" is thus an image that Casey and Dana use to communicate their unconscious feelings for one another and to help bring those feelings to light.

As we shall see, many of the couples in *Sports Night* receive promptings

from their unconscious which call upon them to recognize and declare their desire for each other. Often these promptings are confused at first — clouded by ignorance (lack of self-knowledge) and fear (of rejection by the other). Sometimes these coded messages from the unconscious, as in the case of the fly, seem to be as much about hiding from the truth as about facing it, as if to say, "The feeling that we may love each other is just a minor annoyance." However, these coded messages are also the mind's way of figuring out how it really feels, of working through confusion toward clarity and insight. These surreptitious signals — words and images affected by the unconscious — allow the self to comprehend and dispel the fears that have clouded the free expression of desire.[2]

In a later episode (15) after the one with the phantom fly, Dana tells Casey that Gordon has invited her to go on a snorkeling trip with him and several other couples. Casey responds with words specific enough to convey his jealousy, but vague enough to hide the fact that it is Dana and Gordon he is jealous of: "Sounds like a lot of people are going to be having sex with a lot of other people who aren't me." It's important to note the implied connection here between snorkeling and sex in order to understand the anxiety Dana feels about this trip: "Fish frighten me in a very real way.... They live where it's murky — poisonous, tentacle-bearing, prehistoric sea creatures.... We don't know what the hell's down there." Dana's fish phobia is her unconscious confession to a fear of sex, particularly the male sex, which she views as a dark threat — stinging, entrapping, primitive, and unknown. At first we may think that Gordon is the fish she fears, and in part this may be true, but it turns out that Dana's greatest dread is Casey. While she may be anxious about going snorkeling with Gordon, this trip is really an avoidance of a date with Casey. As a man, Gordon is bland and unthreatening, and Dana's feelings for him do not run deep, whereas Casey is unknown and unpredictable, and her sense that he may be what she really wants makes her vulnerable to deep disappointment. As Casey realizes, Dana isn't afraid of fish, but of "holding out for what she deserves" — a man who will really love her and whom she can love (a man like Casey). As an image, the frightening fish alert Dana to a fear of sex and of love which she must overcome, and they are telling her not to go with Gordon, who is the wrong man for her.

Casey's fly and Dana's fish are thus indirect expressions of their longing for each other, circumlocutions used in place of straightforward declarations of love. Casey and Dana can't bring themselves to talk plainly and just say how they feel. Consider Dana's verbal contortions in discussing Casey with associate producer Natalie Hurley (episode 14):

NATALIE: He's secretly in love with you.
DANA: He's not.

NATALIE: He's only pretending he's not...

DANA: He's pretending he's pretending he's not so I think he is, but he's not, but he thinks he is, which doesn't matter because I'm in love with Gordon.

NATALIE: I know.

DANA: Good.

NATALIE: But you're secretly in love with Casey.

While Natalie states simply and clearly that both Dana and Casey are secretly in love with each other, Dana spins a complex verbal web of defense in which she herself is trapped. She is so intent on protecting herself against the possibility that Casey's love is only a pretense that she gives it no chance to be true.

Both Dana and Casey find it safer to express their interest in one another through coded communications like the fly and the fish. A declaration of love that is never (clearly) made is one that can never be (bluntly) rejected. Veiled expressions of jealousy help to hide the pain of unrequited love. In one episode (13), Dana and Casey are set to go on a double date — she with Gordon, and Casey with another woman. Dana believes that Casey thinks there's a certain point in the evening when Casey will say something wonderful to her that will make her melt and be sorry to have gone out with Gordon. Casey counters that he'll settle for Dana's spilling something on herself. With this aggressive remark, Casey attempts to deny his jealous desire for Dana, but at the same time the "spill" is an equivocal expression of that desire. Is Casey angry because Dana thinks he's jealous, or because he *is* jealous over her going out with Gordon? Is the wish for her to spill something on herself a matter of pure aggression, or does Casey want to ruin Dana's date with Gordon, to make her "melt" for Casey himself, to spill his own love for her? There is a parallel episode (16) in which Jeremy Goodwin, a research analyst, spills eggnog out of his mouth and onto his shirt to show how much he loves Natalie. Jeremy hates eggnog, but he has been making it in order to please Natalie's parents (he thinks they drink eggnog at Easter).

In the same episode (16) as the spilled eggnog, we find out that Casey spilled some wine on one of his shirts when he was spending the night with Sally, another producer at the network and a professional rival of Dana's. Here is another spill with sexual connotations, and it is clear that sleeping with Sally is the closest thing for Casey to sleeping with Dana — his true desire. Casey leaves his shirt at Sally's to be laundered, but a few days later he notices that Gordon, Dana's current beau, is wearing that same shirt.[3] Casey could take the direct route and simply tell Dana that Gordon has been unfaithful to her with Sally, but this would not only have Dana suspecting Casey's jealous interest in ruining her current relationship with Gordon, it

would also involve Casey's own admission that he too has been "unfaithful" to Dana by sleeping with Sally. Casey cannot easily tell Dana that Gordon is the wrong man for her without making himself look self-interested and similarly wrong for her.[4]

It is indirect communication that allows Casey a way out of this difficult situation (episode 22). He tells Dan Rydell, his co-anchor on the show, and swears him to secrecy. But Dan tells Natalie, who then tells Dana. Dan and Natalie thus act as agents of Casey's unconscious, conveying to Dana what he cannot bring himself to do directly.[5] By consciously keeping the truth from Dana, Casey can be thought of as having tried to protect her from pain. At the same time, the indirect communication to her of the truth reveals Gordon's infidelity and leads to her breakup with him, thus clearing the way for Casey. Casey has gotten what he secretly wanted without having to pay a price for his self-interest. Earlier, Casey had said that his only plan to separate Dana from Gordon was Napoleon's battle plan: "First we show up, then we see what happens." To Dan, this had sounded like no plan at all, but by the end of the episode Dan seems to see that it was indeed a brilliant (unconscious) strategy: Casey took the "high road" of keeping Dana safe from the secret of Gordon's infidelity, while others took the "low road" and revealed it to her, causing a breakup with Gordon that benefits Casey.

The plan almost backfires, though, when Dana becomes furious with Casey for his having slept with Sally: "You are a sleazy, slimy, adolescent, oversexed, overpaid blowhole!" However, even Dana's anger proves to be Casey's secret success, for it turns out that she was more upset about Casey's affair with Sally than about Gordon's, and the very words she uses to condemn Casey reveal the depth of her feeling (the jealous rage of a woman betrayed) and the desire behind her ire (that "sleazy, slimy ... oversexed ... blowhole" is reminiscent of those "tentacle-bearing, prehistoric sea creatures" in their sensual particularity).[6] When Casey ends up anchoring the show without pants and Dana tells him he should feel right at home that way, her interest in seeing him exposed is prurient as well as punitive.

In this same episode (22), Dana makes the curious comment that none of the bad things in her life would be happening if she had a camera, and after finding out about Gordon's infidelity and then again after berating Casey for being "oversexed," she declares her intent to buy a camera. Dana's camera-craze is a satire on materialism as a panacea, but it also suggests a desire for phallic fulfillment and loving commitment which Gordon (definitively) and Casey (so far) have failed to provide. In episode 23 where Dana is excited about taking the "maiden photograph" with her newly bought camera, everyone is available for the picture except Casey, and the flash takes too long to go off. When Dana calls this "a little timing problem," she

perhaps says more than she knows: the implication is that she and Casey are out of sync, and that if they could only get together for their virgin date they might both find fulfillment. At the end of this episode, Casey shows that he appreciates Dana's sense of humor in a way Gordon never could, and with Casey in the picture she can laugh when they are all looking the wrong way as the flash pops.

What they are looking at instead of the camera is a TV monitor showing a "ninth-inning rally." One trait that makes Dana and Casey compatible is their joint passion for sports, leading to the possibility that they may finally get it together in the end. This passion is not always shared by others. In an episode (13) before Dana and Gordon break up, they do go on that double date with Casey and another woman named Lisa. Lisa and Gordon both feel sidelined by Casey's and Dana's mutual love of sports broadcasting. During the foursome's dinner conversation, Casey uses words whose latent meaning is that Lisa is not the woman he wants. First of all, Casey notes that Lisa has the same name as his ex-wife (a person whom Dan had described as "an angry, unhappy, punishing woman"). When this Lisa (the dinner date) points out that her name is pronounced with a *z*, Casey marvels that it is nevertheless still spelled with an *s*. With this comment, Casey resists allowing this Lisa to differentiate herself from the Lisa he divorced, thus spelling doom for their relationship. Moreover, Casey then goes on mock his date, inserting a *z* sound into other female names like hers, including "Lucy — Lose-y," which makes Lisa sound like a loser.

In a later episode (32), Casey sabotages a date with another woman by finding special significance in the fact that her name — Pixley — has no special significance. Having a relationship with her would thus be meaningless. To Casey, the names of all these other women mean too little (Pixley) or too much (Lisa), for the only name he wants to hear is Dana's. This is apparent in episode 12 where Dan tells Casey that Sally was acting seductive toward him, and Casey asks, "Do you really think that Dana was flirting with me?" A slip of the tongue — Dana for Sally — reveals Casey's true love interest. Given Casey's tendency to read latent meanings into names, it's not surprising that he should be especially jealous when Dana has dinner with a high school friend who may have been an old flame. The man's name is Cab Calloway, which sounds an awful lot like a substitute for Casey McCall.[7] If that's not enough of a threat, Calloway's name in the school Spanish club was "Guillermo," which makes him sound like a Latin lover (episode 27).[8] Interestingly, Dana tells one of her coworkers (Elliot), who has said that he is late for a date, to "sit your ass down, Valentino" (episode 32). Dana's words are not directed at Casey, but her unconscious is speaking to him, for she knows that Casey is supposed to romance Pixley that night.

Many of the coded words and images used to express desire or jealousy tend to touch on the body. In Episode 32, Casey makes a point of telling Dana that if Pixley goes home with him after their date, he plans on "making her this thing where I hollow out a grapefruit." Although this first date with Pixley does not come to such a fruition, a subsequent meeting leads Casey to use a pen to write his phone number on Pixley's hand, which leaves Dana feeling unfulfilled (episode 33). Dana's jealousy can perhaps be read between the lines in the sports report about "a certain Bear" who "got his hand stuck in the cookie jar" (episode 36). On a tedious date with another man, Dana wriggles out of her underwear while sitting at a restaurant table. By the end of the evening, these panties have magically appeared in Casey's desk (episode 27). Natalie helps to reveal the underlying significance of these events by reading aloud the dictionary definition of "estrus" (episode 33). Somewhat later (episode 36), Natalie is again helpful in pointing out that Dana is "a little sarcastic and short-tempered for a woman who hasn't been having a lot of sex recently. Oh wait, I think I just put my finger on the trigger." In the same episode (36), Dana finds that Sam Donovan, the ratings expert, has entered her office to "play with her gun" (a Revolutionary War musket she has inherited). "This gun hasn't had a lot of use," Sam says, running his fingers over the part of it called the "cartouche." Sam's denial — "I wasn't hitting on you. I was just talking about the musket" — only triggers the thought that he might have been deploying sexual metaphors — a seductive subtext made all the more likely when we realize that William H. Macy (the actor playing Sam) is married in real life to Felicity Huffman (Dana).

The erotically charged gun can be invested with manly as well as womanly significance. Dana says that the musket is "macho," "redneck," and "disgusting," but when Sam points out that it was used by "ragged," "dirty," "crazy" farmers to defend their freedom during the Revolutionary War, she is moved and aroused. Earlier, she had said that Sam might not be so loathsome "if he shaved his moustache," but now his raggedness seems to excite her.[9] When she is with Casey, Dana tends to mock his manhood, but this derision is really desire: her tongue-lashings betray a lascivious interest in the very thing she obsessively mocks. In the episode (32) where she is jealous of Casey's upcoming date with Pixley, Dana contemptuously dismisses doing a news story on a "coxswain" (pronounced "cock-s'n") who fell out of a boat but didn't save anyone from drowning. Her real scorn is directed at "oversexed" Casey and his foolishly evident desire, which Dana wishes would save her. An earlier episode (7) has a similarly risible "bulging dik" misprinted on the teleprompter (the word should be "disk"). This is the episode in which Dana mistranslates the name of the bar where she and Casey go —

El Perro Fumando — as "The Flaming Dog," to which Casey retorts, "The dog's not gay."

Thus, Casey is both too much ("bulging dik") and not enough ("Flaming Dog") of a man, as Dana's imagination obsesses over the excesses and shortcomings of his masculinity. Certainly, Casey can sympathize with Dan's dictionary discovery that "'boned' and 'de-boned' mean the same thing" (episode 25). When Dana's boss Isaac says, "I'm shrinking," and she asks, "Where?" (episode 10), her reductive remark might as well be directed at Casey, who at one point finds his anchor's chair sinking until his head barely overlooks the desk (episode 28). At another point (episode 37), Casey misreads the teleprompter as saying that "Houston goes bunting [not "hunting"] for a new power forward," as if the most he could do is go a short distance. However, all of Dana's taunts seem designed to get a rise out of Casey, as when she calls him "inferior" in relation to Gordon's "obvious physical prowess" (episode 7).[10] Her disparagements are encouragements, inciting his desire, and every time she shows him up she is also confessing that she can't take her eyes off him: "Casey took gymnastics after school for seven years. How's he looking to you now, girls?" (episode 24).

Of course, Dana and Casey are not the only couple whose longing shows through their language, and certain words and images seem to take on a libidinal life of their own, circulating among several characters, including Dan and his love interest, Rebecca. While giving a sports broadcast, Dan is distracted by thoughts of Rebecca, causing him to commit the erotic error of referring to a female player who used to go to "a neighborhood park all covered with cheese" (the word should be "trees") (episode 15). Later, Casey complains about a lack of cheese on the craft table, when what he really means is that he is missing Dana, who at that point is dating Gordon (episode 17). When Casey first finds out about Dana and Gordon, he kicks a fire hydrant, injuring his ankle (episode 4). Casey then asks Dan to tell Dana about the hurt ankle and to make it sound dignified and heroic. The ankle thus becomes Casey's indirect means of communicating to Dana his desire for her: not only does he want her love and sympathy, but he also wants her to sense that he has been wounded by jealousy. In a further episode (12), Sally (Dana's rival) flirts with Casey by showing him her supposedly injured ankle. Finally, during another sports broadcast, Dan errs again, asking about "Rebecca's ankle" instead of player "Rich O'Brien's" (episode 19). Beyond Dan's erotic interest in Rebecca's ankle, there is his concern that she was "wounded" by her husband, Steve Sisco, who cheated on her.

Yes, verbal slips like the one Dan makes about Rebecca's ankle reveal hidden concerns and desires. But more importantly, these communications from the unconscious are ways of working through confusion toward clar-

ity. They are symbols used by the characters to sort out who they are and how they feel. It's no mere accident that the person Dan asks about "Rebecca's ankle" is Bobbi Bernstein, his co-anchor for that show. Bobbi has been insisting that Dan slept with her in the past, never calling her again and just moving on to some other woman, while Dan maintains, "You've obviously mixed me up with someone else" (episode 13). However, Bobbi finally proves that Dan did seduce and abandon her, back when she looked different and was called Roberta (episode 19).[11] So, Dan had "cheated" on Roberta in much the same way that Steve Sisco cheated on Rebecca.

Dan's error in asking Roberta about Rebecca's injured ankle hints at a hidden truth that Dan must face: Roberta and Rebecca are both wounded women, and Dan is like Steve in having done the wounding. Once Dan's repression of the truth about himself and Bobbi is lifted, he can recognize this similarity between Roberta and Rebecca (note how their names sound alike), and he can admit that Steve's bad behavior is also his own.[12] Dan has had other self-revelatory hints from his unconscious, as when he suddenly starts to sing the Three Dog Night song "Eli's Coming" (episode 19). Dan wants to think of Eli as a vague "something bad" coming from outside, but Casey reminds him that "Eli's an inveterate womanizer." These promptings from his unconscious and from Casey lead to character growth in Dan, who acknowledges his womanizing and apologizes to Roberta.

Because Dan is now conscious of his tendency to cheat, he can fight this inclination — in himself and in others. Thus Dan can speak with true self-understanding when he warns about Steve's cheating ways: "He's such a bad guy, Rebecca. I'm sorry if that hurts you, but I know these things. I'm not so good myself" (episode 19). As Casey says in a comment about sports which has hidden meaning for Dan, "There are days that separate the men from the Men." Although they are similar, Steve is a man, while Dan is a Man who owns up to his failings. A comic but meaningful moment in a later episode (22) has Dan and Casey standing side by side while Dana berates Casey for being a "sleazy," "slimy," "oversexed" cheater. "Which one of us are you talking to?" Dan asks, now well aware of his own such propensities.

Dan's womanizing tendencies seem to be rooted in a fear of rejection: with one-night stands, he can abandon a date before she leaves him. Dan's fear of rejection finds its cause in the feeling that he is fundamentally unlikable. Dan's unconscious speaks to him about this cause, but at first he tries to silence it, as when he finds a quick cure for writer's block by casually dating a woman who dotes on his writing. Eventually, though, Dan's craving for all women to like him, combined with his fear that not one of them does, drives him to make a date with an attractive woman he also knows is a therapist (episode 28). Inner promptings are leading Dan to seek the help

he needs. Dan acts out with his therapist, Abby, exhibiting a desperate desire for her to like him, but she resists his transference, refusing to fall into the role of casual date. Instead, she asks about Dan's parents and his past, coaxing his unconscious to make a telling slip: "My father likes me, Abby. She likes me just fine." Dan's dread of women's dislike is grounded in a fear that his father hates him, blaming him for the death of his brother in a car accident. He is "hit-and-run Danny" not only because he seduces and abandons women before they can reject him, but also because his neurotic behavior can be traced back to that long-ago car accident on account of which he first felt rejected by his father (episode 29). (Dan's fear of paternal disapproval is probably the explanation for why he keeps slipping up when he tries to pronounce "Yevgeny" in Yevgeny Kafelnikov.)

By finally listening to his unconscious, Dan is able to make some progress toward articulating and understanding his fears and desires. Earlier, Dan could only use mixed metaphors to describe his confused relationships — "Can I spread it out for you in a nutshell?"—and Casey couldn't tell how many of which people Dan was talking about (episode 14). In tracing his troubles with women back to a problem with his father, Dan clarifies both issues in a way that allows him to work on resolving them. By understanding how they are connected, Dan may be able to overcome both his fears of fatherly and of female disapproval. Dan has already acknowledged his similarity to the womanizing Steve Sisco, and now he recognizes the paternal source of his own womanizing tendencies. Dan's story arc, over the course of the series, moves him from unconscious promptings toward enlightened action. Instead of jilting Rebecca or being jealous when she considers getting back together with Steve, Dan remains steadfastly supportive, trying to win her over by being wonderful (episode 20). In the end, Dan's generous love is recompensed, as Rebecca returns to him in the series' last episode (45).

Another character besides Dan who eventually heeds the heart's promptings is Jeremy in his relationship with Natalie. "Do you want to go get a doughnut?" she asks him, before making her metaphor even more explicit: "Want to go someplace and make out?" (episode 17). Natalie also wants Jeremy to whisper computer talk in her ear, which she compares to phone sex (episode 12), and she invites him to go clubbing with her, but he is embarrassed and resistant. Eventually, they break up over his inability to be more "adventuresome in [their] sex life" (episode 36).[13]

It's at this point (episode 38) that Jeremy goes to a bar and meets a woman named Jenny, a porn star who helps him to overcome his inhibitions. In a single conversation, Jenny moves from telling him, "You really shouldn't watch those kinds of movies, Jeremy," to saying that "It's OK to enjoy the movies, Jeremy." It's as if Jenny were a part of Jeremy (note the

similarity in their names), his unconscious whispering what he needs to hear for his sexual development. Interestingly, in talking to Casey about this relationship with a porn star, Jeremy says, "Any minute now my mother's going to wake me and tell me it's time to go to school"— as if Jenny were indeed a boy's wet dream (Episode 40). In a coded conversation, Jenny accuses Jeremy of being unable to "stand in the rain without an umbrella," adding that "I learned when I was young that the things that frighten me might not be so frightening after all." Eventually, Jeremy proves his symbolic readiness for sexual adventure by allowing himself to get drenched in a downpour (Episode 39).

When Jeremy lies to Natalie about Jenny, saying that she is a choreo-animator (a designer of dance steps for cartoons), Natalie assumes that Jeremy's choice of date is just another sign of his arrested development: "a choreo-animator! Could anything be more symbolic? We broke up, fundamentally, because I wanted to experience more of the world, and he was happy with what he had. Now he can spend the rest of his life with the cartoon characters that graced the walls of his boyhood bedroom" (episode 41). However, when Jeremy tells Natalie the truth about his date —"Jenny was a porn star, for the boy *and* the man in me"— his erotic evolution becomes apparent to her (episode 42). Earlier, Jeremy had reported that a very big sports story was happening but that he just didn't understand what it was: the words and acts in this sport were unfamiliar to him, but they involved a player who "took all ten wickets in an inning" and who could "pick up a low snatch" (episode 21).[14] By the last episode (45) of *Sports Night*, Jeremy has achieved a greater understanding of the words whispered to him by his unconscious, Jenny, and Natalie. He now accepts Natalie's invitation to adventure as the two of them make love on a desk in one of the offices of their workplace.

And what about Casey and Dana? Do they heed the fly, the fish, the spill, the camera, the grapefruit, and the other subliminal messages urging them to declare their love for each other and to come together in the end? For much of the series, a happy ending is in doubt. Dana is the only one who doesn't know that she likes Casey, Natalie insists, while also telling Dana that Casey is "reaching out to you," but "you're missing the signs" (episode 2). In the meantime, Casey, who is gun-shy due to a recent divorce, ignores his inner promptings — such as the song in his head, "Crimson and Clover": "I think I could love her"— and fails to ask Dana on a date in time to prevent her from getting involved with Gordon (episode 16). Even after Dana and Gordon have broken up and Dan insists to Casey that "the time is right," Casey hesitates, claiming he's not a risk-taker: "I can't become this thing that I'm not." But Dan promotes growth rather than stasis in his friend,

arguing that both Dana and Dan think that Casey *is* this thing that he's not — a coded way of saying that Casey does have it in him to be a risk-taker (episode 24).[15]

However, when Casey does get up enough courage to ask Dana out, she insists on postponing their first date for six months so that he can see other women and determine if his interest in her is really serious (episode 25). Now it is Dana who is gun-shy after the failure of her relationship with Gordon, who cheated on her. It's also possible that she is punishing Casey for having "cheated" on her by sleeping with Sally, as if Dana were saying, "you wanted to sleep with other women besides me, and now you have to." Thus, Dana's delay in dating Casey seems to be less about giving his love time to mature than about punishing him and protecting herself. When Dana does finally take the risk of asking him out, it is too late: having grown tired of waiting for her to grow up, Casey has moved on to someone else and says "no" to a date with Dana (episode 34). Casey's reaction is understandable given Dana's immature behavior, but his refusal of a date with her is really as childish as her postponement of a date with him. Now it is he who is punishing her (for delaying their date) and protecting himself (from feeling rejected), and it's his turn for regret when Dana starts to show interest in someone else (Sam).

Dana's and Casey's conscious speech — saying "wait" and "no" to a date — is thus in contradiction to their unconscious desire. Despite the sensual stirrings of their innermost selves, combined with the erotic encouragement of friends Dan and Natalie, Casey and Dana keep missing, ignoring, and repressing the signs of their love for each other until it seems that time has run out. Yet, against all deliberate denial, these irrepressible signs keep coming, as if to say that it is never too late. "Tabby's tempter?" Dana asks, reading the clue to a crossword puzzle, and Casey supplies (himself as) the answer: "Catnip." "Give the slip?" she asks, and the response to her need does not "elude" Casey (episode 28). Later, Dana is excited to discover that "'momentarily' does not mean 'in a moment,' it means 'for a moment,'" as if she could thereby turn a postponement (like her date with Casey) into something happening right now (episode 33). In episode 37, Casey notes a misspelling in "ireversible," as if to say that (the end of his and Dana's relationship) isn't.

While the future of Casey's relationship with Dana may seem to be threatened by her interest in Sam, it is Sam who basically encourages her to flirt with Casey by speaking from her microphone in the control room to his earpiece in the studio: "Men like the sound of women whispering in their ear. It makes them playful" (episode 26). By the last episode (45) of the series, Sam is gone, and Dana is whispering "Quo Vadimus" in Casey's

ear. "Quo Vadimus" is the name of the company that has bought *Sports Night* and agreed to allow the show to continue, thus ensuring that Dana and Casey will still be working together. "Quo Vadimus" ("Where are we going?") are the words used by the owner of the company — and by Dana — to give coworkers a sense of hope and direction.

But most importantly, "Quo Vadimus" is the last coded message of unconscious desire in the series. When Dana whispers the meaning of "Quo Vadimus" ("Where are we going?") in Casey's ear, she is also asking about their relationship, encouraging him with the sense that it too may have a future. Could it be that all their secret longings are finally being brought to consciousness, much as the Latin "Quo Vadimus" is translated into its clear English sense? Will all the subliminal promptings of past episodes finally lead Casey and Dana to declare their desire? Aaron Sorkin, creator and head writer of the series, has said that "someone accused me of writing as if I'm perpetually on a first date with a girl I really want to have a second date with" (qtd. in Levesque). The words Sorkin uses to end the series — "Quo Vadimus" — keep the date between Casey and Dana alive as a perpetual possibility, as something just about to ring true.

Notes

1. It's not clear whether this fly is ever objectively present, or whether, since Casey and Dana are the only ones who see it, its only existence is as their subjective intuition of love for each other.

2. My essay on *Sports Night* is informed by the writings of Sigmund Freud, Jacques Lacan, and the many literary and film critics in their wake who have used psychoanalysis in the interpretation of words and images. Those interested in further exploration of this area will find that Freud himself is quite readable: see his *The Interpretation of Dreams* or the handy collection of some of his most important writings in *The Freud Reader*. For a psychoanalytic approach to a popular television show, see Glen O. Gabbard's *The Psychology of* The Sopranos. Regarding film, Robin Wood has written strong and accessible interpretations of movies from the 1970s, '80s, and '90s in *Hollywood from Vietnam to Reagan ... and Beyond*. Finally, those interested in the psychoanalysis of literature will find that some of the most influential and accessible readings are Bruno Bettelheim on fairytales, Barbara Johnson on *Billy Budd*, and Shoshana Felman on *The Turn of the Screw*. (For full information on all of the psychoanalytic texts mentioned here, see the Works Cited.)

3. In *Sports Night*, shirts are often connected with sexuality, as in Natalie's several references to wearing Jeremy's shirts in order to get him excited (episodes 10 and 24). Compare also the flirtatious compliment that the women of *The View* give to Casey about his ties (episode 11).

4. This is not the first time that covert connections have linked Casey with other men of dubious character. In the series' first episode, Casey has grown disillusioned with the

bad behavior of sports figures (that "double homicide in Brentwood"), while he himself is involved in a painful divorce. Later, Casey denounces the bad plays called by head coach Rostenkowski (Casey may really be railing against his rival, Gordon) before finally admitting (to Gordon) that Casey himself doesn't know any better about which plays to call (episode 6).

5. For Casey, DAN and NAtalie become verbal conduits to DANA. Natalie also acts as an agent of Dana's unconscious flirtation with Casey, as in the episode (27) where Dana tells Natalie, and then Natalie tells Casey, that Dana is not wearing any panties. Natalie herself tends to be more direct in her courtship of Jeremy, as when she tells him straight out that she's not wearing any socks (episode 44). Natalie is like the "maid" or "servant" character in a Shakespearean comedy whose straight talk about sex serves as a comic foil — and a needed antidote — to the main characters' evasion and repression of the subject.

6. It's interesting that when Dana tells her boss Isaac, "Gordon stood me up last night.... He had to work late," Isaac says that "when I was eleven, I had a pet fish that died." This is the same episode (16) in which we find out that both Gordon and Casey have been sleeping with Sally. Such bad behavior on the part of the "slimy" male sex certainly contributes to Dana's fear of "fish." Also, Dana's disgust with men who behave like "oversexed" "blowhole[s]" may explain her mockery of Dan's reference to "blown spume" (episode 3).

7. With Cab Calloway as a threat, Casey may have to rethink what he says to Dan about liking alliteration. Note, too, that Dan's rival is named Steve Sisco.

8. In episode 34, when he asks Jeremy whether "'hallucination' is spelled with two *l*'s," Casey McCa*ll* might ponder the implications for his own wild jealousy over such men as Ca*ll*oway ("Gui*ll*ermo").

9. When Dana says she wants to "smelt" the musket, she perhaps reveals a sensuous interest in it behind her disgust (episode 36). We might also recall what she says to Casey about his words making her "melt" (episode 13).

10. Like Casey, Jeremy seems to suffer from feelings of male inferiority. Sometimes these feelings are presented symbolically, as when his attempts to solve the Y2K problem (or "the KY problem," as Natalie calls it, giving it a sexual connotation) result in a power failure rather than in proof that he can face the future "as the servant of no master.... Take back that 'nerd' thing.... Say, 'Jeremy's your daddy'" (episode 28). At other times, the symbolic (Jeremy's fear of the needle during a blood drive — episode 22) becomes more literal, as when he balks at dating a porn star for fear that she will find him "anatomically" inadequate, and she has to reassure him that "no one is going to take their penis out and hit you in the head with it" (episode 38).

11. Dan gets a sense of what it was like for Roberta to wait anxiously for that call from him that never came when, in a later episode (25), Hillary Clinton never calls him back.

12. Dan and Steve are also alike in that both are sports anchors.

13. One reason that Jeremy is not sexually more adventurous may be that his father was too much so. In the episode (18) where Jeremy attempts to chart how a boat could have gone so far off course, he is really trying to figure out the wandering ways of his father, who is revealed to have been cheating on Jeremy's mother since before Jeremy was born. This revelation (like that of Isaac's stroke) has an undermining effect on Jeremy's confidence in his father, in himself, and in male-female relationships, and it causes Jeremy to break off his relationship with Natalie for a time, probably because he does not want to end up hurting her in the way that his father hurt his mother. Interestingly, in an

earlier episode (3) Jeremy had witnessed a mother deer shot dead by a hunter's gun, leaving behind a bereft fawn with which Jeremy identifies. (Jeremy, who "got the call" to cover a hunting story, finds that what he sees is no "better than a poke in the eye.")

14. The patent sport is cricket; the latent one is sex.

15. Interestingly, Casey has a best friend named Dan and a love interest named Dana. It's as if the transition most boys make as they grow up — from a close male friend to a first interest in girls — were built into these names.

Works Cited

Bettelheim, Bruno. *The Uses of Enchantment: The Meaning and Importance of Fairy Tales.* New York: Knopf, 1976.

Felman, Shoshana. "Henry James: Madness and the Risks of Practice (Turning the Screw of Interpretation)." *Writing and Madness: Literature, Philosophy, Psychoanalysis.* Palo Alto: Stanford U P, 2003. 141–247.

Freud, Sigmund. *The Freud Reader.* Ed. Peter Gay. New York: Norton, 1989.

_____. *The Interpretation of Dreams.* New York: Avon Books, 1965.

Gabbard, Glen O. *The Psychology of* The Sopranos: *Love, Death, Desire and Betrayal in America's Favorite Gangster Family.* New York: Basic Books, 2002.

Johnson, Barbara. "Melville's Fist: The Execution of *Billy Budd.*" *The Critical Difference.* Baltimore: Johns Hopkins U P, 1980. 79–109.

Levesque, John. "Aaron Sorkin Is a Man of Many Words." *Seattle Post-Intelligencer* 7 March 2000.

Wood, Robin. *Hollywood from Vietnam to Reagan ... and Beyond.* Columbia U P, 2003.

His Girl Friday (and Every Day): Brilliant Women Put to Poor Use

Kirstin Ringelberg

I have a love-hate relationship with Aaron Sorkin's work. Hooked on reruns of *Sports Night* on Comedy Central, arranging my schedule on Wednesday nights to catch *The West Wing*, even willing to watch actors I despise (Michael Douglas, Bill Pullman, Tom Cruise) on the big screen in *The American President*, *Malice*, and *A Few Good Men*, I have watched, and yet I know my watching is problematic. You see, I'm a feminist. That's right — the f word — and while I'm drawn to Sorkin's female characters for their swift retorts and fundamental wisdom, I know I'm being duped. These women are there to throw me off the scent of sexism, to make me think Sorkin is different from the other Hollywood writers who base their story-lines on smart men saddled with beautiful bimbos. And he is — don't get me wrong — but his wise-cracking, no-nonsense women are finally incapable of existing without the protection, adoration, and support of the men. In nearly every Sorkin work, I end up with the sick feeling of betrayal, made worse because he actually makes me think this time I'll get a Hollywood heroine I can respect.

Sorkin's seemingly ideal type, the brainy, sassy, but finally dependent woman, harkens back to some classic films and stars of the 1930s and '40s (Rosalind Russell, Carole Lombard, Jean Arthur). Rather than introducing an excitingly consistent group of smart female leads to contemporary film and television, this tendency of Sorkin's is actually a long-standing American tradition of selling to multiple constituencies while reaffirming norma-tive (in this case sexist) values. Sorkin, like some other Hollywood writers, represents an ideal woman that superficially satisfies liberal feminist goals and provides female viewers with a false notion of their equality. Simultaneously, male viewers (and, doubtless, advertisers) are comforted that these women

will be "equal" only on male terms and under male patronage. Not as obviously sexist as *Ally McBeal* but equally assuaging in its pseudo-reality, Sorkin's work provides women with an opiate: a show that represents society as it could be while changing nothing. By examining the close connections Sorkin's characters have to these wonderful, but fundamentally sexist, films of more than 60 years ago, I will show that Sorkin fails to move beyond that old model in terms of women's roles. Widely understood as a mainstream film and television writer whose work promotes progressive liberal objectives, including gender equality, and envisions a "better" America for those traditionally oppressed, Sorkin is, in the end, trapped in a conservative past.

Sorkin's work is clearly influenced by the screwball comedies of the interwar period. He even suggests this connection himself in "Bartlet for America" from *The West Wing* when President Bartlet remarks that the dialogue between Leo McGarry and attorney Jordan Kendall is "like a fifties screwball comedy."[1] A hallmark of Sorkin's style is the snappy patter of the characters; the quick pacing of the dialogue as the characters move around the set on *The West Wing* has been mocked by *Mad TV* and *Saturday Night Live*, but this technique for animating an otherwise static experience (two or three characters merely talking) was originated in such Howard Hawks–directed films as *Bringing Up Baby* (1938) and *His Girl Friday* (1940). These films have become classics, in part, because the female characters were presented as independent, intelligent, indefatigable women, but who used these tools almost exclusively to the benefit of the male lead characters. Sorkin's resuscitation of this style is wise; he has mentioned in interviews that he develops his ideas from conversation and dialogue first and often needs time or assistance to structure that language around a plot or setting. The screwball comedies were excellent films in which dialogue was a key element in both plot advancement and characterization. Although slapstick and comedies-of-error also played a prominent role, the oral dueling between male and female leads was vital to their character development and showed their quick intellect regardless of social background.

Yet the unusually feminist female characters of these classic movies were, in the end, serving the masculinist paradigm that dominates American film culture. This was in no small part due to the creation of the Production Code (instituted in 1930 but not fully enforced until 1934). Although silent films had tended to severely limit the types of female characters depicted, the initial talkies of the pre-code era featured strong, intelligent, independent women who quite often behaved like women in the real world — loving the men (and women) of their choice, often in greater numbers than one and regardless of marital status. As Mick Lasalle argues persuasively in *Complicated Women: Sex and Power in Pre-Code Hollywood*, films such as *The*

Divorcee (dir. Robert Z. Leonard, 1930) starred Norma Shearer, Greta Garbo, and Marlene Dietrich as women who didn't have to die or get married (and often thus chastened) to get what they wanted or say what they thought. The institution of the code changed all that, however.

Developed by Will Hays in conjunction with a variety of Hollywood studio administrators, the code was an attempt to circumvent potential financial woes caused by indecency charges and court cases by setting up a self-imposed set of rules that movie-makers must follow or be sanctioned by the Production Code Administration. The code was established by Hays but not fully upheld until Hays hired Joe Breen to run the PCA. Breen began using the authority of the PCA to review movie scripts and demand changes, as well as charge theaters that screened non-approved films.[2]

The code put a tight leash on behaviors and plots deemed either immoral or amoral, particularly in terms of violence and sexuality. Violent or strongly sexual characters or stories could be shown, but only if the end result was condemned as unacceptable — the femme fatale must die or be imprisoned by the end of the film, and the gangster must be shown both remorseful and in full rigor mortis as the hero (never a gangster unless a reformed one) shakes his head sadly. The freewheeling ladies of the pre-code era were explicitly banned. The code stated clearly: "Out of a regard for the sanctity of marriage and the home, the triangle, that is, the love of a third party for one already married, needs careful handling. The treatment should not throw sympathy against marriage as an institution." If marriage was to be idealized and the final or constant goal of the characters, then there was little room for the type of freedom real women were experiencing in the 1930s to be shown in film.

Screwball comedies, by their very zanyness, could get away with a little more than the average film. As Lasalle points out, "Under the Code, comedy, particularly screwball comedy, became the vehicle for expressing the anarchic impulse. Within that atmosphere of distracting freneticism, truths, at least some truths, could be told about men and women" (210). Much of the audience for code films had seen the pre-code films and thus been exposed to other possibilities for their heroines; the subversions, in various levels of subtlety, were decipherable: "People knew well how to see through and even ignore the straitjacket that every woman's story was stuffed into during the forties" (212). Using witty language and role-reversals, the screwball films presented the possibility for subversion of the code and its old-fashioned moralistic view. However, for Lasalle, these films are not as empowering for women as the pre-code films because the code films inevitably punish or rehabilitate the women who "misbehave."

Maria DiBattista, author of *Fast-Talking Dames*, either ignores or is

unaware of Lasalle's book, whose thesis she does not mention. DiBattista stakes her own position as a supporter of the code era heroine as the most empowered of women in American film history. DiBattista exalts the "happy marriage" ending of many screwball comedies: "The marriage with which comedy traditionally concludes satisfies our deepest desire for personal and erotic happiness and also reassures us that the social future is being joyously imagined" (DiBattista xi). Content in a way that neither Lasalle nor I am with this heterosexist and politically conformist fairy tale, DiBattista can then overlook the fatal flaw of these movies and focus on their greatest strength, the "fast-talking dames": "The classic American comic heroine — the dame who attained her majority with the birth of sound — became a fast-talker not just to keep up with the times, but to run ahead of them. She paved a way for a new class or sort of woman who finally would answer to no one but herself" (DiBattista 11). DiBattista sees the verbal skills of these women as the paramount sign of their intelligence, wit, and superiority over both their male counterparts and their historic counterparts in film.

The question of when we had the most empowered and appealing female role models in film is a contested and well-trod one. At different points on the spectrum, both Lasalle and DiBattista agree on one thing, at least: the ability to talk and the skill to use that ability well created opportunities for women to display strength and intelligence often denied to them in other settings. By resuscitating that emphasis on subversive, sassy, and sublime speech, Sorkin opens a door for women again. Certainly the kind of actor who can carry off a role like the ones Sorkin creates for women must be capable herself, and this might be a hopeful change from the emphasis since the 1950s on the beautiful but often vapid and certainly verbally challenged actress in the mode of Marilyn Monroe, Raquel Welch, and Julia Roberts. (DiBattista explores this trend to deliberate inarticulateness in contemporary movies — think of Meg Ryan's inordinate skill with struggling for words in nearly every film she's made).

Sorkin thus seems at first to be taking us a step forward in equal treatment of male and female characters; after all, his reference point is at least to films that celebrate women as capable and intellectual. His female leads are invariably smart. They dispense wisdom, manage things capably, and guide the male characters through difficult experiences. The male characters often talk about respecting their intelligence. But in every case, the primary character is male and that male character learns he can dispense with the woman or women who have helped him and move beyond their assistance. This is, remarkably, not the case in many of the screwball comedies of the 1930s and '40s, where although the male lead may in various ways "defeat" the female lead, we never doubt that there is a female lead, and we see much

of the film through her perspective. In *His Girl Friday*, for example, Cary Grant wins Rosalind Russell over to both him and his way of life, but the movie revolves almost exclusively around her and her ultimate inability to give up a life she finds exciting.[3]

Although each of Sorkin's television programs and films features at least one strong female character in a position of prominence, the plots and action always focus on the male leads. In fact, of all the code era films — although Sorkin clearly bases his "walking and talking" pace on *His Girl Friday*, *Bringing Up Baby*, and other such banter-based films — it is the films of Frank Capra that most connect to what Sorkin is attempting. *The American President*, and its pursuant spin-off, *The West Wing*, are undoubtedly based on that Capra film in particular. Both Capra and Sorkin are clearly in search of a purer, more ideal America where honesty and intelligence are valued above the machinery of government and big business. They both put honorable men in situations where "most people" would take an easy path of avoidance or dissemblance and then imagine those men doing "the right thing" anyway. Most significantly, though, they both have those men being guided, taught, and supported by smart (sometimes smarter) women.

Mr. Smith Goes to Washington stars James Stewart as the nominal lead, a simple guy (his biggest cause is a summer camp for boys) who is selected to replace a recently dead senator because the other sitting senator from his state believes he will be easily manipulated. Stewart's Mr. Smith arrives in Washington, D.C., full of folksy awe at the noble ideals of the country's founding fathers. He quickly gets in trouble, of course, as his naiveté causes him to be manipulated by the press and unwittingly interfere with a graft plan. To the rescue is Saunders, Smith's world-weary secretary, played by Jean Arthur. Saunders wants to quit, but she also wants a new outfit, so she agrees to stay on (for extra pay, offered by the senior senator) and to tutor Smith in his job. Saunders falls in love with Smith despite her disdain for his lack of sophistication, as she finds what has been missing in her life: someone so genuinely honest even she starts to care again. It is Saunders who convinces Smith to stay and fight corruption, it is Saunders who gives Smith the correct procedures to follow to do so (she quite literally feeds him lines and actions from the Senate gallery), and it is Saunders who gets Smith's accomplices, the young staff of *Boys' Stuff* newspaper, to put out a countering view to the state's corrupt newspapers. Early on in the film, Smith thanks Saunders for her guidance in developing a bill for the boys' camp: "I've never known anyone as capable, intelligent ... why, I don't know where I'd be on this bill of mine without your help." The language in this scene, like that in the rest of the movie, is telling. Smith is in awe of Saunders' intellect and savvy, but primarily as it helps him in "this bill of mine." No one would ever

perceive Jean Arthur as the star of this film or Saunders as its lead, even though she is responsible in some way for most of its action, including its famous redemptive filibustering scene. That is because Capra, like Sorkin, makes sure that we see women as sassy, capable, intelligent people who put these qualities to best use by serving their male superiors. Just as Capra is nostalgic for a nonexistent past in which there was no moral ambiguity and purely good men ruled our country, Sorkin is nostalgic for both that past and the past in which women were "fast-talking dames" who knew how to make those men look good.

In *A Few Good Men*, Sorkin's first feature film based on his play of the same name, we see the character arc of Lt. Daniel Kaffee (Tom Cruise), who shifts from a good-time guy hoping to pass his years as a judge advocate general (JAG) lawyer playing baseball and pleading cases out of court to a bastion of moral and military strength, standing up to a corrupt military machinery that allows its leaders to kill people unchecked. How does Kaffee get the case, the ideas on how to win the case, and the encouragement to make it work? Why, his superior officer Lt. Commander JoAnne Galloway provides them, of course. Although Galloway (played by Demi Moore) outranks Kaffee, he insults her to her face from their first meeting. Although Galloway has more experience than Kaffee, she makes mistakes in court while he is mystically brilliant (it's his first trial case ever). Admittedly, she has limited experience in court, but even that detail is used to further entrench her as incompetent, despite the vital role she plays in solving the case. It is Galloway who suggests that Kaffee call Jessep (Jack Nicholson) to the stand, producing the testimony that wins the case for Kaffee, but the pride of having won the case is clearly Kaffee's. Galloway's simpering inferiority complex throughout the film is humiliating to watch. Surprisingly, Sorkin based this story on an actual case his older sister Debra tried as a JAG lawyer.

Sports Night, the television comedy based on the ESPN television news show *SportsCenter*, tried admirably to give women a better deal. The majority of on-air and on-site correspondents shown are women. The ensemble cast featured two strong women characters, Dana and Natalie, who produced the faux show. As producer, Dana is, in fact, the boss of every other character on the show except Isaac Jaffe, executive producer of the sports channel (played by Robert Guillaume). Nonetheless, Dana is not the recipient of much respect by her employees. In the pilot episode, Dana is told to shut up by one of the two "stars," Casey (Peter Krause), who later kisses her and then hugs her while she cries. While she is trying to run a production meeting, Dana is completely ignored and talked over by her staff, which causes Dan (Josh Charles) to quip, "Dana's the producer, we like to give her the impression she's in charge." Dana is not in charge, and this is made clear

throughout the arc of the entire show, despite her obvious intelligence and capability. Like Saunders and Galloway, she controls from behind the scenes, in this case quite literally, but like Saunders and Galloway, she is there to serve the men — her boss and her two employees, Dan and Casey. Lest the viewer begin to interpret her position implies agency, we first see Dana in pants in episode 24, and an episode later she wears her second pair — this time low-cut leather biker pants she is ostensibly wearing for a themed bachelorette party later. We first see her office in episode 26; otherwise, when we see Dana in an office it is a man's (usually Isaac's, sometimes Casey's and Dan's) and she is not in charge there.

Dana is not the only woman in this kind of position. On one episode, Dana cannot produce the show, so Natalie is put in charge. After she manages quite well, Natalie says to a clearly surprised Jeremy (her boyfriend on the show, played by Sorkin favorite Joshua Malina) "What'd you think I was around here, some gal Friday?" to which Jeremy replies, "No — I just didn't think you were *that* good." But the scene ends with Natalie paying Jeremy for a bet she has lost, saying "Well, you were right about the trade." Although this should be Natalie's moment of triumph, we end with Jeremy's superior knowledge — Natalie concedes to him.

The only other producer on the show is also a woman — Sally, who produces the later edition of the show. Both Sally and Dana compete for power, and they do it in part through competing for Casey's romantic valuation. Both women sleep with Casey over the course of the series, and Sally sleeps with Dana's fiancé, Gordon. Therefore the two women on the show with the most power end up in what is essentially a sophisticated cat-fight, while their object of affection (Casey) rises above the melée, unscathed and honorable in his disgust that Gordon is cheating on Dana.

Let me end on the most popular and successful Sorkin enterprise, *The West Wing*. Like the previously mentioned shows and movies, *The West Wing* has some brilliant, competent women as significant characters. What are their jobs? Is any one of them in a position of power above the president? Well, no, but let's not go nuts. Think about the number of women on the show and then think about what they do (besides verbally spar with the male characters in an appealingly intellectual way). The most significant roles in terms of actual decision-making are held by men, and the brilliant women advise them, clean up their messes, and protect them from danger, but they don't rise above that role. C.J. Cregg, the press secretary, might at first convince one that there is a primary character who is female, even if she is not the president. Certainly at many points throughout the series, C.J. acts to influence the president's decisions. But what is the press secretary's fundamental role? To spin whatever decisions are made by the president and his

cabinet for the rest of the world. She is, in the end, merely a mouthpiece who does not make decisions.[4] And this is the most fully developed female character in the series. Several recent writers discuss the question of the female characters in *The West Wing*. Christina Lane, for example, much like DiBattista before her, sees empowerment in this supporting role:

> *The West Wing* takes not merely as its end point, but rather as its *point of departure*, a progressive, multifaceted, highly politicized understanding of gender and racial relations. The series demonstrates such an understanding by granting narrative authority to its secretarial (or "assistant") characters, all of whom are female or African American, and by suggesting that a commitment to feminism drives those white, male characters who currently hold positions of power [33].

It is extremely hopeful to have white men in power being advised by women and people of color to do "the right thing." But are we doing the right thing by letting the last word be uttered always and only by the white, heterosexual man, even if we put that word in his mouth?

Myron A. Levine, writing in the same anthology as Lane, apologizes for what he more accurately sees as a problematic gender situation by suggesting that "this televised representation may be not so much the result of a conscious or even unconscious bias on the part of the scriptwriters but a reflection of Washington reality" (52). Ah, here we might be at the crux of the problem — reality. We are apparently supposed to accept that because in real life, women (and people of color and queers) are on the margins of actual power, that this is how we should see them portrayed (Levine is more concerned with actual negative treatment of women staffers in presidential administrations). There are two problems with this argument. First, there are actually women in positions of greater power in our last two U.S. presidential administrations than are ever shown on *The West Wing* (Janet Reno, Condoleeza Rice, Madeleine Albright). These women make decisions, they don't just suggest them to the president or his staff in sexually tense office conversations. The second problem with this argument is the implication we're seeing reality on this or any show. If Sorkin can imagine brilliant women secretaries sagely guiding presidents through their errors of judgment, if he can imagine a nearly all-female sports news staff, surely he can imagine that one of these women could actually be in charge, and not just as a joke for the other staff and not just as a support for the final top dog, always male. Oh — yeah — and not just at the head of a feminist organization.

To be fair, Sorkin is a man, and he thus logically places the final decisions, power, and value in his male characters. Yet Sorkin is also Jewish, and

while his Jewish characters are often the intellectual or moral center of each project, they are never the lead — why? In fact, the same case applies to Sorkin's Jewish males (Toby and Josh in *The West Wing*, Leon in *The American President*, Dan in *Sports Night*, Sam in *A Few Good Men*, most of the roles taken by Joshua Malina) as applies to his female characters: they are shown as remarkably useful (maybe even indispensable) to the non–Jewish leads, but their power ends there, at the supporting level. Chances are strong that Sorkin makes his Jewish characters servants to his Gentile characters because that's what his audiences expect; perhaps he does the same with his female characters. I hope that he decides to use his significant influence and talents to create a project in which the lead character, the dominant force, the person whose life is pushed forward in a positive way, can be either Jewish or female — or better yet, both. Instead, by writing homages to Frank Capra and Howard Hawks, and perhaps even Rosalind Russell and Jean Arthur, Sorkin fails to do anything new with his female characters. What we see, instead, are the same women, clothed in the styles of the 1990s and 2000s, but acting just exactly as they did in the 1940s.

Notes

1. Bartlet: How does she look to you?

 LEO: Who?
 BARTLET: Her.
 LEO: She looks good.
 BARTLET: What's she wearing?
 LEO (to attorney): What are you wearing?
 ATTORNEY: What does it matter?
 LEO: Why don't you ask the President that?
 ATTORNEY: Gray Armani suit.
 LEO: Spandex.
 BARTLET: I like you and her. It's like a fifties screwball comedy.
 LEO: You're like a fifties screwball comedy.
 BARTLET: What was that?
 LEO: Nothing.

2. See particularly Leonard J. Leff, *The Dame in the Kimono: Hollywood, Censorship, and the Production Code*. Lexington: University Press of Kentucky, 2001.

3. Russell's role (Hildy, short for Hildegarde) was originally written for a man — in the Ben Hecht and Charles MacArthur 1928 play *The Front Page* (where the name was Hildebrand). It's more than a little ironic that such a plum woman's role was never intended to be so.

4. A crucial example of this issue occurs in the episode "The Women of Qumar" in which C.J. continually brings up the execrable treatment of women in an imaginary Middle Eastern nation with which the U.S. has made diplomatic ties. Throughout the episode,

C.J. compares Qumar unfavorably to Nazi Germany and South Africa under apartheid. Hoping that the points she's making will convince the cabinet to reconsider selling arms to the country, C.J. is instead "schooled" on the impracticality in the "real world" of holding to such noble ideals.

Works Cited

DiBattista, Maria. *Fast-Talking Dames*. New Haven and London: Yale University Press, 2001.

Lane, Christina. "The White House Culture of Gender and Race in *The West Wing*: Insights from the Margins," in The West Wing: *The American Presidency as Television Drama*. Eds. Peter C. Rollins and John E. O'Connor. Syracuse, New York: Syracuse University Press, 2003.

Leff, Leonard J. *The Dame in the Kimono: Hollywood, Censorship, and the Production Code*. Lexington: University Press of Kentucky, 2001.

Levine, Myron A. "*The West Wing* (NBC) and the West Wing (D.C.): Myth and Reality in Television's Portrayal of the White House." The West Wing: *The American Presidency as Television Drama*. Eds. Peter C. Rollins and John E. O'Connor. Syracuse, New York: Syracuse University Press, 2003.

Mick Lasalle, *Complicated Women: Sex and Power in Pre-Code Hollywood*. New York: Thomas Dunne Books, St. Martin's Press, 2000.

Depictions of the U.S. Military: Only "A Few Good Men" Need Apply

Fiona Mills

In the film adaptation of Aaron Sorkin's Broadway play *A Few Good Men*, for which he wrote the screenplay, women are practically invisible with the exception of co-star Demi Moore. In a particularly interesting move, the film's producers and directors went to great lengths to downplay Moore's usual bombshell appearance by hiding her curvaceous figure in dowdy military uniforms, employing a mannish haircut, and utilizing minimal makeup for her role as a military lawyer. Physical makeovers are nothing new for Moore, who, in the 1990s, became infamous for re-constructing her physical image — posing nude while heavily pregnant for two *Vanity Fair* magazine covers, shaving her head and bulking up for her role as a military commando in *G.I. Jane*, and appearing scantily clad in a bikini on *The David Letterman Show* to promote her role as a stripper in her film *Striptease*. Ironically, at first glance, *A Few Good Men* appears to take an almost proto-feminist stance in undercutting Moore's obvious beauty and, instead, emphasizing her intelligence, confidence, and inner strength as she aids Tom Cruise in defending two Marines accused of killing a member of their unit. Counter to most of her film roles, in Sorkin's drama Moore's brain, instead of her body, is her best asset. To add to the film's emphasis on intelligence rather than beauty or physical attraction, there is nary a love scene nor a scantily clad body in the entire movie. Instead, Cruise and Moore maintain a strictly platonic relationship — a factor that initially suggests Sorkin's desire to depict a feminist character by refraining from including an easy to fathom romantic subplot between its leading actors. Curiously, Sorkin's original screenplay alluded to a more than platonic sentiment between Danny (Cruise) and

Jo (Moore); going so far as to end the film with Danny asking her out on an official date and Jo kissing Danny after he has just finished successfully defending their clients. The final film version omits any of this, and, instead, ends with a fade away from a triumphant Danny standing alone in the court-room after winning his first trial and, not inconsequentially, effectively com-ing to terms with his dead father's legacy as one of the greatest trial lawyers in the country. With this, the film confirms its singular emphasis on men in the military and the story of one man in particular; namely, Danny, and his struggle to overcome his fear of not measuring up to paternal expectations.

This essay examines the denigrating depiction of Jo, the sole female character in Sorkin's screenplay and its subsequent reflection of the role of women in the military in the 1990s — a decade during which, not coinci-dentally, the infamous "Tailhook" event, in which dozens of women were sexually harassed at a Navy convention,[1] occurred, and President Clinton unveiled his well-known "don't ask, don't tell" policy on homosexuals in the military.

Best-Laid Plans of Movies and Men

As the film version of A Few Good Men unfolds, it becomes apparent that Demi Moore's character, Jo, although neither dressed nor depicted as typical eye-candy, is little more than that. Sorkin's original attempts to por-tray an admirable, intelligent, three-dimensional female character quickly fall short as Jo is repeatedly ridiculed, ignored, and generally made to look stupid. This denigrating depiction becomes more interesting in light of the fact that Sorkin's own sister, a judge advocate general in real life, inspired him to write the original screenplay based on a military case in which she was involved, and presumably she became the basis for the character of Jo. Given this background, one gets the sense that this play initially was a woman's drama; not only was it based on Sorkin's sister's real life experi-ences, but Jo also bears the film's moral compass through her belief that a much larger and more powerful entity, the U.S. Marine Corps, is culpable for the murder of which two young Marine corporals are accused. She alone insists that these young men stand trial and be given the chance to tell their side of the story instead of acquiescing to Danny's desire to quickly enter a plea bargain. Notwithstanding the maniacal allegiance to "the Corps" of Lieutenant Kendrick, Keifer Sutherland's character, and the unwillingness of the two accused men to dishonor their unit by revealing that they had been ordered by their unit commander to administer a "Code Red," a brutal form of military hazing, to a fellow unit member who was not keeping up

with military standards, Jo best exhibits an unexpected, almost naïve, respect for and awe of what the military symbolizes and, potentially, could be. This surprises and infuriates Danny, Tom Cruise's character, as evidenced by his questioning as to why she likes the accused men so much. Jo firmly, albeit a bit romantically, retorts, "'Cause they stand on a wall. And they say 'Nothing's gonna hurt you tonight. Not on my watch'" (Sorkin 61). Jo's statement reveals a romanticized vision of the military that is implicitly patriarchal — perhaps unintentionally belying her subordinate position as a female officer and cast member. However, it also underscores her unswervable moral conviction and belief in the pursuit of justice for all. A significant consequence of Jo's insistence that the young corporals stand trial is that Danny must rise to the occasion and, acting as their lawyer, try his first case. Accordingly, Jo's moral turpitude enables the drama to zero in on Danny's struggle to overcome his inner demons and step out from under his father's shadow — an act that solidifies Jo's position as a dramatic prop used to propel the real, i.e. male, drama forward. Sorkin, unfortunately, conforms to typical Hollywood conventions by shifting his focus to the plight of Danny. Consequently, despite the actions Sorkin initially takes to create a less than stereotypical female role for Moore, Jo fades into the background, becoming little more than a pretty face — covered up and dowdy, yet eye-candy nonetheless.

To be fair to Sorkin, he initially does create a strong female character in Jo[2] as evidenced by her assertiveness and willingness to speak her mind, and it is easy to applaud his decision to shift the usual emphasis on Moore's attractiveness to a focus on her intellect and self-assurance. In the original screenplay, Jo's character is described as "a Navy lawyer in her early 30's. She's bright, attractive, impulsive, and has a tendency to speak quickly" (Sorkin 2). We first see Jo in a meeting with her superiors during which she hesitatingly requests that she be assigned the case concerning the court martial of the two young Marines — a daring move on her part, as she has never tried a case before. The boldness of this endeavor, though, is quickly diminished as we see her stammering haltingly while making her request — an appeal that, not surprisingly, is denied immediately as one of her superiors snidely declares that "she's not cut out for litigation" while the other remarks that she is "all passion, no street smarts." Both then conclude that the division will literally "assign the right man for the job" — the right man being Cruise's character, Danny Kaffee (Sorkin 2–3). This initial meeting firmly establishes the subordinate role of females in the military both literally, since prosecuting this case is deemed to be a job for a man while Jo is given the task of supporting Danny despite the fact that she outranks him, and figuratively, by bestowing upon Jo the stereotypical female characteristic of being overly emotional. Consequently, this scene also confirms the drama's singular

emphasis on a traditional masculine quest narrative manifested by Danny's journey towards maturity as he struggles to litigate his first trial while following in his father's footsteps.[3]

Significantly, though, this brief exchange does establish Jo's straightforward approach to her work. When describing the initial facts of the case, Jo fearlessly refers to the killing of a young Marine, William Santiago,[4] at the hands of members of his unit as sounding "an awful lot like a Code Red" (Sorkin 2). Clearly, Jo is not afraid to speak out against what she believes to be an abominable practice that is a firmly entrenched, though unacknowledged, part of the good ol' boy method of training young soldiers to obey orders at all costs. As explained later in the play, the military officially denies the practice of Code Reds while privately many unit leaders utilize them as a means of effective training. The very fact that Jo immediately and openly identifies Santiago's death as possibly stemming from this illegal activity establishes her unwillingness to participate in an unspoken military code of silence and subterfuge surrounding the harassment of those whom military higher ups deem unworthy, unsatisfactory, or unwanted. In effect, her outspokenness sets up a dichotomy between men, who represent the traditional military establishment, and women, outsiders within conventional military communities, regarding the admission of unwelcome truths — a policy made abundantly clear in Jack Nicholson's famous "You can't handle the truth" speech.[5] Jo's eagerness to divulge unflattering information about the illicit behavior of those in positions of military authority[6] renders subsequent efforts to silence her all the more urgent.

In comparison to Jo's straight-laced, confident, and focused approach to life, Danny comes across as a brash smart-aleck who, despite his Harvard law degree, is incredibly immature and emotionally stunted.[7] Danny is first described as being "in his late 20's, 15 months out of Harvard Law School, and a brilliant legal mind waiting for a courageous spirit to drive it. He is, at this point in his life, passionate about nothing" (Sorkin 3). The audience quickly learns that Danny has never tried a case either, making his position as lead counsel instead of Jo especially painful for her. However, he has amassed quite an impressive record for successfully plea-bargaining and resolving cases before they go to trial. We first meet him on the softball field where he attempts to off-handedly settle his latest case much to the chagrin of his opposing counsel. This scene firmly establishes Danny's position of immaturity and sets the tone for the play's chronicling of his journey towards mature adulthood and a career as a successful trial attorney. Despite his proclivity towards smugness, Danny is a likeable fellow who spends most of his time playing sports and drinking beer with his fellow officers. Significantly, sports is a recurrent motif in this drama. Later in the play we watch as Danny

clings to his beloved baseball bat and paces his apartment while embroiled in trial preparations claiming at one point that he literally needs his bat in order to think better. His baseball bat, consequently, symbolizes his unwillingness to grow up — something Danny will be forced to let go of if he is to succeed as a lawyer. Danny's happy-go-lucky attitude and unwillingness to rock the military boat stands in marked contrast to Jo's seriousness and moral conviction and sets up their adversarial relationship. As the play's moral barometer, part of Jo's task, much like that of conventional female heroines, is to domesticate Danny by way of establishing a sense of morality in him and facilitating his growth into an adult.

Although Sorkin invests much energy in downplaying Jo's physical appearance as a female and attempts to draw her character as one of unconventional confidence and assertiveness,[8] her self-assuredness and straightforward demeanor negatively denote her as stepping outside of traditional female characteristics, causing the male characters to belittle her consistently. Her depiction as an interfering nag is reinforced throughout the play as Jo continually is told to be quiet and to keep her opinions to herself. Sadly, she is effectively silenced as the drama unfolds. Sorkin unwittingly renders her as a shrew who perpetually badgers Danny and the other men into doing what is morally right. As one film reviewer succinctly stated, Moore's role is that of the "Disapproving Woman" (Howe). Jo's unwillingness to back down coupled with her refusal to conform to the stereotype of the quiet and obedient female leads to her many altercations with the brash yet naïve Danny, among others.

Sorkin establishes Jo's position as the nag through various scenes in which she is shown goading Danny into taking his case seriously. Upon their first meeting, Jo displays her obvious disappointment in the division's decision to assign the case to the wise-cracking Danny, whose initial response is to plea-bargain the case rather than go to trial, by stating that "when I petitioned Division to have counsel assigned, I was hoping I'd be taken seriously" (Sorkin 5). Danny is offended by her refusal to be impressed by his record of successful plea-bargaining and questions her authority to intervene in the handling of the case.[9] Jo responds by stating, "My job is to make sure you do your job. I'm special counsel for Internal Affairs, so my jurisdiction's pretty much in your face" (Sorkin 6). They next encounter one another on a softball field, where Jo has gone to track down Danny who has missed a meeting with his clients. Jo is understandably annoyed, and she confronts him by saying, "I was wondering why two guys have been in a jail cell since this morning while their lawyer is outside hitting a ball." Next, she asks, "Would you feel very insulted if I recommended to your supervisor that he assign different counsel? [because] I don't think you're fit to handle this

defense." Her insulting request rolls right off Danny's back as evidenced by his flippant response: "You don't even know me. Ordinarily it takes someone hours to discover I'm not fit to handle a defense." Jo refuses to back down and rattles off Danny's personal history including the fact that his now-deceased father was a former navy judge advocate and U.S. attorney general, thereby alluding to Danny's struggle to reckon with his father's legacy and posthumous expectations.[10] She continues to then inform him of her moral convictions by stating that "if this case is handled in the same fast-food, slick-ass Persian bazaar manner with which you seem to handle everything else, something's gonna get missed. And I wouldn't be doing my job if I allowed Dawson and Downey to spend any more time in prison than absolutely necessary, because their attorney had pre-determined the path of least resistance" (Sorkin 9). Notable here not only is Jo's no-nonsense use of language as she castigates Danny's usual flashy, devil-may-care attitude, but also her singular commitment to ensuring that the young men accused are given a fair trial. Danny's defensive response to her succinct summary of his less than upstanding principles is to belittle her by saying, "I can't help but be impressed by that speech. Wow. I'm sexually aroused, Commander" (Sorkin 10). Danny's retort evinces his total lack of respect for her intelligence and outspoken forthrightness as he reduces her to a sexual object — an all-too common response toward female members in the military. A little later on, when Jo informs Danny that he has brought Downey, one of the accused men, a few items that he has requested, Danny is infuriated and castigates her for meddling in his pre-trial investigation: "Jo, if you ever speak to a client of mine again without my permission, I'll have you disbarred." Jo casually responds that she has received permission from Downey's aunt Ginny to intercede on Downey's behalf if necessary — actions that are well within her jurisdiction.[11] Danny obviously is frustrated by Jo's determination to remain involved closely in the case and resorts to insulting her by saying, "Does Aunt Ginny have a barn? We can hold the trial there. I can sew the costumes, and maybe his Uncle Goober can be the judge" (Sorkin 13). These are but a few examples of the numerous instances in which Danny humiliates Jo by deriding her intelligence and moral compassion.

Jo's role as the driving force behind Danny's quest to prove himself as a successful trial attorney is reinforced throughout the play as we see her continually questioning Danny's proclivity toward shying away from controversy and pushing him to hold the higher ups in the military chain of command accountable for the death of Santiago. In keeping with her initial instinct at the beginning of the play that Santiago died during a Code Red, Jo follows her hunch and questions Colonel Nathan Jessep, Jack Nicholson's character, while meeting with him at the Marine base in Cuba. Although Jessep is a

formidable and imposing man, Jo boldly takes up her line of questioning[12] and asks him, "Do Code Reds still happen on this base?" Not surprisingly, Jessep sidesteps her question. Significantly, in an attempt to quell Jo's interrogation, Danny tells Jessep that "She has no point. She often has not point. It's part of her charm"—thereby once again insulting Jo and attempting to silence her as means of masking his own inability to confront military authority (Sorkin 21). The disjuncture between Jo's willingness to interrogate military officials and Danny's hesitancy to question authority is a recurring motif. She repeatedly insists that he investigate the possibility that Jessep may be guilty of ordering the accused Marines to brutally attack Santiago despite the enormous risk involved in accusing a highly decorated officer, such as Jessep, of misconduct—an act that could lead to dishonorable discharges for all involved if such accusations should be proven false. Danny eventually acquiesces and Jessep's culpability becomes the crux of the trial. Consequently, Jessep can be read as symbolizing that which Danny must confront literally in order to come to terms with his father's legacy.

Jo outspokenly questions patriarchal models of authority within the military throughout the drama, beginning with her initial identification of Santiago's death as the result of a Code Red, to her refusal to allow Danny to settle the case with a plea-bargain, to her insistence that Colonel Jessep be subpoenaed about his authorization of the illicit and brutal hazing that led to Santiago's death. She also implicitly questions more subtle manifestations of patriarchal ideologies as exemplified by her criticism of Danny's immature behavior, his proclivity towards playing softball when he should be prepping for trial, as well as her questioning of the "buddy system" used to distribute assignments, and the practice of granting favors based on whether or not an officer engages in the requisite masculine activities of playing sports and drinking. For example, after Jo has had her request to have the case reassigned turned down, she relays this information to Danny and rhetorically wonders if "there is anyone in this command that you don't either drink or play softball with." (Sorkin 12). Here, Jo expresses her frustration at being unable to successfully participate in the military's patriarchal system since her gender precludes her from engaging in these masculine activities. Her exclusion confirms her entrenched position as an outsider within this masculinist environment. However, Jo's boldness in repeatedly questioning her superior officers about their knowledge of or participation in the ordering of illicit Code Reds denotes her refusal to play by their rules and hints at the possible existence of an alternate female-identified system of justice based on truth and moral convictions.

Notably, Sorkin almost succeeds in diverting the audience's attention away from Moore's implicit position as a sexual object. In attempting to

eschew a conventional Hollywood situation romance, Sorkin averts turning the typical adversarial male-female relationship into a romantic entanglement. However, he cannot avoid including several allusions to the possibility of sexual tension between Danny and Jo. For the most part,[13] these instances of explicit sexual innuendo are initiated by Danny, not Jo. For example, as Jo is leaving Danny's apartment, after a long night of preparing for their first day of trial, she stops at the door and is about to make a remark when he interrupts her by saying:

> I know what you're gonna say. You don't have to. We've had our differences ... you've said some things that you didn't mean but you're happy that I stuck with the case. And if you've gained a certain respect for me over the last three weeks that you didn't have before, well, of course, I'm happy about that, but we don't have to make a whole big deal out of it. You like me. I won't make you say it.

Jo's response is to casually retort, "I was just gonna tell you to wear matching socks tomorrow" (Sorkin 45). With this exchange, Danny participates in a decidedly masculinist mode of conversation as he attempts literally to speak for Jo and, moreover, to put uncharacteristically flattering words about himself in Jo's mouth. True to form, Jo cuts him to the quick by denying his attempt to talk for her. Furthermore, this exchange exemplifies Danny's inability to see Jo as his equal via his repeated attempts to reduce their relationship to a sexual or romantic nature. Similarly, while they are preparing for their first day of trial, Danny gives Jo and Sam, the third member of their legal team, advice about their trial demeanor. He bestows an additional piece of advice on Jo stating, "And don't wear that perfume in Court, it wrecks my concentration"—an act that again reinscribes Jo's position as a sexual object (Sorkin 44).

Although Danny's comments never reach the level of outright sexual harassment, Jo suffers the brunt of brutal misogynistic verbal abuse from Colonel Jessep while on the Marine base in Cuba. Clearly annoyed by Danny's inability to silence Jo's line of questioning, Jessep ridicules Danny about the fact that Jo "outranks him." He then sadistically declares to Danny, "You're the luckiest man in the world. There is, believe me, gentlemen, nothing sexier on earth than a woman you have to salute in the morning. Promote 'em all I say" (Sorkin 21–22). With this statement, Jessep renders Jo an object of ridicule with his implication that although she is an officer, she is still nothing more than an object of sexual desire. His sexist remarks, made in response to Jo's interrogation of his knowledge or approval of the use of Code Reds, suggests the employment of misogyny to silence military women

who attempt to question lines of patriarchal authority. When Jo refuses to back down, he angrily advises her to "take caution in your tone" — literally telling her to be quiet (Sorkin 22). Futhermore, with his proclamation "Promote 'em all I say," Jessep subtly references Affirmative Action policies in the military implying that although the government may force the armed services to accept women into its ranks, members of the military's inner circle, such as himself, will never consider female officers as their equals.

One can read Jo as a figure of abjection[14] in that, although Jo is routinely silenced, she continues to voice her opinion. Ironically, despite Sorkin's efforts to downplay her feminine appearance by giving her a masculinized demeanor, Jo is quite obviously a woman. Thus, Sorkin's attempt to obscure this fact ultimately fails. Similarly, it is as if the men in the play want her to disappear, yet desire her all the same. In spite of the persistent rebuffs and unwanted sexual advances from the men who surround her, Jo remains a constant presence. Her refusal to disappear from the narrative illustrates Anne McClintock's theory of abjection in which McClintock contends that that which we, as a society, reject as abject can never be completely destroyed or gotten rid of and is something that we subconsciously desire. Rather, the abject remains on the fringe or boundary of the self or society.[15] This is clearly evidenced through the antagonistic relationship that develops between Danny and Jo. Although Danny belittles Jo and is often frustrated by her, he is still drawn to her and cannot help but like her, notably going so far as asking her out on a date at the end of Sorkin's screenplay — an act that unfortunately confirms her position as sexual object since it is the very last scene. Consequently, the play as well as the film epitomizes a woman's struggle to maintain her voice and to keep herself literally in the picture.

In a particularly ironic twist that reinforces Jo's position as a figure of abjection, after Jo finally convinces Danny to put Jessep on the stand, Danny looks for his beloved baseball bat and is unable to find it. When questioned as to its whereabouts, Jo responds, "I put it in the closet.... I was tripping over it" (Sorkin 98). This moment is particularly significant on several levels. First of all, the fact that Jo put his bat in the closet in an effort to tidy up his house can be read as Jo participating in an implicitly feminine act — cleaning up after a man suggestive of her position as his romantic interest rather than his intellectual equal. Secondly, the fact that she, the abject figure, puts something as important to Danny as his baseball bat, a symbol of masculine youth, in the closet reinforces her as a figure of abjection, as the closet is a decidedly queer or abject space. It is also especially significant that it is Jo, as a domesticating female, who puts away Danny's "toy," something that Danny must give up in order to come to terms with his father's legacy. Lastly, it is while Danny is in his closet[16] that he has a crucial revelation about how

he will prove Jessep's implicit involvement in Santiago's death. Ironically, it is Jo's stereotypically feminine action of tidying up a masculine space that serves as the catalyst for Danny's brilliant inspiration. This incident further underscores Jo's position as a haunting figure since her role in Danny's moment of revelation is literally "closeted" and goes uncredited as does the fact that it is she, through her repeated insistence that Jessep be made to bear responsibility for Santiago's death, who sets the stage for Danny's eventual legal triumph; Jessep ultimately admits that he ordered the accused Marines to give Santiago a Code Red.

Santiago similarly functions as a figure of abjection due to his depiction as an ostensibly queer character. Although less than masculine persons such as Santiago are routinely rejected by the military, the efforts of those to purge the corps of him, and others like him, fail in that he maintains a steady presence in the play, albeit from beyond the grave, and his death leads to the downfall of Colonel Jessep, the top officer at Guantanamo Bay who, ironically, epitomizes a highly offensive and exaggerated masculinity. The abjected figure of the deceased queer character literally haunts the play and, ultimately, triumphs over the military's policy of silence and hyper-masculinity. As such, the play can be read as the triumph of David over Goliath[17] — something that presumably led to its popularity among critics and audience members alike. Unfortunately, there is no such triumph for Jo. She fails to achieve a true voice or become a three-dimensional character in the end.

The Reviews

Interestingly, lending credence to the belief that Sorkin's screenplay focuses almost exclusively on a malecentric master narrative, film critics and reviewers alike concentrate almost exclusively on Cruise's character and use surprisingly masculinist language to describe the film's plot. For example, critic Desson Howe describes the film as being "full of loaded, manly moments, great clashes of will and excellent buzz cuts" and is "constantly gripping" while reviewer Rita Kempley remarks that the film is "a brass-buttoned, square-jawed huzzah for military justice" (Howe) (Kempley). Many film reviewers also paid close attention to the testosterone-filled tensions between Cruise's and Nicholson's characters. Kempley describes their showdown as a going "macho a macho," clearly emphasizing their masculinity. Significantly, despite the fact that Moore's and Cruise's characters square off many times during the film, Howe contends that "of course, there's only one match-up that counts: the final encounter between lawyer Cruise and

witness Nicholson." Here, Howe unwittingly reinforces Moore's position as what I would term the "Disappearing Woman" by failing to acknowledge the ongoing tension between Moore's obviously intelligent and assertive Jo, who is Danny's superior officer, and Cruise's smug, smart-aleck Danny.

Curiously, Howe claims that Sorkin's film "doesn't follow Hollywood convention." However, precisely by focusing solely on a male character's journey of self-discovery, thereby relegating the sole female lead to little more than window dressing, despite her de-emphasized physical beauty, I contend that Sorkin's film reinscribes traditional masculinist blockbuster formulas. Although he acknowledges Moore's implicit invisibility by describing her as being "in the thankless role of Disapproving Woman (and one that must surrender the romantic flag first)," Howe, though, does not express much concern for her position on the sideline. By focusing the majority of their criticism on Cruise and the other male actors, the film reviews of *A Few Good Men* mimic Sorkin's screenplay's treatment of Moore's character. Thus, not only does Moore disappear on the screen, she also vanishes on paper; the reviewers consistently write her out of their reviews, thereby implicitly reifying the position of invisibility experienced by women in the U.S. military.

Conclusion

What is the story of women in the military? All too often it is one of subordination, disparagement and, as the infamous Tailhook incident demonstrates, sexual harassment. *A Few Good Men*, as its gender-specific title suggests, does little in the way of dispelling these mythical truths. Although Demi Moore's character does not suffer outright sexual harassment, perhaps due to the slavish de-emphasis on her appearance, she is subjected to repeated denigrating and humiliating remarks, is effectively silenced, and finally forced into the periphery of Sorkin's story. Admittedly, one must bear in mind that this play was written in 1991, with the subsequent film version released in 1992, and acknowledge the marginally higher profile of women serving in the armed forces today due, in part, to the increases in the number of women enrolled in the top U.S. military academies during the past decade. However, as the recent allegations of rape and sexual assault suffered by female students at the hands of fellow cadets enrolled at the Air Force Academy in Colorado and the military's initial cover up reveal,[18] although women now may indeed rise through the ranks of the military, there are still tremendous costs to such ascendancy. Unfortunately, Sorkin's screenplay unwittingly reinscribes the marginal position of women in the military

through its emphasis on the heartwarming ability of Tom Cruise's character to overcome his paternal demons and become a successful trial attorney at the expense of Demi Moore's initial characterization as an unconventionally intelligent and assertive female officer. Perhaps the title really does say it all; when it comes to careers in the U.S. military, it is only a few good *men* who need apply.

Notes

1. According to the PBS website *Frontline* in its series entitled "The Navy Blues," "At the 35th Annual Tailhook Symposium (September 5 to 7, 1991) at the Las Vegas Hilton Hotel, 83 women and 7 men were assaulted during the three-day aviators' convention, according to a report by the Inspector General of the Department of Defense (DOD). The Inspector General and the Naval Investigative Service issues a 2000 page report vividly detailing a drunken scene at Tailhook '91 where dozens of women were accosted and sexually molested. The report provoked more outrage and a call for more investigation. In August of 1992 the Pentagon's Inspector General launched a set of investigations. In total, 119 Navy and 21 Marine Corps officers were referred by Pentagon investigators for possible disciplinary actions. They were cited for incidents of indecent assault, indecent exposure, conduct unbecoming an officer or failure to act in a proper leadership capacity while at Tailhook '91. Further, 51 individuals were found to have made false statements during the investigation. None of these 140 cases ever went to trial. Approximately half were dropped for lack of evidence. Most of the rest of the men "went to the mast"—an internal, non-judicial disciplinary procedure that meted out fines and severe career penalties. Almost all of these cases involved unseemly behavior rather than sexual assault.... As time went on, however, the fallout from Tailhook '91 continued. Ultimately the careers of fourteen admirals and almost 300 naval aviators were scuttled or damaged by Tailhook."

2. Note the gender-neutral abbreviation of Joanne used here — a nod to Sorkin's effort to masculinize Moore's character.

3. In deference to Sorkin, it must be noted that Jo is not completely denied a role in this trial. Downey's aunt later requests that Jo be assigned as lead counsel representing her nephew.

4. Santiago was harassed and eventually killed, albeit accidentally, during a routine yet brutal hazing known as a Code Red. He was guilty of failing to satisfactorily perform routine tests of physical endurance during his time as an enlistee and was very unhappy. As a result, he repeatedly attempted to secure a transfer off the Marine base in Guantanamo Bay, Cuba, going so far as to offer information about an illegal fenceline shooting by one of the men in his unit in exchange. In keeping with the military's code of silence surrounding illegal activities, it is Santiago's willingness to reveal this potentially damaging information that leads his unit commander, Lt. Kendrick, to order Dawson and Downey, the accused, to give Santiago a Code Red in order to teach him a lesson about the importance of remaining silent about such matters. Significantly, I contend that Santiago can be read as a queer figure in that he is depicted as weak, due to his inability to complete arduous physical tasks, and a tattletale — both less than manly traits in

comparison to conventional notions of masculinity promulgated by the military. Thus, his death at the hands of his fellow unit members illustrates heterosexist and patriarchal ideologies undergirding the U.S. military.

5. These efforts of male superiors in the military to obscure the truth mimic President Clinton's "don't ask, don't tell" policy towards homosexuals in the military unveiled during the early 1990s. Effectively, Clinton was advocating a similar style of policy in that officially homosexuals were banned from serving in the military while the homosexual actions or relationships of soldiers in private were tolerated if such encounters were never disclosed.

6. Here, Jo is positioned similarly to the women who came forward with allegations of sexual harassment during the Tailhook scandal.

7. This fact conforms to stereotypical gender dichotomies in that women are penalized for being too emotional while men are rewarded for being emotionally immature.

8. In effect "masculinizing" her — much in keeping with the fact that women who enter the U.S. military must take on masculine personas in order to survive.

9. Danny's obvious dislike of a female being in a position of authority over him, especially one who refuses to conform to typical gender expectations as evidenced by Jo's disinterest in him romantically, reinforces patriarchal propensities within the military.

10. Again, this exchange emphasizes Jo's role in guiding Danny's growth into adulthood.

11. Ginny tells Jo that "she feels like she's known [her] for years." Aaron Sorkin, *A Few Good Men*, original screenplay, New York, 25. In essence, here Jo is working outside the bounds of patriarchal authority and has tapped into an alternative means of power based on female characteristics. Remarkably, this is an instance in which Jo's gender is an asset.

12. Proving herself much braver than either Danny or Sam, the two male members of their legal team.

13. One notable exception occurs when Jo appears on Danny's doorstep and offers to take him out to dinner. Her effort appears completely platonic, yet Danny automatically presumes that she has romantic intentions by asking, "Jo, are you asking me out on a date?" — a remark that he repeats and she denies three times. Aaron Sorkin, *A Few Good Men*, original screenplay, New York, 62. Danny's insistence that Jo is asking him out on a date reinforces his inability to conceive of her solely as his colleague.

14. In *Imperial Leather: Race, Gender, and Sexuality in the Colonial Contest*, critic and scholar Anne McClintock states that abjection "means to expel, to cast out or away." McClintock refers to Julia Kristeva's theory of abjection which states that "in order to become social the self has to expunge certain elements that society deems impure: excrement, menstrual blood, urine, semen, tears, vomit, food, masturbation, incest, and, so on" (McClintock 71).

15. Accordingly, "the expelled abject haunts the subject as its inner constitutive boundary; that which is repudiated forms the self's internal limit" (McClintock 71).

16. While in his closet, Danny notices his clothes hanging neatly and he recalls a similar sight in Santiago's closet after he had died. Consequently, Danny realizes that, if Santiago had received his requested order to be transferred permanently off the Marine base, as Jessep claimed, he would not have left all of his worldly possessions in his closet.

17. Here, I deliberately use a masculine metaphor to emphasize the film's consistent malecentric focus.

18. According to Clara Bingham in "Code of Dishonor," young women who were former cadets at the U.S. Air Force Academy in Colorado recently have come forward

with allegations that they were raped and sexually assaulted by fellow class members. Their testimonies further reveal the existence of a code of silence surrounding such incidents that contributes to an overall climate that routinely denigrates and belittles women, belying the fact that male cadets, and some superior officers, have only begrudgingly resigned themselves to the presence of women and long for the good ol' days when only men walked the hallowed halls of prestigious military academies. Clara Bingham, "Code of Dishonor," *Vanity Fair* December 2003.

Works Cited

Bingham, Clara. "Code of Dishonor." *Vanity Fair*. December 2003: 164–94.

Howe, Desson. Rev. of *A Few Good Men*, dir. by Rob Reiner. *The Washington Post* 11 Dec. 1992. 14 Oct. 2004: http://www.rottentomatoes.com/click/movie1041907/reviews.php?critic=columns&sortby=default&page=1&rid=29019.

Kempley, Rita. Rev. of *A Few Good Men*, dir. by Rob Reiner. *The Washington Post* 11 Dec. 1992. 14 Oct. 2004: http://www.rottentomatoes.com/click/movie1041907/reviews.php?critic=columns&sortby=default&page=1&rid=29020.

McClintock, Anne. *Imperial Leather: Race, Gender, and Sexuality in the Colonial Contest*. New York: Routledge, 1995.

"The Navy Blues." *WGBH/Frontline*. October 1996. 31 Jan. 2004: http://www.pbs.org/wgbh/pages/frontline/shows/navy/tailhook/91.html.

Sorkin, Aaron, writer. *A Few Good Men*. Dir. by Rob Reiner. Original screenplay. New York: June 1991.

Giving Propaganda a Good Name: *The West Wing*

Ann C. Hall

The West Wing's popularity is undisputed. It won nine Emmys for its first season, and it has continued to receive acclaim and awards. And no matter what can be said of the show's politics, the writing is the best available on prime time television.[1] With Aaron Sorkin's recent departure from the writing team, it remains to be seen if the series can sustain its generally outstanding quality of storytelling and exquisite banter. Be that as it may, even the most glowing reviews and readings of *The West Wing* under Sorkin's tutelage faulted him for creating an idealized president, White House, and staff. As quoted by Myron Levine, Caryn James of *The New York Times* is the most outspoken critic of the series' idealism, arguing "that *The West Wing* suffers from 'a split personality'; the show's realism and sardonic insights are undercut by the 'mawkishness,' 'emotional mushiness,' and 'inspirational uplift' of scenes designed for a viewing audience" (43). There is no doubt that the Sorkin White House is not only a liberal's dream come true but a concerned citizen's utopia, as well. Each episode contains intelligent people who are not only committed to making the world better but who also struggle through the complexities of political problems and issues without killing one another, an important goal in any postmodern workplace, let alone politics. Truly, such behavior does not exist in reality, but when viewers fault the series and Sorkin's writing for its idealism, they neglect to consider the fact that the television show is fiction and the fact that it is a sterling piece of postmodern propaganda.[2] It presents a fairly, though not entirely, consistent liberal agenda, but more importantly, *The West Wing's* agenda, its propaganda, illustrates that the United States government is open to all, sexy, smart, and fun — it is *the* place to be. As Donnalyn Pompper concludes,

"These fictional Oval Office inhabitants consider public service a worthy, noble pursuit, and they work there because they hope to do good, not because of personal ambition" (22). By viewing the show as a piece of postmodern propaganda, the faults regarding the idealized presentation of the president, the White House, the staff, and politics in general may be seen as serving specific rhetorical ends rather than representations of Sorkin's poor writing or Sorkin's capitulation to the requirements of prime time television. Specifically, unlike films such as *All the President's Men* or *Wall Street*, *The West Wing* attempts to correct social problems and political errors through its positive representation of government and politicians, *a via positiva*, rather than muckraking, *a via negativa*.

Invoking the term "propaganda" in the post–world war and post–cold war United States is admittedly a risky activity. For the most part, propaganda was given a bad name by the modern totalitarian governments of Germany and the Soviet Union. In both cases, media, from print to film, were controlled by the respective governments, with little else available to their target audiences. In a BBC documentary *Propaganda,* we are shown the films that the Germans used to incite and foster anti–Semitism, films that clearly linked Jews to rats, for example. In her important work *The Origins of Totalitarianism,* Hanna Arendt also notes the propaganda of the Soviets who, in one instance, claimed that they had no poverty because they had just abolished the government office of unemployment. What the Soviets failed to mention was that there were still unemployed; now, they no longer had access to benefits, since the office had been obliterated (341). Through these and further examples from the Nazis, Arendt presents the processes of totalitarian regimes, how they come to power, and how they manipulate people and truth. Propaganda, of course, is an essential element to the process. In one instance, she notes that mysterious threats were important to the perpetuation of political oppression in Russia: "Since the middle thirties, one mysterious world conspiracy has followed another in Bolshevik propaganda, starting with a plot of Trotskyites, followed by the rule of 300 families, to the sinister imperialist (i.e. global) machinations of the British or American Secret Services" (351). She concludes:

> The effectiveness of this kind of propaganda demonstrates one of the chief characteristics of modern masses. They do not believe in anything visible, but only their imaginations, which may be caught by anything that is at once universal and consistent in itself. What convinces the masses are not facts, and not even invented facts, but only the consistency of the system of which they are presumably a part [351].

At this point, it is tempting to think of the current Iraq war and the failure of the United States government to produce the weapons of mass destruction that were supposedly the cause of the war in the first place. Tempting as this may be from a liberal viewpoint, the current administration's use of the media is very different from a totalitarian regime's use, despite some similarities. First, according to Arendt, totalitarian governments use terror to reinforce their propaganda techniques (344). Second:

> The fundamental reason for the superiority of totalitarian propaganda over the propaganda of other parties and movements is that its content, for the members of the movement at any rate, is no longer an objective issue about which people have opinions, but has become as real and untouchable an element in their lives as the rules of arithmetic. The organization of the entire texture of life according to an ideology can be fully carried out under a totalitarian regime [363].

Here, totalitarian propaganda seeks to market itself as the only source of fact and truth in the country and the world. It seeks to obliterate the truth and the individual by serving as a means, not of persuasion, but of oppression.

For many in the United States in particular, this totalitarian method of propaganda is what we think of when we hear the term "propaganda" in any context. As Oliver Thompson, however, demonstrates in his impressive *Easily Led: A History of Propaganda*, it is very difficult to differentiate between the propaganda of the enemy and the propaganda of the ally. As a matter of fact, the term's use seems to be determined by what side one decides to take. As Nicholas Reeves notes, one person's "truth" is all too often another's "propaganda" (11). The origin of the term is Catholic. In response to the rise of Protestantism, Pope Gregory XV "established the Sacred Congregation for the Propagation of the Faith *(de Propaganda Fide)*, a body with a missionary role" (Gorman and McLean 77) during the Reformation.

Thompson notes a number of misconceptions about propaganda, and concludes: "propaganda is sometimes accidental; truthful; may not lead to social unrest; is aligned with education; and is very much part of '"pure art.'" His defense of this last assumption is particularly important when discussing Sorkin:

> Nearly all the great creative talents in every era have devoted at least some of their output to political, religious, or moral propaganda, have received appropriate patronage or commercial success and the work, no whit artistically inferior to the rest of their output, has achieve permanent respectability because the propaganda content is not really noticed by later audiences [4–5].

Propaganda, then, is not a lower art form. Like many of his British counterparts, however, Thompson concludes his remarks with a very broad definition of propaganda, one that unfortunately is so broad that it is indistinguishable from any rhetorical situation.[3] He says propaganda is "the use of communication skills of all kinds to achieve attitudinal or behavioral changes among one group of people by another" (5).

A more specific definition of propaganda, and one that does not link it solely to the work of totalitarian governments, comes from a well-researched and enlightening pamphlet by Nancy Snow which illustrates the insidious and effective marketing of American values and corporations through the United States' own propaganda office, an office that many Americans do not know about even today, the United States Information Agency. In *Propaganda, Inc.: Selling America's Culture to the World*, Snow defines propaganda by the following characteristics:

> 1) it is intentional communication, designed to change the attitudes of the targeted audience; 2) it is advantageous to the persuader in order to further the persuader's cause vis-à-vis an audience (which explains why advertising, public relations, and political campaigns are forms of propaganda); and 3) it is usually one-way information (i.e., a mass media campaign) as opposed to education which is two-way and interactive [40].

Given this definition and criteria, we may be able to see *The West Wing*'s weaknesses in a more positive light. That is, it is not naïve or idealized, but, rather, a successful piece of postmodern propaganda whose goal is to create greater faith in the American political processes.

One of the reasons *The West Wing* succeeds is that the series appears to offer an "insider's look" at the White House. We, as viewers, appear to have a privileged position. We are "special," and we are "allowed in." Sorkin even brought together a diverse and elite corps of political consultants to help him create not only the script but this fictional intimacy. Political celebrities such as Clinton's former press secretary, Dee Dee Myers, former Regan and Bush press secretary Marlin Fitzwater, and Regan speechwriter Peggy Noonan contributed to the series' Washington-insider atmosphere (Challen 20). Admittedly, this strategy laid the series open to the kind of criticism it received regarding the validity of its representation, but at the same time, the strategy worked at attracting audiences and critical acclaim in much the same way the totalitarian governments of the modern age used film to entice its viewers.

The Nazis, perhaps the most prolific producers of propaganda, recognized the efficacy of film for their political agendas. The reason, of course,

is that film offers a level of verisimilitude otherwise unseen at the time, and there are numerous examples of audiences confusing fiction and reality during the viewing of such films (*Propaganda*). Television is equally effective, as noted by Marshall McLuhan in television's infancy: "Television demands participation and involvement in depth of the whole being. It will not work as a background. It engages you" (125). Recent series such as *The West Wing* and *Law and Order* and the expanding number of "reality-based television shows" blur the distinction between reality and fiction even further. Ray Bradbury's *Fahrenheit 451*, which presents reality television as a kind of opiate for the masses, cannot fail to come to mind. Such blurring further emphasizes modern television's attempts to catch viewers and make them feel as if they are viewing "truth," from the inside of the White House to the inside of a frat house. Whether this blurring makes the propaganda more effective is subject to debate, but one conclusion is certain: by presenting material in this way, the method of media production, the strategies which make it clear to audiences that the images are, in fact, constructed and created by numerous artists, writers, performers, technicians, etc., over numerous days, is erased. The images appear seamless, "real," and effortless, interwoven, to borrow from a television advertisement, into the "fabric of our lives." Such seamlessness not only meets Snow's criteria regarding the one-way communication necessary for propaganda, but it also reflects the consistency Arendt deemed necessary to totalitarian propaganda as well. By presenting an "insider's" view of the White House, the series and Sorkin are firmly entrenched in the tradition of propaganda.

 The West Wing's political agenda is also clearly delineated. The Bartlet White House is Democratic, and at its head is the idealized president who not only holds a Nobel Prize in Economics but also follows Notre Dame football. He is not constantly campaigning, and he clearly a man of vision and conscience. He was so popular, in fact, and the series was so effective at blurring the lines between fiction and reality that bumper stickers with "Bartlet for President" appeared during the 2000 election (Hayton 74). This fact, of course, cautions us about the efficacy of propaganda. Though Gore won the popular vote, Bush ended up in the White House. Be that as it may, Sorkin had a challenge in creating this presidential character. Beyond the immediate and nostalgic connections his liberal, Catholic president had to John F. Kennedy, he needed to sustain sympathy for a liberal intellectual on prime time television.

 One of the most noticeable means to this end was casting Martin Sheen in the role of the president. Sheen, of course, was a popular film actor before taking on this role, and moving from film to television is always a risky business, generally indicating a "step down" for the performer. Not so, of course,

for Sheen. Not only is he a talented and popular performer, but Sorkin's script worked almost weekly to expand our understanding and our empathy for this president. In the first episode, for example, rather than idealizing the president, Sorkin goes out of his way to make not only the president but his entire staff exhibit their vulnerabilities, humor, and flaws. Admittedly, Sheen does not have the Clinton-vice, but he and his White House staff have their share of problems, both personal and political. During the pilot episode, for example, the president of the United States is characterized by alternating references to his weakness and power. Referred to by the unflattering acronym POTUS (President of the United States), the president has wrecked a borrowed bicycle into a tree. There is news footage, jokes, and the promise of further embarrassment when he finally returns to the White House.

Creating an offstage character through the comments of the onstage characters is a common theatrical trick: we learn, for example, of Othello's power through the grumblings of Iago. The difference here is that Sorkin is creating a vision of the president as vulnerable, more like Chevy Chase's Gerald Ford than the idealized John F. Kennedy. At the same time, however, we learn that Josh Lyman, the president's deputy chief of staff, has insulted certain leaders from the religious right regarding their closed-mindedness. Everyone is convinced that Josh will be fired by the president, who they believe will do anything to make peace between his liberal administration and the radical right, which wields tremendous political power. When the president finally appears, it is his voice we hear first. He enters the room shouting: "I am the Lord your God, You shall not place false gods before me." This dramatic opening interrupts a volatile White House discussion between the staff and the religious right representative. "Ah, those were the days," concludes Bartlet. By the end of the scene, however, it is clear that those days may be over for God, but they are not for POTUS. Bartlet explains that he has driven the bike into a tree because he had just received word that his granddaughter had received a threat from a radical Christian group because of her pro-choice comments in a teen magazine. The fundamentalists are not only chastised, but they are escorted out.

The scene clearly depicts the power of the presidency, but it does so in such a way that we are predisposed to like the president, and this sentiment is what affords Sorkin the opportunity to voice extremely liberal views, abortion and criticism of the religious right, without damaging the series or the character of the president. All of us understand the embarrassment of falling, particularly when one holds a significant place in a social community. The fall, then, ironically protects the president from viewer judgment. Sorkin further protects the Bartlet character by having him defend his family, again ironically from the attacks of a group which says it is dedicated to protecting

family values. You may disagree with the political views, but it is difficult to fault a grandfather for protecting his grandchild.

Staff members are protected in similar fashions. While the members of the White House are hardworking, articulate, and funny, they are also extremely intelligent and credentialed from some of the nation's top universities. And given the nation's growing intolerance for intellectuals, Sorkin has his work cut out for him when he has characters discussing history, philosophy, medicine, geography, culture, and, surprisingly on prime time television, books. Names such as Immanuel Kant, Plato, Socrates, Thomas Aquinas, St. Augustine and others frequently appear on the series. And while it is refreshing for academic audiences to see the liberal arts put to good use, Sorkin risks being attacked as a liberal elitist. Rather than waiting for the attack, however, the Sorkin scripts make frequent references to the intellectual abilities of the staff and defends against them in interesting and even slapstick ways.

C.J. Cregg, the White House press secretary, for example, falls off a workout machine in the first episode, suffers through the president's endless discussion of fjords during another, survives an emergency root canal, and performs a rap song when the administration's Supreme Court Justice nominee is confirmed — and this is just in the first season. Toby Ziegler, the White House communications director, is permanently morose, knocks down a bunch of folding chairs during a Sabbath service, and when he is actually happy after the Supreme Court justice confirmation, other characters are frightened of him. Josh Lyman, perhaps more than any other character in the series, is the most prone to mistakes, from meeting a deaf, female campaign manager he thought was a man in bright, yellow waders to hugging Leo McGarry. Even Leo, the White House chief of staff, is a reformed alcoholic and drug addict who frequently misjudges a situation and becomes hypervigilant about White House communications. In one of the president's more fatherly moments, Bartlet tells his staff, who happen to be assembled in his bedroom, that they will all make mistakes. Such vulnerability is effective; it makes the representation of the most powerful people in the world human, once again, drawing us in and presenting political views in a protected rhetorical environment. Again, Sorkin masterfully manipulates our impressions of his characters and their views.

In addition to the staff's humanity, Sorkin underscores the strong work ethic that keeps this White House moving, a work ethic that ultimately helps create the "ambience and style of the Clinton White House (1993–2001), not the more structured, hierarchical, and businesslike, manner of the Nixon, Reagan, and Bush presidencies" (Levine 55). During an episode ironically entitled "Take This Sabbath Day," all the major characters attempt to leave

for a day of rest. All dutifully return to work, with the exception of Josh, who decides to attend a bachelor party, even after his assistant Donna has warned him that he cannot and should not drink. The next morning, all the other hardworking West Wingers are fine and in good form. Josh, however, smells like he has fallen into a trash dumpster, embarrasses himself in front of a democratic colleague who has traveled from California to Washington to see him, and is too hung-over to think clearly. In a manner worthy of any medieval morality play, Josh is punished and humiliated, while the hard workers, such as Sam Seaborn, are presented as dignified and noble. This is not to imply that Sam is rewarded entirely. He has been working to save a man from a death sentence, but the president refuses to commute his sentence. In the end, the criminal is executed, and Seaborn loses his case. At the same time, however, Seaborn's work has been dignified and the episode implies that while he may not have won the battle, he was doing the Lord's work on this Sabbath day.

The episode also sacrifices the liberal popularity of the president in order to underscore the criminal nature of the death penalty. Not only does the president refuse to commute the sentence, but he has taken rather ignoble steps to avoid even facing the issue. In the end, he calls in a childhood friend and priest, brilliantly played by Karl Malden, who asks, "did you pray?" The president says, "I prayed for wisdom, and it didn't come. And frankly I'm a little pissed off about that." The priest then tells the president a story about a man who prayed to be saved from a flood, but he denied help from passersby in boats and helicopters, saying, "I'm religious. I pray. God loves me. God will save me." The man, of course, drowns, and God says, "I sent you a radio report, a helicopter, and a guy in a rowboat. What the hell are you doing here?" The priest then reminds Bartlet that through the work of others, through the work of people like Sam Seaborn and Toby Ziegler, he was told to commute this sentence, but he ignored the signs. Stunned, Bartlet realizes that he has made a mistake. By taking the easy political route, he has made a terrible moral and ethical mistake. The scene ends with Bartlet humbled, making his confession to his childhood priest.

In addition to the strong writing by Sorkin and his staff, writing that is rare in film and nearly impossible to find on television, the series bolsters many of the scripts' themes through technical means, camera placement, and lighting. The lighting in the West Wing is particularly important. We rarely see White House staffers out in broad daylight, but rather than suggesting that the group has something to hide, the series transforms the oval office and its support structures into a temple, the inner sanctum. Pools of bright light appear amidst low-level lighting. And there are times that characters appear in these pools of life to be given a divine-like quality. At other

times, characters miss the mark, and they are filmed in half light. While I do not wish to overstate this point because the series certainly does not, it is as if we are witnessing a modern television version of Plato's cave, with the White House being a transitional stopgap between the world of light and truth and the cave where the uninitiated await enlightenment.

The "steadicam," a variation on the hand-held camera technique popularized by the television series *Homicide: Life on the Streets,* as well as numerous films such as Woody Allen's brilliant *Manhattan Murder Mystery,* is used for several purposes. First, by creating a "steady" rather than the shaky effect of the hand-held camera, this technique assures audience members are in good hands; we are figuratively and literally secure (Finn 121). Second, the steadicam highlights the work ethic of the staff. As Myron Levine illustrates:

> Perhaps *The West Wing*'s most famous formal aspect is its use of the "walk-and-talk" (also known as a "peda-conference"). In this hypertextual dance, individuals walk through the halls of the West Wing, sometimes three and four abreast, briskly speaking about crucial issues in domestic and foreign policy, sprinkling their conversations with essential narrative elements and office gossip.... These characters are witty, attractive, and hyperintelligent. Moreover, they have purpose; they believe strongly in *something*. This all-pervasive belief helps address the tension the show builds around technology and policies. As such, it is central to what makes the show appealing [115].

This attention to technical detail, as well as the strong writing, writing which makes use of what playwrights call "the overlap," two people talking at the same time, does not confuse audiences, it reinforces the idea that the staff work hard and the government is secure. Only recently has the show, with Sorkin no longer writing, left someone behind in the hallway. In the case of the first two episodes of the 2003–04 season, a young Ivy League assistant is more concerned about his weekend plans than his duties to the White House, which happen to be secretarial at the time. And as all West Wing aficionados know, there is no job too small at the White House, so this young man is punished for his lack of commitment by walking into a wall he does not see as he trails behind two other staff members.

This is an important difference because one of *The West Wing*'s most important pieces of propaganda has everything and nothing to do with politics. Sorkin's White House is one not only filled with people who are committed to a common goal, the betterment of the nation and the world, but they are able to work together despite the stresses, difficulties, and blunders, an art form sadly lacking in many American workplaces. In a world in which

singles compete against one another for the prize bride or groom, in which talk shows are frequently graced with physical violence, and in which co-workers frequently sue rather than talk to one another, the people in *The West Wing* collaborate with one another amicably. Ironically, this collaborative presentation has brought the most criticism from the press, perhaps best articulated by Myron Levine:

> *The West Wing* also overstates the degree of camaraderie that characterizes White House staff relationships. Despite a shared sense of mission and loyalty to the president, there are conflicts among White House staffers that result from personal ambition, competition, and conflicting policy perspectives [45].

Truly politics is a messy business, as is any other group organization in which hierarchies, power-plays, and results are present — in other words, every community of workers. What *The West Wing* offers us is a model for group interaction that includes conflicting desires on the part of the characters but does not result in dysfunctional working relationships. In a brief encounter between C.J. Cregg and Josh Lyman in the episode "A Proportional Response," for example, Josh disagrees with C.J.'s handling of a situation which involves Sam Seaborn's affair with a prostitute. Josh thinks it is a private matter, and C.J., by virtue of her job, must consider it politically and publicly:

> JOSH: You're overreacting.
> C.J.: Am I?
> JOSH: Yes.
> C.J.: As women are prone to do?
> JOSH: That's not what I meant.
> C.J.: Yes, it is.
> JOSH: No, it isn't.
> C.J.: It's always what you mean.
> JOSH: You know what C.J., I really think I'm the best judge of what I mean, you paranoid Berkeley shiksa feminista. [beat] Whoa, that was *way* too far.
> C.J.: No, no. [beat] Well, I've got a staff meeting to go to and so do you, you elitist Harvard fascist missed-the-dean's-list-two-semesters-in-a-row Yankee jackass.
> JOSH: Feeling better getting that off your chest there, C.J.
> C.J.: I'm a whole new woman [85].

Clearly, if this were a documentary on sexual harassment, Josh would not have apologized, and C.J. would have gone to court, but here, the two of

them, committed to a common goal and respectful of one another's talents, can have their differences, vent them, and move on. Both characters are able to take it and dish it out. Sorkin here and elsewhere seems to be saying to all — lighten up; we can get more done that way.

While *The West Wing* clearly presents an idealized view of the White House, it is not a fault. It is part of its agenda as propaganda. It offers propaganda for liberal democrats; it offers propaganda for government in general; and it offers propaganda for collegial working environments. It is successful, particularly the first season, for presenting that propaganda in subtle and effective ways. How successful is propaganda ultimately? According to Arendt, totalitarian regimes and their propaganda contain the seeds for their own destruction, and so they are ultimately ineffective. Nicholas Reeves concludes his study on film propaganda during the world wars similarly. Oliver Thompson, however, concludes his exhaustive study by saying that "Man ... has been manipulated by his fellows from the beginning of time and has in turn often been manipulative. We do not mind being manipulated. We often benefit from it, but equally there have been numerous occasions when we have been quite easily led into the most preposterously dangerous behavior" (331). In terms of *The West Wing*, it is very difficult to prove whether or not the series had any effect on the voting population. According to Heather Richardson Hayton, the appearance of Bartlet only made the other candidates look worse by comparison (78–79). What is clear is that by examining Sorkin's scripts we begin to understand how his means of propaganda works, an important skill for all modern citizens, and it is clear that *The West Wing* presents government processes in particular and people working together in general in a positive light, perhaps also offering a hopeful call to us all to become more involved with one another and less concerned with the battles brewing on remote desert islands among middle-class survivalists.

Notes

1. For a quick overview of the critical reaction to *West Wing*, see chapter three of Paul Challen's *Inside* The West Wing.

2. Nowhere is this better illustrated than in the second season's opener, a response to the events of September 11, the episode "Issac and Ishmael." The writing was well-intentioned, but weak, embarrassing even; the series could not respond to a real-life crisis in the manner that it could respond to fictional attacks.

3. Compare, for example, the BBC documentary *Propaganda*, which presents the campaigns of Tony Blair and the Nazis in a similar light, and Nicholas Reeves' and Hilmar Hoffmann's works, which present the term as a solely Nazi phenomenon.

Works Cited

Arendt, Hannah. *The Origins of Totalitarianism.* 2nd. Ed. New York: Harcourt Brace, 1973.

Challen, Paul. *Inside* The West Wing: *An Unauthorized Look at Television's Smartest Show.* Toronto: ECW Press, 2001.

Finn, Patrick. "*The West Wing's* Textual President: American Constitutional Stability and the New Public Intellectual in the Age of Information." The West Wing: *The American Presidency as Television Drama.* Eds. Peter C. Rollins and John E. O'Connor. Syracuse: Syracuse UP, 2003: 101–124.

Gorman, Lynn, and David McLean. *Media and Society in the Twentieth Century.* Malden, Mass.: Blackwell, 2003.

Hayton, Heather Richardson. "The King's Two Bodies: Identity and Office in Sorkin's *West Wing.*" The West Wing: *The American Presidency as Television Drama.* Eds. Peter C. Rollins and John E. O'Connor. Syracuse: Syracuse UP, 2003: 63–81.

Hoffmann, Hilmar. *The Triumph of Propaganda: Film and National Socialism, 1933–1945.* Providence: Berghan Books, 1996.

Levine, Myron A. "*The West Wing* (NBC) and the West Wing (D.C.): Myth and Reality in Television's Portrayal of the White House." The West Wing: *The American Presidency as Television Drama.* Eds. Peter C. Rollins and John E. O'Connor. Syracuse: Syracuse UP, 2003: 42–62.

McLuhan, Marshall, and Quentin Fiore. *The Medium is the Massage.* New York: Bantam, 1967.

Pompper, Donnalyn. "*The West Wing*: White House Narratives That Journalism Cannot Tell." The West Wing: *The American Presidency as Television Drama.* Eds. Peter C. Rollins and John E. O'Connor. Syracuse: Syracuse UP, 2003: 17–31.

Reeves, Nicholas. *The Power of Film Propaganda: Myth or Reality.* New York: Cassell, 1999.

Snow, Nancy. *Propaganda, Inc.: Selling America's Culture to the World.* New York: Seven Stories Press, 2002.

Sorkin, Aaron. "Pilot." The West Wing *Script Book: Six Teleplays by Aaron Sorkin.* New York: New Market Press, 2002: 9–76.

Sorkin, Aaron. "A Proportional Response." The West Wing *Script Book: Six Teleplays by Aaron Sorkin.* New York: New Market Press, 2002: 77–150.

Thompson, Oliver. *Easily Led: A History of Propaganda.* Phoenix Mill, U.K.: Sutton, 1999.

Handling the Truth: Sorkin's Liberal Vision

Spencer Downing

Aaron Sorkin's scripts are seldom what they purport to be on the surface. *A Few Good Men* is hardly the tale of a murder on a military base. *The American President* says much more about the nature of political dealmaking than about how a president might fall in love. *Sports Night* may have been witty, but it had less to do with sports or comedy than about the nature of American business. Even *The West Wing*, the vehicle that comes closest to its billing, is as much about the principles behind the policies as it is about the nuts and bolts of everyday life in the White House. Sorkin has little interest in telling stories for their own sake. Instead, his narratives serve other purposes, and often as not those purposes are political. Sorkin wants to engage American's civic sensibilities, and takes an active role in the struggle for the nation's political center. He believes that conservatives have moved mainstream discourse too far rightward, and he wants to pull it back.

When asked directly, Sorkin contends that his work has no specific political bias. "I don't think that television shows or, for that matter, movies or plays or paintings or songs can be liberal or conservative. I think that they can only be good or bad," he told one interviewer (Sorkin 2000). Insofar as he does not advocate a coherent policy approach, his claim is persuasive. Yet, his political allegiances and goals cannot be denied. Sorkin strives to reinscribe liberalism into the political mainstream by encouraging audiences to see liberal values as plausible, pragmatic, and patriotic. Above all, he asserts that liberal principles still hold currency. He has some personal stake in the project. His introduction to political wrangling came when he was eleven years old, when an angry woman wrenched a McGovern campaign sign out of his hands and hit him with it (Waxman 206). Perhaps that experience guides his rhetorical style. Given a fair hearing in an open market-

place of ideas, his work suggests, liberalism will win back its place in the American public's hearts and minds.

Sorkin is more than just a liberal who writes drama. Instead, he uses drama to advance a distinctly liberal understanding of the world. This essay concentrates on a few of Sorkin's works —*A Few Good Men, The American President,* and *The West Wing* (a play, a film, and a television series)— to examine the liberal impulse that runs throughout his writing. The concern here is not to prove Sorkin's liberal credentials, but rather to understand the rationales he puts forward and the tactics he employs in making his case. As we shall see, he infuses his dramas with moral quandaries (particularly political ones), emphasizes the difficulties attendant to exercising power, and exhibits a fascination with minutiae and trivia. These are not merely writerly quirks, however. They are rhetorical strategies Sorkin employs to further the fundamental cause of proving to audiences that it is in fact liberals who can handle the truth.

Sorkin sees liberalism as traditionally American. He hearkens back to consensus politics such as that described by historian Arthur Schlesinger, Jr., who in 1949 argued that the mainspring of American politics was rooted in a "vital center." The nation's genius, he believed, rested upon its rejection of ideologies from either end of the political spectrum. Americans had fought fascism in World War II and, as the Cold War chilled, were able to resist the lures of communist ideology. They held fast to a political faith based on "an unconditional rejection of totalitarianism and a reassertion of the ultimate integrity of the individual" (Schlesinger xxiii). Schlesinger was responding most directly to attacks on centrist liberalism from the left. He wanted to temper the attractions of Communism and Socialism by reminding readers that Americans could look to their own history for an indigenous, and more pragmatic, progressive idealism. He claimed that American liberalism possessed an inherent dynamism that transcended easy, empty ideologies. Whereas ideologically driven politics require utopian notions, liberals have the courage to face up to the world's complexity. Liberals understood that humanity is imperfect and that progress does not come without difficult choices involving the sometimes-painful exercise of power. Liberalism, he maintained, stands for "responsibility and for achievement, not for frustration and sentimentalism; it has been the instrument of social change, not of private neurosis" (Schlesinger xxi).

When Schlesinger wrote *The Vital Center* he could safely assume that readers recognized liberal principles stood at the core of American thought. More recently, that core has been called into question. Factors such as the implosion of international Socialism and the vibrancy of Reagan-style conservatism presumably have made the notion of the vital center irrelevant.

Even Bill Clinton, the great liberal hope, presided over the erosion of such quintessential liberal inventions as the welfare state. How then, one might ask, can Sorkin expect a liberal vision to resonate with a popular audience? A closer look at the nation's political history suggests that his invocation of the vital center is not a cry in vain.

In 1992, just before Bill Clinton unseated the first President Bush, historian Alonzo L. Hamby published a revision of his six-year-old analysis of American presidential history, *Liberalism and Its Challengers*. The book attempted to make sense of a seeming incongruity. On the one hand, liberalism appeared to be out of fashion, out of step, and almost out for the count as the nation's political compass took a decidedly rightward swing. Ronald Reagan had come out swinging against one of liberalism's fundamental assumptions — that government agencies could effect positive change. His first inaugural proclaimed, "In this present crisis, government is not the solution to our problem; government is the problem" (Reagan).[1] George H. W. Bush and his managers pushed even further in the 1988 campaign. They maneuvered public opinion against Michael Dukakis so as to make "liberal" into a word almost as damning as "communist" had been. When Hamby set about revising his manuscript, liberals seemed to be an endangered species.

Yet as the historian placed the *fin de siècle* political climate in a larger context, he found that liberals, instead of being pummeled on the ropes, had already won. Hamby asserted that the country was following a trajectory first set in Franklin Roosevelt's administration. Despite partisan vitriol, "liberalism in the larger twentieth-century sense of reverence for individual rights, an acceptance of majority rule, a basic welfare state, and a commitment to American international involvement remained the basic American ideology" (Hamby 395). Even as they excoriated their liberal opponents, most conservatives did not reject such New Deal programs as Social Security or regulatory agencies such as the Securities and Exchange Commission, much less the Enlightenment thinking that had spawned liberalism. "They were unhappy with a contemporary variant of the [liberal] tradition that seemed to promote license rather than liberty and was increasingly seen as the creed of a privileged elite that had little interest in the problems of ordinary people," Hamby noted, but they had little problem with Roosevelt (Hamby 391). He maintained that the vital center still held, and would for the foreseeable future.

How then should one understand the growing disparagement of liberals? Was Hamby's analysis simply wrong? Not necessarily. By his lights, the nation agrees on fundamental principles. It is, however, in stalemate between what might be called the Roosevelt and Johnson wings of American liberalism. The sides divide on such issues as the extent to which government

should be active in American life, proper legal protection for minorities, or the nation's proper role in world affairs. Vehement exchanges between them signal not that the nation has rejected its vital center, but how evenly matched they are. That the term "liberal" has been tagged with pusillanimous anti–Americanism, therefore, is not a result of conservative triumph, but a rhetorical product of a frustrating deadlock. In truth, argues Hamby, neither side can claim complete victory.

Sorkin's place in the dispute is clear. His work invokes the ideals of Roosevelt, but its thrust is unmistakably Johnsonian. He believes that government institutions hold a responsibility to take an active part in American life. Where conservatives have faith that a laissez faire approach allows for the most effective solutions to social problems, Sorkin assumes that the American credo demands action. He holds governmental institutions are best able to act, for only those who wield power can look out for the powerless. As Sorkin sees it, when the government abdicates its responsibility to work on behalf of its citizens, especially its least empowered ones, it does a disservice to the entire nation. Likewise, he believes it is more important to offer a hand up than to agonize over whether it is only a handout. By the same token, he is an internationalist who believes that the United States should exercise its power to foster freedom and democracy abroad.

Sorkin is also idealistic. Unapologetically patriotic, he creates characters that take the Declaration of Independence as a credo and the Constitution as a sacred text. With similar idealism he asserts that the nation could be easily improved if the right people were in charge. Since Roosevelt instituted his "Brain Trust," populist conservatives have been suspicious of intellectual elites guiding government policy. Sorkin, however, maintains that government's institutions would function better if they were led by intelligent people thoughtful enough to understand the tough choices, moral enough to recognize the path of just action, and courageous enough to pursue it. Critic Chris Lehmann summarized the goals of Sorkin's television White House,

> *The West Wing* sets out, week after week, to restore public faith
> in the institutions of our government, to shore up the bulwarks
> of American patriotism, and to supply a vision of executive
> liberalism — at once principled and pragmatic; mandating both
> estimable political vision and serious personal sacrifice; plying an
> understanding of the nation's common good that is heroically heed-
> less of focus groups, opposition research, small-bore compromise,
> and re-election prospects [Lehmann 215].

High ideals permeate Sorkin's work, but his intentions are not Capraesque. He creates fictional societies so close to our own that one is led to

believe that his vision is a realistic possibility — a reality that could be instead of one that ought to be. His world comes laden with ambiguity. In it, even good people must do bad things and people continue to suffer from inequality or injustice, and there are always tensions between necessity and morality, idealism and practicality. Sorkin wants audiences to believe that the primary difference between his imaginary world and our own is simply that in his world people are working to make things better. By the same token, he wants audiences to see that doing the right thing is no easy task. Countering charges that liberals are weak willed and morally indecisive, Sorkin portrays the hard choices demanded by high ideals.

Sorkin's first major piece, *A Few Good Men*, demonstrates the essentially political nature of his writing. The story of a supposedly perfunctory court martial case could be a mystery. Instead, Sorkin makes it an investigation into the nature of ultimate moral responsibility. As he sees it, even if a marine died in the hands of two comrades, the lieutenant colonel who ordered the attack ought to shoulder the most blame. The marines under his command never meant to kill; they acted out of honor and duty and are prepared to take appropriate punishment. Their commander, however, has acted unjustly and misused his power. He had fostered an atmosphere condoning unsanctioned punishment and demanded unorthodox retribution for minor offenses.

A Few Good Men is not a simple morality play, however. Sorkin recognizes the ambiguities of power. He accepts that Guantanamo rests on a fault line between safety and danger and that someone must perform Jessep's duties. Sorkin neither questions whether soldiers like Jessep guard civilian freedoms, nor do his characters dispute the need for a United States military base on Cuba. On the contrary, the climactic courtroom scene rests on Sorkin's appreciation for harsh realities. By rights, this is the young lawyer Daniel Kaffee's moment to shine. He will reveal that that Lieutenant Colonel Nathan Jessep hid his complicity in the marine's death by altering official military documents. But before he can spring his evidence, the impatient colonel challenges whether Kaffee has the right to demand answers from him. "I have neither the time nor the inclination to explain myself to a man who rises and sleeps under the blanket of freedom I provide, and questions the manner in which I provide it." He reminds Kaffee that the world is a dangerous place, and that the men he commands are among the few who keep the danger at bay for the rest. While he and his kind perform the disagreeable tasks that preserve freedom, most Americans live blithely unaware. They have, in his words, "the luxury of the blind." Rebuking the attorney for even suggesting that those sitting comfortably in a Virginia courtroom could fully understand the harsh realities he faces in Guantanamo, Jessep insists, "You can't handle the truth."

Sorkin's most famous line comes from a character that would probably have no use for his creator's work.[2] Yet Sorkin does not want Jessep to be merely a straw man. The audience understands that the colonel's warped sense of duty drove him to make dangerous mistakes, but it also realizes that he is partially right. Most people do not want to acknowledge difficult truths. One might even wonder if he is correct when he tells Kaffee as he is led off to the brig, "All you did here was weaken the country. That's all you did, so you give yourself a pat on the back. You put people in danger."

In truth, Jessep's invective is not a monologue aimed at Kaffee, but a soliloquy addressed to the audience. Those of us who sympathize with two young marines caught up in forces they cannot control; we who are suspicious of military power and its abuses; we who believe that force is unnecessary and that all conflicts can have peaceful resolutions — we are the ones who cannot handle the truth. We might wish to forget our real and constant need to rely upon people who live by a code more important to them than life itself; nevertheless the need remains. Jessep reminds us that our safety depends upon the men and women who must do the terrible tasks that ensure security for the rest of us. He challenges us, demanding that for one moment we take stock of such discomforting realities. He may have done wrong, but what he said is right. The world is not all sweetness and light, and someone must deal with unpleasant truths.

Sorkin's point, of course, is that Kaffee, the audience and the nation can indeed handle the truth. We are all able to understand and accept unpleasant facts even if we do not think about them every day. Sorkin comprehends and appreciates the marine colonel's position, and affirms the need for a strong military capable of making difficult choices and acting upon them. At the same time, he asserts, one can have discipline without cruelty, strength without bullying. Sorkin's faith is not in the men whose sense of duty compels them to forsake their own safety, but in the institutions and principles that give meaning to their duty. Jessep, in contrast, tied his men's sense of honor to himself. He established a fiefdom with neither respect for the individual nor deference to the rule of law. In Jessep's Guantanamo, American values do not apply. That, to Sorkin, is the colonel's worst sin. Entrusted with power, he failed to exercise it with morality and restraint. He followed the easy path of his whims instead of making the difficult choice of doing right. In the end, Jessep is a tragic character, a good officer who succumbed to hubris. When he is led off, the audience realizes that it is a grim necessity. There is no mourning, but neither is there cheering.

Characters such as Nathan Jessep create dramatic conflict, but more importantly, they legitimize Sorkin's deeper political arguments. In contrast to what he perceives as a conservative impulse to stifle debate, he takes pains

to represent oppositional viewpoints. He wants audiences to convince themselves that his ideas are legitimate. By giving ostensibly fair hearing to these views, his conclusions appear to survive balanced contests of ideas. A character like Jessep, who is deeply flawed yet reasonable, buys credibility for Sorkin's point that one can handle the truth while maintaining ideals of fair play and respect for individual rights. He then capitalizes on this awareness of the tough choices that come with authority and responsibility, such as when Daniel Kaffee throws Jessep's words back at him: "You trashed the law. But we understand.... You provide us with a blanket of freedom.... Not Willy Santiago, not Dawson and Downey, not a thousand armies, not the Uniform Code of Military Justice, and not the Constitution of the United States. That's the truth, isn't it Colonel? I can handle it." Kaffee (i.e., Sorkin) sees that brave men bound by duty preserve something precious for the rest of us. Those men lose sight of the truth, however, when they forget that it is the nation, its people and its institutions that give meaning to their duty.

The American President allowed Sorkin to explore more fully characters who exercise real power and to articulate his political ideals more explicitly. Sorkin and director Rob Reiner originally planned the film to be a romantic comedy about a widowed president jumping back into the dating pool, a concept offering richly humorous possibilities. Sorkin's writing, however, toned down the concept's farcical potential in favor of its dramatic, directly political nature. His script is less about the ups and downs of early romance made comical by a White House setting than about a president with a sense of humor struggling over serious choices.

Early in the writing process Sorkin became engrossed in the political stories the White House allowed, and the romance faded to the background. He had written some eighty pages before introducing the love interest, a significant problem considering that most film scripts only run to one hundred twenty pages or so. The script eventually metastasized to over three hundred pages and had to be cut back to a more common movie length (Levesque). Reiner brought the romance to the fore, but the political struggles Sorkin envisioned within his White House remained crucial to the story.

The set-up is classic Sorkin. Romantic and dramatic tensions play out against the backdrop of a contest over legislative options. Sorkin shows President Andrew Shepherd (Michael Douglas) and lobbyist Sydney Ellen Wade (Annette Bening) as plausibly real political animals. As proof, he posits that they care deeply about such policy details as the differences between types of assault rifles and ten-point gaps in emission standards. Although they have little difficulty weathering the storms of gossip stirred up by Shepherd's Republican rival, Senator Bob Rumson (Richard Dreyfuss), over a president

literally sleeping with a lobbyist, the relationship reaches a crisis point when their pet agendas come into conflict. Shepherd will not surrender to conservatives who lambaste his family values, but upon learning that he can trade Wade's environmental bill for easy passage of his crime legislation he quickly cuts the deal. What is important to them and their relationship is furthering their individual agendas. As Shepherd works to obtain passage of a crime bill and Wade struggles to further an environmental bill, the audience watches idealism come into conflict with political pragmatism. In the end, love and liberalism win out. Shepherd concedes the crime bill's weakness and takes the high road by supporting tougher environmental bill.

The American President opened Sorkin to criticism for what San Francisco Chronicle's Edward Guthmann called "a 90's version of liberal wishfulfillment" (Guthmann). Guthmann gave the film four stars, but he recognized that beneath the trappings of plausibility, the film relied on a suspension of disbelief. Still, he maintained, it was a portrayal of government that went beyond Hollywood's usual simplistic formulas. Lloyd Grove at The Washington Post was less sympathetic. Both Guthmann and Grove pointed out that the film called to mind the films of Frank Capra and both rejected the comparison, but for different reasons. Guthmann argued that "'Capraesque' ... with its implications of facile hokum, doesn't do the film justice. 'The American President' is tougher, smarter than that" (Guthmann). Grove saw it differently.

> Capra was an unabashed populist who celebrated and even revered ordinary Americans. Producer-director Rob Reiner and screenwriter Aaron Sorkin appear to believe that the people (at least those of the great unwashed who don't regularly lunch at the Ivy) are, alas, dupes and knaves [Grove].

Grove detailed the film's inaccuracies extending from the seating arrangements at a state dinner (dignitaries never sit at the same table as their consorts) to mislabeled policy initiatives (there is no such thing as a "White House Resolution," as Shepherd calls his bill) to unrealistic lobbying practices. To him, this was representative of Hollywood's endemic insouciance toward the political process in specific and the American people in general.

What Guthmann understood, however, is that the accuracy of such details matters less to Sorkin's fans than their rhetorical function. The script teems with trivia designed to make the president and his policy choices more convincing, but the actual facts are less important than the recognition that this ultra-competent president and his staff care about the small things that inevitably make up real policy. "White House Resolution" may be a fictional category, but Sorkin's fans overlook such flaws in their appreciation of his

ability to present a world ruled by wonks who actually do care about details. By the same token, Sorkin's fictional president sets realistic goals. His administration fights passionately for small changes. President Shepherd does not plan to outlaw guns forever; his environmental bill will not do away with pollution. Still, he expects that, given time and the country's size, these policies will have large results down the road.

Compare Sorkin's version of the American presidency with another romantic comedy set in the White House, Ivan Reitman's 1993 film, *Dave*. This story of an ordinary guy, Dave Kovic (Kevin Kline), accidentally thrown into the presidency has stronger claims to Capra's legacy than *The American President*. In Reitman's film, Kovic cuts red tape, circumvents selfish special interests, and restores faith in national politics by simply being decent and applying common sense. At one point he sits down with an accountant friend and two copies of the federal budget to find $650 million in government waste that could be used to help poor children. *Dave's* point is clear: Washington is run by corrupt politicians who neglect regular Americans as they squabble over pork barrel projects and line their own pockets. Although ostensibly "liberal" in its sympathies for government welfare programs, *Dave's* vision of "the system" mirrors neoconservative critiques. As Ronald Reagan said, government *is* the problem. In like manner, *Dave* imagines that it takes an outsider to return integrity and sound thinking to the halls of power.

In contrast, Aaron Sorkin embraces government and its mechanism. He argues that things are not as simple as *Dave* would have them. The mechanisms of government are complicated and progress must be measured in inches rather than miles; change cannot just come overnight, with the stroke of a pen, or by jotting on scratch paper. Steering clear of a notion dating back at least to Capra's *Mr. Smith Goes to Washington*, Sorkin rejects the idea that simple common sense will triumph over beltway sophistication. He believes that the only ones capable of making change are those who are smart enough to work within the system. One cannot simply have a heart in the right place. For that reason, Sorkin fetishizes intelligence. Although Sorkin's presidents have their hearts in the right place, their capacity to lead derives as much from their intelligence as much as from their morality and strength.

No project exemplified this understanding more than *The West Wing*. The series transformed Aaron Sorkin from a *wunderkind* into an institution. By the same token, Sorkin is inextricably linked to the show. In the four years Sorkin wrote for the show, he took head writing credit for eighty-seven of the eighty-eight episodes. Even when others developed storylines, Sorkin provided crucial dialogue and character development that gave the show its distinct characteristics. When Executive Producer John Wells announced

that Sorkin would no longer write for the series, many predicted its rapid demise.

As with *The American President, The West Wing* posits a White House run by brilliant, impassioned people attempting to do the right thing. Sorkin wants to paint a portrait of a working White House where the everyday concerns drive the drama. However disparate in subject, the show's plots culminate in similar fashion. *The West Wing*'s bread-and-butter is the tough choice. It might be the president's decision not to pardon a murderer, or the White House's position against stronger hate crime legislation, or the choice between a politically expedient Supreme Court nominee and a morally just one. The show is even more successful when it explains the dramatic tensions beneath the seemingly mundane details such as census counting, choices for Supreme Court nominees, and the process for interring veterans in Arlington cemetery. In every situation, whether the drama is writ large or small, Sorkin attempts to demonstrate the costs that come with doing the right thing. The president's choices could, and sometimes do, result in people having to drop out of college, losing their jobs or even dying.

The episode "Guns Not Butter" exemplifies Sorkin's approach. Originally aired January 8, 2003, it was the fourth season's twelfth installment, and is largely unremarkable within the context of the series. It was not made for a ratings "sweeps week," it coincided with no holidays, it received little attention from print critics, and has won no national awards. The show's only unusual feature is a reference to the real-life Heifer International, a non-profit organization that "supplies sustainable resources of livestock and agricultural training to communities in 47 countries around the world" (Heifer International).

The episode follows staff members trying vainly to save a foreign aid bill from dying by only a few votes in the Senate. The bill's importance is primarily symbolic. An early congressional victory would set the tone for President Josiah "Jed" Bartlet's (Martin Sheen) second term. Yet support is crumbling. A poll has found that 68 percent of American voters believe the nation gives too much in foreign aid and 59 percent want cuts in the foreign aid budget. White House staff members scramble to find the necessary votes. Looking for any possible leverage, a frantic Deputy Chief of Staff Josh Lyman (Bradley Whitford) sends aide Donna Moss (Janel Moloney) to contact a wavering senator who has chosen to hide rather than refuse the president's direct appeal for her vote. Moss must crisscross the city, using wit and guile to track her prey. Meanwhile Lyman learns that he could obtain the necessary vote if the president agrees to allocate $150,000 for a study on the health benefits of intercessory prayer.

In the end, Moss corners the senator seconds too late, and no one except

Lyman will countenance using government funds to support religious causes. He futilely attempts to convince Bartlet that the prayer study will go unnoticed in the budget, crying, "One hundred and fifteen thousand is less than Commerce spends on Post-Its." The president shuts him down, but not because he hates or fears religion. Bartlet, a believing Catholic, quips, "In my faith we've known [prayer has] worked for two thousand years. I never knew there was data available." He still rejects the idea on principle. As Communications Director Toby Ziegler (Richard Schiff) explains, "Threats to civil liberties only come a few dollars at a time." Bartlet will not throw out his commitment to timeless civil liberties simply to further his temporary agenda. Although Bartlet concedes that the bill's defeat is "a tough beat," he remains secure in the decision that he was right to take the moral high road. The best leaders, Sorkin asserts, are the ones who do not make their decisions based on skewed polling data or short-term gains.

Sorkin uses the story of the foreign aid bill to accomplish several tasks. First, he asserts the United States' duty to act beneficently in the world. He wants to know why real live Democrats do not remind voters of their ties to the liberal center. The episode opens with Bartlet appealing to the Senate's sense of mission, declaring that foreign aid deserves support because it is good policy:

> We live in an interdependent world and we should act like it. We
> live in a global community and we should sustain it. We should
> cross borders. We should cross borders and build sustainable
> democracies that can banish privation and fear. And we should
> cross borders to bring food and medicine and roads and schools
> and teachers to parts of the world forgotten by all but the warlords.
> We're going to pass the Foreign Ops bill. This should be a century
> of hope and prosperity everywhere. And America's going to lead the
> world and not just bully it.

Press Secretary C. J. Cregg (Allison Janney) adds factual support, pointing out that the United States allocates the lowest percentage of its Gross Domestic Product to foreign aid of any country in the world. Sorkin seals the argument with a speech that could have come from Arthur Schlesinger Jr. He shows Cregg and *Washington Post* reporter Danny Concannon (Timothy Busfield) watching the vote tally on C-SPAN. Concannon gives a post-game analysis of the failed effort:

> You can't make this about charity. It's about self-interest. We cut
> farm assistance in Colombia. Every single crop we developed was
> replaced with cocaine. We cut aid for primary education in north-
> west Pakistan and Egypt. The kids went to madrassahs. Why weren't

you making a case that Republican senators are bad on drugs and
bad on national security? Why are Democrats always so bumfuzzled?

Cregg responds that it is only one vote, that the White House and the party
are not "bumfuzzled" and that he should shut up. Still, the questions remain.

At the episode's end Jed Bartlet gives another speech. His staff has
arranged for him to be photographed with a goat on behalf of Heifer Inter-
national. The original bargain had been for a photograph with a cow, and
Cregg wonders if a picture with a goat will lead to mockery, reflecting the
bill's failure. Bartlet decides to proceed.

> BARTLET: Half the world's people live on less than two dollars a
> day. One hundred and thirty million will never step inside a
> schoolhouse. Ingredients for bombs can be purchased at hard-
> ware stores and we've just given the Third World what the
> doctor ordered: rollbacks. Heifer International: they give free
> cows and goats to people who need milk?
> CREGG: Yes, sir.
> BARTLET: Well, then, I don't think that we're in any position to
> be snotty.

Bartlet fully understands the political realities that come with the pres-
idency, yet he still maintains his faith in liberal values. In typical fashion,
Sorkin strives to make that faith believable by presenting counter arguments
against the aid bill. Early in the episode, Josh Lyman talks with a Senate
staffer whose boss is using the poll data as justification for voting against the
bill. Lyman protests the helpfulness of such a poll.

Lyman exclaims, "Of course foreign aid polls badly. The people it's
helping aren't the ones who are answering the phones."

"Or paying the taxes or voting," the staffer retorts. She reminds Lyman
of the political reality that the question boils down to asking American tax-
payers to send money to other countries.

Sorkin answers this argument with both moral and pragmatic reasons
for American foreign aid. He wants viewers to believe that they have wit-
nessed the marketplace of ideas in action. Furthermore, he suggests that
often the public is cut off from such free exchange. Later in the show, for
example, Lyman points out that by the poll's numbers, 9 percent of Amer-
icans cannot figure out what they believe. Sorkin does not infer that Amer-
icans are stupid. On the contrary, he believes they make good decisions when
the issues are presented clearly.

For Sorkin, the marketplace of ideas does not necessarily entail a con-
test between competing ideologies. He shows that people on the same side

argue, too. In the fourth season's first episode, "20 Hours in America – Part I," Bartlet meets with the secretary of commerce, who is upset with the president's recent advocacy of a limitation on greenhouse gas emissions. He argues that the United States should not support restrictions that do apply to 80 percent of the world's nations. Bartlet lectures the secretary, "I think what's lunacy is a nation of SUVs telling a nation of bicycles that they have to change the way they live before we'll agree to do something about greenhouse emissions." The secretary rejoins that economic competition depends on fairness. Raising his voice slightly, Bartlet intones, "Well in international law there is a principle called differentiated responsibilities. We're the ones making the greenhouse gasses." The scene concludes with a reminder of what is at stake. The secretary tells him, "You're losing the support of the business community." Proving both a solid commitment to right action and his personal firmness, Bartlet ends the conversation by stating, "Mr. Secretary, it's not your job to tell me whose support we're losing. We have people who do that. It's your job to tell me whose support you just got for me." These are people with real disagreements; the exchange is serious, but cordial and respectful, throughout.

Sorkin does not craft arguments between his protagonists to advance specific legislation. Instead, they constitute part of his rhetorical strategy designed to make his vision convincing. For all his attention to detail, Sorkin actually has very little interest in policy *per se*. The stories he writes do not set forth sustained courses of action; he does not expect a viewer watching *The West Wing* to turn off the set and write a congressperson. Instead, the heated debates that drive his dramas serve to limn an implicit central core. Sorkin wants to create a broad vision for government's proper role and the values that should guide its leaders.

One cannot fully comprehend the ideological foundations of Sorkin's work without accounting for the techniques he employs to make his ideals convincing. Sorkin's most obvious technique is to suggest that audiences are looking into a conceivably real world. He peppers his scripts with details that imply his omniscience about the material; and the more arcane the item, the better. He has his characters bring up obscure references to little-known legal proceedings, obscure sports statistics, arguments over the proper collection of census data or such mundane topics as the White House parking options. Often the details set Sorkin's work apart from other popular portrayals. In *Dave*, for instance, Kovic and Murray work on the federal budget by thumbing through a couple notebooks. But when staffers in *The West Wing* call for a copy of the federal budget, the boxes of paper fill an office.

Sorkin's characters often deliver information in an off-hand manner, as if everyone ought to know such things already. A fact is briefly noted, rapidly

absorbed, and the subject changes abruptly. The casual exchanges between Sorkin's characters give them an aura of intrinsic expertise. Their comprehension is so quick that only a few words are necessary. Conversation frequently resembles a kind of haiku in which mundane lines are interspersed with succinct declarations carrying significant meaning. A change in subject tells the characters, and the audience, as much as an answered question.

A dialogue in "Guns Not Butter" illustrates the technique. From the start it relies on the audience's awareness of earlier plot developments. The viewer must know that in a previous episode President Bartlet ordered the illegal assassination of an official from the fictional Middle Eastern country of Qumar. Reporter Danny Concannon, who is romantically interested in C. J. Cregg, suspects foul play in the Qumari official's disappearance. Against this back-story, Concannon and Cregg exchange barbs and information as they walk down the hall to her office. Cregg has just ended a press conference by refusing to respond to a reporter's "blind quote"—a statement from an anonymous source. Walking back to her office, she leaks information to Concannon, giving her own blind quote. "I'm a senior administration official," she tells him. "You can say several senior administration officials say the White House will have a good memory when the transportation bill comes up again next year." Concannon jibes, "You don't mind blind quotes so much when they come from you."

In return for leaking her information, Concannon asks for an administration statement about the pilot flying the Qumari official's plane. His assistant, Maisey, has not been able to find any records confirming his existence. Cregg shrugs him off:

> CREGG: You know, I've got to tell you your tie goes with your shirt and your jacket... You're dating a college graduate aren't you?
>
> CONCANNON: Maisey and I are never going to find [the pilot], C.J. [His name] is an invented identity for someone. It has to be. For this thing to have worked, the pilot had to be one of our guys.
>
> CREGG: Yeah, I just meant it was a nice tie.
>
> CONCANNON: I'll be around all day for the quote.

The issue seems to be unresolved, and to the casual observer it appears that Cregg and Concannon have simply talked past each other. Yet, the exchange has done quite a bit for Sorkin. It advances the plotline that President Bartlet's illegal action will probably become public knowledge. The audience knows that Bartlet agonized over the decision to order an assassination and can believe he acted correctly, but the revelation and ensuing

scandal will again test his moral leadership. The conversation's coyness also reminds the audience of the attraction between the reporter and the press secretary whose careers prevent any hope of consummating the romance.

Most important, Sorkin signals to the audience that they are privy to something honest and real. They see spin in action. The audience watches as Cregg releases a quote that assuredly will appear in the *Post* with the tagline, "Senior administration officials say...." They have seen the news at the start of the manufacturing process. The quote itself is not relevant, nor does Sorkin want to call attention to the function of spin in media-driven politics. Instead, he shows Cregg leaking information to let viewers know that they have stepped behind the veil. They are witnessing politics in its true form. The scene suggests that what is then said within that space can be taken to be accurate.

Sorkin enhances believability by making characters passionate about matters that might seem small to outsiders. Sorkin's White House struggles daily over minutiae of budget allocations, policy technicalities, and the seemingly unending process of massaging, balancing and patching easily bruised Washington egos. This is not because Sorkin wants to paint a slice of life. On the contrary, he is almost exclusively interested in broad issues such as freedom and justice. Telling details make his larger vision more compelling. Sorkin realizes that most people spend their days working with minutiae. He wants his world to be so similar to our own, that one believes in the legitimacy of the vision he sets forth.

Sorkin's strategic goals shape the way he draws his characters. He wants his stories to be realistic, but he is less interested in interactions between real people than in examining the complexities of circumstances he creates. Instead of letting situations develop his characters, Sorkin uses characters to illuminate the situations. He uses common types that, given enough opportunity, coalesce into familiar relationships. There is the wise, experienced father overseeing his brood; the hyperintelligent men nearing the peaks of their careers; the competent middle manager dealing with being a successful woman in a man's world; the young upstart coming in to learn the ropes from the experts; the female underling speaking truth to the power she holds dear. They are people defined by their careers. Sorkin has shown little ability to sketch a person not consumed by his or her profession. They are suffused with a sense of purpose — whether that purpose is to get to the bottom of a crime, to produce the best sports program on television, or to run earth's most powerful nation. Sorkin's characters tend toward the heroic, and so they have their flaws. Perhaps they are afflicted by hubris, plagued by self-doubt, or unable to play well with others. Maybe they have vices like President Bartlet's clandestine smoking. Often they are torn between duty and

desire. Whatever the case, the flaws never become fatal or tragic; they remain strong and potent despite their wounds. What is important is that they weather the slings and arrows of fate after having made the difficult but right choices. They are fundamentally idealistic; winning or losing matters less than fighting the good fight.

To Sorkin's fans, his version of *The West Wing* demonstrated the real drama underlying complex political disputes. It showed how principled stands are not easy, and require the exercise of power that can hurt as well as help people. They also saw in it a model for good, effective, and principled government. For many the show was a weekly sacrament of their civil religion. Millions expectantly tuned in to bask in Sorkin's deeply patriotic and unapologetically liberal rhetoric. *The West Wing* not only gave voice to progressive ideology, it seemed to provide rationales for its goals and explanations of its mechanisms. It reminded Americans that public service ought to be a noble calling and that they should expect both intelligence and idealism from those called to it. "For its admirers," writes columnist Sharon Waxman, "*The West Wing* has become an example of television that can entertain and educate and — in some measure — elevate viewers above the prevailing forces of political cynicism and ennui" (Waxman 207).

The series spurred passionate responses from widely diverse people. *The West Wing*'s vocal fans included members of both ends of the Washington's political spectrum, people who knew very well the difference between idealized politics and the real rough-and-tumble within the beltway. Clinton's chief of staff John Podesta and Secretary of Health and Human Services Donna Shalala confessed to enjoying show. So, too, did Reagan administration stalwarts speechwriter Peggy Noonan and press secretary Marlin Fitzwater (although both were at times were Sorkin's paid consultants). Even Bill Clinton, presumably the target of many of the show's early barbs, gave it kudos. By the same token, the program evoked loathing among staunch conservatives. When *The National Review*'s Jonah Goldberg read an article in which Sorkin claimed to be nonpartisan and only interested in writing entertaining television, he called the writer "a habitual and inveterate liar" (Goldberg). *The Weekly Standard*'s Jon Podhoretz described *The West Wing*'s appeal as "pornographic" to liberals (Podhoretz 226).

Detractors pointed out that Sorkin's vision failed to stand up to scrutiny. Close examination exposed places where the narrative's broad brushstrokes left gaps and inconsistencies. Both amateur and professional critics delighted in pointing out misrepresentations, inaccuracies, and logical impossibilities. Even those willing to forgive venial sins could not help noticing that the series left important holes agape. Most importantly, *The West Wing* never

portrayed what might actually happen in a country led by the ideal president. One never saw the results of effective gun control legislation, better school funding, or more progressive taxation. The audience could only watch the administration lay the groundwork for such changes and trust that because Bartlet's people had their hearts in the right place these best-laid plans would come to fruition.

The West Wing's faith in brilliant and well-intentioned public servants troubled some whom conventional wisdom might otherwise have pegged as fans. Many politically astute progressives found the series insipid if not dangerous. In March 2001, during the hiatus between the trauma incurred by a fouled election and the shock inflicted by foul terrorism, Chris Lehmann excoriated *The West Wing* in the pages of *The Atlantic.* Citing the "pseudo-politics" of a "feel-good presidency," he condemned the series for providing liberals starving for idealism a "wish-fulfillment fantasy" of a presidency with "both moral gravitas and political backbone" yet without the solid linkages that had formed the bedrock of Roosevelt's coalitions (Lehmann 215). The show put no difficult policy issues or ideals actually at stake, he complained. *The West Wing* may have portrayed a Clintonesque presidency minus the embarrassments of waffling and infidelity, he continued, but it maintained the worst of Clintonism — It rejected the hard realities of traditional liberal politics in favor of a politics of feeling. Lehmann noted that the series placed emotions at the center of national power, and that even the most important political stances could be traced back to the characters' personal experiences. He perceived a façade of empathy masking an absence of real political leadership. In sum, the series had no ideas. Taken to its extreme, Lehmann warned, *The West Wing*'s idealization of Josiah Bartlet carried the seeds of totalitarian leader-worship. To his critics, Sorkin simply fantasizes about politics and his fantasies are about simple politics. For all the style, there is no substance.

Powerful as they are, most of these critiques miss the point. Aaron Sorkin does not want to shape a policy agenda. He never intended to. Instead, he wants to shift the terrain of national debate. Sorkin clearly advocates a particular kind of liberalism. He believes that government institutions should actively use their power as a force for good, especially on behalf of those with the least power. He thinks that those who seek to limit government's ability to ensure equality and justice, or to use it to further benefit the wealthy and connected, are anti–American. But more than anything he wants the American public to remember that their ideals are based on fundamentally liberal values. They need not agree on specific policies, but they should respect each other enough to engage in free and open debate within the marketplace of ideas. That marketplace, he posits, is an essentially liberal con-

cept, and the nation's rightward shift has worked to diminish its importance. He desires neither revolution nor even reformation, but simply a return to a consensus based upon the principles born in the Progressive era and nurtured in the New Deal. As Sorkin sees it, his liberal vision is nothing other than the recognition of America's fundamental values. He simply wants everyone else to recognize that, too.

Notes

1. There is a small bibliographic conflict over the precise content of Reagan's inaugural address. The printed text said simply, "Government is not the solution to our problem." When he spoke Reagan said, "Government is not the solution to our problem; government is the problem." For the printed text, see http://www.bartleby.com/124/pres 61.html. The spoken text is referenced in the works cited list.

2. It should be noted that virtually no reviews of the play, whether of its Broadway production or the touring version, called attention to the phrase "You can't handle the truth." If they focused on a particular phrase, most reviewers singled out Kaffee's final injunction to Corporal Dawson, "You don't need to wear a patch on your arm to have honor." The combination of Jack Nicholson's acting and Rob Reiner's choice of shots turned an otherwise ordinary line into a classic Hollywood sound bite.

Works Cited

The American President. Dir. Rob Reiner. Perf. Michael Douglas, Annette Bening, Martin Sheen, Michael J. Fox, Richard Dreyfuss. Written by Aaron Sorkin. Warner Bros., 1995. VHS Warner Home Video, 1999.

Dave. Dir. Ivan Reitman. Perf. Kevin Kline, Sigourney Weaver, Frank Langella, Charles Grodin, Ben Kingsley, Ving Rhames. Written by Gary Ross. Warner Bros., 1993. VHS Warner Studios 1994.

Edelstein, David. "Pols on Film." *Slate,* 18 Aug. 2000. http://slate.msn.com/id/88247/.

Goldberg, Jonah. "Aaron Sorkin is Lying." *National Review Online.* 1 March 2002. http://www.nationalreview.com/goldberg/goldberg030102.shtml.

Grove, Lloyd. "Advise and Lament: 'American President' Ignores Political Realities." *Washington Post,* 19 Nov. 1995, G2.

Guthmann, Edward. "'The President' Gets Political." *San Francisco Chronicle,* 17 Nov. 1995, C1.

Hamby, Alonzo. *Liberalism and Its Challengers: From F.D.R. to Bush.* 2nd ed. New York: Oxford UP, 1992.

Heifer International. "About Heifer." http://www.heifer.org.

Lehmann, Chris. "The Feel-Good Presidency: The Psuedo-Politics of *The West Wing.*" *Atlantic Monthly,* March 2001. Reprinted in Eds. Peter C. Rollins and John E. O'Connor. The West Wing: *The American Presidency as Television Drama.* Syracuse, New York: Syracuse UP, 2003. 213–221.

Levesque, John. "Aaron Sorkin is a Man of Many Words." *Seattle Post-Intelligencer,* 7 March 2000, http://seattlepi.nwsource.com/tv/sork07.shtml.

Podhoretz, Jon. "The Liberal Imagination." *The Weekly Standard*, 27 March 2000. Reprinted in Eds. Peter C. Rollins and John E. O'Connor. The West Wing*: The American Presidency as Television Drama*. Syracuse, New York: Syracuse U P, 2003. 222–231.

Reagan, Ronald. First Inaugural Address. Washington D.C., 20 Jan. 1981. Sound file available at: "The American Presidential Election: A *Britannica* Feature." *Encyclopedia Britannica*. http://search.eb.com/elections/pri/Q00109.html.

Schlesinger, Arthur. *The Vital Center*. Boston: Houghton Mifflin, 1949.

Sorkin, Aaron. 1990. *A Few Good Men*. New York: S. French, 1990.

_____. 2000. *PBS NewsHour*. Television interview by Terence Smith. Sept. 27. Transcript available at: http://www.pbs.org/newshour/media/west_wing/sorkin.html.

Waxman, Sharon. "Inside *The West Wing*'s New World." *George*, November 2000. Reprinted in Eds. Peter C. Rollins and John E. O'Connor. The West Wing*: The American Presidency as Television Drama*. Syracuse, New York: Syracuse UP, 2003. 203–212.

West Wing. 2000. "Take This Sabbath Day." Season 1, episode 14, first broadcast 9 February 2000. Written by Aaron Sorkin. Dir. Thomas Schlamme.

_____. 2002. "20 Hours in America — Part I." Season 4, episode 1, first broadcast 25 Sept. 2002. Written by Aaron Sorkin. Dir. Christopher Misiano.

_____. 2003. "Guns Not Butter." Season 4, episode 12, first broadcast 8 Jan. 2003. Written by Eli Attie, Kevin Falls and Aaron Sorkin. Dir. Bill D'Elia.

10

Virtue from Vice: Duty, Power, and *The West Wing*

Nathan A. Paxton

Premiering in autumn 1999, Aaron Sorkin's television program *The West Wing* quickly became one of the most popular and critically acclaimed shows in the country. The weekly hour of drama follows a fictional president of the United States and his staff as they pursue their policy and political goals, charting the ups and downs of a Democratic administration in an America that, although not quite in the same universe as reality, looks quite close to reality. The show devotes a significant portion of its time to discussing the meat of political and policy issues — from the death penalty and the politics of Supreme Court nominations to the arcana of U.S. Census sampling and estate tax policy. It comes as little surprise that *The West Wing* has been called a "running civics lesson"; some commentators have even suggested that it has helped to make public service and civics more honorable and more interesting pursuits, not just for professionals but even for the average American citizen.

Whether or not one can actually credit *The West Wing* with making service sexy, a more fundamental question remains to be answered. How does *The West Wing* explain the motivations and rewards of its characters? What motivation animates and drives them to spend years of their lives in pursuit of so much uncertainty — policy battles they may or may not win; daily distractions from the core of their agenda; unexpected threats to the health, safety, and well-being of the nation and its citizens; or even the unrelenting boredom and slowness of creating public policy and pursuing politics in the American governmental system?

Against our most base expectation for the conduct of politics, "pursuit of power" does not provide *The West Wing*'s answer to the above questions. For the characters on *The West Wing*, power's rewards rarely enter into the

calculus of their service, and the pursuit of such for its own sake brings about discouragement or rebuke. Instead, *The West Wing* answers that duty motivates and rewards the people in the universe of *The West Wing*. The program proffers a running discussion of the concept of duty as played out in the American political ideology and the contemporary political arena. Indeed, duty's obligations and objects provide the leitmotif of the series, binding its episodes together into a more coherent whole.

The *West Wing* does not offer a new political theory of what it means to be an American or to act as an American. The program does try to reinvigorate an old conversation in American political thought, asserting that duties exist that are incumbent upon all who would lead. And *The West Wing* does not ignore the role that the pursuit of power plays for most professional politicians. Instead, the show turns its attention to what happens when duty and power conjoin, and what results when one concept gets the better of the other. In regard to duty, the show asks and attempts to answer a nexus of questions: What is duty? To whom is duty owed? How does one demonstrate a commitment to duty? Why should one follow one's sense of duty, as opposed to other more rewarding virtues or vices? The second nexus of questions that this paper addresses focus upon power and its combination with duty: Can those who pursue duty also pursue power? What is the relationship of duty to power? Can they co-exist? How is one dependent upon or prior to the other? What happens if this relationship is perverted? This essay will consider each of these two sets of questions in turn. However, before proceeding, I will begin with a brief discussion of the concept of duty in other areas of American political ideology.

Duty in American Political Ideology

As often proves the case, the first questions are possibly the hardest to answer. What is duty?[1] What role does duty play in the construction of American identity? Almost from the beginning of the American Republic, creators and leaders of the polity have sensed that they existed in a milieu where the highest form of social service lay not in the pursuit of meeting individual desires and goals but in work toward the good of the commons. The founders were good children of the Enlightenment, and the teachings of Locke, Rousseau, and Montesquieu formed and informed their political opinions. For the founders, the republican polity aggregated from the individuals that composed it, yet the polity exceeded simple summation to create a synergistic, new, separate political entity. This polity also demanded the highest loyalty of its members. The duty of the members of such a republic

was to place service to the country above all other considerations. Such service ideally lay not in blind obedience to the political masters of America. Because the American Republic, even while exceeding individuals, flowed from its citizens, each citizen had to follow the dictates of conscience and personal belief regarding the best course of action for the polity, even should such dictates and beliefs contradict the reigning political ideology or current leadership. This understanding of American duty has survived relatively intact through more than two hundred years of American political and social history. It has not always been a defining characteristic of the actual conduct of American politics, but it serves as a popular and elite understanding of how American life should be conducted. By no means can this paper present a complete survey of "duty" in the progression of American political thought; a brief survey of how the concept plays out in the classic roots of the genre will prove instructive as we proceed to consideration of *The West Wing*.

One need look no further than early American rhetoric to confirm that duty, understood as tending to the business of the public over and even in controversion of individual interest, offered one of the founding ideals of the new polity. In declaring themselves a new nation, separated from the bonds of the mother country, the signers of the Declaration of Independence proclaimed, "And for the support of this declaration, with a firm reliance on the protection of Divine Providence, we mutually pledge to each other our lives, our fortunes, and our sacred honor." For the fifty-five signers, no individual characteristic or possession could prove as important as service to the common good; duty required the very real risk of impoverishment, imprisonment, and death.

Similarly, the other founding scripture of the American political religion, the Constitution, emphasized that individuals must fulfill their duty to the common element. As the preamble proclaims,

> We the people, in order to form a more perfect union, establish justice, ensure domestic tranquility, provide for the common defense, promote the general welfare, and to secure the blessings of liberty to ourselves and our posterity, do ordain and establish this Constitution for the United States of America.

The pattern in this list of tasks that the Constitution aspires to complete starts with the general, moves to the specific, and returns to the general. The first goal of the Constitutional order lay in the attempt to bring the union of the several states closer to perfection than the previous system allowed. To do this, the text argues, the people must form public institutions — institutions that might intrude upon the maximal freedom of the individual but

that would provide the greatest freedom to the generality of the people. These institutions would perform the several requisite tasks of government — "establish justice, ensure domestic tranquility, provide for the common defense, [and] promote the general welfare." In the end, the move to perfect the political order through better institutions fell subsidiary to the most important motivation of all — "to secure the blessings of liberty to ourselves and our posterity." The Constitutional preamble, then, sets out the duties of the American government — to safeguard freedom by the common life of government and politics. Moreover, it sets out the objects of that duty — not only must the present figure prominently but the future had claim also — by noting that the order was done "for ourselves and our posterity."

Duty was not simply the special province of the American elite. As the United States developed beyond its republican roots into a democratic polity,[2] the form of duty became democratized. As Alexis de Tocqueville noted in *Democracy in America*, "A man understands the influence which his country's well-being has on his own; he knows the law allows him to contribute to the production of this well-being, and he takes an interest in his country's prosperity, first as a thing useful to him and then as something he has created."[3] Tocqueville implicitly recognizes that the motive of self-sacrifice in service may not be enough to motivate the mass of citizens in the American Republic, and self-interest must figure as part of the dynamic of creating the dutiful American. In this, it appears that duty does not need to occur as a work of altruism; duty may contain a selfish component. The apparent contradiction is striking: service to the good of the many may derive at least some of its initial force from individual motivation. As Tocqueville notes in the latter part of this passage, individual desire transforms into something more akin to duty, as the "interest" in the well-being of the country begins in utility but over time becomes pride in creation.

Democratic duty firmly planted itself within the soil of the American political ideology. Perhaps the best evidence for this phenomenon occurs in the letters and diaries of soldiers at war. For example, as Union soldier Sullivan Ballou wrote to his wife a week before the Battle of Bull Run (Manassas),

> I know how strongly American Civilization now leans upon the triumph of the Government and how great a debt we owe to those who went before us through the blood and suffering of the Revolution, and I am willing, perfectly willing, to lay down all my joys in life to help maintain this Government and to pay that debt.[4]

Of course, perhaps the most famous of all calls to duty in American rhetoric comes from President John F. Kennedy's inaugural speech in 1961,

where he issued a challenge to all of America, at a time that seemed to promise new hope and opportunity. "Ask not what your country can do for you. Ask what you can do for your country." The duty of an American was clear: place the good of the country above your own, give selflessly to the common weal, and acknowledge the necessity of sacrifice.

According to Judith Shklar, duty and American citizenship have become equivalent in some sense.

> Good citizenship as political participation ... concentrates on political practices, and it applies to the people of a community who are consistently engaged in public affairs. The good democratic citizen is a political agent who takes part regularly in politics locally and nationally, not just on primary and election day. [Good citizens] also openly support policies that they regard as just and prudent. Although they do not refrain from pursuing their own and their reference group's interests, they try to weigh the claims of other people impartially and listen carefully to arguments.[5]

Duty and this form of citizenship thus have a close, if not identical, relationship.

Duty on The West Wing

The pursuit of American duty provides the driving force of action on *The West Wing.* Aaron Sorkin, the creator of the series, notes that the show offers a paean to public service:

> [The characters] are fairly heroic.... That's unusual in American popular culture, by and large. Our leaders, government people, are portrayed either as dolts or as Machiavellian somehow. The characters in this show are neither.... All of them have set aside probably more lucrative lives for public service. They are dedicated not just to this president, but to doing good, rather than doing well. The show is kind of a valentine to public service.[6]

Virtually any viewer of the show would agree with Sorkin's statement about his creation, but the more interesting question remains, "Why do these characters engage in public service?" What motivation lies behind the choice to forsake lucrative individual pursuits, even if those could be construed as helping people, to pursue the life of public service? In short, the president and his staff understand that they bear the duty to devote their considerable talents to the service of the public life; not only do they bear this duty, but they bear it pleasurably. While tough wins and dispiriting losses provoke

anger, weariness, and even tragedy, the show emphasizes that duty is not an onerous burden but a fulfilling vocation.

Although demonstrated throughout the show, the pleasure of bearing duty finds its best demonstration in the first season episode "Let Bartlet Be Bartlet." The staff of the administration expresses frustration not that they lose policy and political battles that they fight but that they do not even "suit up" for the conflict of modern democratic politics. President Bartlet (Martin Sheen), convinced by his chief of staff, Leo McGarry (John Spencer), to follow his conscience, decides that speaking his mind is more important than reelection. For Bartlet, his duty as the president is to do what he believes right, not what proves expedient. Following conscience does not merely serve a personal sense of comfort — in the West Wing, it is the correct public action. Leo then meets with the staff and tells them that they have the free reign to pursue the agenda they believe they were elected to serve.

> LEO: We're gonna lose a lot of these battles, and we might even lose the White House, but we're not gonna be threatened by issues; we're gonna put them front and center. We're gonna raise the level of public debate in this country, and let that be our legacy. That sound all right to you, Josh?
>
> JOSH: I serve at the pleasure of the President of the United States.[7]
>
> LEO [to C.J.]: Yeah?
>
> C.J.: I serve at the pleasure of the president.
>
> *[Leo turns to Sam]*
>
> SAM: I serve at the pleasure of President Bartlet.
>
> LEO: Toby?
>
> TOBY: I serve at the pleasure of the president.
>
> *[Everyone smiles.]*
>
> LEO: Good. Then let's get in the game.

The duty to engage in public service proves both serious and pleasurable to these men and women. The statement "I serve at the pleasure of the president of the United States" invokes a vow for the staff, similar to that taken by their boss to preserve, defend, and protect the Constitution. So long as they (political appointees who may be hired and fired at will) work for the president, they share in the duty of working to preserve, defend, and protect not just the Constitution but the whole of the American way of life. Their vow is a subsidiary of the president's constitutional oath.

In *The West Wing*, duty locates in two primary sites. First, the drama contends that the appropriate locus of American duty starts with service and assistance rendered to other people (individuals or groups), whether friend

or adversary. From this place, duty expands to locate itself in the whole of the country, to the good of a polity that is more than the whole of its parts, and, in a reflection of the founding moment encapsulated in the constitution's preamble, to the future and the past.

American duty, by its very nature, requires that the person performing it look outward rather than inward, to the improvement of many rather than the gain of one or a few. In one sense, to focus on duty to others may seem tautological. However, the object of the duty — the "others" — reveals the range of *The West Wing*'s vision of who counts and why. Duty in Sorkin's world requires that the drama's characters act with tolerance and catholicity toward the people they meet, so long as those people act similarly; those who do not receive chastisement for violating their own obligation to American duty.

To Others, Especially Those Who Disagree

The people of *The West Wing*, involved as they are in professional politics, must deal constantly with those who disagree, even vehemently, with them. This, in some sense, marks them as different from the rest of Americans, who can structure their daily lives and work to avoid significant disagreement with other people on public matters, social and political. Even so, Americans generally know that the health of the Republic depends upon the cultivation of debate and disagreement, but they often leave the matter to politicians, talking heads, academics, and other members of the "chattering classes." Every step of life in *The West Wing* brings the staffers and the president into regular contact with conflict. As fulfillers of their duty, to serve the public interest, what duty do these characters bear toward those who disagree with them?

This question has been answered in various fashions since the beginning of the series. In the pilot episode, many of the answers to the above question appear via a major subplot. As the episode opens, we learn that the deputy chief of staff, Josh Lyman (Bradley Whitford), has insulted a leader of the Christian right-wing on one of the Sunday morning talk shows that are a staple of the political game.

> MARY MARSH: Well, I can tell you that you don't believe in any God that *I* pray to, Mr. Lyman. *Not* any God that *I* pray to.
> JOSH: Lady, the God you pray to is too busy being indicted for tax fraud.

For this comment and possibly angering a powerful constituency the president can ill-afford to cross at this point, Josh's job is in danger. We learn in

the meantime that the president is a "deeply religious man" who discourages young women from having abortions but who "does *not* believe that it's the government's place to legislate this issue." White House Communications Director Toby Ziegler (Richard Schiff) arranges a meeting between the staff and the Christian conservatives angered by Josh's remark. Josh apologizes for the tenor of his remark and notes that any person willing to debate ideas deserves better than glib insults. Mary Marsh speaks up, asking what her group will get in return for the insult, quickly demanding a presidential radio address in support of school vouchers or against pornography (with the implication that neither is a policy position the president would normally take). Finally, the president appears in the midst of heated argument, and asks the visitors why they have not denounced a fringe group called the Lambs of God. He explains that he is upset and extremely angry:

> BARTLET: It seems my granddaughter, Annie, had given an interview in one of those teen magazines and somewhere between movie stars and makeup tips, she talked about her feelings on a woman's right to choose. Now Annie, all of 12, has always been precocious, but she's got a good head on her shoulders and I like it when she uses it, so I couldn't understand it when her mother called me in tears yesterday.... Now I love my family and I've read my Bible from cover to cover so I want you to tell me: from what part of Holy Scripture do you suppose the Lambs of God drew their divine inspiration when they sent my 12-year-old granddaughter a Raggedy Ann doll with a knife stuck in its throat? [pause] You'll denounce these people. You'll do it publicly. And until you do, you can all get your fat asses out of my White House. [Everyone is frozen.] C.J., show these people out.
> MARY MARSH: I believe we can find the door.
> BARTLET: Find it now.

This president does not remain above menace and intimidation when he believes that the various peoples he must deal with have violated their own duties. As the statements above indicate, the president's duty includes a mutual respect for his adversaries, until they violate the compact of democratic deliberative discourse. Once they have done that, or people associated with them have done so (as the Lambs of God were loosely associated with but not part of the organizations the lobbyists represented), they are no longer worthy to participate in the public sphere that the president controls (a fairly significant portion).

The above dialogue also indicates that the president in *The West Wing*

perceives part of his duty to be the control of the public discourse. If locking radicals out of the White House proves to be his solution, he sets himself up as an arbiter of what and what is not acceptable for people to say to gain entry into the public sphere. No support for the actions of the fictional radicals is implied here, but the president indicates from the very beginning of the series that he will serve as a cop for republican conduct in American politics. One also wonders whether the president would have acted so forcefully on the (implied) right side had the victim of the radical act not been his granddaughter. Unfortunately, we are given no further clues as to the extent of the president's duty to act as republican policeman or whether he acts on a particular duty when it does not affect him in a personal way.

One of the criticisms of the show lies in the personalization of policy that often occurs. The West Wing leaves unanswered how duty's pursuit springs from the nexus of personal and public. Chris Lehmann commented on this theme in *Atlantic Monthly,*

> In the thickets of controversy that crop up in the Bartlet Administration, the strongest objection to a policy or a decision to overstep protocol is usually that it doesn't feel right. And when the members of Team Bartlet chart a new policy course, it is because they agree that it suits the perceived national mood or because it springs ... from a profound personal experience.... If one of the sixties' most enduring — if dubious — notions is that the personal is political, *The West Wing* operates from the converse: the political is, above all, personal.[8]

Lehmann's center-right critique indirectly poses another question. What are the sources of action, belief, and opinion when a public servant follows one's sense of duty? *The West Wing*, unfortunately, either does not answer or offers a vague notion like "love of country."

Benefits of Following Duty

Duty for the characters in *The West Wing* extends to helping all American citizens, whether they disagree, agree, or are uninvolved in the world of public service. The burden of public service does not weigh down the White House staff or the president. Quite to the contrary, the yoke is easy and the burden is light, because the staffers know that the joy of public service outweighs the bane of the moment's political storm. (As just noted, of course, the motivation often appears unclear.)

Moreover, not only does doing one's duty mean that the worries of the day are lifted away, but following the dutiful vocation lifts the other concerns

of life from the characters, and the implication, of course, is that American duty in the form of public service becomes a salvific, redemptory act. When one does it, one receives the intangible satisfaction of knowing one is pursuing his or her life's vocation. Rather like a call to the priesthood, the characters, through struggle and service, receive satisfaction and transformation. *The West Wing* contends that the public servant may serve as the modern American "vocation," to use the old language for a calling to religious service. The season two premiere, "In the Shadow of Two Gunmen," makes this point most clear.

The season begins just as an apparent assassination attempt against the president has taken place. In the course of the episode, we learn that the true target was Charlie, President Bartlet's young African-American aide, whom white supremacists want to kill because he is dating the president's daughter. In the course of the confusion, Josh is hit seriously; the concern that all his friends show becomes the device by which one sees a series of flashbacks to the Bartlet campaign and learns how this group came together.

Two flashbacks, in particular, merit attention, for they make clearest the transformative nature of doing one's duty to look beyond the merely self-interested to the good of the *res publica*. We learn through the course of these flashbacks that Josiah "Jed" Bartlet entered the race an underdog candidate, a two-time New Hampshire governor, a Nobel Prize–winning economist, and a plain-speaking liberal idealist, with a touch of pragmatism. Some future staffers have their doubts about whether he'll make it.

> JOSH: Leo, the Democrats aren't gonna nominate another liberal
> academic governor from New England. I mean, we're dumb,
> but we're not that dumb.
> LEO: (smiles) Nah. I think we're exactly that dumb.

Sam Seaborn (Rob Lowe) has risen to the highest rungs of the corporate legal ladder, about to be made a partner in the second-largest law firm in New York. A committed lover of the environment, he finds himself helping oil companies to buy sub-par tankers at cut-rate prices and under terms that will help them to escape virtually any legal liability if disaster strikes. Josh, doing a favor for Leo and checking out Bartlet, comes to ask Sam whether he will write speeches for Senator Hoynes, who is also running for the nomination. Sam turns the offer down, because he doesn't believe Hoynes is "the real thing." But should Josh see the real thing in New Hampshire, Sam asks, Josh should tell him. In the second part of the episode, Josh returns to Sam's firm as Sam works the final details of an oil tanker deal, trying to convince the businessmen to buy safer, more responsible, but more expensive, boats. After a frustrating attempt to persuade the oilmen to be more

environmental, Sam looks up and sees Josh standing at the window. Realizing that, however unlikely, Josh has seen the real thing, Sam walks out of the meeting and the law firm. As he gets up out of his seat, his boss asks, "Sam, where are you going?" "New Hampshire," Sam replies.

Similarly, we learn that three years ago, about a year before Bartlet's election, C.J. Cregg (Allison Janney) had just been fired from her job as a top-rated publicist for a Beverly Hills P.R. firm that seemed to specialize in entertainment-industry hand-holding. She walks into her back yard, finds Toby sitting there, and hears out his pitch to land her as the press secretary for the Bartlet campaign.

> C.J.: How much does it pay?
> Toby: What were you making before?
> C.J.: Five hundred fifty thousand dollars a year.
> Toby: This pays six hundred dollars a week.
> C.J.: So this is less.
> Toby: Yeah.

With the barest hint of a smile, C.J. notes that she has never worked national politics, just state-level. But she's in.

Both of these vignettes emphasize that the call to duty occurs suddenly, often out of the blue, and that it presents a moment of choice, between acceptable self-interest and sanctified service to others. But the very sanctification of the process removes these characters from the realm of what most viewers can understand. These women and men who serve the president and the country have been washed clean, transformed into saints, and made more unattainable to the mass of Americans. Sorkin complained in a 2000 interview to PBS' *News Hour with Jim Lehrer* that public servants have been vilified and presented in a Machiavellian light. Perhaps, however, this is the case because the public at large can identify with the more venal impulses of the image of the selfish politician than *The West Wing*'s selfless servants. We like these men and women, but we don't understand them. Their commitment to their duty is so clear that they forsake relationships, marriages, money, and perhaps even their lives in service of an ideal. For the viewer, such a commitment to duty can provoke admiration, but, in its inaccessibility, it is ignorable and finally ineffective.

Duty to Country

Almost *contra* Tocqueville's and Shklar's observations, the characters in *The West Wing* do not appear to act out of self-interested motivation, even

in a partial sense. Their commitment to the service of others and their country appears to come from a high prioritization of the "public." They serve because they are needed — the overriding motif of the series is that to those whom much is given, much is also demanded. The characters know this and carry this, as we have noted many times before.

The dedication to country is such that even when a character receives the call to do something that she or he cannot fathom or bear, duty will override all consideration. The call is virtuous, but should it trump all other claims on the soul of the republican citizen?

In two back-to-back episodes, "In This White House" and "And It's Surely to Their Credit," we meet the lawyer Ainsley Hayes (Emily Procter), a Republican who opposes just about everything the White House stands for. She initially appears as one of the first talking heads to out-argue Sam on one of the Sunday morning political talk shows. Sensing intelligence and a sense of service, Leo calls her into the White House and offers her a job, explaining that the president likes smart people who disagree with him and that he is asking her to serve. Ainsley, noting that she has wanted to work in the White House since she was two, resists the call and decides not to take the job on account of her partisanship. But as she spends the day in the White House, she sees the staff and the president engage in acts both of partisan politics and of service to the country and the world. Meeting her friends late that evening, they ask her if she met anyone who "wasn't worthless." Suddenly shaken from her reflective reverie, she rebukes her friends:

> Say they are smug and superior. Say their approach to public policy makes you want to tear your hair out. Say they like high taxes and spending your money. Say they want to take your guns and open your borders, but don't call them worthless.... The people I have met have been extraordinarily qualified. Their intent is good. Their commitment is true. They are righteous, and they are patriots. And I'm their lawyer.

When the White House counsel finds out that a fire-breathing Republican has been hired into his office, his temper explodes. After making a scene with the president, the counsel traipses down to Ainsley's basement office and demands to know why she is working in this administration. "She sweetly professes that she's serving her country, she feels a sense of duty."[9]

What does Ainsley give up to become a member of the opposition in service to the Bartlet White House? Clearly, one of the actions she may never engage in while she follows her duty includes making public appearances on behalf of the causes that she believes in as Republican — no television, no forums, no place where her views may publicly contradict those of the

administration or bring embarrassment upon it. (We are given to believe that she would never engage in the latter, her concept of duty, honor, and service being unimpeachable in this regard.) But she can become the premier voice for Republican views to the members of the White House staff, providing an empathetic mouth for policies and people they might normally regard as enemies.[10]

Ainsley sacrifices her own good for what she perceives as the good of the country. As a rising Republican star, her friends assured her that she could become a power player on the Washington circuit and implied that she could make significant money also. But when the president calls on her, she realizes that she must follow the call to duty. Even as she tries to resist, at first refusing the job, she clearly has a road-to-Damascus moment: when her friends call the White House "worthless," her task becomes immediately clear. There is a sense of inevitability to her call and actions.

Duty thus contains a compulsory aspect. Once an American understands it and receives a clear directive, he or she must obey. One wonders if the aspect of choice retains any power in *The West Wing*; it would seem that it does, but in a very muted way. One can choose to serve or not, but duty may only have one path — the service of the president. What if Ainsley had chosen some other form of political engagement *and* she had played by the Bartlet ground rules of liberal democracy (speak only to issues, make no *ad hominem* or personal attacks, only involve the lives of those directly at work in the political arena, and so forth)? What if she had chosen to remain a commentator outside the administration? What if she had become an opposition party staffer? It's not clear, but *The West Wing* has not portrayed any extensive character (main, supporting, or recurring) doing any of these. One senses that the role of the member of the loyal opposition is to be subsumed; the evidence from the series, however, remains inconclusive, as we have not seen many other models. The sin of omission does not make a sin of commission. Even so, political service in *The West Wing* always occurs in the context of the White House.

And yet — a lofty and inspiring element exists in portraying such a person, a partisan who puts aside party difference with co-workers and boss for the good of the country. If this situation seems unbelievable to the viewer, it is just as implausible to the characters, which thereby increases its believability. When Ainsley does agree to become part of the counsel's staff and the counsel visits her, asking why she took the job, she says, "I feel a sense of duty.... Is it so hard to believe in this day and age that someone would roll up their sleeves, set aside partisanship and say, 'What can I do?'" The counsel responds, "Yes!"

Many cultural critics and academics have noted that the 1990s have

proved one of the most rancorous eras of partisan conflict in recent memory; even to describe the level of animosity requires one to examine the Federal period, the Jacksonian epoch, the Progressive era, or some other period belonging to history and not to memory. Sorkin's *West Wing* calls us as Americans to move beyond our particular impulses. Implying that we have moved away from our duty, *The West Wing* provides a call to fulfill duty once again, in the best spirit of American mythologies regarding the united nature of the United States. The drama says that the problems facing the America of the turn of the century are as great as any that have ever faced the Republic, and it argues that the great problems of our history have required more unified action than we see now. *The West Wing* asks that, in the name of duty, we Americans set aside the politics that we currently conduct, that we follow our consciences, and that we work for the good of the whole republic, even if this is detrimental to our selfish interests. In the name of this, the show will even invoke traditional political theorists like John Rawls and his concept of the "original position."[11] Even as the introduction of the Ainsley character invokes our cynical reaction, Sorkin asks for the suspension of our disbelief (by having the characters themselves unable to suspend their own disbelief) and for us to be persuaded for a short time that duty may still impel us.

Duty to Those Who Have Been Forgotten or Passed Over

The duty to make amends for the victims of injustice plays a large role in the catalog of public obligations that duty entails on *The West Wing*. Although most of the characters are straight, white males, Christina Lane notes that the attention to matters around historically disadvantaged groups makes up a large portion of the show's political issue focus. "*The West Wing* takes not merely as its end point, but rather as its *point of departure*, a progressive, multifaceted, highly politicized understanding of gender and racial relations."[12] Even if most of the primary characters are male and white,[13] Lane notes that the series continually privileges viewpoints from the margins, by allowing the viewer to see the action from the viewpoint of one of the main characters in a marginal group or from the view of supporting characters (many of whom are women or minorities or both). "Indeed, the series continually articulates the philosophy that its male characters can redefine their personal relation to patriarchal structures in ways that might advance the cause of feminists, people of color, and the working classes."[14]

Even more interesting than the (possible) trope of seeing a white male power structure easily, consciously, and conscientiously giving itself to the

dutiful service of the marginalized, *The West Wing* has also demonstrated how the marginalized can be brought into the service of one another. In the Thanksgiving episode from the third season, "The Indians in the Lobby," C.J. gets word that there are two Indians from the Stockbridge-Munsee tribe waiting in the lobby. They had an appointment in the West Wing, but when it was cancelled, they decided to stay in the lobby in silent protest. If the White House police are called, there will be a press scene. As press secretary, she must deal with the episode. Jack Lonefeather, tribal councilor, and Maggie Morningstar-Charles, tribe member and lawyer, clarify their problem for her. When the government moved them to Wisconsin, they signed a treaty that was supposed to guarantee their sovereignty, but the Dawes Act then forced them to sell three quarters of their land. A 1934 law allowed them to buy the land back and guaranteed that this time it would not be forfeit, so long as they placed it in trust with the federal government. But they have been unable to do this, because their application with the Interior Department has been delayed for fifteen years.

Much of the rest of C.J.'s character action in this episode revolves around trying to get the Indians in the lobby a meeting with someone, anyone, in the West Wing. None of the other staffers will do this, and we watch C.J. become more and more personally invested in helping these Indians. She returns to talk with them several times, and on her final visit learns the following.

> C.J.: How many treaties have we signed with the Munsee Indians?
> MAGGIE: Six.
> C.J.: How many have we revoked?
> MAGGIE: Six.
> C.J.: What were the Munsees doing in 1778?
> MAGGIE: Fighting in George Washington's Army.
> C.J.: And why aren't you in New York anymore?
> MAGGIE: 'Cause he marched us to Wisconsin.
> C.J.: And whose land was it in the first place?
> MAGGIE: Ours.
> *[She then tells the Indians that she has been able to get them a meeting to hear their concerns and to set up a further meeting for action. We can tell she admires and respects their tenacity, and she asks a final question before the episode ends.]*
> C.J.: How do you keep fighting these smaller injustices when they are all from the mother of all injustices?
> MAGGIE: What's the alternative?

C.J., in the world of *The West Wing*, takes on the duty of assisting the Indians because it is within the purview of her job's responsibilities. There is also power and poignancy in having the most influential woman staffer take up the burden of the Indians. We viewers often see *The West Wing's* political world through C.J.'s eyes (on more than one occasion, e-mails that she writes to her father serve as the narrative basis for an episode). C.J.'s status as a member of a marginalized group (even if she as an individual does not experience real marginalization) provides her the empathy and access to carry and convey the Indians to a power that will ultimately sympathize with them. In a sense, C.J., because she is a woman, is one of the very few in power who can shoulder this.

Minorities and women are not the only forgotten people the Bartlet White House has dedicated itself to bringing into its vision of America. Veterans of the armed forces receive recognition for the marginalized place many of them occupy in today's society. In the first season Christmas show, "In Excelsis Deo," Communications Director Toby Ziegler receives a call from the D.C. police asking him to come identify the body of a homeless man; he discovers that he received the call because the police found his business card in the man's coat pocket, a coat Toby had donated to charity. Toby recognizes that the man as a Korean War veteran, but since he's homeless, his body gets little attention or respect. Toby feels connected to the man because of the coat and because he served in Korea himself (in the '70s or '80s, we are led to believe). He begins to make arrangements and discovers that the bureaucratic obstacles are significant. Using his power to cut through the barriers, he arranges for a full-honors military funeral at Arlington cemetery. The president is not happy:

> TOBY: He went and fought a war 'cause that's what he was asked to do. Our veterans are treated badly. And that's something history'll never forgive us for.
> BARTLET: [pause] Toby, if we start pulling strings like this, don't you think every homeless veteran's gonna come out of the woodwork?
> TOBY: I can only hope, sir.

While a boys' choir sings "The Little Drummer Boy" as part of the White House's Christmas festivities, the episode comes to its conclusion and climax simultaneously.

> The montage is jam-packed with gloriously patriotic brief shots (the visual equivalent of the verbal snippet) of the veteran's interment at Arlington National Cemetery. The young voices sing in harmony

back at the White House, serving as a reminder of a similarly orchestrated effort of young manhood during wartime. Director Alex Graves intercuts the precision honor guard reverently folding an American flag with a shot of the West Wing staff falling into line formation to listen to the carolers. The intercutting makes the formal point that both groups are soldiers serving the same higher good: the nation.[15]

Judith Shklar, in a series of essays considering the qualifications and implications of certain institutions for the idea of citizenship (especially the franchise and the right to labor), notes that there has been a powerful connection in American thought between military service and full "citizenship." Those who fight for the country should have the full exercise of the franchise and opportunity to labor — the willingness to make ultimate sacrifice by the person requires concordant willingness by the nation.[16] Certainly this point has been recognized throughout American socio-political history, from the demands for enfranchisement by black soldiers of the Civil War to the criticisms raised by World War II Japanese-American soldiers whose families were interred in concentration camps in the United States.

The West Wing makes the further point that duty to veterans, like to other forgotten American groups, extends beyond simply assuring them voting rights or other of the most basic political rights. Responsible action with regard to veterans means that the nation must take care of them. This is not to say that paternalism must be involved; duty in this case recognizes that although the veterans of American wars have little more claim to political or social rights than the rest of the country's groups, veterans' special willingness to sacrifice requires fuller attention to making sure that they are not left behind in the pursuit of their lives in America than the government might give to the "average citizen." It is hard to square this notion with the generally egalitarian impulses of Sorkin and his characters, and one wonders what may lie beneath the surface of this contradiction. Smith argues that an episode like this provides the people of *The West Wing* the opportunity to reclaim patriotism as a value not just of the right but of the left and all Americans.[17] Whatever the case may be, the point about duty remains broadly the same: the government and the dutiful American must remember and assist those Americans who have been "left behind" or who cannot help themselves.

Power and Duty

Americans have been of at least two minds, so far as the pursuit and use of power are concerned. On the one hand, we distrust those who seek

after power, and our political ideology reflects a continuing project to limit power's accrual and (ab)use (for the fear seems to be that the use of power will lead almost inevitably to its abuse). On the other, we acknowledge that going after power and the rewards that it can bring have played and do play a fundamental role in the construction and maintenance of our political life and that we could not really exist as a polity without the desire by at least some of our members for having and holding power.

Until now, a reading of this paper may have left the impression that the characters portrayed in *The West Wing* pursue careers of near-pure altruism. In other words, they perform careers of public service entirely from their senses of duty. Although Aaron Sorkin has indicated the show is a "valentine to public service," hagiography hardly seems to be the point. Whether or not the cast and crew of the show consciously appreciate it, this weekly drama portrays the delicate dance of pursuing duty and power in the American presidency.

Power and duty highly intertwine in the American political context, and it is the combination of power with duty that allows power to exist in an American context of distrust for power. Duty cannot be fulfilled without some measure of power, for power gives the obligation of duty its sinews and strength. Similarly, duty should temper power, providing limits on its exercise, serving as the stopgap to prevent power from fulfilling the old prophecy and corrupting. In short and as we shall see, *The West Wing* supports this line of argument, showing by example how various configurations of duty and power can either edify the American Republic or provide a glimpse of the seeds of its destruction.

Can Political Americans Pursue Power?

A distrust of power's use shoots through the political landscape — our ideology, from *The Federalist* papers and the Constitution to our contemporary debates about the appropriate size and role of the government, shows it; our institutions — federalism, separated powers, checks and balances, even our written constitution — reflect a continuing attempt to limit power's accrual and (ab)use.

Alexis de Tocqueville noted that democratic people, like Americans, resent the use of power by one person over another.

> Let us suppose that all the citizens take a part in the government and that each of them has an equal right to do so. Then no man is different from his fellows, and nobody can wield tyrannical power; men will be perfectly free because they are entirely equal, and they

will be perfectly equal because they are entirely free. Democratic people are tending toward that ideal.[18]

For Tocqueville, the desire to prevent another from gaining power over one-self manifested in a drive for equality, a drive so strong as to be called "ardent, insatiable, eternal, and invincible."[19]

Americans have built their institutions, especially the federal government, in such a way as to reflect their ideological distrust of power. The Constitution's provisions for federalism, separated powers, checks and balances, and the very fact that the constitution was a written one all belie a distrust of power and especially power's concentration. In introductory classes on American politics, it is almost a cliché to explain to students that the founders' goal in establishing the constitutional system was neither efficiency nor ease of action. For the founding generation, the distrust was rooted in their particular conception of human nature: men grasped after personal advantage and selfish gain, and the goal of government was to turn native human impulses toward the management of collective affairs and to blunt men's worst impulses. As James Madison famously remarked in "Federalist No. 51":

> Ambition must be made to counteract ambition. The interest of the man must be connected with the constitutional rights of the place. It may be a reflection on human nature, that such devices should be necessary to controul the abuses of government.... If men were angels, no government would be necessary. If angels were to govern men, neither internal nor external controuls on government would be necessary. In framing a government which is to be administered by men over men, the great difficulty lies in this: You must first enable the government to controul the governed; and in the next place, oblige it to control itself.[20]

The overall gist of Hamilton, Madison, and Jay's argument was that although the new government would have larger powers than the Articles of Confederation government, these powers were the absolute minimum necessary for effective governance and were filled with plenty of provision to prevent their usurpation or abuse.

Even more saliently, Tocqueville noted that Americans fundamentally distrusted people who pursue power because it seemed an assault upon the equality they valued more highly than almost anything else. For Americans, those who seek power set themselves up over their equals in a democratic society, and the power seekers' perceived attempt at inequality rankles their fellow citizens.[21] Not only that, but Tocqueville warned that overwhelming ambition threatened democratic citizens:

In democratic countries [ambition's] field of action is usually very narrow, but once these narrow bounds are passed, there is nothing left to stop it.... As a result, when ambitious men have seized power, they think they can dare to do anything. When power slips from their grasp, their thoughts at once turn to overthrowing the state in order to get it again.[22]

Duty Through Power, Power Through Duty

The pursuit of power intrigues and attracts Americans no less than any other peoples. Even our greatest, most dutiful leaders have admitted that power pulls on them, but they have been fairly reticent to admit such in public. As Abraham Lincoln scholar Michael Johnson noted, "The excitement [about being suggested as a possible nominee in the 1860 presidential contest] caused Lincoln to confess to a Republican friend who asked if he intended to compete for the nomination, 'I will be entirely frank. The taste is in my mouth a little.'"[23] Even when confronted with a general who publicly questioned his leadership, Lincoln was loath to back away from his idea that pursuing power was by necessity a negative quality. In an 1863 letter to Joseph Hooker appointing him the general of the Army of the Potomac, Lincoln wrote,

> You have confidence in yourself, which is a valuable, if not
> indispensable quality. You are ambitious, which, within reasonable
> bounds, does good rather than harm.... I have heard, in such a
> way as to believe it, of your recently saying that both the Army
> and Government needed a Dictator. Of course it was not *for* this,
> but in spite of it, that I have given you the command. Only those
> generals who gain successes, can set up dictators. What I now ask
> of you is military success, and I will risk the dictatorship....[24]

Lincoln knew that people find power attractive, and the combination of the pursuit of power along with duty (i.e., wanting to gain power while concurrently wanting to do one's duty to the country) did not cheapen the fulfillment of duty, as long as duty remains one of the primary motivations of political actors.

The West Wing argues throughout its five seasons that power and duty must be firmly tied to one another and that power must be subordinate to duty. Without duty to guide power, to give sinews and skeleton to power's muscles, power becomes dangerous, in the way that Tocqueville notes above. Supported by a frame of duty, however, power mobilizes duty and makes its

desires attainable. *The West Wing's* concept of appropriate American power relies upon duty driving the uses of power, either the seeking of it or the abdication of it.

Most often, it is through stories of partisan conflict that *The West Wing* addresses duty and power in combination. Two sets of stories about elections — Bartlet's two campaigns for the presidency — and the fourth and fifth season storyline about the president's temporary abdication of office under the 25th Amendment offer some clear insights into how Sorkin and the rest of *The West Wing's* cast and crew conceptualize the appropriate use of power in American politics.

In the two-part episode "In the Shadow of Two Gunmen," the flashback motif mentioned above serves as the device to examine the interplay of duty and power in a contentious election. The election device allows the show's creative minds to present the characters as they appear under contest pressure; we see the characters' mettle when tested, and the contention of the electoral process acts as a refiner's fire, separating the pure from the impure (or the dutiful from the undutiful, in this case).

In particularly telling flashback, we see Senator John Hoynes (the future vice president) arguing with Josh Lyman, his aide at the time, about Social Security. Hoynes is the presumptive Democratic nominee, and he wants to avoid talking about Social Security in the New Hampshire primary because "Social Security is the black hole of American politics.... It is the third rail. You step on it and you die." After Josh and Hoynes conclude this public argument, Hoynes has a private conversation with Josh in the hall:

> HOYNES: You don't seem to be having a very good time lately.
> JOSH: I don't think the point of this is for me to have –
> HOYNES: I'm saying you've been pissed off at every meeting for a month.
> JOSH: Senator, you're the presumptive favorite to be the Democratic Party's nominee for president. You have $58 million in a war chest with no end in sight, and I don't know what we're *for.*
> HOYNES: Josh —
> JOSH: I don't know what we're for, I don't know what we're against. Except we seem to be for *winning* and against somebody else winning.
> HOYNES: It's a start.
> JOSH: Senator —
> HOYNES: Josh, we're gonna run a good campaign. You're gonna be proud of it. And when we get to the White House, you're

gonna play a big role. In the meantime, cheer up. And get off my ass about Social Security.

As we know, Josh will eventually leave his work for Hoynes to join the Bartlet campaign, where it is clear what everyone is for.

And Hoynes will lose the nomination to the plucky Bartlet campaign, forcing Hoynes to accept the vice presidential nomination in the knowledge that he must occupy the republic's potentially most boring job if he is to ever have a shot at the top. In the world of *The West Wing*, Hoynes' loss seems to occur for two reasons, and neither of them has much to do with the strategy we see Bartlet's staff devising later in the episode. First, in a mechanical and ideological sense, Bartlet will win because his liberal populism will resonate with voters and because they'll sense his honesty, compassion, and forthrightness, and they will reward this man who plays politics as if it actually matters rather than as a game of business as usual. (We see these qualities later in the same episode, as Bartlet explains to a dairy farmer why the candidate voted to cut milk subsidies: "I voted against that bill 'cause I didn't want to make it harder for people to buy milk. I stopped some money from flowing into your pocket. If that angers you, if you resent me, I completely respect that. But if you expect anything different from the president of the United States, you should vote for someone else.") True virtuous duty, in the form of Bartlet, will be present in this set of primaries, and since the American voter often complains (on television drama and in real life) of being fed up with insincere politicians, the voters will reward that virtue when it appears.

Second, the metaphysics of *The West Wing* demands that the reward take place. Since, as I have argued, *The West Wing* is a drama about duty, its moral universe rewards duty, giving it a chance to operate, to make successes and mistakes, and to offer an example of what an American politics of duty could be. None of these can happen without a grant of power. Thus, the dutiful American politician, who operates according to the virtue as outlined above, must be granted power so that we viewers can see duty in action. Such a moral universe is almost Olympian or Calvinist, in the sense that the larger forces "out there" reward those who share their ideals and values. Some set of gods or larger metaphysical powers ensures that duty receives power as a reward, for without power duty is an impracticable virtue. We viewers recognize that these are not gods in the sense of some set of real forces or entities that have material and spiritual effects in people and societies. These gods are actually the forces of narrative convention, stories following certain patterns, letting us know that we will not have to worry at the end of the day because everything has to work out all right, so that we can have further

episodes and seasons. In the story world of *The West Wing*, this effect operates as if deities of duty punish the selfish and reward the dutiful, doling out power and political patronage to the Bartletistas and denying it to those who desire it most of all and above all.

To be sure, the staffers of *The West Wing* and the president seek after power, but their power is attained through following one's duty. Duty, thus, becomes both means and end for power: means in the sense that the show's cosmology rewards the dutiful with power and denies the greatest prize to those who are not fully given over to duty; end in the sense that power allows the characters to do their duty. In other words, doing one's duty allows one to attain power, and power used allows one to complete one's duty.

It is less this circular logic that offends the philosopher and more that the quality lauded as a supreme virtue (duty) and an end after which Americans should seek has also been made into a means. The larger metaphysical forces on *The West Wing* reward the dutiful Bartlet and his staff over and over again. Whenever they forget that the pursuit of power must not be done for its own sake but to serve the good of the whole nation, they encounter frustration and difficulty in achieving their day-to-day and long-term goals. Several examples make this point clearer.

In season four of the series, the Bartlet administration embarks upon its campaign to retain the White House in the face of a Republican competitor widely portrayed as an intellectual lightweight, who seems to want to be president for no discernibly thought-out reasons. This Florida Republican presents a campaign based upon the repetition of palliative sound bites and catch phrases without elaboration of any substance behind them.[25] Throughout the several episodes devoted to the campaign (and the concurrent running of the country), the staff struggles to understand how to present Bartlet not as the know-it-all, smartest (and thus most resented) kid in the class, but as the only one of the two candidates able to deal with the challenges of the presidency. As Toby notes in the episode "20 Hours in America," "If our job teaches us anything, it's that we don't know what the next president's going to face.... If we choose someone to inspire us, then we'll be able to face what comes our way.... Instead of telling people who's the most qualified, instead of telling people who's got the better ideas, let's make it obvious. [pause] It's going to be hard."

The continuing struggle to act in integrity with oneself and one's duty — to be the presidential candidate who won't insult the voters by assuming they neither can nor want to hear the complexities of policy — returns over and over in the episodes devoted to Bartlet's re-election. In "Game On," the president and his staff struggle with how they can present the complexity, depth, and nuance of the political and policy decisions that the president

must make every day. The morning of the final presidential debate, the staff is still trying to come up with "ten words" for several vital issues — sound bites for each of the major issues that he might be asked about in the debate. When the time of the debate comes, the president runs with it from the first minute, challenging the simplicity and simple-mindedness of his competitor's canned responses. Finally, when one moderator asks the challenger about a plan to cut taxes, even in the face of information suggesting that such will damage the economy, Governor Ritchie responds with another pre-digested bit of policy.

> RITCHIE: We need to cut taxes for one reason. The American people know how to spend their money better than the federal government.
>
> BARTLET [*calmly*]: There it is.
>
> [*Intercut of a reporter watching on a video monitor and asking, "What the hell?" C.J. Cregg, the press secretary, says almost to no one in particular, "He's got it."*]
>
> BARTLET [*continuing*]: That's the ten-word answer that my staff's been looking for for two weeks. There it is. Ten word answers can kill you in political campaigns. They're the tip of the sword. Here's my question [back to Ritchie]. What are the next ten words of your answer? Your taxes are too high? So are mine. Gimme the next ten words. *How* are we gonna do it? Gimme ten after that, I'll drop out of the race right now.[26]
>
> Every once in a while, every once in a while, there's a day with an absolute right and an absolute wrong, but those days usually involve body counts. Other than that, there aren't too many un-nuanced moments in leading a country. That's way too big for ten words.
>
> I'm the president of the United States, not the president of the people who agree with me. And by the way, if the Left has a problem with that, they should vote for somebody else.

C.J. then takes the gloves off in her "spin room" offstage; there's no reason to force experts who can elaborate administration positions to keep it simple in the name of winning. "The president just reminded us that complexity isn't a vice." In the next episode, where the actual election takes place, President Bartlet ends up winning by a very comfortable margin of several percentage points.

Again, *The West Wing* emphasizes the dual, intertwined nature of duty and power. President Bartlet's duty to his constituents appears to be to remind them that politics is a complex, difficult undertaking and that the

promise of programs and agendas that seem too good to be true are probably exactly that — too good to be true.[27] Duty in this situation requires that Bartlet be honestly who he is, honor the voters' right to know that politics and government require hard work with the expectation that not much will come out of it, and that he will work for the good[28] of *all* the people. And when Bartlet, in this most public forum, commits himself to doing his best for all, not just for re-election, not just for political vindication, not just to prove that smart should beat simplistic, he receives his reward. The narratological gods of *The West Wing*'s world make sure he wins the election, in spite of his perceived arrogance, in spite of his covering up a significant and possibly serious health condition, and in spite of any past sins.

When Power Is Put Before Duty

What happens when power's pursuit or retention comes between the characters and their duties? What occurs when the White House forgets to place the good of the whole nation above that to self, friends, family, or party? In brief, chastisement of some sort occurs, and the people involved are called back to the pursuit of duty, with the pursuit of power no longer serving as end but as means. Placing power ahead of duty results in a disequilibrium in *The West Wing*'s universe, and the show's politics (both inside and outside the story line) move to correct the imbalance.

In the opening of the fifth season of the series,[29] President Bartlet, due to the kidnapping of his daughter and his realization that he is unable to make rational, thoughtful decisions, decides to avail himself of the 25th Amendment's provision that allows the president to temporarily step aside.[30] As a result of the vice president's recent resignation, the speaker of the house — the leader of the Republican opposition — takes over as acting president. The staff takes this as a particularly hard state of affairs, but Deputy Chief of Staff Josh Lyman takes the new reality even more threateningly than most.

Josh has the job of playing the hardball side of politics more than most of the characters (although they all play the political game, Josh plays the hardest version of it). It's he who most often must hammer recalcitrant, balking Democrats into line and peel off weak Republicans with threats and bribes. Josh does not lack a moral center, but his role requires him to always regard and use the political ramifications of every situation in pursuit of the president's agenda. For Josh, his duty to the country often becomes tangled and confused with his duty and loyalty to his party and to Bartlet.

Josh immediately considers the political aspects of this radical change.

One staff member says, "The president has handed over power to his political enemy. It's a fairly stunning act of patriotism...." Josh worries that the president looks weak to the nation: "It's gonna say we're not handling [the crisis]. We're gonna lose the [next] election." Josh decides that the president's temporary abdication of his powers is a mistake and that the Bartlet administration needs to find out how the crisis is playing to the public.

Leo McGarry, the chief of staff, appears to have no such hesitancies. In a meeting with senior Democratic leaders who accuse him of failing to consult them, of putting his friendship with the president ahead of the good of the country, and of elevating the opposition, Leo responds. "I didn't elevate them — the Presidential Succession Act of 1947 did. And I'm not prepared to think about politics while we are under terrorist attack. The republic comes first." After the meeting, in a private conversation with Leo, Josh pushes him to think about the politics, even suggesting that the White House do polling on the crisis. Leo emphatically refuses.

Josh becomes more and more convinced that the Republicans are planning some form of political *coup d'état*, using the presidential crisis as an excuse to carry out their "radical right" agenda, to "start legislating with their guy in the Oval" Office, and to get everything they want. Josh confronts the acting president's chief aide in the bathroom.

> JOSH: You're campaigning in the middle of a national tragedy!
> STEVE ATWOOD: You don't get it, do you? The Republicans are in awe of Bartlet. He recused himself in the only way he could. In the way envisioned by the Constitution. The whole notion of the 25th Amendment is that the institution matters more than the man. Bartlet's decision was even more self-sacrificing because he willingly gave power to his opposition.
> JOSH: The institution may matter more, but it's your guy protecting it, not ours.
> ATWOOD: A truly self-sacrificing act usually involves some sacrifice.
> JOSH: So, now you're going to nail us to the cross.
> ATWOOD: No. You beat the terrorists at their own game. We're not stupid, Josh. We try to use this to our advantage, it will blow up in our faces. We'd seem callous and unfeeling. In contrast to Bartlet's extraordinary gesture of courage and patriotism. *(pause)* And anyone who thinks otherwise has a particularly craven way of looking at politics.

Atwood leaves the scene, and Josh looks particularly chastened. For the rest of the episode, Josh's paranoia and suspicion are considerably lowered, and

after President Bartlet's daughter is found and the acting president leaves office, Josh and Atwood are even able to share a (relatively) genial farewell.

It is "the enemy" who must remind Josh to what he owes allegiance. The above indicates that duty is recognized by opposites in *The West Wing*'s universe, and those most committed to their duty know that power must be brought in line with the service of duty. When power overwhelms duty and escapes its control, all dutiful men and women must bring the violator back into the fold. Atwood reminds Josh that the Republicans, enemies of the Bartlet administration that they might be, are doing what the good of the nation requires of all people. They won't take partisan advantage of the situation. Even if they wanted to, there exists a check upon such behavior: "It would blow up in our faces." The media, other politicians, and presumably the citizenry would punish the Republicans for their temerity, by doing that which will most control a democratic politician — denying victory at the ballot box.

Furthermore, the understanding that "it would blow up in our faces" serves as a reminder to Josh that there also exist checks upon his behavior, his pursuit of power, his amnesia about the dictates and requirements that duty imposes. The episode does not draw out the consequences explicitly, but we can surmise what might happen if Josh followed through on his plan to leak the information that the GOP leadership meets regularly in the White House and plans to foment its own agenda under cover of national crisis. Quite likely, Josh's leaks would have the intended effect. However, the leaks might also paint Josh as a partisan infighter, willing to use a national emergency to disable and crush Republicans, resulting in press, political, and public disapprobation for the Democratic party. In wounding his enemy, Josh may wound his allies as badly, leaving the national political mood much worse with no real or apparent gain.

Power must be treated carefully, we learn. Power and its pursuit are morally neutral forces in human life; moral color comes depending upon whether one uses power as means or end. *The West Wing* appeals to viewers because it depicts the insides of the halls of power, but the show argues that power's animating force must not be itself, or it will turn in upon itself, cancerously eating away the body politic. No, duty must attenuate and animate power, checking power while simultaneously making it greater through putting it in service to others.

Conclusion

The West Wing does not create new political theory, nor does it attempt to do such. As entertainers, the creative team of the show has indicated that education is not one of its real functions.[31] The drama does, however, engage

with some of the classic questions of the American ideology of governance, and it poses these questions in a fairly unique way — by positing that American leaders have a discernable call to duty and that they can best serve the problems and challenges of the republic with reference to the demands of duty. This emphasis on duty provides perhaps the most distinctive aspect of *The West Wing*'s project and the one of most interest to those who study politics and political theory. For in framing the solution to the challenges of American common life in terms of duty, subsuming the pursuit of power to something more ennobling, *The West Wing*'s creative team suggest a way out of our perceived miasma of partisanship and posturing. Plenty of work in this regard that may still be done — work that a television program does not (and perhaps cannot) do. We must critically consider the further development of our understanding of duty, the specific goals that duty might pursue, and the ways that this political value might sustain democratic republican institutions. Only then will the opportunity come to make virtue from vice.

Notes

1. The origins of the word itself lie in the Latin *dēbēre*, which signifies obligation, debt, and service.

2. Dahl 1978.

3. Tocqueville 1969, p. 236.

4. Ballou 1861.

5. Shklar 1991, p. 5.

6. Sorkin 2000.

7. This echoes one of Leo's lines earlier in the episode, where, in response to the president's barb that Leo pulls the president to the political center, Leo responds, "I serve at the pleasure of the president." Leo emphasizes that he understands his duty lies in implementing the president's will and that responsibility for the administration's direction lies with the president and no one else.

8. Lehmann 2001, pp. 93–96.

9. The West Wing: *The Official Companion*, p. 203.

10. Many media critics contended that the introduction of the Ainsley character provided Sorkin a means to soften criticism that his show offered only liberal viewpoints and unfairly criticized the right wing. Sorkin denied that this was his motivation; Ainsley came about as a natural development of the entertaining story he wanted to tell. Interestingly, after Emily Procter left the show as a recurring character, the fourth season introduced another Republican lawyer (this time a white male played by Matthew Perry), who applied to work at the White House because he also wanted to serve and because he had been blacklisted by his party. He ended up with the same office as Ainsley and for two episodes fulfilled many of the roles the previous character had.

11. A recent episode, "Red Haven's On Fire," explicitly used John Rawls' veil of ignorance to explain why progressive rates provide a fair way to conduct tax policy. Woven into the story line, one character explains that the most just way to design such a policy

is to, in supposed ignorance of one's eventual status in life, create a system that is broadly just. Again, we see duty, in that the philosophical set-up asks us to leave aside particular interest and look to the best social good.

12. Lane 2003, p. 33.

13. Of the series' nine regular characters, three are female and one is an African-American male.

14. *Ibid.*, p. 38.

15. Smith 2003, p. 134.

16. Shklar 1991, pp. 13–23 *passim.*

17. Smith 2003.

18. Tocqueville 1969, p. 503.

19. Tocqueville 1969, p. 506.

20. Hamilton et al. 1982, p. 263.

21. Tocqueville 1969, pp. 671–73.

22. Tocqueville 1969, p. 631.

23. Johnson 2001, p. 82.

24. Johnson 2001, p. 232.

25. The parallels between the campaigns of Bartlet's competitor and the George W. Bush campaign of 2000 are not subtle, and they do not seem to be designed to be such.

26. At this point, we see intercut shots of the challenger, played by James Brolin, looking alternately befuddled and enticed by the possibility that the president might somehow drop out.

27. The show itself also seems to enter into a call to the viewers and thus the American people (which may be largely synonymous in the creators' minds) to stop settling for a politics of the simple and the selfish and demand more of themselves and their leaders. Even if voters seem to reward those politicians who appeal to the lowest common denominator, *TWW* production staff and crew imply with these episodes about the Bartlet re-election that the American people have a duty to ask more not just of their politicians but also of themselves.

28. As he sees it, of course. *TWW* never seems to consider the possibility that Bartlet and his staff may not be able to see the good of all, because of some blinder of partisanship, temporality, or other consideration.

29. This story line involved two episodes, "7A WF 83429" and "The Dogs of War," and I treat them as one.

30. Section Three of the Amendment reads, "Whenever the President transmits to the President pro tempore of the Senate and the Speaker of the House of Representatives his written declaration that he is unable to discharge the powers and duties of his office, and until he transmits to them a written declaration to the contrary, such powers and duties shall be discharged by the Vice President as Acting President."

31. Sorkin 2000, http://www.pbs.org/newshour/media/west_wing/sorkin.html, accessed 22 May 2003.

Works Cited

The West Wing

"And It's Surely to Their Credit." Season 2, episode 5, first broadcast 1 November 2000. Written by Aaron Sorkin, story by Kevin Falls and Laura Glaser, directed by Christopher Misiano.

"The Dogs of War." Season 5, episode 2, first broadcast 1 October 2003. Written by John Wells, directed by Christopher Misiano.

"Game On." Season 4, episode 6, first broadcast 30 October 2002. Written by Aaron Sorkin and Paul Redford, directed by Alex Graves.

"In Excelsis Deo." Season 1, episode 10, first broadcast 15 December 1999. Written by Aaron Sorkin and Rick Cleveland, directed by Alex Graves.

"In This White House." Season 2, episode 4, first broadcast 25 October 2000. Written by Aaron Sorkin, story by Peter Parnell and Allison Abner, directed by Ken Olin.

"The Indians in the Hallway." Season 3, episode 7, first broadcast 21 November 2001. Written by Allison Abner, Kevin Falls, and Aaron Sorkin. Story by Allison Abner. Directed by Paris Barclay.

"In the Shadow of Two Gunmen: Parts I and II." Season 2, episodes 1 and 2, first broadcast 4 October 2000. Written by Aaron Sorkin, directed by Thomas Schlamme.

"Let Bartlet Be Bartlet." Season 1, episode 19, first broadcast 26 April 2000. Written by Aaron Sorkin, Peter Parnell, and Patrick Cadell, directed by Laura Innes.

"Mr. Willis of Ohio." Season 1, episode 6, first broadcast 3 November 1999. Written by Aaron Sorkin, directed by Christopher Misiano.

"Pilot." Season 1, episode 1, first broadcast 22 September 1999. Written by Aaron Sorkin, directed by Thomas Schlamme.

"Red Haven's on Fire." Season 4, episode 17, first broadcast 26 February 2003. Written by Aaron Sorkin, story by Mark Goffman and Debora Cahn, directed by Alex Graves.

"7A WF 83429." Season 5, episode 1, first broadcast 24 September 2003. Written by John Wells, directed by Alex Graves.

"20 Hours in America." Season 4, episode 1, first broadcast 25 September 2002. Written by Aaron Sorkin, directed by Christopher Misiano.

Books, Articles, Letters, and Interviews

Ballou, Sullivan. 1861. "Letter." *The Sullivan Ballou Film Project*. 20 May 2003. www.sullivanballou.com.

Beavers, Staci. "*The West Wing* as a Pedagogical Tool: Using Drama to Examine American Politics and Media Perceptions of Our Political System." The West Wing: *The American Presidency as Television Drama*. Eds. Peter Rollins and John O'Connor. Syracuse, N.Y.: Syracuse University Press, 2003, 175–86.

Dahl, Robert. "On Removing Certain Impediments to Democracy in the United States." *Political Science Quarterly* 92.1 (Spring 1978): 1–20.

De Tocqueville, Alexis. *Democracy in America*. Trans. George Lawrence. New York: HarperPerennial, 1969, rev. 1988 [1835 and 1840].

Hamilton, Alexander, James Madison, and John Jay. *The Federalist Papers*. New York: Bantam Books, 1982 [1787–88].

Johnson, Michael P., ed. *Abraham Lincoln, Slavery, and the Civil War: Selected Writings and Speeches, The Bedford Series in History and Culture*. Boston: Bedford/St. Martin's, 2001.

Lane, Christina. "The White House Culture of Gender and Race in *The West Wing*: Insights from the Margins." The West Wing: *The American Presidency as Television Drama*. Eds. Peter Rollins and John O'Connor. Syracuse, N.Y.: Syracuse University Press, 2003, 32–41.

Lehmann, Chris. "The Feel-Good Presidency." *Atlantic Monthly* March 2001: 93–96.

Rollins, Peter C. and John E. O'Connor, eds. The West Wing: *The American Presidency as Television Drama.* Syracuse, N.Y.: Syracuse University Press, 2003.

Shklar, Judith. *American Citizenship: The Quest for Inclusion.* Cambridge, Mass.: Harvard University Press, 1991.

Smith, Greg M. "The Left Takes Back the Flag: The Steadicam, the Snippet, and the Song in *The West Wing*'s 'In Excelsis Deo.'" The West Wing: *The American Presidency as Television Drama.* Eds. Peter Rollins and John O'Connor. Syracuse, N.Y.: Syracuse University Press, 2003, 125–35.

Sorkin, Aaron. "Interview." *NewsHour With Jim Lehrer.* 2000. Public Broadcasting Service. 22 May 2003. www.pbs.org/newshour/media/west_wing/sorkin.html.

_____. *The West Wing Script Book.* New York: Newmarket Press, 2002.

Warne, B.E. The West Wing *Continuity Guide.* 1999–2003. Personal site. 17–22 May 2003, 27–31 October 2003. westwing.bewarne.com/default.html.

Waxman, Sharon. "Inside *The West Wing*'s World." *George* November 2000: 54–59, 94–96. Rpt. in The West Wing: *The American Presidency as Television Drama.* Eds. Peter Rollins and John O'Connor. Syracuse, N.Y.: Syracuse University Press, 2003, 213–22.

The West Wing: *The Official Companion.* New York: Pocket Books, 2002.

11

Women of *The West Wing*: Gender Stereotypes in the Political Fiction

Laura K. Garrett

During the last fifteen years, women have increased their prominence in the sphere of U.S. politics, achieving greater visibility in powerful positions and in elective office. Throughout their history, Americans have held an ambivalent attitude toward women in politics that often corresponds to discomfort with changing gender roles and ideologies. Despite many gains in political representation, American culture retains its uneasy relationship with strong, powerful women. Often, women in public office are perceived as manipulative, power-hungry, or masculine, and as a result, not portrayed with much depth. Even so, women in public roles receive more airtime and attention than a few decades prior and take leading roles as the subjects of films and television shows. Since media of all kinds — the mainstream press as well as a television drama — contribute to the American interpretation of women in politics, it is important to explore how these women's roles are portrayed through the popular culture lens of television and how they compare to real-life examples. Screenwriter Aaron Sorkin's scripts for the television drama *The West Wing*, which were written over four seasons spanning from 1999 to 2003, offer fertile ground to examine the main female characters and underlying gender dynamics that he presents in the political arena.

In *The West Wing*, Aaron Sorkin creates memorable, quick-witted, and loquacious female characters, with a range of admirable traits and in professional positions of power. On the surface, these women appear fully competent and equally match their male counterparts when paired in debates or other situations. Sorkin assigns a variety of issues to their characters, such

as the environment, the military, and even women's rights. However, upon close analysis, many of these women — especially the cameo roles on *The West Wing*— play into narrow frameworks and stereotypes of women's roles, undermining and demeaning the strength and credibility ascribed to Sorkin's other female protagonists. Sorkin's female characters have been cast with physically beautiful women, and the dialogue cadence and trivialized subject matter for some of them falls into traditional stereotypes. While *The West Wing* offers a glimpse of political women, it does not reflect an accurate portrayal of modern women in politics, and instead it comes close to perpetuating the stereotypes created by the media.

When *The West Wing* first aired in 1999, the fictional presidential administration echoed a version of the Clinton administration on many levels. The White House dynamic Aaron Sorkin created reflects an idealized, liberal President Josiah Bartlet, played by Martin Sheen, surrounded by a diligent, righteous staff working with a sense of duty for the good of the United States. This scenario romanticizes public service by allowing its characters room to stake out clear, ethical positions from a liberal perspective. Another reflection of life in the Clinton White House was the greater diversity in the cast of characters and the increasing profile of women and African Americans at higher levels of power. Even though the television show was not modeled directly after the Clinton White House, audiences accepted these characters more readily because of their basis in political life. Within the walls of the White House, Sorkin creates a gender dynamic that mirrors the demographic found in most government entities in Washington, D.C.— male leaders with female secretaries and assistants, with a few token women in leadership posts. Sorkin's female characters are limited by this reality at times, even when the women hold positions of power.

Most of the female characters in *The West Wing* are peripheral ones, figures who would not be seen by the public in real life and therefore have no distinct modern counterpart, but Sorkin writes two intriguing characters in First Lady Abigail Bartlet, played by Stockard Channing, and Press Secretary C.J. Cregg, played by Allison Janney. With the first lady cast in a traditional female role and press secretary as a traditional male role, these two characters represent opposing challenges for a writer. Because of the media's influence over constructing culture, comparing the portrayal of Abigail Bartlet and C.J. Cregg to their real-life counterparts in Hillary Clinton and Dee Dee Myers, who served as press secretary for President Clinton, is relevant to the question of how women are portrayed in the media at large. Upon closer analysis, the similarities become apparent in the way Sorkin creates these female characters and how the media portray people like Hillary Clinton. Sorkin had strong female role models upon which to base his

characters, but he missed an opportunity to push past the stereotypes created by the media.

Portraying the First Lady

Traditionally, the function of a first lady has been largely ceremonial, amounting to the status of national hostess, good wife, and mother. Most first ladies remained unseen by the public and performed in an official capacity only in social circumstances. Even when some first ladies felt comfortable in the public spotlight, for instance as Jackie Kennedy, the role remained one confined to traditional feminine traits of modesty, deference, and privacy. Jackie Kennedy focused her energies on aspects of the presidency that were acceptable in a woman's domain — education, the arts, and fashion. This ceremonial role of the first lady has come to serve a greater cultural purpose with the spread of media, especially television. The first lady serves as a cultural icon that symbolizes the aspirations and qualities of an American woman. Outspoken and unabashed, First Lady Eleanor Roosevelt reshaped the role of first lady, allowing the president's wife to hold independent political thoughts from her husband and to exert influence in the administration's policies. However, few first ladies have followed her lead so brazenly, possibly because the media are not as forgiving of first ladies as it once was in Eleanor's time. Since the first lady serves as a symbolic role of how the country wants to view its women, women in that position who stray from traditional feminine roles have caused controversy, in fiction and reality. Hillary Clinton is a perfect example of a modern first lady grappling with increased media scrutiny of every aspect of her life. When Aaron Sorkin wrote his character of Abigail Bartlet, he no doubt used Hillary as a model. Given the media attention to the role of first lady, the challenges Sorkin creates for Mrs. Bartlet and the ones the media portrayed of Hillary Clinton exemplify the delicate balancing act first ladies have with the public perception of their roles.

HILLARY CLINTON

Beginning with the 1992 presidential campaign and continuing through her years as first lady, Hillary Clinton received an unprecedented barrage of press coverage. The media dubbed the question over whether she would be an asset or liability to her husband's campaign as "The Hillary Factor." Most mainstream news publications framed her role in this dichotomous way, including *U.S. News and World Report*, which followed up with the article,

"Hillary Clinton: Does She Help or Hurt?" The article begins by characterizing Hillary in this way: "For some, she's an inspiring mother-attorney. Others see in her the overbearing yuppie wife from hell — a sentiment that led GOP media guru Roger Ailes to quip that 'Hillary Clinton in an apron is like Michael Dukakis in a tank.'"[1] The media created and capitalized on an image of Hillary Clinton that stirred up much controversy in the press and one that would follow her throughout her time as first lady. In many ways, this construction of Hillary's image parallels the role Aaron Sorkin would subsequently create for the first lady of *The West Wing*.

Women in politics are often judged on a superficial level in the news, and the media's focus on Hillary Clinton was no exception to this. When covering Hillary, the news concentrated on the images and values she supposedly symbolized, helping to perpetuate a certain image of her for the public. Some of what the media covered was generated from Hillary's own self-admitted public relations missteps while speaking out on issues about her professionalism. Among the incidents that the media seized upon were her references to "standing by her man" and to "baking cookies." When defending her rocky marriage in a *60 Minutes* interview, Hillary said, "I'm not sitting here, some little woman standing by my man like Tammy Wynette. I'm sitting here because I love him and respect him."[2] The press highlighted this excerpt of the interview, which partially overshadowed the main point of the session which sought to put the issue of Bill Clinton's marital infidelity to rest.

Similarly the "cookie baking" incident was widely reported, in which Hillary said, "I suppose I could have stayed home and baked cookies and had teas, but what I decided to do was fulfill my profession...." This came in a brief televised interview in which she answered a question regarding the alleged conflict of interest with her law firm and her husband as governor. The media seized upon this as an affront to homemakers, branding her with the moniker of "cookies and tea." With the assistance of the media, the political attacks on her came soon after, labeling Hillary a "radical feminist," a "militant feminist lawyer," and the "ideological leader of a Clinton-Clinton Administration that would push a radical-feminist agenda."[3] Because the media decided to focus on these peripheral issues instead of substantive ones, they helped generate this "cultural war" over the proper role for female public figures in America. This is similar to the White House world that Sorkin creates in that the first lady is often demonized for her "radical" stances on women's issues, even while they only suggest gender equity.

Physical appearance is another obstacle with which political women must contend. While male political figures are also subject to media criticisms, few concentrate repeatedly on issues of appearance. One only need

look at the coverage of Hillary Clinton's hair, clothing, and make-up during the 1992 presidential campaign and all throughout Bill Clinton's presidency in order to witness this obsession with women's appearance. Even so, Hillary played into this concern over her appearance by hiring consultants to improve her image. She changed her wardrobe, lost the headbands, and experimented with a range of hairstyles, which the media often equated with the Clinton's reliance on public opinion for their ideas. As Hillary Clinton wrote about becoming first lady, "I was no longer representing only myself. I was asking the American people to let me represent them in a role that has conveyed everything from glamour to motherly comfort."[4]

Additionally, women in politics walk a fine line between appearing weak or too aggressive, either of which will cost them votes or approval with the public. Hillary Clinton was originally seen as shrewish, manipulative, and not motherly enough to be the country's leading female role model. However, during the 1984 presidential race, the media and political opponents questioned if Geraldine Ferraro was not strong enough to make difficult military decisions precisely because she was perceived as a maternal figure. Many first ladies have battled with gender stereotypes, as have women in other high-ranking positions at the White House. Whether in fiction or real-life political drama, women in these roles struggle in different ways than their male counterparts.

ABIGAIL BARTLET

In *The West Wing*, First Lady Abigail Bartlet plays a prominent though intermittent character, which stirs up controversy in her role as a strong-willed, confident professional. Sorkin captures that controversy well in Mrs. Bartlet's character by showing the benefits, constraints, and contradictions inherent in the title of First Lady. Mrs. Bartlet, a trained medical doctor, sacrifices much of her career to accommodate her husband's political life, even losing her medical practitioner's license in the process. Technically, she lost her license because she violated medical ethics codes by giving her husband medication, but she violated these codes in an attempt to shield her husband's multiple sclerosis from the rest of the world to save his career. She plays a strong-willed, charismatic woman, often at odds with her husband over political issues. While she serves as his moral grounding on certain issues, she is perceived to be manipulative and domineering. Even so, Sorkin continually reveals how powerless she is next to her husband because her entire life is constrained by her role as first lady.

Though Sorkin portrays Mrs. Bartlet as a strong figure to balance the president, her influence and her role are usually peripheral. Originally Sorkin

wrote her character as a smaller role in order to accommodate Channing's schedule, and in the first season she appears somewhat petty as she occasionally obstructs the president's political business. As the wife of a former congressman and governor, it would seem that Mrs. Bartlet would be more politically savvy than she is portrayed at first. In the episode "White House Pro-Am" from the first season, the staffs of the president and first lady argue about statements Mrs. Bartlet makes regarding the abuse of foreign child labor. In the end, the first lady concedes defeat over her issue, but the dialogue reveals the power dynamic in their relationship.

> FIRST LADY: I concede I was wrong about the thing.
> PRESIDENT: Good.
> FIRST LADY: However.
> PRESIDENT: No "however." Just be wrong. Just stand there in your wrongness and be wrong. And get used to it.

The exchange firmly establishes that the power dynamic of the presidency extends into their marital relationship as well as their public personas, no matter how feisty, strong, or "unfeminine" Sorkin writes the first lady's character.

Mrs. Bartlet stands as a champion of women's issues through the first four seasons, though this is often merely symbolic. In the episode "And It's Surely to Their Credit," President Bartlet offends Mrs. Bartlet when he cannot name the significance of one of her heroines, investigative journalist Nellie Bly. She hounds him about this, even refuses to sleep with him at that moment until he later rewrites his entire Saturday morning radio address to reflect the important contributions of women in American history. Only when Mrs. Bartlet withholds sex does the president consider taking a public stand about women as important historical figures. The character of Amy Gardner (Mary-Louise Parker), introduced in the third season, appears in the series as a women's rights ally of the first lady and eventually as her chief of staff. Both women are strong-willed, sharp-tongued, and have a flair for the dramatic. On Amy's first day as chief of staff, Mrs. Bartlet asks her to privately help defeat the president's foreign aid bill that has an antiabortion clause. While these women know how to play the political game, Sorkin portrays them as underhanded and reckless, with a pathetic plea to her husband at the end of the episode, "I want to contribute is all." Her repeated apologetic nature undermines the strength Sorkin writes into her character; at the same time it also demonstrates her flexibility and range as a character. Mrs. Bartlet's struggle to define herself as a meaningful first lady reminds the audience of Hillary Clinton's effort to stake out her own positions, sometimes at the expense of her husband.

With Mrs. Bartlet, Sorkin creates a complex character that illustrates the hamstrung position of a professional first lady, but he could push her character further to act instead of react. In an interview, Stockard Channing explained that she is not trying to recreate the life of Hillary Clinton through her role. While her acting strategy may seek to distance herself from a real-life model, Sorkin's written creation of Mrs. Bartlet mirrors the media perception of Hillary Clinton as first lady. By limiting Abigail to confrontational scenarios with the president, Sorkin fails to mine the potential depths of her character or allow her to grow. The constrained character of Abigail Bartlet reflects the limitations the media placed on Hillary Clinton by confining their understanding of her to predictable stereotypes.

High-Ranking Women in the White House

While the role of first lady can be viewed as a traditionally feminine post, women have had difficulty breaking into traditionally male-dominated positions in the White House. Women have made greater strides in elective office than they have in high-level appointed positions. During the Great Depression, Franklin Delano Roosevelt appointed the first woman to the cabinet in Frances Perkins as secretary of labor. Since then, very few women have served as cabinet members or close advisors until the last fifteen years in the Clinton and Bush administrations. Women such as Press Secretary Dee Dee Myers, Secretary of State Madeline Albright, and Attorney General Janet Reno took prominent roles in the Clinton administration, as have National Security Advisor Condoleeza Rice, Secretary of the Interior Gail Norton, and Communications Director Karen Hughes in the Bush White House. Since the perception of these positions remains anchored in traditionally male jobs, opinions about women who assume these positions, whether in real life or fiction, are significant.

DEE DEE MYERS AND OTHER LEADING WOMEN

Modern women in the White House have confronted similar sexist situations and needed to prove themselves even more than their male counterparts. Someone who has confronted sexism in the press and in the White House firsthand is Dee Dee Myers, the youngest and also the first woman press secretary. She served in this capacity during Bill Clinton's presidential campaign and on the White House staff from 1993 to 1994. Having helped run many campaigns in the past for people such as Dianne Feinstein, Walter Mondale, and Michael Dukakis, she came to this position with substantial

experience dealing with the press. However, in her official capacity in the White House, that experience would not be enough to bypass the male hierarchy within the administration.

In recent years, Myers has been outspoken about the obstacles she confronted within the White House, explaining that sexism still exists at the highest levels of power even within a liberal administration. During a public speech, Myers pointed out, "I had a smaller office, lower rank and less salary than my predecessors."[5] During her tenure as press secretary, she said that the power structure in the communications office prevented her from doing her job in the way the subsequent press secretary, Mike McCurry, had.[6] Despite Myers' own struggles and setbacks, she conveys optimism about the increasing opportunities women have in politics. She utilized the lessons she learned as press secretary to enhance the scripts of *The West Wing* in her capacity as script advisor. The depth of C.J.'s character reflects not only Sorkin's good writing, but also Myers' keen understanding about gender dynamics and the unique struggles facing women within the White House.

Other women within the Clinton White House grappled with a variety of internal and media-generated sexism. For example, Attorney General Janet Reno was often ridiculed for her physical appearance as being too manly or stern. *Saturday Night Live* even parodied this feature of her by casting one of their male actors to play her in a sequence of skits. The satire about Reno implied that the act of appointing a woman with perceived masculine traits meant that she would be domineering and somehow upset the regular hierarchical power structure within the White House. Despite these stereotypes, Dee Dee Myers is hopeful for women in politics because of the certain "style" women bring to communicating their ideas. As an example, Myers cites how Madeleine Albright, just out of a State Department meeting, would not hesitate to be blunt, and offer a comment like, "That was the dumbest meeting." Myers says that men will not offer such frank remarks, suggesting that this is a limitation on the part of men.[7] Regardless of male or female "style," the playing field of politics remains a place of gender inequity but that offers some hope for improvement.

C. J. CREGG

The character of C.J. Cregg stands as the most powerful woman in the ensemble cast in *The West Wing*, and she was the only consistent female cast member since the beginning of the show. While the roles of Press Secretary C.J. Cregg (Allison Janney) and Public Relations Consultant Mandy Hampton (Moira Kelly) were slated as consistent cast members during the first

season, only C.J.'s character functioned as part of the inner circle of the White House. After the first season when Sorkin dropped Mandy's character, he admitted to the difficulty he had finding the right voice for Mandy, "who rarely amounted to much more than corridor filler for all those dashing-through-the-halls scenes."[8] In this way, Sorkin depicted a reality of most White House staff as an old boys' network, and C.J.'s role mirrored that of White House Press Secretary Dee Dee Myers. To Sorkin's credit, he wrote C.J.'s character as one with depth and as one of the few staff members — male or female — that evolves and grows over the course of the seasons. Even so, there are limitations to her role.

Possibly thanks to input and personal experience by Dee Dee Myers, C.J. plays a complex, deep character that rises to the challenge of the White House and evolves throughout the first four seasons. She exhibits strengths and weaknesses much like her male counterparts, yet is often left out of the information loop of the men, mainly due to her role as press secretary. Her strong-willed and witty personality, coupled with her towering height and ability to learn quickly, make her an equal match for the rest of the male inner circle. During the episode "And It's Surely to Their Credit," C.J. plays political hardball with a retiring chief of staff of the army who threatens to trash the president on live television. Knowing this man had not earned one of the medals he wears, she holds her ground and threatens to expose him. She triumphs when he backs down.[9] By putting her up against a high-ranking military official, her strength of character and aptitude for her job are displayed.

By virtue of her job as press secretary, C.J. is often kept out of the information loop and looked at by other characters as someone who is inexperienced. C.J. must work even harder because she does not hail from a political background. As press secretary she does not make political decisions but instead frames them for the press and the world. In the episode "The Crackpots and These Women," President Bartlet and Leo McGarry (John Spencer) "admire" the women in their offices, referring to C.J. as "a fifties movie star, so capable, so loving, and energetic."[10] The traits make C.J. sound like a lovable pet, not a professional woman. While these comments were meant to laud the women in the White House for being confident, they actually objectify them.

The sexism that C.J. encounters mirrors the subtle and overt sexism that modern political women face. C.J.'s character develops a tough demeanor over the seasons, especially due to the sexist situations in which she finds herself. She has to weed through the sexist rhetoric of the men around her and finds her opinion often discounted, as it was in the episode "Lies, Damn Lies, and Statistics." When C.J. learns that Leo told the president

that his staff assumed the polling numbers on his presidency would drop by a few points even though they climbed, she confronts Leo because earlier she had predicted the correct outcome.[11]

> C.J.: I was in with the president this morning. He mentioned that you told him that when you asked for predictions, everyone said we'd hold steady at 42.
>
> LEO: Yeah?
>
> C.J.: But, I didn't say that. I said we'd go up five points.
>
> LEO: I meant in general, on average.
>
> C.J.: Yeah.
>
> LEO: C.J., like lopping off the score from the East German judge.
>
> C.J.: Leo, it wasn't woman's intuition. I think it's strange...
>
> LEO: Don't read too much into it.
>
> C.J.: I'm saying it's strange my take wasn't...
>
> LEO: I'm saying don't read too much into it. All right?

C.J. suspects unfair treatment because she is a woman, and her role serves as a reminder to the latently sexist cadre of men with whom she works. C.J. also stands out as one of the few staff members who evolves and grows with her position because of her reflective nature.

Since physical appearance factors in as a component in how political women are judged, C.J.'s appearance is important to consider. While C.J. is usually professionally and modestly dressed, Allison Janney points out in an interview that Sorkin would like to expand her character's sexuality. "I think (Sorkin would) love it if I wore a rubber skirt," Janney said. "He really wants to bring out C.J.'s sexuality more and he's always flirting with it, but I think he's a little shy because he doesn't want to seem sexist in any way."[12] This comment illustrates that Sorkin is self-conscious of the potential drawbacks to exploiting C.J.'s sexuality in any way that could undermine her character. With C.J., Sorkin succeeds in creating a multi-faceted, compelling female character, and she stands out as the best developed female character on the staff.

SUPPORTIVE WEST WING STAFFERS

Aside from the first lady and the press secretary in *The West Wing*, women fulfill a range of supportive roles in the cast that leave a mixed impression about the success of women in politics at this level. By casting women in supportive roles as staff secretaries and assistants, Sorkin recreates a common gender dynamic found in Washington politics of male superiors and

female aides. Donna Moss (Janel Moloney) emerges as the most prominent assistant staff member, but others like Mrs. Landingham (Kathryn Joosten) and Debbie Fiderer (Lily Tomlin) as the president's secretaries all play supporting positions no less important to the happenings of the White House. Staff assistants for C.J., Leo, and others are only important enough to garner first names and are viewed as two-dimensional characters. This anonymity reflects the gender hierarchy apparent in White House circles, which illustrates how entrenched this power dynamic is.

However, it is not the casting of women in subordinate roles that makes them inferior, but it is the way in which Sorkin employs these characters to act as foils or create sexual tension that limits their depth and progress as women figures. For example, assistant Donna Moss and the First Lady's Chief of Staff Amy Gardner both play roles that cast them in sexual competition for another staff member, Josh Lyman (Bradley Whitford). Donna also serves as a contrast for Josh and a source for witty banter when he mulls over political problems.

The short-lived cast member of "the blond and leggy fascist" Ainsley Hayes offered a unique window into potential sexual harassment issues in the White House. In the episode "And It's Surely to Their Credit," Ainsley experiences harassment by two of her male co-workers who dislike her aggressive demeanor. As a result, they send her a bouquet of dead flowers with a card that reads "BITCH." Sam Seaborn (Rob Lowe) comes to her defense by firing the two staffers while making reference to the potential for a sexual harassment suit. Sorkin displays a lifelike scene in Washington where a woman may be demonized because of certain "unsuitable" traits for women. One of the persistent issues women face is "the narrative, which continues to be structured around boys taking action, girls waiting for boys, and girls rescued by the boys."[13] Since Sam rescues her in this case, Sorkin removes any agency Ainsley's character has in dealing with this situation and avoids the larger question about sexist treatment or the language of other staff members.

In the world of *The West Wing*, Sorkin has created a dynamic that offers many possibilities for his memorable leading and supporting casts of women. On the surface his women appear to be strong and equal to their male counterparts, but a closer look reveals that he limits their range. All of the women he includes are bright, quick-witted, and hard working, which are commendable traits. The message Sorkin conveys by creating such a disparate cast of women is ambiguous. While C.J. and Abbey appear strong and capable, Donna and Ainsley come off as dim or neurotic. Only C.J. represents a female character with true depth equitable to that of Toby, Josh, or Leo. The audience learns gradually of her motivations and about C.J.'s connection to

her father, a man ailing from Alzheimer's disease. Even Abigail Bartlet's personal side is usually only shown in conjunction to her husband's life. In addition, Sorkin allows the male cast members to bond as a unit, while the women are isolated from each other and only paired off with men.[14] By exploring the depths of the other female characters, Sorkin could have created an even richer ensemble cast and pushed beyond the stereotypes of women that the press and Hollywood construct.

Political Reality vs. Media Fiction

It is fitting that this controversy over the way Aaron Sorkin portrays gender comes at the end of a decade rife with gender controversy and discussion. The 1990s ushered in a decade, and possibly longer, of debate about lack of equitable representation of women's views and issues. Percolating during the Anita Hill–Clarence Thomas Senate hearings, the country witnessed an all-male Senate Judiciary Committee grapple with the issue of sexual harassment. The stark gender disparity of no female representation on this panel galvanized women's groups into action. Stemming from a tide of women running for elected office in 1992, the media dubbed that election cycle "The Year of the Woman." From 1991 to 1993, the proportion of women in Congress increased from six to ten percent. As some political scientists speculated, there was an expectation that this would serve as a turning point for women's rights and gender equality in the United States; however, it has been far from successful. The media's eagerness to seize upon "The Year of the Woman" moniker helped contain women's gains into just one election cycle of progress, instead of analyzing the patriarchal power structure of politics or how minuscule even ten percent of elected office-holders was. In reality, women in politics share a similar burden to the fictional ones presented in *The West Wing* scripts. They battle subtle and overt sexism, are treated professionally at times and demeaning at others, and face additional professional challenges to men.

While life in movies and television rarely reflects reality, there is a point at which Washington politics intersect with Hollywood. Both actresses and female politicians have difficulty achieving strong leading roles. If they rise to a challenge, often the media portrays them as no more than a stereotype, lacking the complexity of their male counterparts. Sorkin has created roles where talented women can shine, but he could push them even further. With so many rich, real-life examples, it is unfortunate that Aaron Sorkin has not created more depth or clout for his female characters.[15] With impressive actresses like Allison Janney, Stockard Channing, and Mary-Louise Parker,

he surely had the necessary range of talent to pull this off. To Sorkin's credit, these roles provide new avenues for actresses to play more prominent individuals with great challenges, especially C.J.'s character. More female characters that exhibit the depth of C.J. Cregg would enrich the image of women in television as well as women in politics.

While it may not be the show's ultimate responsibility to convey a perfect, gender-neutral world of politics, Hollywood must recognize its power over the general public and on female identity. Press coverage of women in public life feeds off of and reinforces the stereotypes of women that Hollywood presents, making the jobs of women even more difficult. As a result, shows like *The West Wing* have a great responsibility to the public, and to women in particular, to stretch beyond stereotypes for women. Sorkin takes a step in the right direction with *The West Wing* and comes closer than most shows, but if Hollywood could use its collective imagination to portray women in positions of power and influence without reducing them to stereotypes, women in the public sphere would be able to accomplish more.

Notes

1. Dorothee Benz, "The Media Factor Behind the 'Hillary Factor,' Fairness and Accuracy in Reporting" (October/November 1992), http://www.fair.org/extra/9210/hillary.html.
2. Hillary Clinton. *Living History* (New York: Simon & Schuster, 2003), p. 107.
3. Clinton, pp. 109–110.
4. Clinton, p. 111.
5. Bette Wineblatt Keva, "Dee Dee Myers Delivers Inspirational Message to Women," *Jewish Journal* (September 1999), http://www.jewishjournal.org/archives/archiveSept3_99.htm.
6. Chris Bury, "The Clinton Years: Interviews — Dee Dee Myers," *Nightline: Frontline* (June 2000), http://www.pbs.org/wgbh/pages/frontline/shows/clinton/interviews/myers3.html.
7. Keva.
8. John Levesque, "Aaron Sorkin's Smart Women Always Seem to Get Dumber," *Seattle Union Record* (Nov. 22, 2000). http://www.unionrecord.com, search "Levesque."
9. "And It's Surely to Their Credit." The West Wing Continuity Guide, Unofficial: http://westwing.bewarne.com/ and The West Wing: Episode Guide: http://www.westwingepguide.com/.
10. "The Crackpots and These Women." Excerpt also found in Christina Lane, "The White House Culture of Gender and Race in *The West Wing*," in The West Wing: *The American Presidency as Television Drama*, eds. Rollins and O'Connor (New York: Syracuse University Press), pp. 34–35.
11. "Lies, Damn Lies, and Statistics." The West Wing Continuity Guide, Unofficial: http://westwing.bewarne.com/ and The West Wing: Episode Guide: http://www.westwingepguide.com/.

12. "First Lady of Drama," http://www.joshlyman.com/articles/allison-flod.html.

13. Susan Douglas. *Where the Girls Are: Growing Up Female with the Mass Media* (New York: Random House, 1994), p. 293.

14. Caroline Baum, "Where Men Are Men, and Women Are Cardboard Cut-outs," *The Sydney Morning Herald* (July 24, 2003). Also found at: http://www.smh.com.au/articles/2003/07/23/1058853133745.html.

15. Baum, http://www.smh.com.au/articles/2003/07/23/1058853133745.html.

Works Cited

Baum, Caroline. "Where Men Are Men, and Women Are Cardboard Cut-outs." *The Sydney Morning Herald* (July 24, 2003). Also found at: <http://www.smh.com.au/ articles/2003/07/23/1058853133745.html>

Benz, Dorothee. "The Media Factor Behind the 'Hillary Factor,' Fairness and Accuracy in Reporting" (October/November 1992), <http://www.fair.org/extra/9210/hillary. html>

Bury, Chris. "The Clinton Years: Interviews — Dee Dee Myers," *Nightline: Frontline* (June 2000), <http://www.pbs.org/wgbh/pages/frontline/shows/clinton/interviews/myers3. html>

Clinton, Hillary. *Living History* (New York: Simon & Schuster, 2003).

Douglas, Susan. *Where the Girls Are: Growing Up Female with the Mass Media.* New York: Random House, 1994.

"First Lady of Drama," http://www.joshlyman.com/articles/allison-flod.html

Keva, Bette Wineblatt. "Dee Dee Myers Delivers Inspirational Message to Women." *Jewish Journal* (September 1999), <http://www.jewishjournal.org/archives/archiveSept3_ 99.htm>

Levesque, John. "Aaron Sorkin's Smart Women Always Seem to Get Dumber." *Seattle Union Record* (Nov. 22, 2000). (http://www.unionrecord.com, search "Levesque.")

12

The Republic of Sorkin: A View from the Cheap Seats

John Nein

I designed a city once; when I was eleven. I don't remember why. It might have had something to do with this elaborate role-playing game I played in which my acquisition of wealth as a space pirate allowed me to buy a planet. Don't ask.

What I do remember is that I wanted my city to be good — to be better than real cities. I devised for it a robust public transportation system, mapped out its streets, its electrical grid and power plants, configured its government, emergency services, residential and business zones, built office buildings, a library, sports stadiums, a sewage system, etc. I was inventing a place with safer streets, high living standards, alternative energy, and improved public services. In short, my foray into urban planning was actually the product of naïve, early-adolescent utopian thought. In adult terminology, acquired years later through prolonged exposure to college, my city was ideal.

Plato designed an ideal city too. His *Republic* accounted for every aspect of a city's governance, the myriad qualities of its philosopher kings, as well an expansive conception of virtue. His work became the cornerstone of Western political philosophy, but in all fairness, he was older than eleven.

Not to be outdone, America's founding fathers also built a republic (not at all unaware of Plato's). Given a relatively clean slate, they reflected upon numerous prior forms of government and endeavored to create a new and better one; a more perfect union.

Two centuries down the road, Aaron Sorkin has taken their experimental republic and reinvented it once more, this time for millions of viewers who have tuned in every Wednesday night for four seasons.

That tradition of writing about "Kings and Palaces" (as Sorkin terms

it) is as old as writing.[1] Writers love the trappings of power because the drama is instantly elevated. The stakes are higher, characters have more to lose, and the setting is bountiful. We want to go to where we are not allowed to go, into the halls of power and behind the closed door. We want to know how things work.

And on the surface, Sorkin's *The West Wing* seems painstakingly observant to the detailed workings of the White House. But in truth, it's not showing us how things really work, but how we want them to work. It has only the appearance of authenticity. The lamps in the Oval Office might be in the right places, but this government is very much ideal.

The West Wing, born largely of Sorkin's earlier screenplay, *The American President*, has garnered critical and commercial success since its debut in five years ago — an achievement considered noteworthy because seldom has a work dealing directly with politics actually met with anything other than doom in American popular culture.

The entertainment industry has, for the better part of its peacetime history, regarded politics as the kiss of death to a project. In Hollywood, Samuel Goldwyn, Jr.'s famous quip, "Pictures are for entertainment, messages should be delivered by Western Union," has had a half-life longer than plutonium. Pitching a story about politics runs a close second to walking into a meeting with "Has Anybody Seen the Turnip Truck" tattooed to your forehead. Politics are associated with divisive issues (therefore alienated audiences) and dust-covered social studies textbooks (therefore alienated audiences). And there's a good deal of empirical evidence to support this assumption, which puts executives whose reputations and jobs ride on the performance of a project in a risky position. As a result, scripts about politics are, by and large, shunned as "message" stories and stuck on the same shelf as scripts about potato famines and root canals.

Moreover, because film and television are essentially emotional mediums, stories comporting political ideas usually come out as didactic, flat, and intellectual rather than dramatic. Somehow the "breath of life" you feel in real stories about real people is replaced by a stodgy self-importance and terribly literal characters cut from prefabricated political stereotypes rather than personalities.

Sorkin has been the first to point out that *The West Wing* is popular entertainment, not a social studies lesson. And of course, he's right. *The West Wing* works first and foremost because it's great storytelling. Without a doubt, Sorkin knows a great deal about how the White House works, but the show is good because he knows how people work. Sorkin's White House seduces us with its wit, its bristling pace, its quickly shifting currents, and its humanity. The characters are so quirky and contoured, the dramatic

situations so smartly conceived and interwoven, and the dialogue so sharp that you can't help but be roped in. And for the most part, it avoids that stale tone of self-importance. A crisis in this White House is certainly a serious matter, but it will also be infused with small idiosyncratic touches like the president losing his glasses.

But in truth, *The West Wing*, along with *A Few Good Men* and *The American President*, are very much studies in society — our society. They are about (in the words of *The American President* Andrew Shepherd) "who we are and what we want." While their point of access is dramatic, they carry a viewpoint about politics and democracy that raises a series of interesting questions.

Sorkin's *The West Wing* might not be real, but its ideal depiction of politics as the realm of difficult decision-making by enlightened humanists and rigorous thinkers not only creates a moral complexity that is sadly lacking in both popular entertainment and the public face of politics, but begs the question, why should we so readily dismiss its idealism? His writing is an exploration of virtue and the seemingly naive merit of idealism — the courage of conviction amidst a world of compromise.

"Two houses, both alike in dignity" (and virtue)

In *The American President*, Andrew Shepherd comments, "Someday somebody's going to have to explain to me the virtue of a proportional response." He is weighing his options after Libyan fighters have bombed a defensive missile system deployed in Israel, resulting in American casualties. Having authorized the retaliatory bombing of a Libyan ministry building, his advisor calls his actions very "presidential." That does not appease his sense of virtue: "Leon, somewhere in Libya right now there's a janitor working the night shift at the Libyan Intelligence Headquarters. He's going about his job 'cause he has no idea that in about an hour he's gonna die in a massive explosion. He's just going about his job 'cause he has no idea that an hour ago I gave an order to have him killed. You just saw me do the least presidential thing I do."

For his exploration of American politics, Sorkin has created two ideal White Houses, two ideal presidents, and two ideal staffs. Andrew Shepherd (*The American President*) and Jed Bartlet (*The West Wing*) are educated, intelligent, self-aware, funny, compassionate, charming, and demanding. Shepherd is a charismatic intellectual who holds a degree from Stanford, undertook graduate work with a Nobel prize–winning economist, and taught history at the University of Wisconsin before moving to politics. Bartlet has

a Ph.D. in economics, has won the Nobel Prize, and has a vast knowledge of human history as well as the Bible. Both men act in a principled manner, their wisdom commands the respect of their staff, and they naturally have a sense of humor. They are enlightened rulers that even Plato would have voted for. They may not be true philosopher kings, but as "lovers of knowledge" they are clearly kings who are philosophers.

The word *virtue* isn't easily defined. One can look at its roots (its classical connotation of manliness or association with a manly or strong, courageous action) or employ a rather limited modern conception of it as a moral quality regarded as good or right. But like all great abstract notions, it requires more scope. Plato himself does not offer one, but rather develops the idea of virtue by placing it in numerous situations that seek to grow an understanding.

President Bartlet wrestles with a situation similar to Shepherd's in "A Proportional Response" from the first season of *The West Wing*. A plane carrying his personal physician, Morris Tolliver, on a humanitarian mission to Jordan is shot down by a Syrian missile. His military advisors advocate the bombing of four strategic targets, prompting Bartlet to ask, "What is the virtue of a proportional response?" The military advisor explains the method by which it's determined — essentially an equivalency of assets, a calculation. They shoot down a plane; we destroy a communications network. It's a weighted response which ultimately comes down to, as Bartlet puts it angrily, "the cost of doing business." Bartlet suggests it isn't virtuous at all and instructs the military staff to put together a response scenario that is disproportionate — that will actually hurt the Syrian government.

In this case, Bartlet's quest to act with virtue boils down to the more classical conception of virtue as strength — the power of retribution. He asks, was there not virtue when a Roman was free to walk the span of the earth unharmed, "so great was the retribution of Rome, universally understood as certain should any harm befall one of its citizens."

In this moment we gain a deeper sense of character and Bartlet's flaws — many of which will reemerge throughout the show; all of which create a more complex character. Having been loosely established as a peace-loving man, he is anxious around his military staff. Much is made of both the real and perceived doubts about his ability as a commander-in-chief. He even tells Tolliver, "I'm not comfortable with violence. I know this country has enemies, but I don't feel violent toward any of them." And Bartlet, for all his wisdom, also allows himself to be emotional. When the incident is reported to him, he is full of wrath and threatens to "blow them off the face of the earth with God's own thunder." In the following episode, he has grown impatient and tells Leo, "It's been seventy-two hours, Leo. That's more than

three days since they blew him out of the sky. And I'm tired of waiting, damn it. This is candy-ass! We're going to strike back today." Leo responds, "I wish you wouldn't say *him*, Mr. President.... Three days since they blew *him* out of the sky?"

Ultimately, the disproportionate response that Bartlet's military advisors come up with (bombing the airport in Damascus) would involve significant civilian casualties as well as a major disruption in humanitarian aid efforts. Leo ultimately convinces him that to command with humanity is far from "doing nothing."

These kinds of predicaments are the basis of Sorkin's dramatic structure — dilemmas encountered not only by the president, but by his staff who, like their boss, also have a deep love of their country and wrestle with making the right choices. Their respective staffs are smart, loyal, dedicated and, like their president, they have a deep love of their country. They also have good haircuts and cool ties. The clever conceit of the writing is to approach these issues dramatically. Through these characters we feel the immense complexity of decision-making. And, as political dilemmas would have it, there are no easy answers.

America Isn't Easy

The Greek context of the word *dilemma* (literally "two propositions") implies equally unfavorable alternatives. What makes the texture of Sorkin's writing interesting is that no situation has an easy resolution. Most real problems in the world don't even have just two sides. They are full of contradictions and paradoxes. In almost every dilemma no answer is entirely adequate. The political realm is one of murk and compromise where victories are rarely more than pyhrric and idealism is routinely trampled. As a result, the most common storyline and repeated theme is the notion of the staff's political "coming of age." Welcome to day-to-day democracy.

Bartlet wants to pass a gun bill, but discovers at the beginning of the episode ("Five Votes Down") that he will have to win five key votes in order to pass the legislation. Congressman Katzenmoyer has pulled back because with a re-election campaign low of funds, he can't risk rousing the ire of the NRA in his state. Josh coldly forces the issue by threatening to have the president back a democratic rival to his seat. They have lost freshman Democratic Congressman Wick's vote because the president hasn't given him a meaty enough photo op. His vote is bought for the price of a photograph. Congressman Tillinghouse argues that "as long as they have a gun, I want my wife to have a gun, I want my daughter to have a gun, and dammit, I

want one too." This vote is also bought off, but not by Leo or Josh. It's Vice President Hoynes who reels it in, but in the interest of his own gain as he schemes to bolster his own power and undermine Bartlet's. Votes are being bought and sold. Here. In America. Land of the free. Home of the brave.

And to add even more complexity to the situation, the show posits an interesting tension between the staff's hopes for the bill and its practical value. Having poured their sweat and blood into it, so much so that Leo's marriage is very close to capsizing, a key democrat, Congressman Richardson, suggests that the compromise bill will achieve very little. He refuses to back it on the grounds that it's too weak and won't change anything. Obviously it's been created as a compromise, but at what point does the watered-down version become a waste of time? What are they all working so hard for? As Leo's wife leaves him, he defends his long hours by saying, "This is the most important thing I'll ever do." Even more important than your marriage? she asks. And he replies, yes. And yet what have they achieved by the end of the episode is the passage of a timid gun control law in which Vice President Hoynes, who secured the deciding vote solely in the interest of undermining Bartlet, gets all the credit.

In another episode, Sam's meeting with military advisors reaches the expected stalemate between the progressive notion of including people of all sexual orientations in armed forces and the counterclaim that a unit's moral and combat performance will be negatively affected. When the chairman of the joint chiefs, Admiral Fitzwallace (an African-American) arrives, he acknowledges that the military advisors are right — a unit's cohesion would suffer. But then, almost as an afterthought, he points out that of course, they said the same thing about allowing Blacks into the service 50 years earlier. And it was true. But they got over it and look where it's gotten him.

Strewn across every season, the same pattern of examining complex situations through drama replays itself, whether it's political assassination, the drug wars, education or the environment. None of those problems are easy. There are no "clean" truths. The halls of power are full of compromise, frayed idealism, egoism, and quid pro quo deals. There are schemes and ulterior motives and disillusionment and arguments within arguments. Sorkin wants access to the murk. He wants to expose the convolutions of power in a way that real world politics doesn't offer.

Sorkin's writing structure acts somewhat as the Socratic dialogues do in *The Republic*, talking through a dilemma in order to come nearer to an *idea* of virtue. *The West Wing*, despite its final lurch toward liberal conclusions, clearly attempts to engage ideas as dialectical propositions. In one form or another, opposing viewpoints are advanced, whether they're expressed by a member of the opposing party (trips up to The Hill, conferences in the

White House, walks down the Mall, etc.), whether it's adopted by one of the staff to play "devil's advocate" (Sam taking the role of school voucher proponent in order for the staff to develop defenses, Mandy writing a "critique" of Bartlet for a competing Democrat, Donna challenging Josh as part of their bickering nature), or whether it's one of the group genuinely taking an opinion which strays from "common" liberal beliefs (Bartlet seeming more a hawk than a peacenik, Toby's attitude toward Islamic fundamentalism — "they'll like us when we win"— or C.J. being troubled by affirmative action because it held back her father's career). In almost every case, a real complexity emerges, and while the politics are ultimately liberal (after all, they have to be one or the other), the core idea remains that America isn't easy.

This skill with handling moral complexity has existed in Sorkin's work from the beginning. *A Few Good Men*, originally a play and then adapted to film and directed by Rob Reiner, concerns two marines who inadvertently cause the death of a fellow marine when they bind and gag him as part of an unofficial disciplinary action called a code red (a covert punishment doled out to a marine when fails to meet standards).

What also distinguishes it from a conventional courtroom drama is the sophisticated way it creates a moral terrain that doesn't fit into simple notions of right and wrong. The two marines are guilty of causing the death, but it was not premeditated as the case against them contends. Rather, they were acting on orders which, were they not followed, would have resulted in disciplinary action against them.

Their counsel, Lt. Kaffee (Tom Cruise) is a hotshot Ivy League lawyer reluctantly serving his time in the military who has been coasting by without effort. As his co-counsel, Sam, points out, "He's successfully plea bargained 44 cases in nine months," which is exactly what he suggests in this case. He secures a deal that would set the two marines free in as little as six months. But Downey and Dawson refuse the deal. It means they would be dishonorably discharged, which is disgracing to the code. In their minds, they have done nothing but follow orders.

The moral paradox begins to take form here. Kaffee puts it to Sam, "You don't believe their story, do you? You think they oughta go to jail for the rest of their lives." He replies, "I believe every word of their story and I think they oughta go to jail for the rest of their lives." Although the death was accidental, Sam believes that virtue should have compelled them to defend Santiago by refusing orders. They are guilty of not making an individual moral choice.

Over time we learn that the base commander, Colonel Jessep (Jack Nicholson), ordered the Code Red. When Kaffee finally gets Jessep on the witness stand, he goads him into angrily confessing to the order. But Jessep's

tirade is a brilliant piece of writing because it implicates us all — everyone living under the protection of the American military:

> Son, we live in a world that has walls. And those walls have to
> be guarded by men with guns. Who's gonna do it? You? You, Lt.
> Weinberg? I have a greater responsibility than you can possibly
> fathom. You weep for Santiago and you curse the marines. You
> have that luxury. You have the luxury of not knowing what I know:
> that Santiago's death, while tragic, probably saved lives. And my
> existence, while grotesque and incomprehensible to you, saves lives.
> You don't want the truth. Because deep down, in places you don't
> talk about at parties, you want me on that wall. You need me on that
> wall. We use words like honor, code, loyalty ... we use these words
> as the backbone to a life spent defending something. You use 'em as
> a punchline. I have neither the time nor the inclination to explain
> myself to a man who rises and sleeps under the blanket of the very
> freedom I provide, then questions the manner in which I provide it.
> I'd prefer you just said thank you and went on your way. Otherwise,
> I suggest you pick up a weapon and stand a post. Either way, I don't
> give a damn what you think you're entitled to.

It would be simple if Jessep were malevolent or just crazy. But he's not. He's a soldier whose mission is to protect our way of life, and we know that in some small way, he's right. We do want him on that wall. What makes Jessep a great character is that we can't dismiss his outlook so easily. It may not be virtuous, but it contains a truth. In the real world, freedom has a cost. So where do you draw the line? How many shades away is he from a Jed Bartlet who, swayed by the power of retribution, was ready to bomb an international airport in Damascus?

Dawson and Downey are exonerated of murder, but are still dishonorably discharged for conduct unbecoming. It's Dawson who realizes their mistake. Their moral obligation was to protect Santiago. "We're supposed to fight for people who couldn't fight for themselves." The same notion of virtue is echoed later in *The American President* when A.J. MacInerney says: "You fight the fights that need fighting."

The problem with so many mainstream films and television programs today is the simple mentality that they engender. They have almost entirely lost their ability to create a complex moral structure — anything that would actually make us experience something deeper than mere gratification. In effect, they simply reinforce dominant ideologies — reiterate what we already believe rather than asking questions about it.

Obviously, we're not looking for dissections of our society in every popular film. But too many stories that actually want to be taken seriously wind

up dividing their moral structure into tidy extremes of good and bad to such a degree that they amount to nothing. Take, for example, the 1996 film *A Time to Kill*, in which a young African-American girl is brutally raped by two white men in a rural Mississippi town. The girl's father, sensing that no justice will be served at the hands of Southern courts in this racist district, takes an assault rifle to the courthouse and promptly guns the two men down.

Rather than actually deal substantively with the issue of a judicial system that clearly does not work, the film basically ends up saying it's morally legitimate to take the law into your own hands and gun down two men in cold blood and then walk free (after your lawyers have committed countless breaches of ethics, not to mention broken several laws in order to defend you). The film shaves all the complexity out of the situation in order to create that morally simplistic hero association. Unlike *Dead Man Walking*, in which the character of a rapist-murderer is explored in detail, the characters here are portrayed as one dimensional, loudmouth, beer-guzzling redneck stereotypes who are made as repulsive as humanly possible. The court system is made as corrupt as humanly possible, and Carl Lee is made as sympathetic as humanly possible. This allows for the film to establish a completely simplistic moral spectrum where the audience is literally just waiting for good to triumph over evil. Is anything in life so unencumbered by deeper truths? The film actually avoids formulating any real moral quandary while it blindly instills a visceral complicity with vapid vigilante justice. And while that might work in a stylized, politically revolutionary film like *Sweet Sweetback's Baad Asssss Song*, in this case it's pure ignorance.

Unfortunately, this is par for the course in mainstream film and television. The Oscar-winning *Braveheart* can be similarly characterized as systematically stripping the story of any real complexity. William Wallace (Mel Gibson) sees his family slaughtered by an English lord. Therefore, he is good and the English are bad. And that's it. We're twenty minutes into the movie and the moral dimension is closed. This isn't a critique of getting the history right (an entirely different matter), but rather a critique of getting life right. The filmmakers weren't interested in portraying the complexity of a situation. Wallace does not worry about consequences or about his own responsibility (as Presidents Bartlet and Shepherd do). That the thousands of dead English soldiers were largely conscripts with no interest in being there and in many ways no different from the Scots (and certainly not all murderers) does not concern the film as much as stacking the deck against them so their slaughter raises nothing but cheers. Instead, this story of William Wallace is merely a story of uncomplicated revenge. There are no shadings

to his character and the speech he gives to his men before the battle is so bereft of substance it begs the question of what exactly made him a great man.

Contrast that to a similar situation in Shakespeare. *Henry V* also finds himself with his soldiers on the eve of a great battle, but the experience of Henry as a character is the exact opposite of William Wallace. Henry V walks through his army's encampment on the eve of the great battle at Agincourt. He is not so far removed from his more "spirited" days as a carefree youth; he fits only loosely into his new wardrobe as king. He has been lured by conspiring clerics into this "claim" with France (and subsequent war), which elicits self-doubt, particularly about his "rashness." His troops are "but a weak and sickly guard" and yet he is asking them to go into battle, almost certainly to death. Earlier, faced with the flagging morale of his men, Harry learns that the pitiable, dim Bardolph (his old friend) has been caught thieving — an offense punishable by hanging. Henry does not spare him. Now, wandering disguised through his greatly outnumbered army, he comes across John Bates and Michael Williams, who bring up the virtue of leading men into battle. They assume his cause is just, "But if the cause be not good, the king himself hath a heavy reckoning to make." Henry then wanders alone:

> Upon the King!— let us our lives, our souls,
> our debts, our careful wives,
> Our children, and our sins, lay on the king! [*Henry V*, IV. I. 233].

This is the burden of leadership when the issues are complex, when the answers are not clear. Andrew Shepherd in *The American President* walks alone at night through the empty, isolating hall of the White House, unsure of his path. The camera passes in front of one of the most resounding images of the loneliness of leadership, Aaron Shikler's portrait of John F. Kennedy with his head bowed in thought. All kings are alone in that moment. It is a character test. As Shepherd says, "Being president is *entirely* about character."

At a time when American popular entertainment has (like American politics) consciously avoided moral complexity, Sorkin has embraced it. His films as well as *The West Wing* are very much about America the Difficult. This distinction between complex and simple storytelling is hardly trivial. These are the stories we use to think through our society. It's no wonder we expect easy answers from politics. Why would we expect the world to be complicated when most of the stories we tell and the news we see are not? We have become far less critical thinkers in part because popular entertainment has ceased to provoke critical thought.

America Is Easy

Sorkin begins *The American President* with an amusing conceit that to some degree underscores the whole point of the film. In having made a speech the night before, President Shepherd fails to complete his statement that "Americans can no longer afford to pretend they live in a great society...." It prompts Lewis to scold him for leaving it "hanging out there." The mistake leads the press and other aides to wonder what kind of a society we do live in.

But when Shepherd finally finds his voice at the end and steps up to the microphone to answer the character attacks of his political opponent, Bob Rumson, the thought is very much fully formed. We live in a society whose problems are too serious for shallow political rhetoric. He lashes out not only at Rumson, but the cynical political philosophy he represents.

> Everybody knows American isn't easy. America is advanced citizenship. You gotta want it bad, 'cause it's gonna put up a fight. It's gonna say, "You want free speech? Let's see you acknowledge a man whose words make your blood boil who's standing center stage and advocating, at the top of his lungs, that which you would spend a lifetime opposing at the top of yours.... I've been operating under the assumption that the reason Bob [Rumson] devotes so much time and energy to shouting at the rain was that he simply didn't get it. Well, I was wrong. Bob's problem isn't that he doesn't get it. Bob's problem is that he can't sell it. Nobody has ever won an election by talking about what I was just talking about.

And it's true. Nobody has, which amounts to the sad reality that so much of politics has fallen into a kind of entertainment, trying to simplify issues or spinning them to cater to what polling data tells us people want to hear: that American is easy. It's the backbone of Popularism — the fuel of campaigns like Arnold Schwarzenegger's that manage to promise easy answers in campaigns only to discover that the answers aren't so easy in office. It's the broken record of an administration bent on breaking the world down into simple categories (it's "us" and "them," it's an "axis of evil"). The job of rhetoric is to obscure the deeper truths of any issue, to remove ambiguity from the world, to give people easy handles to understand everything from their government to their needs and their feelings. Rhetoric buries complexities by appropriating abstractions like freedom, courage, democracy, terror — abstractions that cannot possibly explain any issues in detail. It furnishes us with the illusion of having formulated an opinion, when in fact, they are merely pre-packaged sound bites pushed on us by politicians, mass-media, and popular entertainment, and driven by market analysis of

what people want — not what will challenge them. In fact, it's exactly the opposite, it's predicated on what will *not* challenge them.

In both *The American President* and *The West Wing*, Sorkin's blatant desire to have people just tell the truth, speak from their conviction rather that employ rhetoric, represents the conclusion that it's not virtuous to rule from cynicism — from the perspective of what you can sell. In a scene omitted from the final film, Shepherd tells his daughter, Lucy, over breakfast that his real problem with Rumson isn't his politics, it's his character. "The difference is that he says he loves America. Saying you love America is easy. What takes character — and this is what you have — what takes character is loving Americans." While it may be the case that most Americans don't know very much about the nuances of government, foreign policy or the economy (that they drink the sand because they don't know the difference), it's the height of cynicism to offer then an America that is easy.

The Republic of Sorkin

America has reinvented itself over and over again, and Sorkin's work is part of the cycle. He is deconstructing certain myths while affirming others. From the very beginning of his two political screenplays and *The West Wing*, a tension is established between the symbols of America and the day-to-day nuts and bolts of trying to operate a government in their service. The title sequence of *The American President* is a reverential montage of presidential portraits, statues, books, and flags. *A Few Good Men* opens with images of a marine drill parade — celebrating the precision, order and discipline of the marines. They are impressions of surface, and the ensuing films are, in part, about looking beneath those surfaces, looking at an America that is more complicated than its symbols. But at the same time, the institutions themselves remain intact. Both films end with equally reverential shots — one of Andrew Shepherd walking triumphantly into Congress to deliver the State of the Union address (the camera slowly zooming out as the music swells) and one of Lt. Kaffee looking around the courtroom which has meted out justice (as the camera rises and the music swells). Ultimately his stories do nothing if not reinforce our faith in the fundamental mechanics of democracy — the faith that despite the ills of society, goodness still treads water. Idealism is the basis for attaining virtue.

In Sorkin's conception of politics, to act with virtue is complicated by the dialectic between idealism and real-world practicalities, but it isn't stopped by it. President Shepherd is a man who has, somewhat understandably, bought into the notion of political compromise. He operates under

what he considers the sobering reality that in order to enact legislation, he has to appease his opponents. It's for this reason that he plans to advance a crime bill without restrictions on hand guns (as he had once planned) and an environmental bill that calls for only 10 percent reductions in fossil fuel emissions instead of the 20 percent that, according to aides, would generate a real impact. When his policy advisor, Lewis, appeals briefly to his sense of idealism, Shepherd replies, "We gotta fight the fights we can win, Lewis."

Lewis, while by no means impractical or naïve, is the staff idealist. He is the bright, young, and passionate aide whose idealism has found a home with a president who clearly inspires him. Not yet jaded by the system and unmoved by the need for compromise, he places his faith in the progressive agenda of Shepherd. His idealism comes to a head with Shepherd towards the end of the film when Lewis appeals for him to show leadership, to answer the attacks of his opponent and reclaim the idealism that would actually make a difference in the country.

> LEWIS: They want leadership, Mr. President. They're so thirsty for it, they'll crawl through the desert toward a mirage, and when they discover there's no water, they'll drink the sand.
> SHEPHERD: Lewis, we've had presidents who were beloved, who couldn't find a coherent sentence with two hands and a flashlight. People don't drink the sand 'cause they're thirsty, Lewis. They drink it 'cause they don't know the difference.

Later, Shepherd's trusted friend and advisor, A.J., follows suit. Having just told him to pull his head out of his ass, he corrects Shepherd's earlier statement, saying, "You fight the fights that need fighting." Shepherd replies angrily, "Is the view pretty good from the cheap seats, A.J.?" The cheap seats are where idealism doesn't have to face the real world. But Shepherd knows A.J. is right, and he'll wind up standing in front of the press room cameras announcing a new, tougher crime bill and 20 percent cuts on fossil fuel emissions. Leadership is thus equated with conviction in idealism, not acceptance of compromise.

It's the same dilemma for Jed Bartlet and the staffers of *The West Wing.* In fact, the entire arc of the first season (and a recurring motif) follows the journey of the staff from the "bad faith" of compromise to the courage of idealism. They begin by treading carefully, not sticking their necks out, pushing an agenda that's only cosmetically radical but falters when push comes to shove and the weight of the presidency is needed. "We're stuck in neutral," one of them says. When will Bartlet find the courage of his convictions, cast off the fear of re-election, the safety of middle of the road politics? When will he let his staff really start changing the world?

The staff's frustrations mount (as does Bartlet's) and the floodgates open. A new administration is born in "Let Bartlet be Bartlet." They will take on the tough issues. They will not cave to "the system." They will lose some battles no doubt, but at least they will fight them. Leo convenes his reinvigorated staff and tells them, "We're going to raise the level of public debate in the country, and let that be our legacy."

Later, in the fourth season, Bartlet wants to unveil "a new doctrine for the use of force" which would essentially call for military intervention across the world to stop injustice, or as Toby puts it, "Mother Theresa with first-strike capabilities." But in the course of honing in on the policy, Bartlet is faced with a rapidly unfolding civil war in the fictional African country of Kundu (a situation clearly meant to address American and UN failure to intervene in Rwanda). While the staff deflects Congressional concern that they are now being circumvented by a major foreign policy shift, Bartlet is also being undermined by his secretary of defense, Miles Hutchinson, who inflates the casualty estimates were America to send forces. And of course, the ghost of Vietnam lingers throughout, particularly with Bartlet. His dilemma has to do with weighing American lives vs. the "mass slaughter" in Kundu. Leo suggests that losses would only be 150, not 1,000 as Miles claims. "And that's acceptable to you in Kundu?" replies Hutchinson.

Will Bailey, the new staff idealist (brought on here to help with the inaugural address) breaks a boundary in casual conversation with the President Bartlet, who asks, rhetorically, "Why is a Kundunese life worth less to me than an American life?" Will replies, "I don't know, sir, but it is." Later at a restaurant, Toby reiterates the danger: "We're talking about the president sending other people's kids to do that." C.J. responds, "And in addition to being somebody's kids, they're also soldiers and sailors, and if we're about freedom from tyranny, we should be about freedom from tyranny, and if we're not, we should *shut up!*"

Ultimately, Bartlet does announce the new doctrine and send troops to Kundu and he makes Will his deputy communications director—a thank you for the shot of idealism. With the rest of the staff present, he invokes Margaret Mead's famous line, "Never doubt that a small group of thoughtful, committed citizens can change the world." Will completes the thought, "It's the only thing that ever has."

This may be the purest idealism, but Sorkin hasn't arrived at the point cheaply. He's walked the long route. He hasn't erased the country's problems, but rather highlighted them dramatically. Democracy has to be pursued virtuously, every day. It's the product of struggle. It's actually not even a "product" because it's never finished, but rather a work in progress.

In "Six Meetings Before Lunch," Josh has to meet with Jeff Brecken-

ridge, an African-American nominee for assistant attorney general for civil rights, to prep him for confirmation hearings (Leo is concerned because he has lent his name to a book called *The Unpaid Debt* that advocates slavery reparations). After an entire day of arguments, Breckenridge finally tells Josh that no amount of money could compensate African Americans. He asks for a dollar bill and points to the seal's words *annuit coeptis*— He (God) favors our undertaking. "The seal is meant to be unfinished because our country is meant to be unfinished. We're meant to keep doing better; to keep discussing and debating. And we're meant to read books by great historical scholars and then talk about them, which is why I lent my name to a dust cover."

It's a moment steeped in the prophetic wisdom of John Stuart Mill and *On Liberty*. Mill's world may have been different, but his concern was that the minute we stop questioning greater truths, we stop experiencing them as "living truths" (i.e. keeping them alive in our experience — questioning them and constantly challenging their basis) they become "dead dogmas."

> There is a progressive tendency to forget all of the belief except the formularies, or to give it a dull and torpid assent, as if accepting it on trust dispensed with the necessity of realizing it in consciousness, or testing it by personal experience; until it almost ceases to connect itself at all with the inner life of the human being....
>
> The loss of so important an aid to the intelligent and living apprehension of a truth, as is afforded by the necessity of explaining it to, or defending it against, opponents, though not sufficient to outweigh, is no trifling drawback from, the benefit of its universal recognition. Where this advantage can no longer be had, I confess I should like to see the teachers of mankind endeavoring to provide a substitute for it; some contrivance for making the difficulties of the question as present to the learner's consciousness, as if they were pressed upon him by a dissentient champion, eager for his conversion.
>
> But instead of seeking contrivances for this purpose, they have lost those they formerly had. The Socratic dialectics, so magnificently exemplified in the dialogues of Plato, were a contrivance of this description. They were essentially a negative discussion of the great questions of philosophy and life, directed with consummate skill to the purpose of convincing any one who had merely adopted the commonplaces of received opinion, that he did not understand the subject — that he as yet attached no definite meaning to the doctrines he professed [Mill 102, 106].

The West Wing may not always reach this lofty plateau, but how many instances can we find of a vivid, direct dialectical connection to politics in

popular entertainment? It encourages us to ask what kind of real effect an ideal White House can have on our country's current fiercely politicized, but largely ignorant, political and social consciousness?

Asking where that kind of idealism fits in political philosophy is like asking where John Lennon's "Imagine" fits in. Nowhere and everywhere. It's both unrealistic and profoundly necessary. When asked if his ideal state could ever exist, Socrates did not answer.

Sorkin's White House is a fiction. Its goal is not verisimilitude. As Aristotle wrote, "The aim of art is to represent not the outward appearance of things, but their inward significance." But as fiction, it brings us nearer to truths that we cannot directly experience, but about which we must formulate opinions as citizens. It allows us to experience the dramatic shadings and complexity of political issues. It entreats us to rediscover the virtue of political action based on ideals. In Sorkin's version, this may be the courage of liberal progressivism, but it demands that politics find conviction. As a call for public debate, a window to complex issues, an appeal for virtue and idealism, are the cheap seats really that shabby?

H.W. Brands' recent *Atlantic Monthly* article "Founders Chic" (September 2003, p. 110) observed that the real difference between government today and that of the founding fathers was largely courage:

> But Franklin would have been dismayed by the popular denigration of politics, and exceedingly impatient with us for acting helpless in the face of problems that the Founders would have tackled at once.... The one trait the Founders shared to the greatest degree is the one most worth striving after today — but also one that is often forgotten in the praise of their asserted genius. These men were no smarter than the best our country can offer now; they were no wiser or more altruistic. They have been more learned in a classical sense, but they knew much less about the natural world, including the natural basis of human behavior. They were, however, far bolder than we are. When they signed the Declaration of Independence, they put their necks in a noose; when they wrote the Constitution, they embarked on an audacious and unprecedented challenge to custom and authority. For their courage they certainly deserve our admiration. But even more they deserve our emulation.

At one point in the first season, Jed Bartlet gives a speech in front of a banner that reads "Practical Idealism." It's amusing because on one hand, the phrase is so laughably vacant. But on the other hand, is there a more apt description of Sorkin's invented White House? It might be a view from the cheap seats (Sorkin doesn't have to actually figure out a doctrine of humanitarian invention, how standards would be set, how we could actually follow

through on it, etc.), but its utility is in the practical value of people collectively reaching for an ideal. If we strive for that, we may never actually attain the ideal, but we would come to accept complexity, demand truth and not rhetoric, and "raise the level of public debate in this country." Certainly we would be better off than we are now, stuck in the desert drinking the sand because it's the only drink out there. From here, the cheap seats seem like paradise.

Note

1. Sorkin has referred to this on many occasions, including an interview with Terence Smith on the *News Hour* with Jim Lehrer (September 27, 2000), PBS.

Works Cited

Brands, H. W. "Founders Chic." Atlantic Monthly. Sept. 2003: 101–110.

Mill, John Stuart. *On Liberty*. Penguin Classics. 1987.

Shakespeare, William. "King Henry V." *The Complete Works*. Edition of The Shakespeare Head Press Oxford. Dorset Press. 1988.

Sorkin, Aaron. Interview with Terence Smith. *NewsHour with Jim Lehrer*. PBS. 27 Sept. 2000. http://www.pbs.org/newshour/media/west_wing/sorkin.html.

The West Wing

"Five Votes Down." Teleplay: Aaron Sorkin. Story: Lawrence O'Donnell, Jr. and Patrick H. Caddell. Dir.: Michael Lehmann. NBC. 13 Oct. 1999.

"Inauguration: Over There." Teleplay: Aaron Sorkin. Story: David Gerken and Gene Sperling. Dir.: Lesli Linka Glatter. NBC. 12 Feb. 2003.

"Let Bartlet Be Bartlet." Teleplay: Aaron Sorkin. Story: Peter Parnell and Patrick H. Caddell. Dir.: Laura Innes. NBC. 26 April 2000.

"Post Hoc, Ergo Propter Hoc." Teleplay: Aaron Sorkin. Dir.: Thomas Schlamme. NBC. 29 Sept. 1999.

"A Proportional Response." Teleplay: Aaron Sorkin. Dir.: Marc Buckland. NBC. 6 Oct. 1999.

"Six Meetings Before Lunch." Teleplay: Aaron Sorkin. Dir.: Clark Johnson. NBC. 5 April 2000.

Appendix: Sorkin's Works for Film and Television

FILMS

A Few Good Men
Script: Aaron Sorkin. Dir.: Rob Reiner. Columbia/Tristar Studios, 1992.

Malice
Script: Aaron Sorkin and Scott Frank. Dir.: Harold Becker. MGM/UA, 1993.

The American President
Script: Aaron Sorkin. Dir: Rob Reiner. Castle Rock, 1995.

TELEVISION

Sports Night (1998–2000)

Season 1

Episode 1: "Pilot." Teleplay: Aaron Sorkin. Story: Paul Redford. Dir.: Thomas Schlamme. ABC. 22 Sept. 1998.

Episode 2: "The Apology." Teleplay: Aaron Sorkin. Dir.: Thomas Schlamme. ABC. 29 Sept. 1998.

Episode 3: "The Hungry and the Hunted." Teleplay: Aaron Sorkin. Dir.: Thomas Schlamme. ABC. 6 Oct. 1998.

Episode 4: "Intellectual Property." Teleplay: Aaron Sorkin. Dir.: Thomas Schlamme. ABC. 13 Oct. 1998.

Episode 5: "Mary Pat Shelby." Teleplay: Tracey Stern and Aaron Sorkin. Dir.: Thomas Schlamme. ABC. 20 Oct. 1998.

Episode 6: "The Head Coach, Dinner and the Morning Mail." Teleplay: Matt Tarses and Aaron Sorkin. Dir.: Thomas Schlamme. ABC. 27 Oct. 1998.

Episode 7: "Dear Louise...." Teleplay: David Walpert and Aaron Sorkin. Dir.: Thomas Schlamme. ABC. 10 Nov. 1998.

Episode 8: "Thespis." Teleplay: Aaron Sorkin. Dir.: Thomas Schlamme. ABC. 17 Nov. 1998.

Episode 9: "The Quality of Mercy at 29K." Teleplay: Bill Wrubel and Aaron Sorkin. Dir.: Thomas Schlamme. ABC. 1 Dec. 1998.

Episode 10: "Shoe Money Tonight." Teleplay: Aaron Sorkin. Dir.: Dennie Gordon. ABC. 8 Dec. 1998.

Episode 11: "The Six Southern Gentlemen of Tennessee Tech." Teleplay: Aaron Sorkin, Matt Tarses, David Walpert, Bill Wrubel. Dir.: Robert Berlinger. ABC. 15 Dec. 1998.

Episode 12: "Smoky." Teleplay: Aaron Sorkin. Dir.: Robert Berlinger. ABC. 5 Jan. 1999.

Episode 13: "Small Town." Teleplay: Paul Redford and Aaron Sorkin. Dir.: Thomas Schlamme. ABC. 12 Jan. 1999.

Episode 14: "Rebecca." Teleplay: Aaron Sorkin. Dir.: Thomas Schlamme. ABC. 26 Jan. 1999.

Episode 15: "Dana and the Deep Blue Sea." Teleplay: Aaron Sorkin. Dir.: Thomas Schlamme. ABC. 9 Feb. 1999.

Episode 16: "Sally." Teleplay: Rachel Sweet and Aaron Sorkin. Dir.: Robert Berlinger. ABC. 23 Feb. 1999.

Episode 17: "How Are Things in Glocca Morra?" Teleplay: Rachel Sweet and Aaron Sorkin. Dir.: Marc Buckland. ABC. 3 March 1999.

Episode 18: "The Sword of Orion." Teleplay: David Handelman, Mark McKinney, Aaron Sorkin. Dir.: Robert Berlinger. ABC. 23 March 1999.

Episode 19: "Eli's Coming." Teleplay: Aaron Sorkin. Dir.: Robert Berlinger. ABC. 30 March 1999.

Episode 20: "Ordnance Tactics." Teleplay: Aaron Sorkin. Story: Paul Redford. Dir.: Alex Graves. ABC. 6 April 1999.

Episode 21: "Ten Wickets." Teleplay: Aaron Sorkin. Story: Matt Tarses. Dir.: Robert Berlinger. ABC. 13 April 1999.

Episode 22: "Napoleon's Battle Plan." Teleplay: Aaron Sorkin. Dir.: Robert Berlinger. ABC. 27 April 1999.

Episode 23: "What Kind of Day Has It Been." Teleplay: Aaron Sorkin. Dir.: Thomas Schlamme. ABC. 4 May 1999.

Season 2

Episode 24: "Special Powers." Teleplay: Aaron Sorkin. Dir.: Thomas Schlamme. ABC. 5 Oct. 1999.

Episode 25: "When Something Wicked This Way Comes." Teleplay: Aaron Sorkin. Dir.: Robert Berlinger. ABC. 12 Oct. 1999.

Episode 26: "Cliff Gardner." Teleplay: Aaron Sorkin. Dir.: Robert Berlinger. ABC. 19 Oct. 1999.

Episode 27: "Louise Revisited." Teleplay: Miriam Kazdin and Aaron Sorkin. Story: Miriam Kazdin. Dir.: Marc Buckland. ABC. 26 Oct. 1999.

Episode 28: "Kafelnikov." Teleplay: Matt Tarses and Bill Wrubel. Dir.: Robert Berlinger. ABC. 2 Nov. 1999.

Episode 29: "Shane." Teleplay: Kevin Falls, Matt Tarses, Bill Wrubel. Dir.: Robert Berlinger. ABC. 7 Dec. 1999.

Episode 30: "Kyle Whitaker's Got Two Sacks." Teleplay: Tom Szentgyorgyi and Aaron Sorkin. Dir.: Dennie Gordon. ABC. 14 Dec. 1999.

Episode 31: "The Reunion." Teleplay: Kevin Falls and Aaron Sorkin. Dir.: Dennie Gordon. ABC. 21 Dec. 1999.

Episode 32: "A Girl Named Pixley." Teleplay: David Walpert. Dir.: Dennie Gordon. ABC. 28 Dec. 1999.

Episode 33: "The Giants Win the Pennant...." Teleplay: Matt Tarses and Aaron Sorkin. Dir.: Pamela Dresser. ABC. 11 Jan. 2000.

Episode 34: "The Cut Man Cometh." Teleplay: Bill Wrubel and Aaron Sorkin. Story: Bill Wrubel. Dir.: Alex Graves. ABC. 18 Jan. 2000.

Episode 35: "The Sweet Smell of Air." Teleplay: David Handelman, Kevin Falls, Matt Tarses, Aaron Sorkin. Story: David Handelman. Dir.: Alex Graves. ABC. 25 Jan. 2000.

Episode 36: "Dana Get Your Gun." Teleplay: David Walpert. Dir.: Alex Graves. ABC. 1 Feb. 2000.

Episode 37: "And the Crowd Goes Wild." Teleplay: Tom Szentgyorgyi and Aaron Sorkin. Story: Tom Szentgyorgyi. Dir.: Alex Graves. ABC. 8 Feb. 2000.

Episode 38: "Celebrities." Teleplay: Aaron Sorkin. Dir.: Robert Berlinger. ABC. 28 Feb. 2000.

Episode 39: "The Local Weather." Teleplay: Aaron Sorkin. Story: Pete McCabe and Aaron Sorkin. Dir.: Timothy Busfield. ABC. 7 March 2000.

Episode 40: "Draft Day Part 1: It Can't Rain at Indian Wells." Teleplay: Matt Tarses and Aaron Sorkin. Dir.: Bryan Gordon. ABC. 14 March 2000.

Episode 41: "Draft Day Part 2: The Fall of Ryan O'Brian." Teleplay: Aaron Sorkin. Story: Kevin Falls. Dir.: Danny Leiner. ABC. 21 March 2000.

Episode 42: "April Is the Cruelest Month." Teleplay: Bill Wrubel and Matt Tarses. Dir.: Don Scardino. ABC. 28 March 2000.

Episode 43: "Bells and a Siren." Teleplay: Chris Lusbardi, David Walpert, Aaron Sorkin. Dir.: Don Scardino. ABC. 4 April 2000.

Episode 44: "La Forza del Destino." Teleplay: Aaron Sorkin. Dir.: Timothy Busfield. ABC. 9 May 2000.

Episode 45: "Quo Vadimus." Teleplay: Aaron Sorkin. Dir.: Thomas Schlamme. ABC. 16 May 2000.

The West Wing (1999–2003)

Season 1

Episode 1: "Pilot." Teleplay: Aaron Sorkin. Dir.: Thomas Schlamme. NBC. 22 Sept. 1999.

Episode 2: "Post Hoc, Ergo Propter Hoc." Teleplay: Aaron Sorkin. Dir.: Thomas Schlamme. NBC. 29 Sept. 1999.

Episode 3: "A Proportional Response." Teleplay: Aaron Sorkin. Dir.: Marc Buckland. NBC. 6 Oct. 1999.

Episode 4: "Five Votes Down." Teleplay: Aaron Sorkin. Story: Lawrence O'Donnell, Jr. and Patrick H. Caddell. Dir.: Michael Lehmann. NBC. 13 Oct. 1999.

Episode 5: "The Crackpots and These Women." Teleplay: Aaron Sorkin. Dir.: Anthony Drazan. NBC. 20 Oct. 1999.

Episode 6: "Mr. Willis of Ohio." Teleplay: Aaron Sorkin. Dir.: Christopher Misiano. NBC. 3 Nov. 1999.

Episode 7: "The State Dinner." Teleplay: Aaron Sorkin and Paul Redford. Dir.: Thomas Schlamme. NBC. 10 Nov. 1999.

Episode 8: "Enemies." Teleplay: Ron Osborn and Jeff Reno. Story: Rick Cleveland, Lawrence O'Donnell, Jr. and Patrick H. Caddell. Dir.: Alan Taylor. NBC. 17 Nov. 1999.

Episode 9: "The Short List." Teleplay: Aaron Sorkin and Patrick H. Caddell. Story: Aaron Sorkin and Dee Dee Myers. Dir.: Bill D'Elia. NBC. 24 Nov. 1999.

Episode 10: "In Excelsis Deo." Teleplay: Aaron Sorkin and Rick Cleveland. Dir.: Alex Graves. NBC. 15 Dec. 1999.

Episode 11: "Lord John Marbury." Teleplay: Aaron Sorkin and Patrick H. Caddell. Story: Patrick H. Caddell and Lawrence O'Donnell, Jr. Dir.: Kevin Rodney Sullivan. NBC. 5 Jan. 2000.

Episode 12: "He Shall, From Time to Time...." Teleplay: Aaron Sorkin. Dir.: Arlene Sanford. NBC. 12 Jan. 2000.

Episode 13: "Take Out the Trash Day." Teleplay: Aaron Sorkin. Dir.: Ken Olin. NBC. 26 Jan. 2000.

Episode 14: "Take This Sabbath Day." Teleplay: Aaron Sorkin. Story: Lawrence O'Donnell, Jr., Paul Redford, and Aaron Sorkin. Dir.: Thomas Schlamme. NBC. 9 Feb. 2000.

Episode 15: "Celestial Navigation." Teleplay: Aaron Sorkin. Story: Dee Dee Myers and Lawrence O'Donnell, Jr. Dir.: Christopher Misiano. NBC. 16 Feb. 2000.

Episode 16: "20 Hours in L.A." Teleplay: Aaron Sorkin. Dir.: Alan Taylor. NBC. 23 Feb. 2000.

Episode 17: "The White House Pro-Am." Teleplay: Lawrence O'Donnell, Jr., Paul Redford, and Aaron Sorkin. Dir.: Ken Olin. NBC. 22 March 2000.

Episode 18: "Six Meetings Before Lunch." Teleplay: Aaron Sorkin. Dir.: Clark Johnson. NBC. 5 April 2000.

Episode 19: "Let Bartlet Be Bartlet." Teleplay: Aaron Sorkin. Story: Peter Parnell and Patrick H. Caddell. Dir.: Laura Innes. NBC. 26 April 2000.

Episode 20: "Mandatory Minimums." Teleplay: Aaron Sorkin. Dir.: Robert Berlinger. NBC. 3 May 2000.

Episode 21: "Lies, Damn Lies and Statistics." Teleplay: Aaron Sorkin. Story: Patrick H. Caddell. Dir.: Don Scardino. NBC. 10 May 2000.

Episode 22: "What Kind of Day Has It Been." Teleplay: Aaron Sorkin. Dir.: Thomas Schlamme. NBC. 17 May 2000.

Season 2

Episode 23: "In the Shadow of Two Gunmen: Part I." Teleplay: Aaron Sorkin. Dir.: Thomas Schlamme. NBC. 4 Oct. 2000.

Episode 24: "In the Shadow of Two Gunmen: Part II." Teleplay: Aaron Sorkin. Dir.: Thomas Schlamme. NBC. 4 Oct. 2000.

Episode 25: "The Midterms." Teleplay: Aaron Sorkin. Dir.: Alex Graves. NBC. 18 Oct. 2000.

Episode 26: "In This White House." Teleplay: Aaron Sorkin. Story: Peter Parnell and Allison Abner. Dir.: Ken Olin. NBC. 25 Oct. 2000.

Episode 27: "And It's Surely to Their Credit." Teleplay: Aaron Sorkin. Story: Kevin Falls and Laura Glasser. Dir.: Christopher Misiano. NBC. 1 Nov. 2000.

Episode 28: "The Lame Duck Congress." Teleplay: Aaron Sorkin. Story: Lawrence O'Donnell, Jr. Dir.: Jeremy Kagan. NBC. 8 Nov. 2000.

Episode 29: "The Portland Trip." Teleplay: Aaron Sorkin. Story: Paul Redford. Dir.: Paris Barclay. NBC. 15 Nov. 2000.

Episode 30: "Shibboleth." Teleplay: Aaron Sorkin. Story: Patrick H. Caddell. Dir.: Laura Innes. NBC. 22 Nov. 2000.

Episode 31: "Galileo." Teleplay: Kevin Falls and Aaron Sorkin. Dir.: Alex Graves. NBC. 29 Nov. 2000.

Episode 32: "Noël." Teleplay: Aaron Sorkin. Story: Peter Parnell. Dir.: Thomas Schlamme. NBC. 20 Dec. 2000.

Episode 33: "The Leadership Breakfast." Teleplay: Aaron Sorkin. Story: Peter Parnell. Dir.: Thomas Schlamme. NBC. 10 Jan. 2001.

Episode 34: "The Drop In." Teleplay: Aaron Sorkin. Story: Lawrence O'Donnell, Jr. Dir.: Lou Antonio. NBC. 24 Jan. 2001.

Episode 35: "Bartlet's Third State of the Union." Teleplay: Aaron Sorkin. Story: Allison Abner and Dee Dee Myers. Dir.: Christopher Misiano. NBC. 7 Feb. 2001.

Episode 36: "The War at Home." Teleplay: Aaron Sorkin. Dir.: Christopher Misiano. NBC. 14 Feb. 2001.

Episode 37: "Ellie." Teleplay: Aaron Sorkin. Story: Kevin Falls and Laura Glasser. Dir.: Michael Engler. NBC. 21 Feb. 2001.

Episode 38: "Somebody's Going to Emergency, Somebody's Going to Jail." Teleplay: Paul Redford and Aaron Sorkin. Dir.: Jessica Yu. NBC. 28 Feb. 2001.

Episode 39: "The Stackhouse Filibuster." Teleplay: Aaron Sorkin. Story: Pete McCabe. Dir.: Bryan Gordon. NBC. 14 March 2001.

Episode 40: "17 People." Teleplay: Aaron Sorkin. Dir.: Alex Graves. NBC. 4 April 2001.

Episode 41: "Bad Moon Rising." Teleplay: Aaron Sorkin. Story: Felicia Willson. Dir.: Bill Johnson. NBC. 25 April 2001.

Episode 42: "The Fall's Gonna Kill You." Teleplay: Aaron Sorkin. Story: Patrick H. Caddell. Dir.: Christopher Misiano. NBC. 2 May 2001.

Episode 43: "18th and Potomac." Teleplay: Aaron Sorkin. Story: Lawrence O'Donnell, Jr. Dir.: Robert Berlinger. NBC. 9 May 2001.

Episode 44: "Two Cathedrals." Teleplay: Aaron Sorkin. Dir.: Thomas Schlamme. NBC. 16 May 2001.

Season 3

"Isaac and Ishmael." Teleplay: Aaron Sorkin. Dir.: Christopher Misiano. NBC. 3 Oct. 2001.

Episode 45: "Manchester: Part I." Teleplay: Aaron Sorkin. Dir.: Thomas Schlamme. NBC. 10 Oct. 2001.

Episode 46: "Manchester: Part II." Teleplay: Aaron Sorkin. Dir.: Thomas Schlamme. NBC. 17 Oct. 2001.

Episode 47: "Ways and Means." Teleplay: Aaron Sorkin. Story: Eli Attie and Gene Sperling. Dir.: Alex Graves. NBC. 24 Oct. 2001.

Episode 48: "On the Day Before." Teleplay: Aaron Sorkin. Story: Paul Redford and Nanda Chitre. Dir.: Jeremy Kagan. NBC. 31 Oct. 2001.

Episode 49: "War Crimes." Teleplay: Aaron Sorkin. Story: Allison Abner. Dir.: Alex Graves. NBC. 7 Nov. 2001.

Episode 50: "Gone Quiet." Teleplay: Aaron Sorkin. Story: Julia Dahl and Laura Glasser. Dir.: John Hutman. NBC. 14 Nov. 2001.

Episode 51: "The Indians in the Lobby." Teleplay: Allison Abner, Kevin Falls, and Aaron Sorkin. Story: Allison Abner. Dir.: Paris Barclay. NBC. 21 Nov. 2001.

Episode 52: "The Women of Qumar." Teleplay: Aaron Sorkin. Story: Felicia Wilson, Laura Glasser, and Julia Dahl. Dir.: Alex Graves. NBC. 28 Nov. 2001.

Episode 53: "Bartlet for America." Teleplay: Aaron Sorkin. Dir.: Thomas Schlamme. NBC. 12 Dec. 2001.

Episode 54: "H. Conn —172." Teleplay: Aaron Sorkin. Story: Eli Attie. Dir.: Vincent Misiano. NBC. 9 Jan. 2002.

Episode 55: "100,000 Airplanes." Teleplay: Aaron Sorkin. Dir.: David Nutter. NBC. 16 Jan. 2002.

Episode 56: "The Two Bartlets." Teleplay: Kevin Falls and Aaron Sorkin. Story: Gene Sperling. Dir.: Alex Graves. NBC. 30 Jan. 2002.

Episode 57: "Night Five." Teleplay: Aaron Sorkin. Dir.: Christopher Misiano. NBC. 6 Feb. 2002.

Episode 58: "Hartsfield's Landing." Teleplay: Aaron Sorkin. Dir.: Vincent Misiano. NBC. 27 Feb. 2002.

Episode 59: "Dead Irish Writers." Teleplay: Aaron Sorkin. Story: Paul Redford. Dir.: Alex Graves. NBC. 6 March 2002.

Episode 60: "The U.S. Poet Laureate." Teleplay: Aaron Sorkin. Story: Laura Glasser. Dir.: Christopher Misiano. NBC. 27 March 2002.

Episode 61: "Stirred." Teleplay: Aaron Sorkin and Eli Attie. Story: Dee Dee Myers. Dir.: Jeremy Kagan. NBC. 3 April 2002.

Episode 62: "Documentary Special." Dir.: Bill Coultouris. NBC. 24 April 2002.

Episode 63: "Enemies Foreign and Domestic." Teleplay: Paul Redford and Aaron Sorkin. Dir.: Alex Graves. NBC. 30 April 2002.

Episode 64: "The Black Vera Wang." Teleplay: Aaron Sorkin. Dir.: Christopher Misiano. NBC. 8 May 2002.

Episode 65: "We Killed Yamamoto." Teleplay: Aaron Sorkin. Dir.: Thomas Schlamme. NBC. 15 May 2002.

Episode 66: "Posse Comitatus." Teleplay: Aaron Sorkin. Dir.: Alex Graves. NBC. 22 May 2002.

Season 4

Episode 67: "20 Hours in America: Part I." Teleplay: Aaron Sorkin. Dir.: Christopher Misiano. NBC. 25 Sept. 2002.

Episode 68: "20 Hours in America: Part II." Teleplay: Aaron Sorkin. Dir.: Christopher Misiano. NBC. 25 Sept. 2002.

Episode 69: "College Kids." Teleplay: Aaron Sorkin. Story: Debora Cahn and Mark Goffman. Dir.: Alex Graves. NBC. 2 Oct. 2002.

Episode 70: "The Red Mass." Teleplay: Aaron Sorkin. Story: Eli Attie. Dir.: Vincent Misiano. NBC. 9 Oct. 2002.

Episode 71: "Debate Camp." Teleplay: Aaron Sorkin. Story: William Sind and Michael Oates Palmer. Dir.: Paris Barclay. NBC. 16 Oct. 2002.

Episode 72: "Game On." Teleplay: Aaron Sorkin and Paul Redford. Dir.: Alex Graves. NBC. 30 Oct. 2002.

Episode 73: "Election Night." Teleplay: Aaron Sorkin. Story: David Gerken and David Handelman. Dir.: Lesli Linka Glatter. NBC. 6 Nov. 2002.

Episode 74: "Process Stories." Teleplay: Aaron Sorkin. Story: Paula Yoo and Lauren Schmidt. Dir.: Christopher Misiano. NBC. 13 Nov. 2002.

Episode 75: "Swiss Diplomacy." Teleplay: Eli Attie and Kevin Falls. Dir.: Christopher Misiano. NBC. 20 Nov. 2002.

Episode 76: "Arctic Radar." Teleplay: Aaron Sorkin. Story: Gene Sperling. Dir.: John David Coles. NBC. 27 Nov. 2002.

Episode 77: "Holy Night." Teleplay: Aaron Sorkin. Dir.: Tommy Schlamme. NBC. 11 Dec. 2002.

Episode 78: "Guns Not Butter." Teleplay: Eli Attie, Kevin Falls, and Aaron Sorkin. Dir.: Bill D'Elia. NBC. 8 Jan. 2003.

Episode 79: "The Long Goodbye." Teleplay: Jon Robin Baitz. Dir.: Alex Graves. NBC. 15 Jan. 2003.

Episode 80: "Inauguration: Part I." Teleplay: Aaron Sorkin. Story: Michael Oates Palmer and William Sind. Dir.: Christopher Misiano. NBC. 5 Feb. 2003.

Episode 81: "Inauguration: Over There." Teleplay: Aaron Sorkin. Story: David Gerken and Gene Sperling. Dir.: Lesli Linka Glatter. NBC. 12 Feb. 2003.

Episode 82: "The California 47th." Teleplay: Aaron Sorkin. Story: Lauren Schmidt and Paula Yoo. Dir.: Vincent Misiano. NBC. 19 Feb. 2003.

Episode 83: "Red Haven's on Fire." Teleplay: Aaron Sorkin. Story: Mark Goffman and Debora Cahn. Dir.: Alex Graves. NBC. 26 Feb. 2003.

Episode 84: "Privateers." Teleplay: Paul Redford, Debora Cahn, and Aaron Sorkin. Story: Paul Redford and Debora Cahn. Dir.: Alex Graves. NBC. 26 March 2003.

Episode 85: "Angel Maintenance." Teleplay: Eli Attie and Aaron Sorkin. Story: Kevin Falls. Dir.: Jessica Yu. NBC. 2 April 2003.

Episode 86: "Evidence of Things Not Seen." Teleplay: Aaron Sorkin. Story: Eli Attie and David Handelman. Dir.: Christopher Misiano. NBC. 23 April 2003.

Episode 87: "Life on Mars." Teleplay: Aaron Sorkin. Story: Paul Redford and Dee Dee Myers. Dir.: John David Coles. NBC. 30 April 2003.

Episode 88: "Commencement." Teleplay: Aaron Sorkin. Dir.: Alex Graves. NBC. 7 May 2003.

Episode 89: "Twenty-Five." Teleplay: Aaron Sorkin. Dir.: Christopher Misiano. NBC. 14 May 2003.

About the Contributors

Susann Cokal is assistant professor of English at Virginia Commonwealth University and author of the novels *Mirabilis* and *Breath and Bones*. She has published articles on authors such as Marianne Wiggins and Georges Bataille, and on pop culture subjects such as supermodels and Mary Poppins.

Spencer Downing teaches U.S. history at the University of Central Florida in Orlando. His dissertation, "What TV Taught: Children's Television and Consumer Culture from Howdy Doody to Sesame Street," examines the growth of television and marketing in children's lives. His recent work deals with the way cultural producers hail consumers by examining subjects as diverse as Hopalong Cassidy films and hotels at Walt Disney World.

Thomas Fahy received his Ph.D. from the University of North Carolina at Chapel Hill in 2001. He is co-editor of both *Peering Behind the Curtain: Disability, Illness, and the Extraordinary Body* (2002) and *Captive Audience: Prison and Captivity in Contemporary Theater* (2003). He is also author of the monograph *Gabriel García Márquez's* Love in the Time of Cholera: *A Reader's Guide* (2003), and he recently published his first novel, *Night Visions*, with HarperCollins (2004).

Laura K. Garrett received her M.A. in history from San Francisco State University and formerly worked as a researcher for the Smithsonian Institution. Her research interests include women's history, social movements, and the media and politics. She teaches history in the San Francisco Bay Area.

Robert F. Gross teaches theater at Hobart and William Smith colleges. He is the author of *Words Heard and Overheard* and *S. N. Behrman: A Research and Production Sourcebook*, the editor of *Christopher Hampton: A Casebook* and *Tennessee Williams: A Casebook*, as well as the author of numerous articles on modern dramatists, from Henrik Ibsen and Gerhart Hauptmann to John Guare, Edward Albee, and Wendy Wasserstein.

Ann C. Hall is author of *"A Kind of Alaska": Women in the Plays of O'Neill, Pinter, and Shepard* and currently serves as president of the Harold Pinter Society and

as English Department chair at Ohio Dominican College. She has published widely on modern drama, literature, and feminism.

Douglas Keesey teaches twentieth-century fiction and film at California Polytechnic State University, San Luis Obispo. He has published a book on Don DeLillo as well as essays on James Dickey, Stephen King, Thomas Pynchon, and Peter Weir.

Fiona Mills is an assistant professor of English at Curry College. She has recently published articles in *Safundi* and *Americana: The Institute for the Study of American Popular Culture*. Currently, she is co-editing a book of collected essays on Gayl Jones.

John Nein grew up in both Europe and the United States. His undergraduate degree in history is from Carleton College. He recently graduated from the UCLA School of Theater, Film and Television, where he earned his MFA in film directing and lobbied tirelessly for better coffee in the vending machines. He lives in Los Angeles, where he is a writer and director.

Nathan A. Paxton, a Ph.D. candidate in the Department of Government at Harvard University, studies political philosophy and international relations.

Kirstin Ringelberg is an assistant professor of art history at Elon College. She has forthcoming articles in *Prospects: An Annual of American Cultural Studies* and the *Journal of Popular Culture*. As a scholar, she is interested in nineteenth-century American art as well as television and film.

Index

Frank, Scott 37
Freud, Sigmund 22, 27, 56, 88n.2

Gallop, Jane 39
Gelbart, Larry 12
gender 3, 5, 6, 11, 15, 98, 107, 113n.11;
 constructions of 6, 31–32; inequality
 7, 9, 91–92, 94, 98, 107, 111, 112n.2,
 160–161; stereotypes about 9, 113n.7,
 113n.9, 179–192
genius 1–3
The Glass Menagerie 24
Goldberg, Jonah 142
government 8, 9, 62–63, 95, 109, 115–
 118, 123, 125, 129–130, 134–144, 144n.1,
 147–155, 160–166, 170, 171–173, 180,
 193–194, 203–204, 208
grammar 4, 6, 62, 72–73
Grove, Lloyd 134
Guthmann, Edward 134

Hamby, Alonzo L. 129–130
Hamlet 23
Hawks, Howard 92, 99
Hays, Will 93
Hayton, Heather Richardson 119, 125
HBO 16–17, 21
Heifer International 136
Hemingway, Ernest 4
Henry V 202
heterosexist 94, 113n.4
heterosexual 21–22, 33, 98
His Girl Friday 92, 95
Holmes, Sherlock 1, 3
homoerotic 31
homosexual 102, 113n.5
Howe, Deson 105, 110–111
humor 5, 6, 64, 70–72, 74, 81, 120, 133,
 196

idealism 9, 14–15, 26, 29, 33, 91, 93, 95,
 100, 115–120, 125, 128–131, 133–144,
 149, 156–157, 165, 168, 180, 193–208

James, Caryn 115
Johnson, Michael 166

Kelley, David E. 2
Kempley, Rita 110
Kennedy, Jackie 181
Kennedy, John F. 119, 120, 150–151, 202

Lane, Christina 98, 160
Lasalle, Mick 92–94
Lehmann, Chris 130, 143, 155
Levine, Lawrence W. 75n.3
Levine, Myron A. 98, 115, 121, 123, 124
liberalism 8, 127–145
Liberalism and Its Challengers (Hamby)
 129
Lincoln, Abraham 166
Long Day's Journey into Night (O'Neill)
 19

Madison, James 165
Malice (Sorkin and Frank) 3, 5, 6, 19–35,
 37–60
Mamet, David 4, 15–16
manhood 6, 26, 51, 82, 163
mannerism 5, 19–35
"Mannerism and Claustrophobia"
 (Aleinikov) 19
Mary Tyler Moore Show 12
masculinity, 7, 23, 25, 30, 31, 60n.12,
 83, 110, 113n.4
M.A.S.H. 12–13
McClintock, Anne 109, 113n.14, 113n.15
McLuhan, Marshall 119
Mead, Margaret 206
Menander 20
Meyers, Dee Dee 9, 118, 180, 185–187
Mill, John Stuart 207
Mr. Smith Goes to Washington 20, 95,
 135
morality 3, 9, 61–69, 74–75, 93, 96,
 97–99, 102–110, 117, 121–123, 128,
 130–144, 168–173, 195–203
motherhood 28–34, 43, 50, 181–183
Mulvey, Laura 27
Murphy Brown 12

narrative 6, 8, 31–33, 34n.1, 37–60,
 61–69, 104–111, 127–144, 162, 166–
 171, 189
New Deal 129, 144
News Hour with Jim Lehrer 62, 157,
 209
Night and the City 21, 28
Noonan, Peggy 118, 142
Nussbaum, Martha C. 63, 64

On Liberty 207
O'Neill, Eugene 19